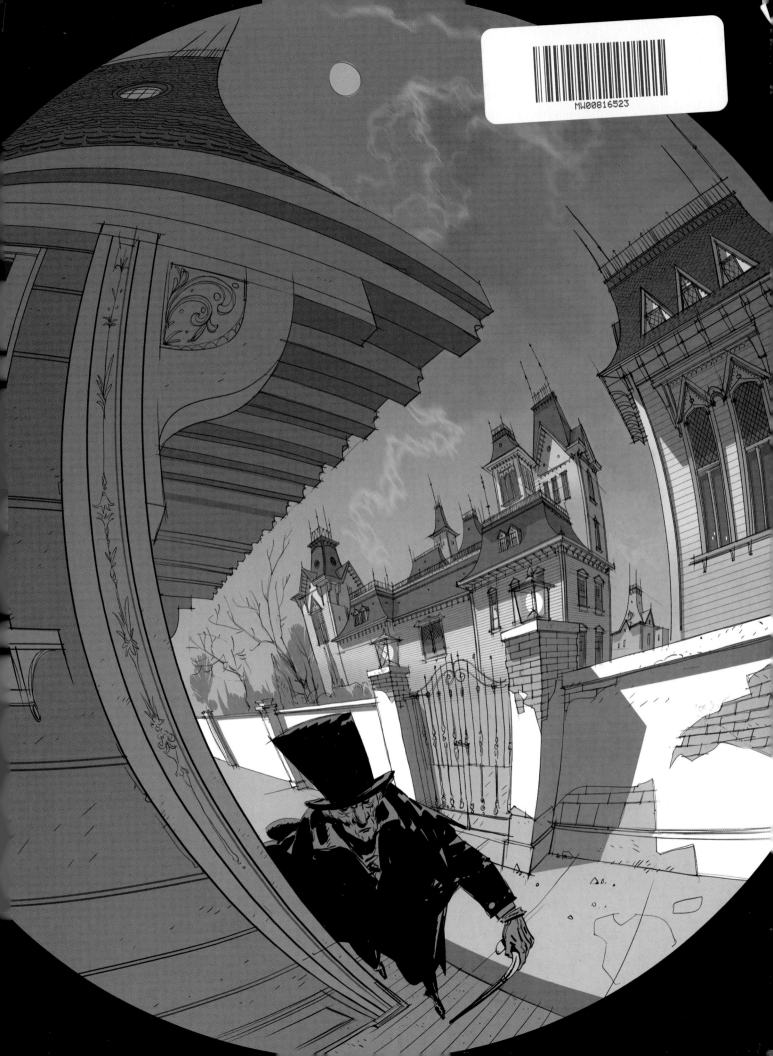

Copy Editors: Melissa Kent, Scott Robertson, Heather Dennis
Graphic Design: Marcos Mateu-Mestre,
 Alyssa Homan,
 Christopher J. De La Rosa

Published by Design Studio Press
Website: www.designstudiopress.com
E-mail: info@designstudiopress.com

Printed in China | First Edition, September 2016

10 9 8 7 6 5

Library of Congress Control Number 2016949360
ISBN: 978-1-624650-30-7

MARCOS MATEU-MESTRE

FRAMED PERSPECTIVE VOL. 1

TECHNICAL PERSPECTIVE AND VISUAL STORYTELLING

designstudio|PRESS

To Alfie and Arianna

Special thanks to:

Joan Mateu

Margalida Mestre

Carme Mateu

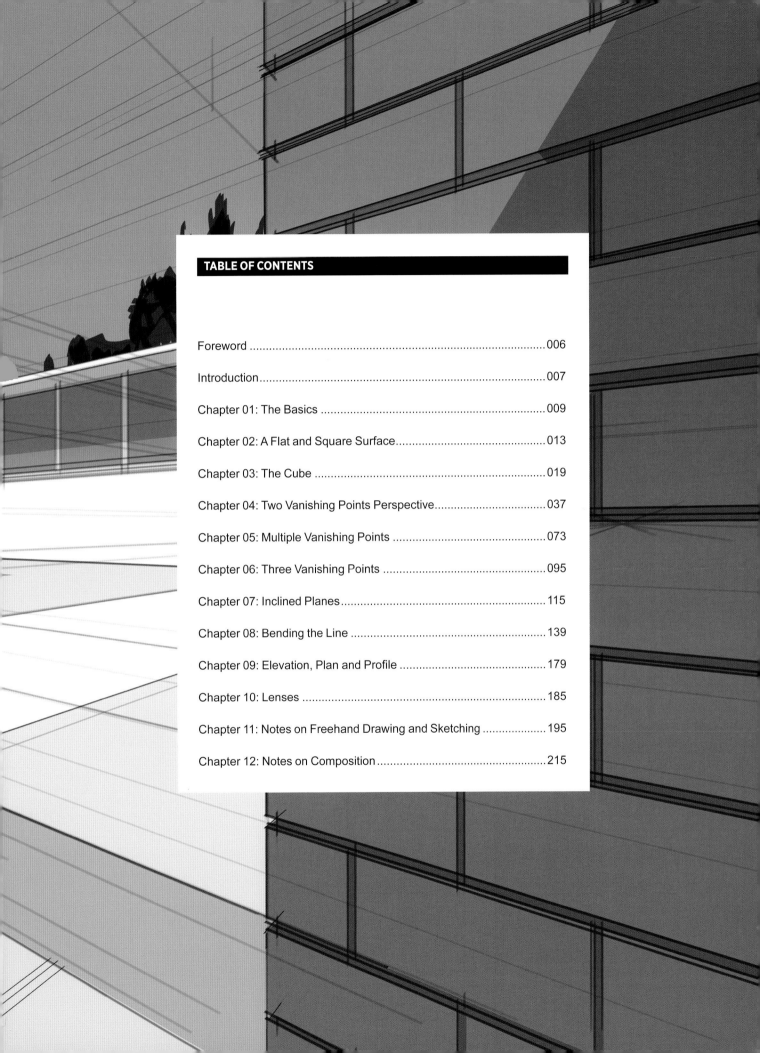

TABLE OF CONTENTS

FOREWORD

You are clearly already an enlightened person for your interest in learning to improve your perspective drawing skills, and you have chosen a wonderful book to help you do just that. Marcos is an exceptional teacher on this subject, and, perhaps even more importantly, looking at his artwork just makes one want to draw! Not only is the technical knowledge shared and his command of composition, line quality, and visual storytelling impressive, but it can also help any beginner or pro alike to improve the often frustrating task of technical perspective drawing.

Once you begin to master the skill of creating believable-looking worlds in perspective, what might have been one of your drawing liabilities will soon instead become one of your assets, and eventually second nature. For many years now I have enjoyed applying the fundamentals of perspective drawing within my own work, and I know it has immense value. I applaud you for wishing to learn this knowledge and apply these techniques to your own work. Enjoy the journey, and here's a big thanks to Marcos for the commitment of energy and time it takes to create a book of this nature!

Scott Robertson.

Author of *How To Draw, How To Render*
Founder of Design Studio Press

Los Angeles
August 2016

INTRODUCTION

About the spaces we move within.

As we get older, we are expected to have better judgment and to make more mature decisions, which should then lead to more effective outcomes. The more experience we have, the more we have seen, the more we have suffered the consequences of poor decisions and the rewards of well informed ones, the more we know what to do and where it will take us.

It could all come down to how many references are archived in our system. These memories allow us to see the same situation from many different points of view simultaneously, many more than if certain experiences had yet to take place.

In a way this is what perspective is all about: being aware of the space we are immersed in and being able to understand it from many different angles at the same time so that we know how to deal with it properly.

Once our understanding of a situation has become richer or more complex, then we can preview things more easily, knowing from where to take off and where we should end if we follow a certain path.

Essentially, we can be more confident to aim for a goal and know that our chosen path will lead us there.

The intention of this book is to hopefully be yet another set of shoes and a compass that will help set up a solid ground on which to travel confidently and comfortably.

—Marcos
Mateu
3-2016

1 THE BASICS

From the first moment of starting to draw in perspective, there are some necessary basic ideas and vocabulary with which to become familiar, as they will be common across the whole process.

Parallel: Two or more lines that are at an equal distance from each other and therefore no matter how long they are they will never come in contact or cross each other, fig. 1.1–1.2.

fig. 1.1

fig. 1.2

Perpendiculars: Lines that are right angles (90-degree angles) to each other, figs. 1.3–1.5.

fig. 1.3

fig. 1.4

fig. 1.5

Diagonal: A straight line that connects two nonconsecutive vertices of a polygon, like the opposite corners of a rectangle. It is also commonly used to describe any line with a slant, figs. 1.6–1.8.

fig. 1.6

fig. 1.7

fig. 1.8

Eye Level: Eye level is located exactly at the height of sight (or eyes) at any given time; therefore it follows wherever the viewer goes: sea level, atop the highest mountain, inside the cockpit of an airplane (as long as it does not go so high that the curvature of the planet's horizon becomes too obvious). Except for some rare cases, eye level coincides with the actual horizon (or the line where sea and sky meet), figs. 1.9–1.10.

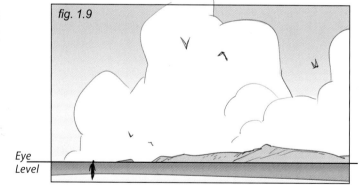

fig. 1.9

Eye Level

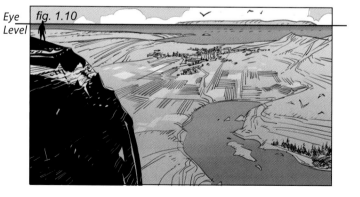

Eye Level

fig. 1.10

Zenith: A point located at the top end of an imaginary line that is perpendicular to the ground plane, as if such a line were coming straight out from the center of the Earth, past its surface, and up. It could also be described as an imaginary point right above the place where the object we are observing is located.

Nadir: The point located at the opposite end of a zenith, basically the center of the Earth.

The Observer: The character through whose eyes the scene is viewed. Whether that person is 7-feet tall or 1-foot small, the eyes are always the specific point of reference.

Line of Sight: An imaginary line that represents the straight direction in which the observer's eyes are looking, fig. 1.11.

Horizon Plane: A plane that, going through the viewer's eyes, contains the line of sight, fig. 1.11.

Center of Vision: The precise point on which the eyes of the observer are focused. This point is at the end of the line of sight.

The Cone of Vision: The area that a character's eyes naturally see at any given time, including peripheral vision. It so happens that the area forms the shape of a cone, and its axis is the line of sight. The cone of vision has an aperture of approximately 60 degrees when looking straight ahead, so in order to see more of a landscape's surroundings while still focusing on the same center

of vision, the observer must pull back so that more landscape can be included in this same cone of vision. In reverse, the closer one gets to an object being focused on (that is, following the path of the line of sight toward the center of vision) the less will be seen of the object's surroundings, figs. 1.11–1.12.

The Picture Plane: An imaginary plane, perpendicular to the observer's line of sight that is located somewhere between the observer's eyes and the object being observed. Vision is the perception of light, reflected off objects, that comes straight toward the eyes. So the picture plane is like a sheet of glass where all this visual perception gets stopped and somehow trapped on this new flat, bidirectional reality that eventually will become the drawing, figs. 1.14–1.15.

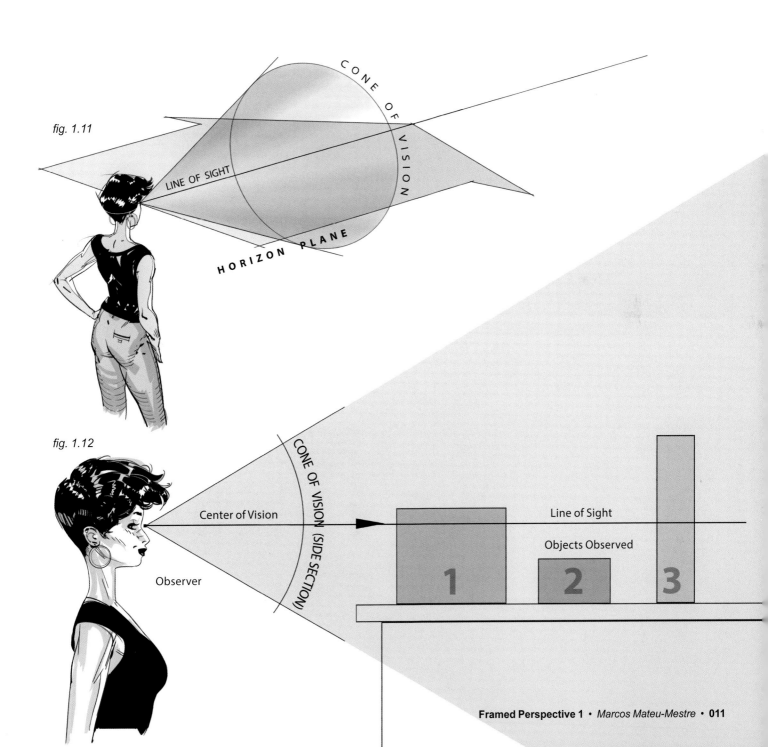

fig. 1.11

fig. 1.12

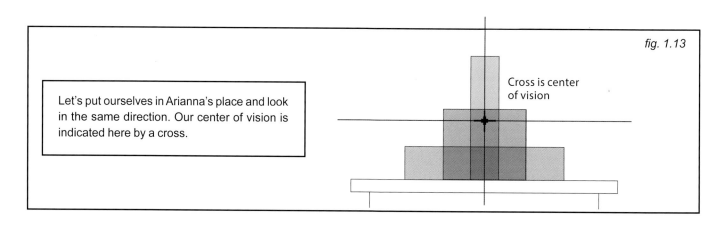

Let's put ourselves in Arianna's place and look in the same direction. Our center of vision is indicated here by a cross.

fig. 1.13

Cross is center of vision

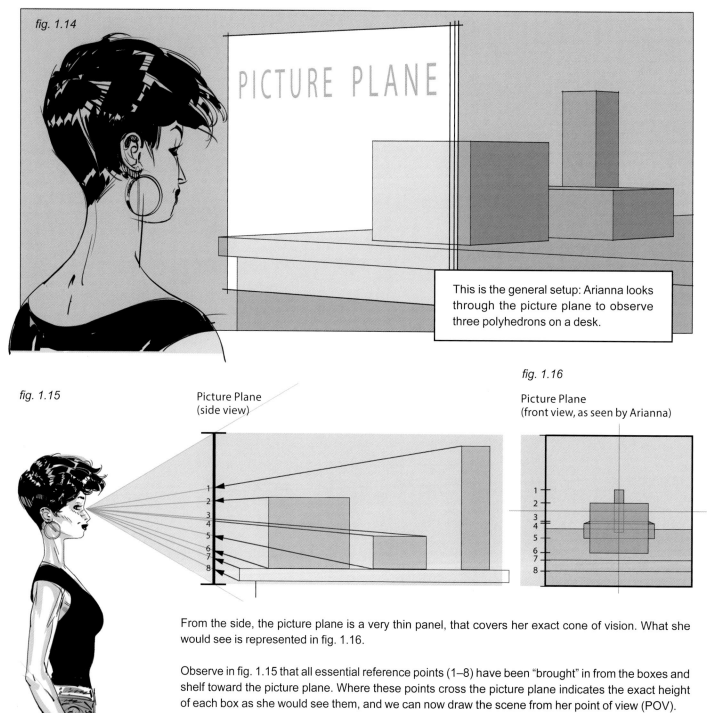

fig. 1.14

PICTURE PLANE

This is the general setup: Arianna looks through the picture plane to observe three polyhedrons on a desk.

fig. 1.15

fig. 1.16

Picture Plane (side view)

Picture Plane (front view, as seen by Arianna)

From the side, the picture plane is a very thin panel, that covers her exact cone of vision. What she would see is represented in fig. 1.16.

Observe in fig. 1.15 that all essential reference points (1–8) have been "brought" in from the boxes and shelf toward the picture plane. Where these points cross the picture plane indicates the exact height of each box as she would see them, and we can now draw the scene from her point of view (POV).

2

A FLAT AND SQUARE SURFACE

fig. 2.1

fig. 2.2

Arianna's Eye Level

Fig. 2.1: Here Arianna stands in front of a square surface that is positioned vertically, just like a painting hanging on a wall. Obviously, being square, all sides have the same length. Because this surface is in a flat, vertical position in front of her, she perceives its shape as an actual square, without any perspective distortions.

Fig. 2.2: Now the square lies flat and parallel to the horizontal floor plane, as indicated. Side A is farther away from Arianna than side B, which remains where it was in fig. 2.1.

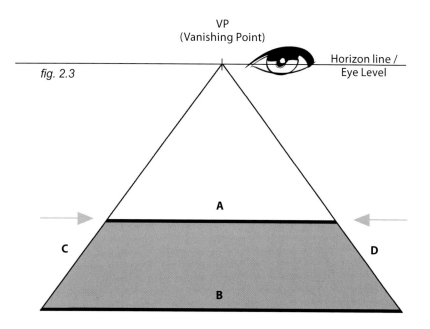

VP
(Vanishing Point)

Horizon line / Eye Level

fig. 2.3

Fig. 2.3: Sides A and B have the same length, but since side B is now closer to Arianna than A, it appears to her that B is longer than A. In other words, A looks shorter or smaller than B. Because this is a square, sides C and D are in fact parallel to each other, but now they appear to converge toward a distant point that is called the **vanishing point** (VP).

The horizontal line on which the vanishing point is located is called the **horizon line** (HL), and it will indeed coincide with the eye level of Arianna. Whatever is below her eye level in reality will, in the drawing, be below the horizon line. Conversely, whatever is above her eye level in reality, will appear above the horizon line in the drawing.

fig. 2.4

fig. 2.5

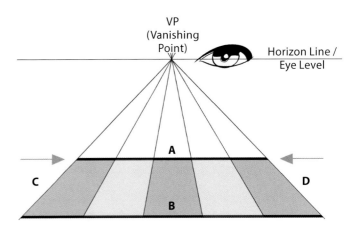

Fig. 2.4: We know that when parallel lines, like C and D, extend away from the viewer into the distance, they all converge to the same vanishing point. Imagine therefore that the square in this exercise has a number of parallel lines painted on its surface.

Fig. 2.5: The moment this surface is laid down on the flat floor, then all parallels converge to the same vanishing point on Arianna's eye level, also called the horizon line.

fig. 2.6

fig. 2.7

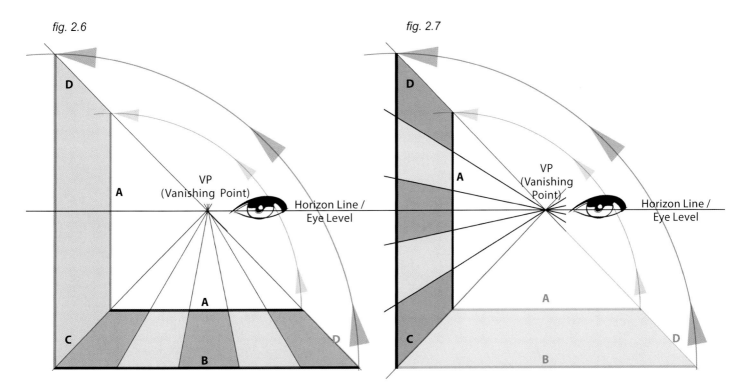

Fig. 2.6: We can flip the square back to vertical, this time by rotating it on its "C" side. Because sides C and D are parallel, they still converge to the same vanishing point as before.

Fig. 2.7: This is what such a square would look like from our point of view, with all parallel lines extending into the distance and converging on one single vanishing point on the horizon line, located at eye level. Let's not forget, this is all an optical illusion, a way to represent three-dimensions on a two-dimensional surface.

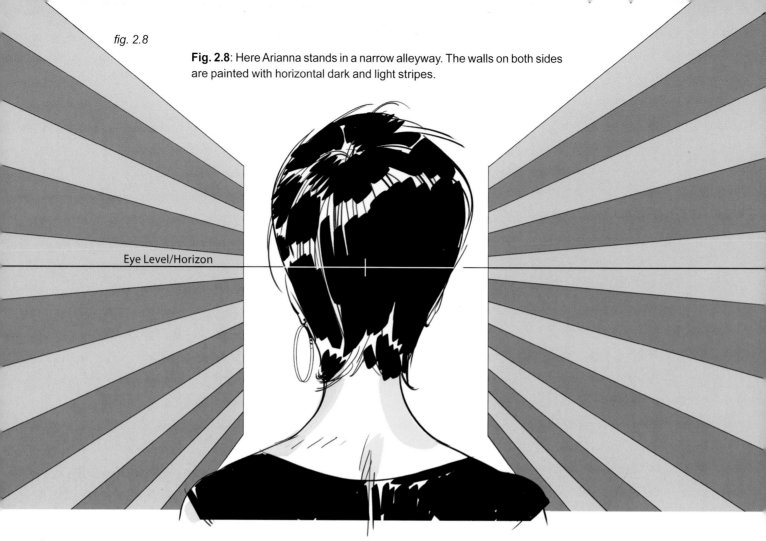

fig. 2.8

Fig. 2.8: Here Arianna stands in a narrow alleyway. The walls on both sides are painted with horizontal dark and light stripes.

Eye Level/Horizon

Fig. 2.9: In everyday examples of this sort (e.g. city streets) there is always a good way to tell what lines (e.g. windows) are above eye level and which ones are beneath.

Starting at the top, all lines go upward from left to right. Observe that as the lines get closer to the horizon, the angle of the incline diminishes.

There is a point where the angle changes and the lines actually start going downward from left to right.

At the very point this change happens; that is the location of the horizon line.

As simple as this may sound, it has many practical applications, like when reading a cityscape or similar, and will be discussed in more detail later.

fig. 2.9

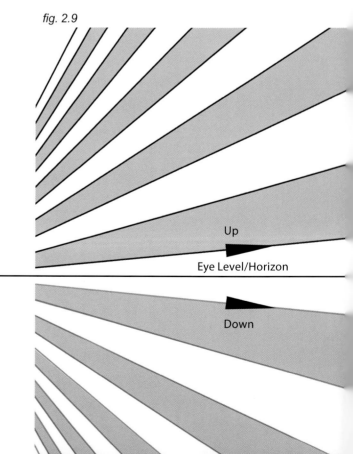

Up

Eye Level/Horizon

Down

HL VP

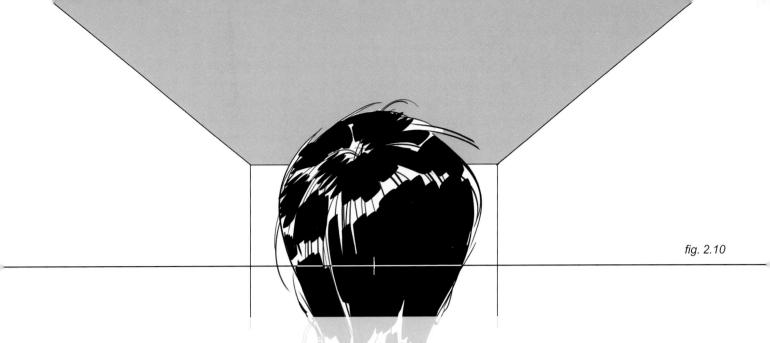

fig. 2.10

Fig. 2.10: If we were to add a flat ceiling above the corridor, that surface would look similar to the one in fig. 2.3. However, because this surface is above her eye level, she now sees this surface from underneath, as opposed to fig. 2.3 when she saw the plane from above.

Fig. 2.11: So this flat plane, located above eye level and therefore seen from underneath, appears to look like this to Arianna.

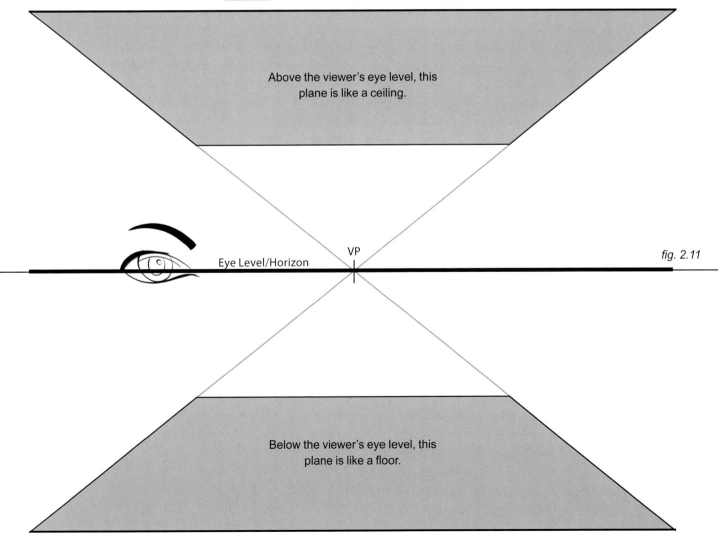

Above the viewer's eye level, this plane is like a ceiling.

VP

Eye Level/Horizon

fig. 2.11

Below the viewer's eye level, this plane is like a floor.

3

THE CUBE

FRONTAL VIEW/ ONE VANISHING POINT

THE CUBE

Fig. 3.1: Now that we are familiar with a flat plane and how visual perception of it varies depending on the viewer's relative position to it, as well as how things appear smaller when farther away, it is time to examine a new figure: **the cube.**

We will use a cube made of glass. It is transparent and therefore every side, edge and corner of it is visible from any position.

We will, in this case, position such a cube in front of Arianna, as if it were floating in midair with her "eye level" right in the middle of the side facing her, the same as with the square in the previous examples.

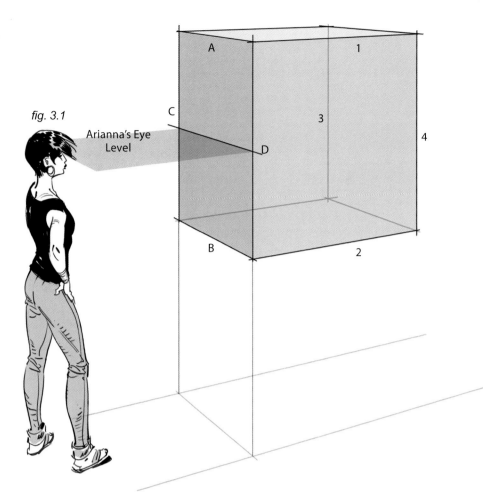

fig. 3.1

Arianna's Eye Level

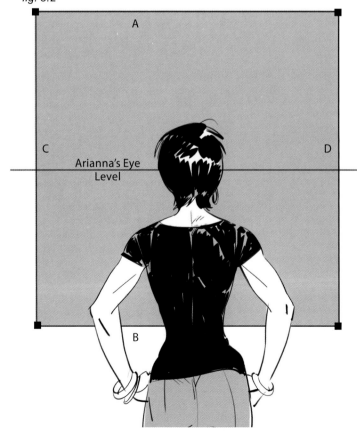

fig. 3.2

Arianna's Eye Level

Fig. 3.2: Seen from behind Arianna, the image of her and the cube looks exactly like fig. 2.1 (page 014), but now she is not in front of a flat, two-dimensional surface but in front of a cube, which has a depth and is three-dimensional.

Given this new situation, how will things look from Arianna's point of view?

Fig. 3.3: Here is the cube viewed more from the side. The side that faces Arianna straight on is shaded darker. From each of the four corners of this dark side, those edges appear to point away from her (thicker lines). It is very important to note that these four edges are perfectly parallel with one another.

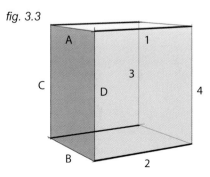

fig. 3.3

Fig. 3.4: Following the principle that all parallel lines converge to the same vanishing point, these four edges must converge at the same vanishing point located right on the horizon line, at eye level.

The square on the far side of this cube (whose four corners coincide with the four edges of the cube, as well with the four corners of the side facing Arianna) appears to be smaller than the closer side. This is the way it is naturally perceived.

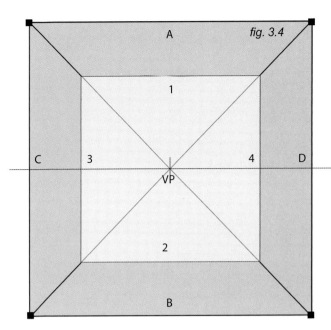

fig. 3.4

fig. 3.5

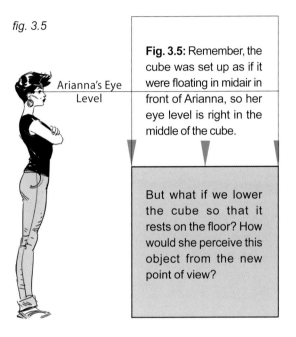

Fig. 3.5: Remember, the cube was set up as if it were floating in midair in front of Arianna, so her eye level is right in the middle of the cube.

But what if we lower the cube so that it rests on the floor? How would she perceive this object from the new point of view?

Figs. 3.6–3.7: Because the cube is entirely below her eye level, the whole cube will be beneath the horizon line in the drawing.

The top of the cube that she used to see from below (see arrows), she now sees from above.

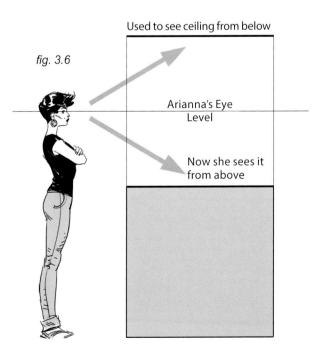

fig. 3.6

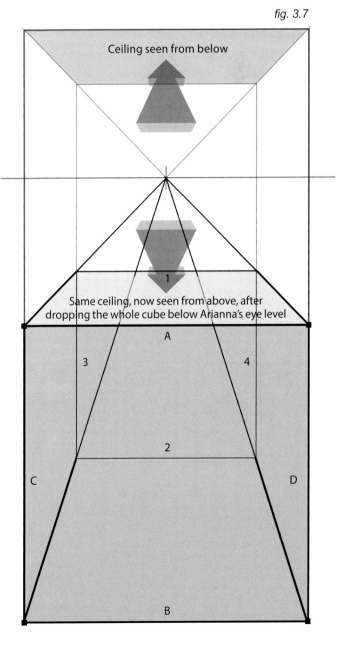

fig. 3.7

Ceiling seen from below

Same ceiling, now seen from above, after dropping the whole cube below Arianna's eye level

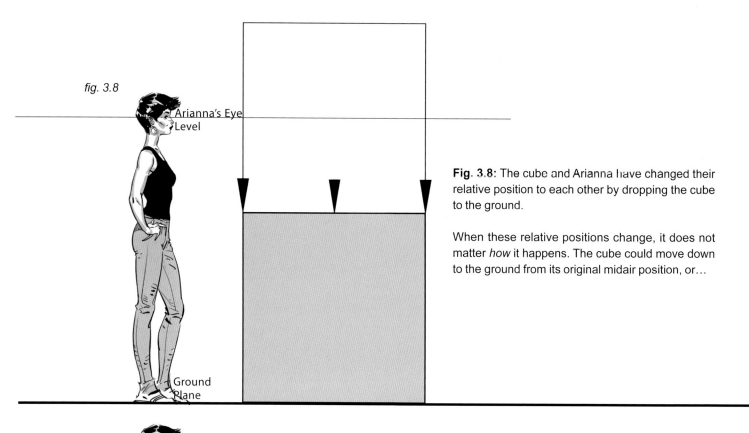

fig. 3.8

Arianna's Eye Level

Ground Plane

Fig. 3.8: The cube and Arianna have changed their relative position to each other by dropping the cube to the ground.

When these relative positions change, it does not matter *how* it happens. The cube could move down to the ground from its original midair position, or...

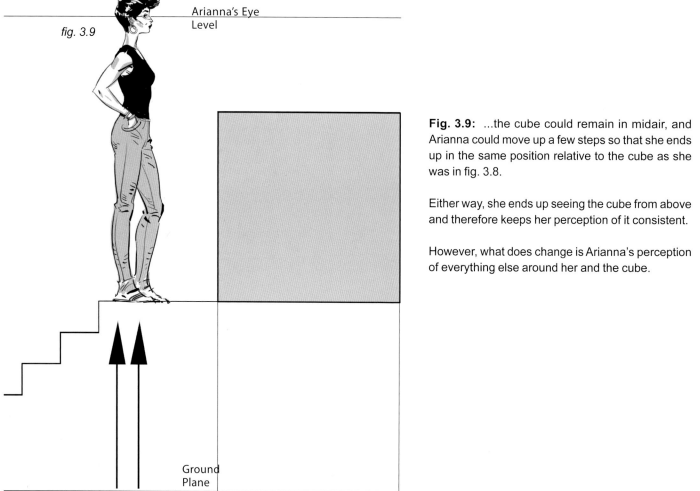

Arianna's Eye Level

fig. 3.9

Ground Plane

Fig. 3.9: ...the cube could remain in midair, and Arianna could move up a few steps so that she ends up in the same position relative to the cube as she was in fig. 3.8.

Either way, she ends up seeing the cube from above and therefore keeps her perception of it consistent.

However, what does change is Arianna's perception of everything else around her and the cube.

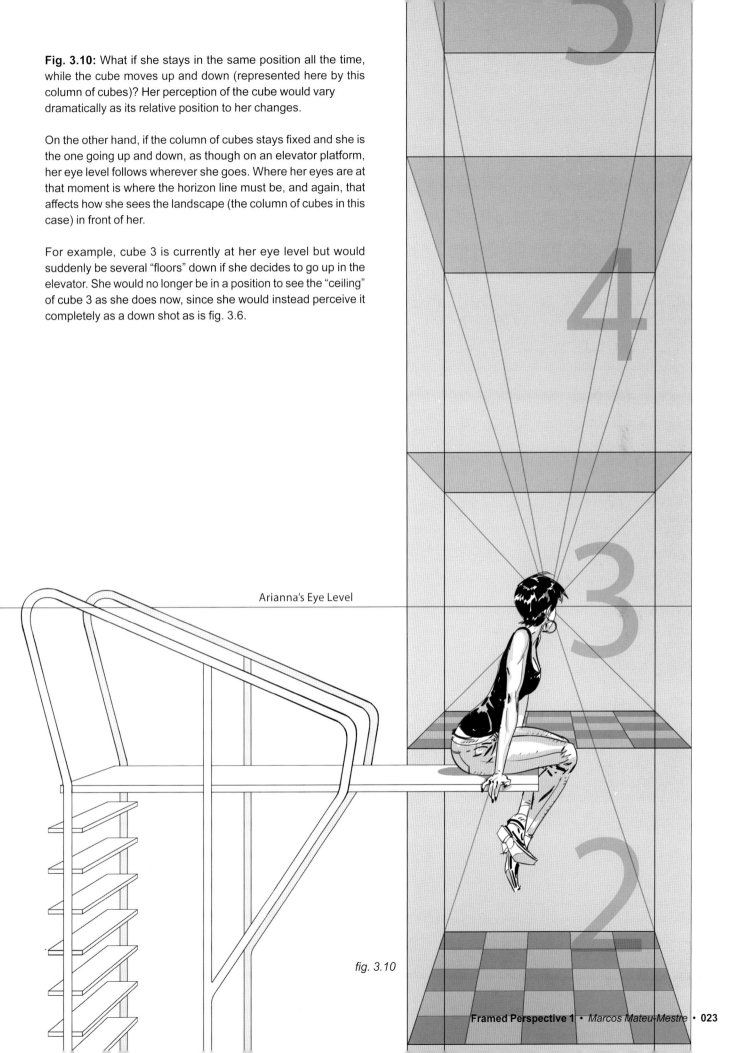

Fig. 3.10: What if she stays in the same position all the time, while the cube moves up and down (represented here by this column of cubes)? Her perception of the cube would vary dramatically as its relative position to her changes.

On the other hand, if the column of cubes stays fixed and she is the one going up and down, as though on an elevator platform, her eye level follows wherever she goes. Where her eyes are at that moment is where the horizon line must be, and again, that affects how she sees the landscape (the column of cubes in this case) in front of her.

For example, cube 3 is currently at her eye level but would suddenly be several "floors" down if she decides to go up in the elevator. She would no longer be in a position to see the "ceiling" of cube 3 as she does now, since she would instead perceive it completely as a down shot as is fig. 3.6.

Arianna's Eye Level

fig. 3.10

Figs. 3.11–3.14: In these examples, the theories explained in the previous pages are applied to very basic exercises, creating volumes that make sense within the space in which they are located.

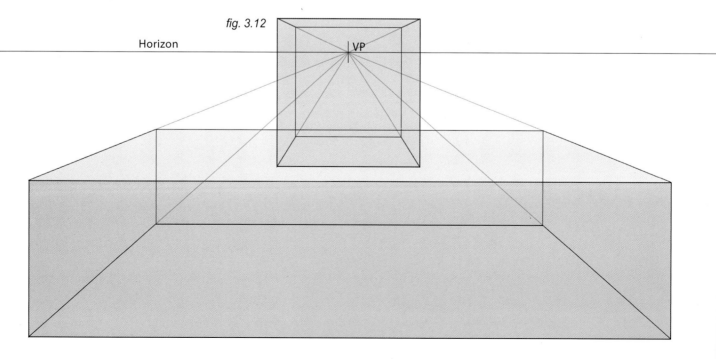

fig. 3.11

Horizon VP

fig. 3.12

Horizon VP

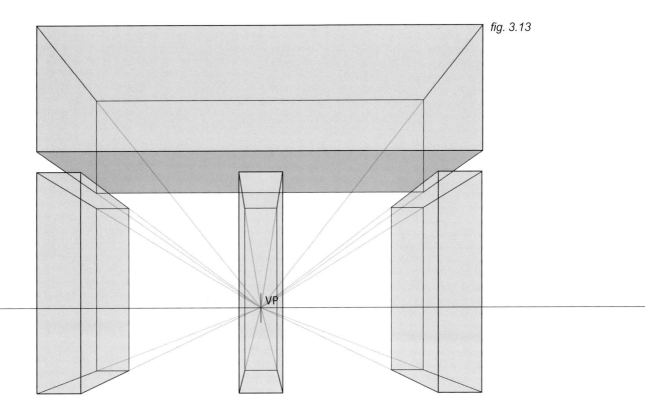

fig. 3.13

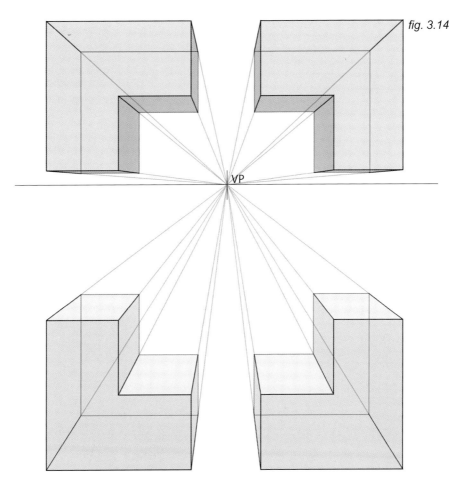

fig. 3.14

fig. 3.15

Figs. 3.15–3.16 are two more examples of how a number of polyhedrons would look within a certain space, seen in one-point perspective, meaning there is only one single vanishing point. Fig. 3.15 could be viewed as either a modern three-dimensional piece of artwork hanging from a vertical wall while we look straight into the center of it, or simply as a down shot or bird's eye view into an irregularly shaped box containing three polyhedrons.

Fig. 3.16 would also be a good basis for an illustration of a cabaret dressing room, as we'll see later (fig. 3.34 on page 035).

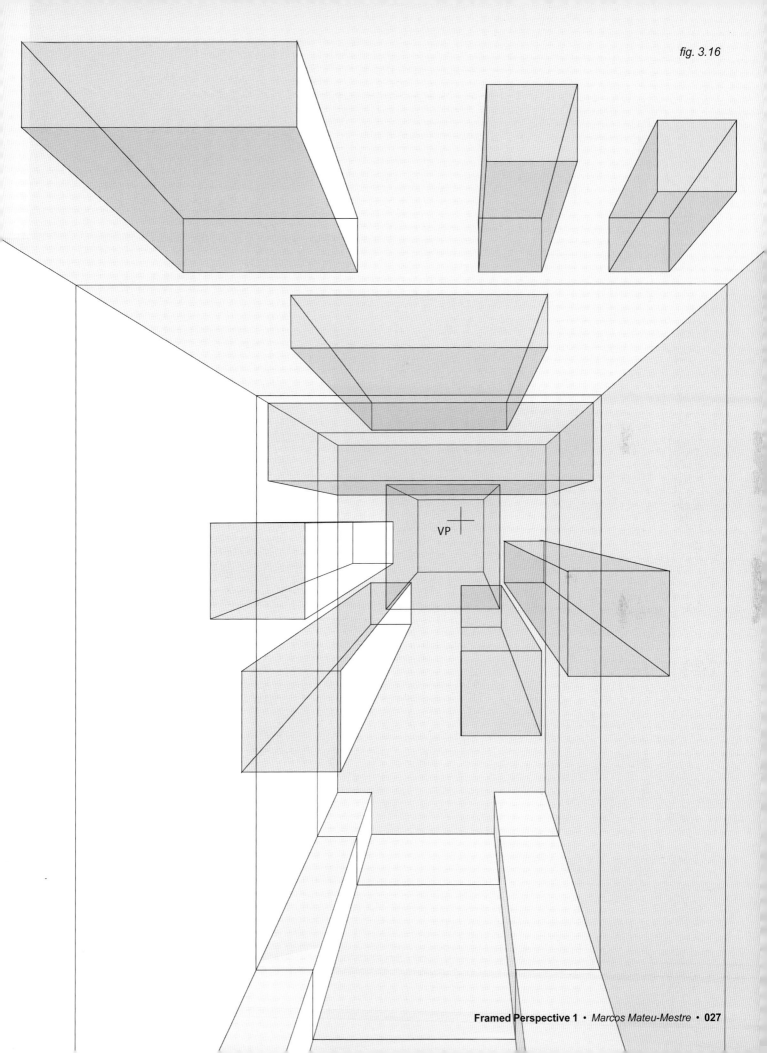

fig. 3.16

VP

Fig. 3.17: When working with cube-like volumes and shapes, one more fact about perspective that leads to more dynamic shots is represented here. A number of equal-sized cubes were drawn using a one-point perspective. The cubes are aligned horizontally and we are at one end, looking through all four cubes and straight into the vanishing point.

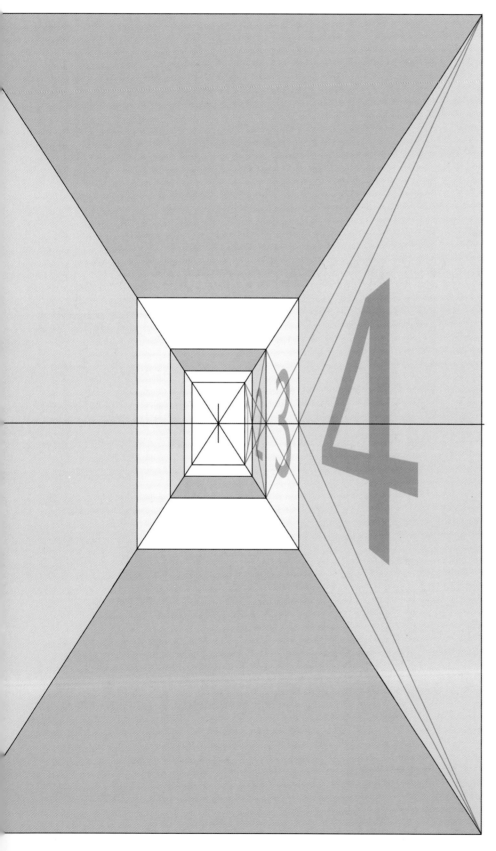

The space was narrowed here by pulling the left and right walls toward the center. When the walls are close to the axis between the spectator and the VP—in other words, when the viewer is very close to one or both of the walls—the apparent size of the sections (1, 2, 3 and 4) scales up pretty quickly as they get closer. Number 1 looks really small and narrow, while number 2 barely changes size. Number 3 appears somewhat bigger and finally number 4 appears much larger than the rest.

To create the correct proportional size progression as the cubes come closer to us, please refer to pages 050–055, or to fig. 4.51 on page 054.

fig. 3.17

BASIC FACTS SO FAR

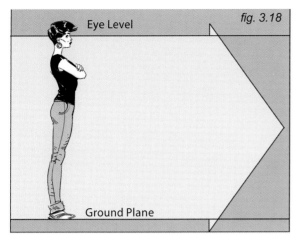

Fig. 3.18: At this point we assume that we are always looking straight to the horizon, meaning our eye-level plane and the ground plane are parallel to each other.

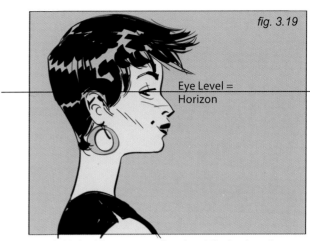

Fig. 3.19: In this case, eye level and the horizon line are one and the same.

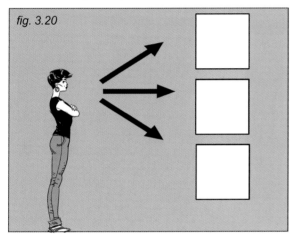

Fig. 3.20: It is all about our relative position to the objects we see.

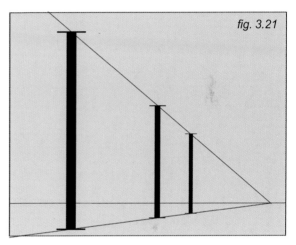

Fig. 3.21: Objects appear to be smaller in size; the farther they go into the distance. This is called foreshortening.

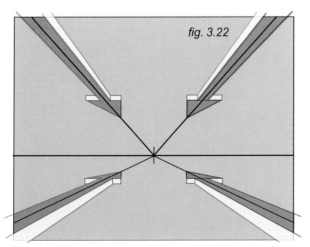

Fig. 3.22: Lines that in reality are parallel to each other will converge to the same spot, called the vanishing point. When these parallel lines are also parallel to the ground plane, such a vanishing point will be located on the horizon line. (In Chapter 7, we will see what happens when parallel lines are not parallel to the ground plane.)

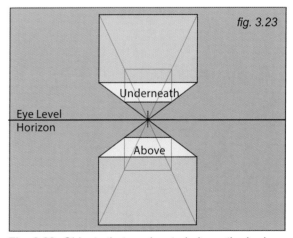

Fig. 3.23: Objects that are located above the horizon line (eye level) we see from underneath. Objects that are below the horizon line, we see from above.

EXAMPLES

fig. 3.24

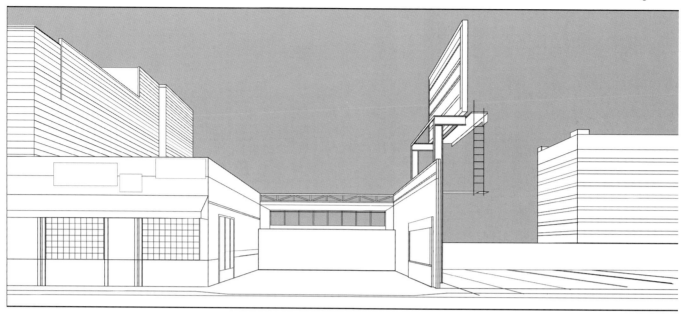

Here are some examples of one-point perspective. To achieve the image in fig. 3.24 we have to first understand where the horizon line is and where on it the vanishing point should be located.

Once we have that and an idea of the environment we want to create (based on sketches, photographic reference, etc.) we go for a very basic construction like the one in fig. 3.26.

fig. 3.25

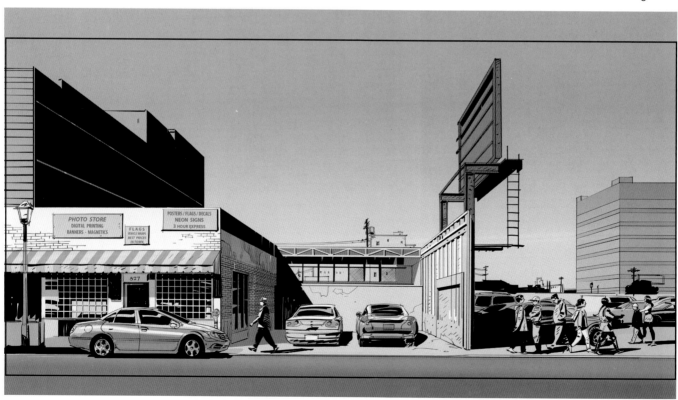

fig. 3.26

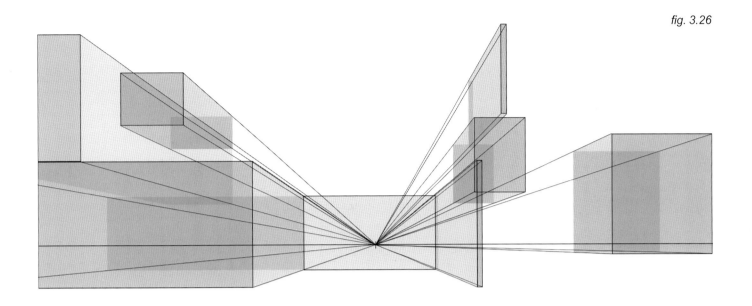

Fig. 3.26: In one-point perspective, the construction is based on the idea of simple boxes, making sure all parallel lines, edges and sides converge toward and meet at a single vanishing point. All doors, windows, bricks and signs on those walls either converge to that vanishing point or look flat on the walls that face the viewer.

The side-view of the car at the very left of fig. 3.25 is an exception because it is on an inclined plane, given the slight curve of the road. This is something that will be addressed later in this book.

Once there is a solid start and basic structure, it is a matter of creating the details that make the scene look and feel real. It is also time to decide on a lighting aspect for the drawing, which was covered in detail in my previous book, *Framed Ink*.

Framed Perspective 2 will address how to create shadows in the correct perspective.

fig. 3.27

fig. 3.28

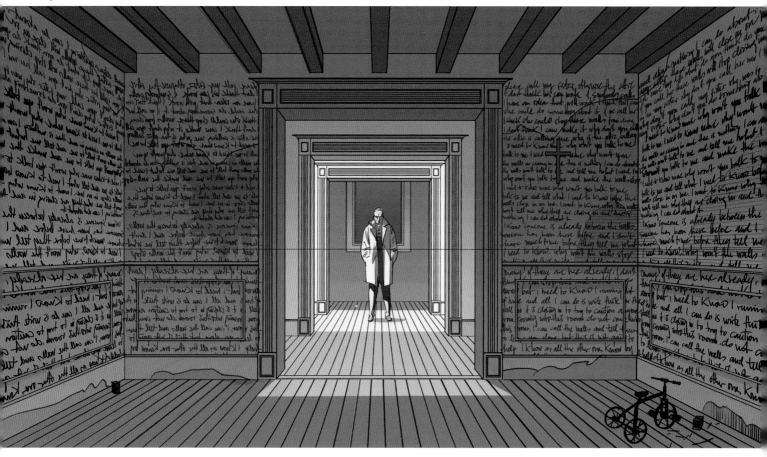

Fig. 3.28: One-point perspective is an effective way to express the multilayered intricacy and maze-like quality of the haunted room.

In addition to the lines converging to the vanishing point, the overlapping of the different walls creates a sense of depth and mystery.

fig. 3.29

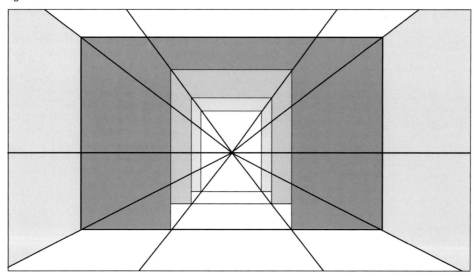

Fig. 3.29: The basic structure of this shot is very simple. After thinking and sketching it out, create the horizon line and the vanishing point (here almost centered in the frame) and then create the space for the front (haunted) room. All the chambers down the hall have exactly the same repetitive shape and size, like clones of this first room. For clarity and readability of the image, be careful that each door frame in the shot does not obscure the one behind it.

As long as the door frames do not overlap, each will be properly seen with a clear and fast read, so that the viewer does not have to guess what is going on. This automatically gives a clear mental image of the walls on either side of the doors since this is visually explained and clarified by the foreground wall of which they are pretty much a clone.

Chapter 4, pages 044-048, will explain how to figure out the exact placement of each wall, assuming the space between them is exactly the same. In this illustration such spaces are perceived to get smaller as they go farther into the distance, foreshortening.

fig. 3.30

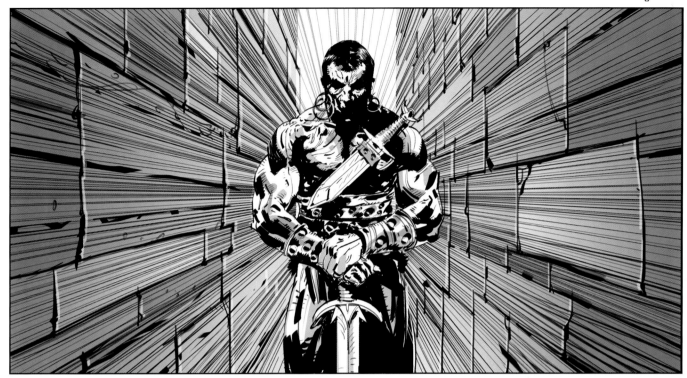

The use of various perspective solutions for the background brings different feelings to the frame, even when the character or main subject remains the same. **Fig. 3.30** has a much more dynamic impact by using one-point perspective to create the sense of a deeper space. The feel is more proactively aggressive and expansive. This particular method can sometimes create the visual illusion of wings or some type of aura, giving the character a somewhat otherworldly feel.

Fig. 3.31: By eliminating depth cues and creating a solid, flat space behind the warrior, the image automatically becomes calmer while still offering a certain unchallengeable image of the warrior.

fig. 3.31

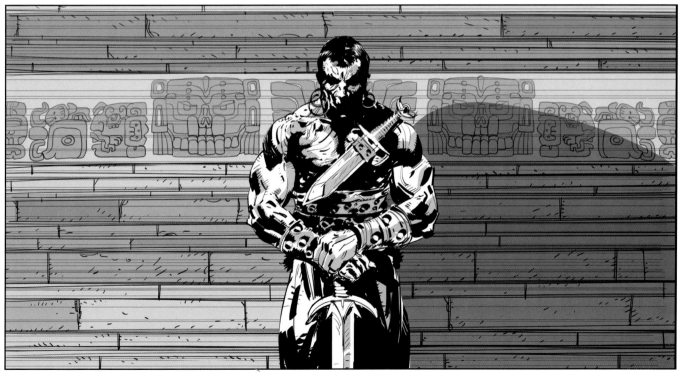

fig. 3.32

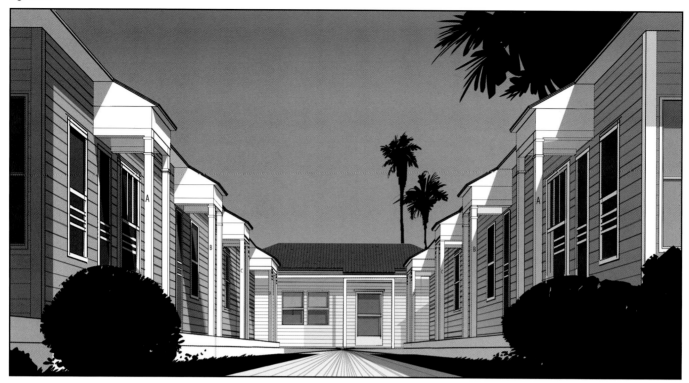

The choice of perspective can influence the perception of the same location in different ways. By lowering the camera (fig. 3.32), the apartment block becomes a rather imposing structure given the perfect symmetry of the shot and an implicit degree of claustrophobia, as none of the surroundings are visible except for the front yard.

Fig. 3.33: The choice of a higher "camera" (*or point of view, eye level* or *horizon*) gives the viewer a good comprehension of the location in general, since not only is the apartment block visible, but also the immediate surroundings as well as the city in the distance, which puts everything in a more geographical context. This could be a good choice for an establishing shot for an upcoming story.

fig. 3.33

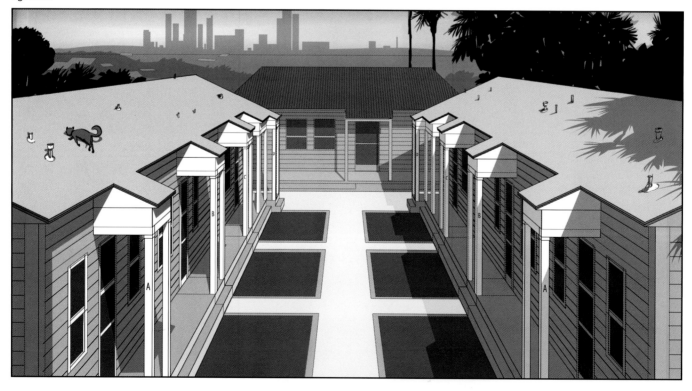

Fig. 3.34: Although a one-point perspective might seem very basic in its essence, it can provide us with the right resources to come up with unusual points of view, helping to enhance a story moment.

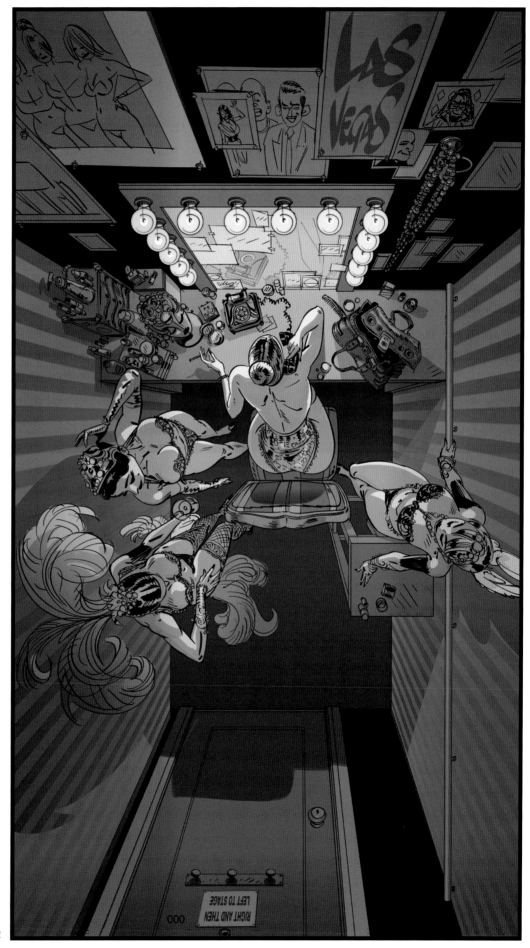

fig. 3.34

fig. 3.35

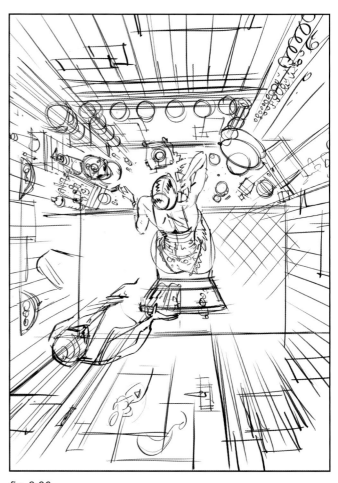

fig. 3.36

Figs. 3.35–3.36: The first sketch for the previous illustration was done by putting down the basic idea on a restaurant's napkin (or was it a children's menu?), then going home and starting to polish up the idea a bit more. Remember, the perspective structure that the illustration is built upon must service the artwork and not the other way around. Always sketch the idea first from a loose, artistic stand point, and -then- work the right perspective structure that will support your idea based on said preliminary sketch. Check the image on Fig 3.16, page 027.

— TWO VANISHING POINTS PERSPECTIVE —

The examples so far have one thing in common. The point of view is from a flat, straight-on position so that the objects (squares, cubes) are visible from one side and one side only.

This can be very interesting and useful in the telling of a story as a means to express a certain flat, simplistic, non-complicated outlook. The equivalent in music would be "mono" audio.

Fig. 4.1: As seen from directly above, the square represents either a flat surface or the cube from the previous examples; the circle represents Arianna.

Fig. 4.2: What happens the moment our position moves, either dramatically or just slightly, relative to the object we are observing? This could mean Arianna moves to a new position or the object rotates while she stays in the same place. Either way Arianna ends up seeing it from a different point of view, and that is what counts.

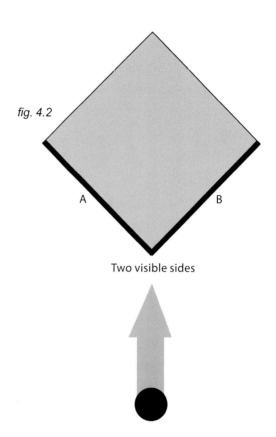

fig. 4.1

A

Only one visible side

fig. 4.2

A B

Two visible sides

Fig. 4.3: Now two sides of the cube are visible instead of one. Remember, a cube has three distinct sets of parallel lines, as illustrated here. When the cube is viewed from the front, only one set of parallel lines recedes into the distance while the other two sets remain equally distant from the viewer.

We know that each set of parallel lines going away from us converges to the same vanishing point. When the cube is rotated, two sets of parallels (four lines in each set) behave this way, as illustrated by the white arrows. This automatically means there are two vanishing points, and the cube should be drawn in two-point perspective.

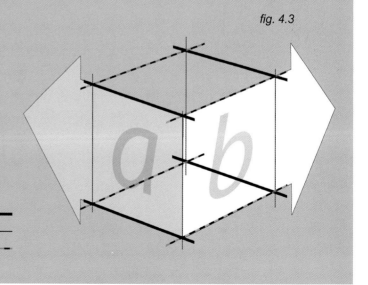

fig. 4.3

Fig. 4.4: In this example, the cube is again floating in midair and Arianna's eye level is right in the middle of it. How will she see the cube the moment it rotates like the one in fig. 4.2?

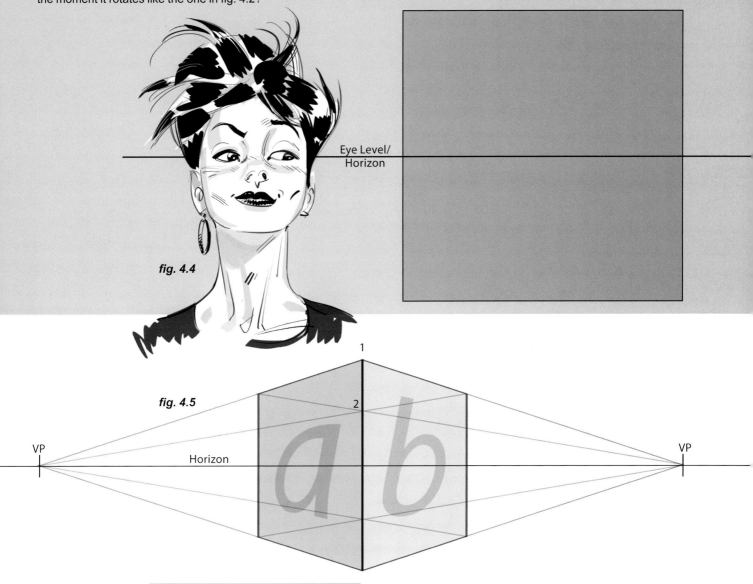

fig. 4.4

Eye Level/ Horizon

fig. 4.5

VP

Horizon

VP

1

2

a b

Fig. 4.5: Just like this, with each set of converging parallel lines going to its own vanishing point.

2

Line of Sight

A

B

1

ARIANNA

Fig. 4.6: In this case Arianna is looking at a perfect cube (all sides are identical in size). From her point of view, edges 1 and 2 are aligned exactly on her line of sight and sides "A" and "B" are perfect mirror images of each other. Therefore, both vanishing points are exactly the same distance from edge 1, resulting in a perfectly symmetrical image.

fig. 4.6

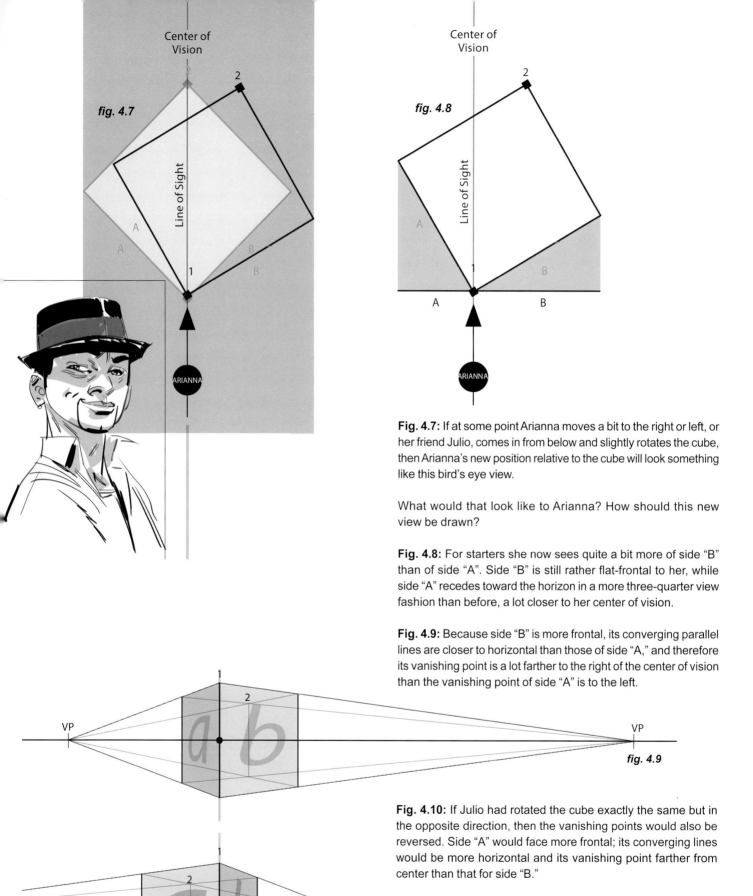

Fig. 4.7: If at some point Arianna moves a bit to the right or left, or her friend Julio, comes in from below and slightly rotates the cube, then Arianna's new position relative to the cube will look something like this bird's eye view.

What would that look like to Arianna? How should this new view be drawn?

Fig. 4.8: For starters she now sees quite a bit more of side "B" than of side "A". Side "B" is still rather flat-frontal to her, while side "A" recedes toward the horizon in a more three-quarter view fashion than before, a lot closer to her center of vision.

Fig. 4.9: Because side "B" is more frontal, its converging parallel lines are closer to horizontal than those of side "A," and therefore its vanishing point is a lot farther to the right of the center of vision than the vanishing point of side "A" is to the left.

Fig. 4.10: If Julio had rotated the cube exactly the same but in the opposite direction, then the vanishing points would also be reversed. Side "A" would face more frontal; its converging lines would be more horizontal and its vanishing point farther from center than that for side "B."

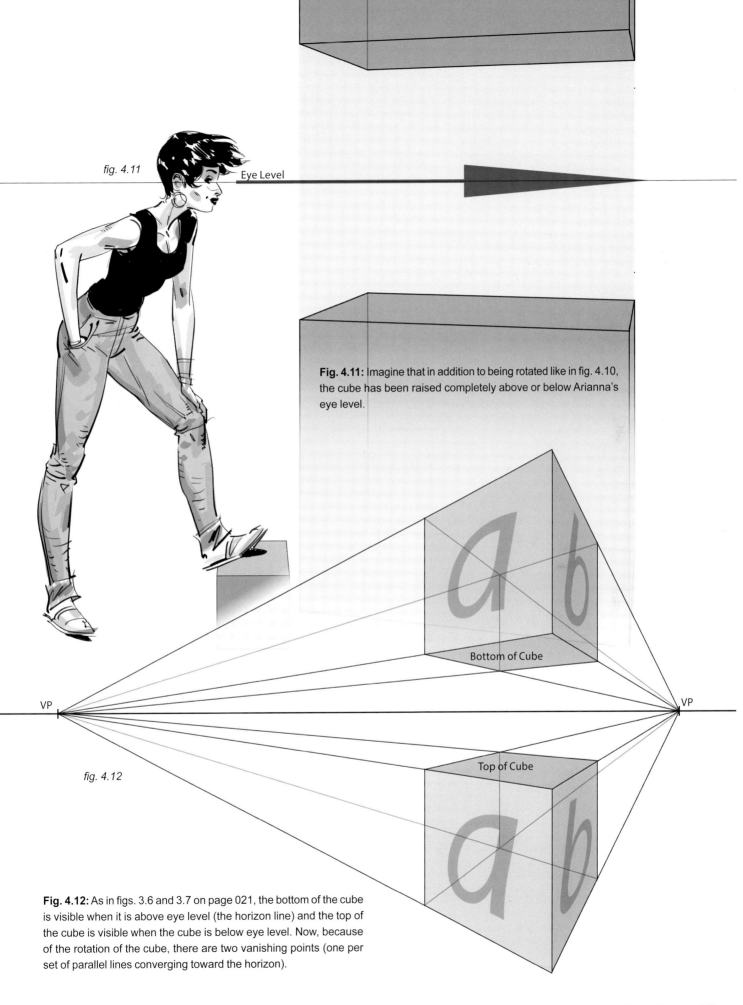

fig. 4.11

Eye Level

Fig. 4.11: Imagine that in addition to being rotated like in fig. 4.10, the cube has been raised completely above or below Arianna's eye level.

Bottom of Cube

VP

VP

Top of Cube

fig. 4.12

Fig. 4.12: As in figs. 3.6 and 3.7 on page 021, the bottom of the cube is visible when it is above eye level (the horizon line) and the top of the cube is visible when the cube is below eye level. Now, because of the rotation of the cube, there are two vanishing points (one per set of parallel lines converging toward the horizon).

PROPORTIONAL DISTANCES

Figs. 4.13 and **4.14**: Let's talk about the basics of how to draw a grid made of squares (like tiles on a floor) in perspective. Fig. 4.13 represents sets of parallel lines that are either perfectly parallel or perpendicular to our eye. Fig. 4.14 shows a grid set at a 45-degree angle in top view.

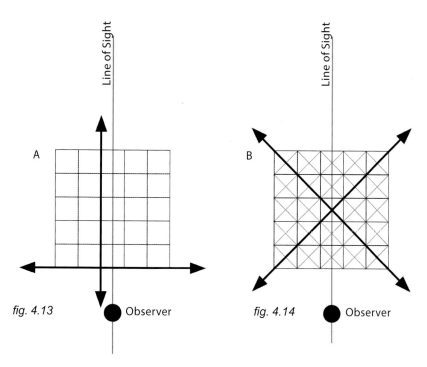

fig. 4.13

fig. 4.14

Fig. 4.15: Imagine a surface divided by five squares or tiles per side. First, draw a horizon line, and then a horizontal line below it. Divide that foreground edge into five equal segments. Next, draw the left and right sides all the way to a center vanishing point.

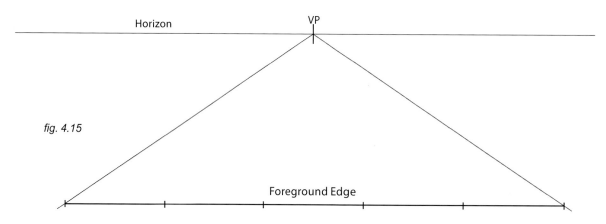

fig. 4.15

Fig. 4.16: Draw a line connecting each of the points that divide the foreground side to the center vanishing point. The next step is to determine the depth of the foreground tiles. How is this accomplished so that the tiles look square and properly foreshortened?

(The next step is to determine the depth of the foreground tile.) We will go ahead and eyeball this one. Now, make sure the chosen depth feels right to our eye as the tile obviously needs to appear foreshortened. As we keep practicing this exercise we will keep getting better at it. In this particular case and from this point of view, the perceived 'height' of the tile only measures a bit more than a third of its width.

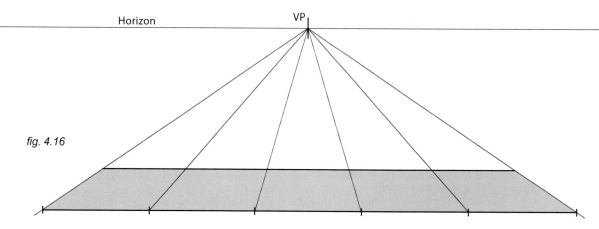

fig. 4.16

Fig. 4.17: Next we will determine the depth of each of the succeeding rows as they go further away from us. The way to find this precise diminishing perceived size is to draw a diagonal line from the front corner of a tile all the way to the horizon line. The point where the diagonal crosses the horizon is the vanishing point for this entire set of parallel diagonals, the right vanishing point (RVP) below.

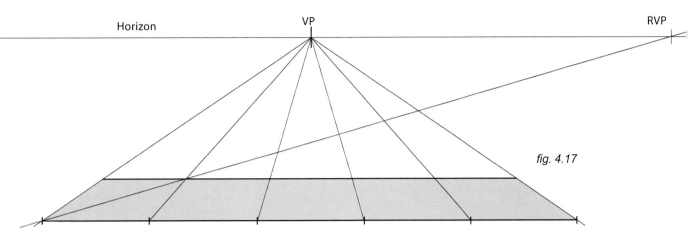

fig. 4.17

Fig. 4.18: Finish drawing the diagonals to the right, and then do the same going to the left. The more points of reference the better.

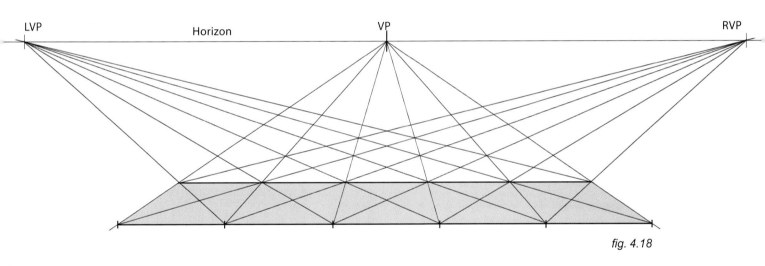

fig. 4.18

Fig. 4.19: Finally, draw parallel horizontal lines through the intersections of the lines going to the RVP and LVP. These create the illusion of distance by successively foreshortening the size of the tile rows as they go farther away from the viewer.

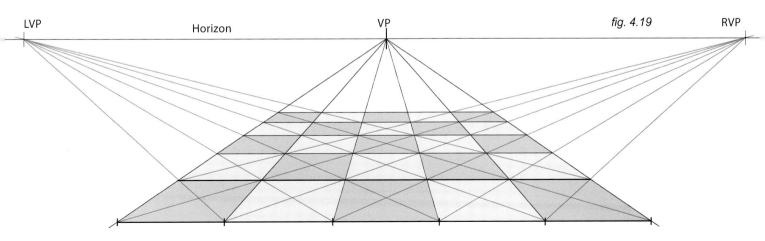

fig. 4.19

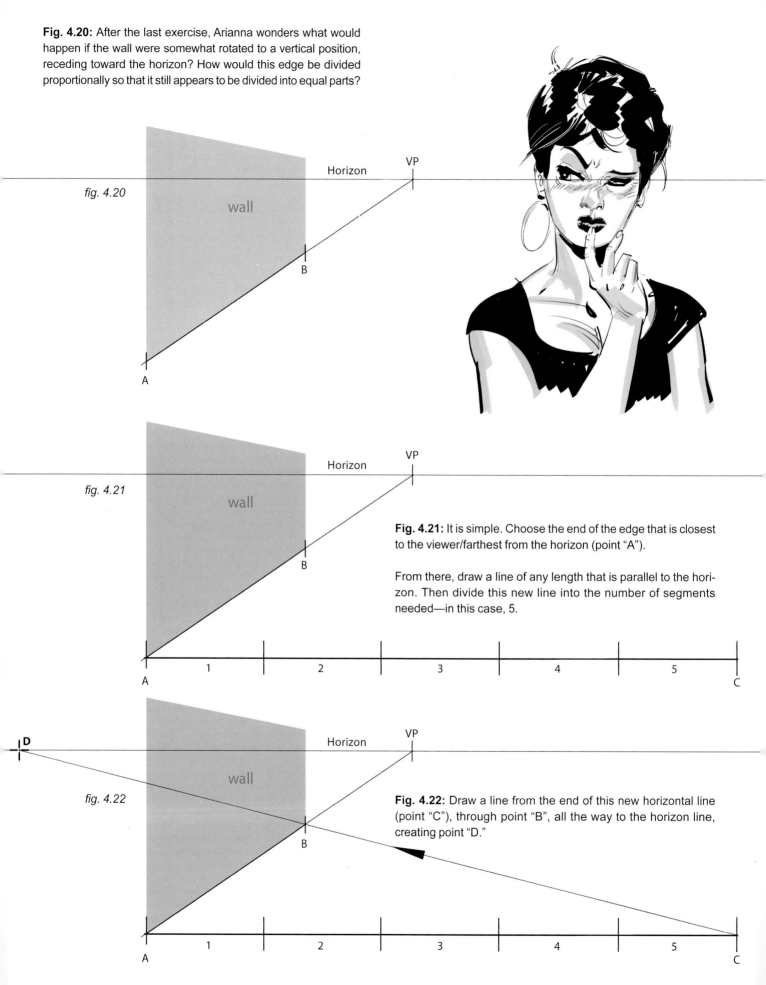

Fig. 4.20: After the last exercise, Arianna wonders what would happen if the wall were somewhat rotated to a vertical position, receding toward the horizon? How would this edge be divided proportionally so that it still appears to be divided into equal parts?

fig. 4.20

Horizon — VP — wall — B — A

fig. 4.21

Horizon — VP — wall — B — A — 1 — 2 — 3 — 4 — 5 — C

Fig. 4.21: It is simple. Choose the end of the edge that is closest to the viewer/farthest from the horizon (point "A").

From there, draw a line of any length that is parallel to the horizon. Then divide this new line into the number of segments needed—in this case, 5.

fig. 4.22

D — Horizon — VP — wall — B — A — 1 — 2 — 3 — 4 — 5 — C

Fig. 4.22: Draw a line from the end of this new horizontal line (point "C"), through point "B", all the way to the horizon line, creating point "D."

Fig. 4.23: Draw a line from each division point on line "A–C" to point "D." The points at which these lines cross line "A–B" determine how to divide it proportionally.

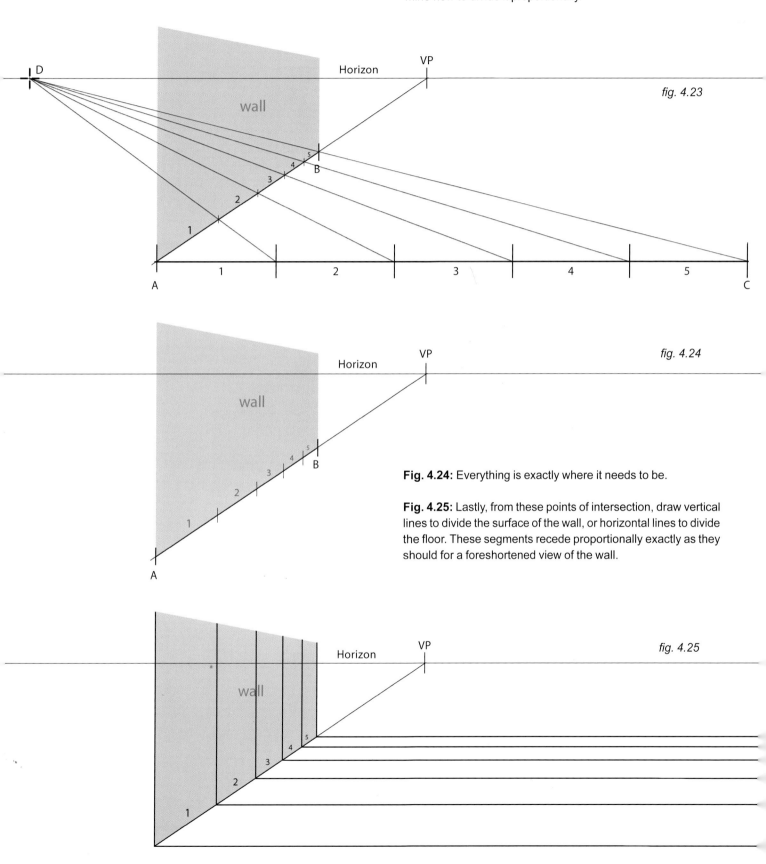

fig. 4.23

Fig. 4.24: Everything is exactly where it needs to be.

Fig. 4.25: Lastly, from these points of intersection, draw vertical lines to divide the surface of the wall, or horizontal lines to divide the floor. These segments recede proportionally exactly as they should for a foreshortened view of the wall.

fig. 4.24

fig. 4.25

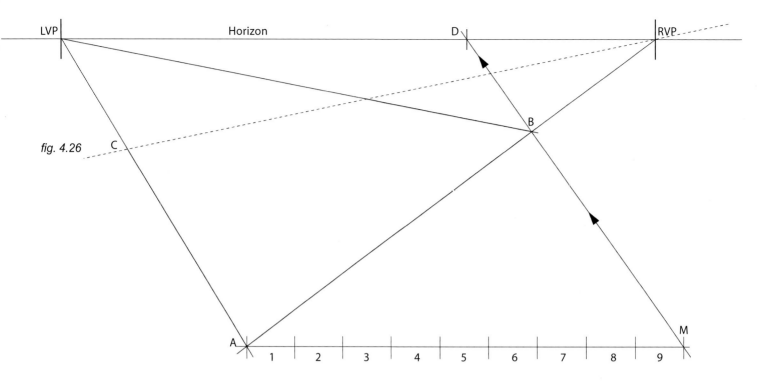

Fig. 4.26: To divide a flat surface drawn in a two-point perspective, the process is basically the same. For example, let's divide the two sides of this shape into nine equal parts.

Point A is at the end of the edge farthest from the horizon; so draw a line from point A parallel to the horizon, of any length. Divide this line into nine equal parts. Draw a line from its other end (point M) through point B to the horizon line, creating a new vanishing point (point D).

Fig. 4.27: Draw a line from each of the nine divisions on the foreground line to point D on the horizon, creating 9 segments on line A–B. From each of these new intersection points, draw a line to the LVP.

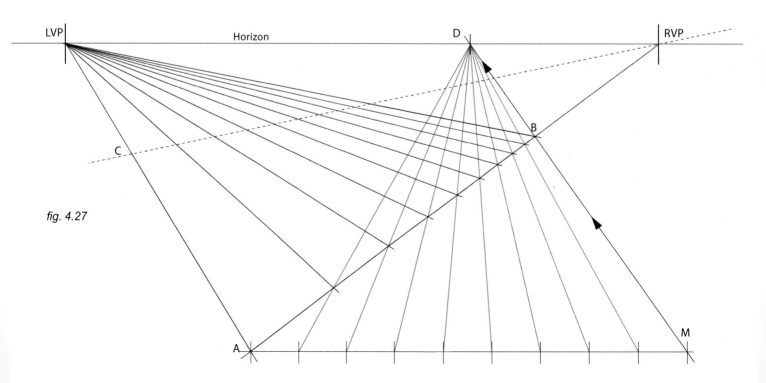

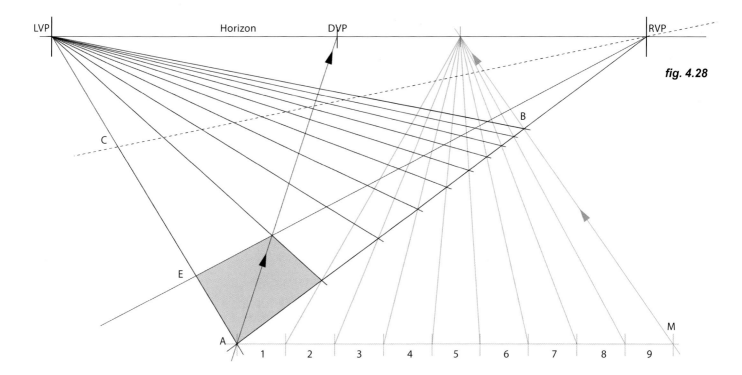

Fig. 4.28: A best guess for the location of the far side of the tiled floor has been drawn as a dotted line. Its placement depends ultimately on whether the depth of the floor (the distance between points A and C) is set in stone, or can be adjusted for the artist's convenience.

If the depth can be adjusted a bit, then take a best guess for the placement of point E and draw a line from E to the RVP, so that the tiles appear to be proper squares in perspective.

Then draw a diagonal line from point A, through the opposite corner of the first tile, all the way to the horizon line, creating a diagonal vanishing point (DVP). This is the vanishing point for all the diagonals of the tiles, which are parallel to the first one drawn.

Fig. 4.29: As we see in this particular case we will have to stop just a bit short of reaching side "C." No more rows will fit inside the originally predetermined space.

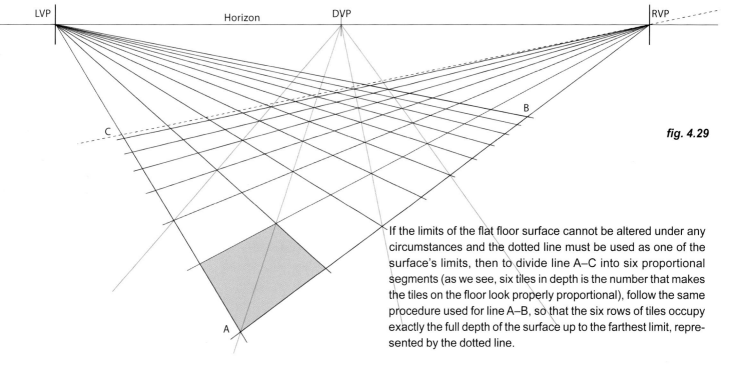

If the limits of the flat floor surface cannot be altered under any circumstances and the dotted line must be used as one of the surface's limits, then to divide line A–C into six proportional segments (as we see, six tiles in depth is the number that makes the tiles on the floor look properly proportional), follow the same procedure used for line A–B, so that the six rows of tiles occupy exactly the full depth of the surface up to the farthest limit, represented by the dotted line.

Fig. 4.30: Here is a practical exercise based on the drawing of the apartment complex (fig. 4.37) using a simplified version of the left façade.

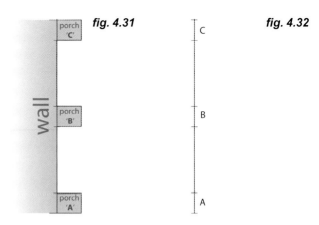

Fig. 4.31: The goal is to draw three porches extending from the wall, as shown here in top view (or blueprint).

Fig. 4.32: To better understand the proportions, compress all of the information into one simple line, representing the length of the wall, with indications where the porches are to be placed.

Fig. 4.33: Draw a horizontal line ("D–E") from point 1, parallel to the horizon. Then, draw the compressed blueprint on it. From point "E" draw a line that passes through point 2, and then on to the horizon line. Use the intersection points along line 1–2 to determine the placement of the porches in perspective.

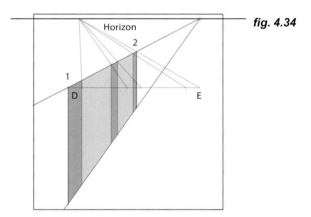

Fig. 4.34: As a result, the zones where the three porches contact the wall have been determined. It is time to draw the structures in their proper placement.

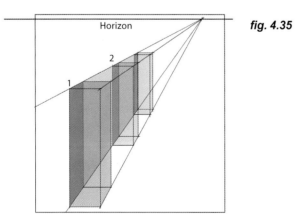

Fig. 4.35: This reflects the diminishing proportions, as every porch gets farther and farther away.

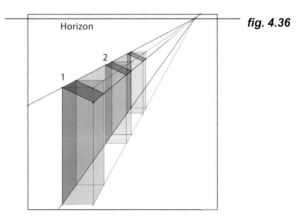

Fig. 4.36: In order to create angled roofs on every porch, just chop off the portion of the structures that is no longer needed. As long as all parallel lines still go to the same vanishing point on the horizon, everything is fine.

fig. 4.37

GREAT.
LET'S GET BACK
TO THE CUBE AND LEARN
HOW TO WORK WITH IT TO
CREATE MORE COMPLEX
SHAPES AND VOLUMES, IN
ORDER TO TACKLE BIGGER
CHALLENGES.
THIS IS IMPORTANT BECAUSE
ALL COMPLEX SHAPES ARE
BASICALLY A COMBINATION
OF MORE SIMPLE ONES.
SO LET'S SEE!

fig. 4.38

YEAH, AND MORE
IMPORTANTLY, WHEN
DO I GET TO PLAY A
JUICY PART IN ONE
OF THESE SAMPLE
SCENES?

SOON JULIO,
VERY SOON, YOU
TOO WILL HAVE
YOUR MOMENT
IN THE SUN....

WHEN VANISHING POINTS ARE OFF THE PAGE

Something that happens often in the process of drawing objects in perspective is that one or more vanishing points might be located off the page. It is helpful to start by making a small, quick sketch of the object, with vanishing points on the page, to have a rough idea of what it will look like finished.

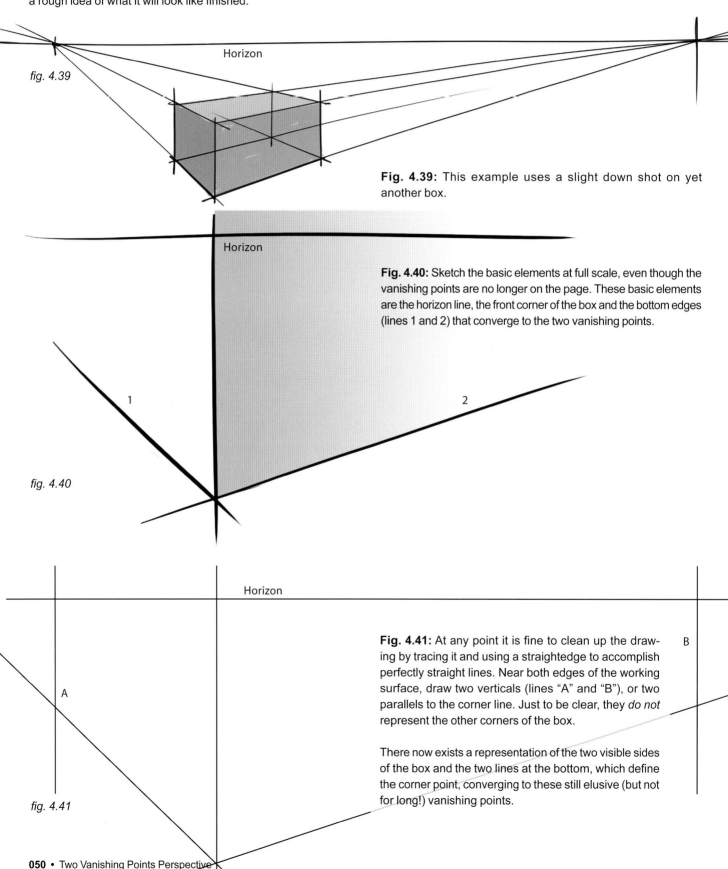

Fig. 4.39: This example uses a slight down shot on yet another box.

Fig. 4.40: Sketch the basic elements at full scale, even though the vanishing points are no longer on the page. These basic elements are the horizon line, the front corner of the box and the bottom edges (lines 1 and 2) that converge to the two vanishing points.

Fig. 4.41: At any point it is fine to clean up the drawing by tracing it and using a straightedge to accomplish perfectly straight lines. Near both edges of the working surface, draw two verticals (lines "A" and "B"), or two parallels to the corner line. Just to be clear, they *do not* represent the other corners of the box.

There now exists a representation of the two visible sides of the box and the two lines at the bottom, which define the corner point, converging to these still elusive (but not for long!) vanishing points.

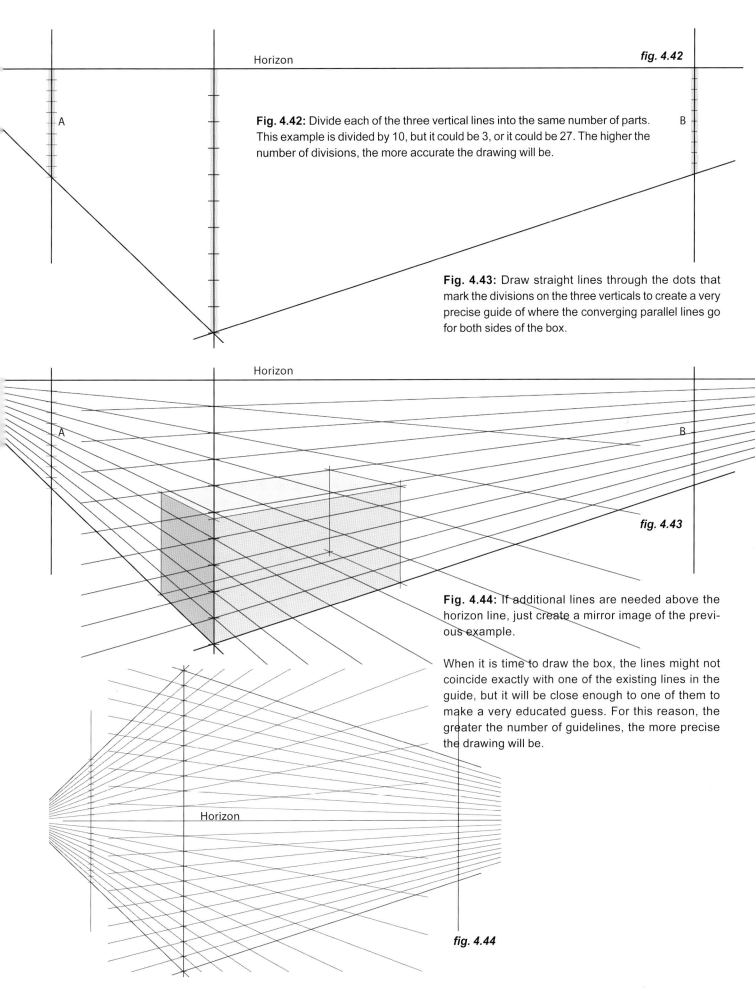

Fig. 4.42: Divide each of the three vertical lines into the same number of parts. This example is divided by 10, but it could be 3, or it could be 27. The higher the number of divisions, the more accurate the drawing will be.

Fig. 4.43: Draw straight lines through the dots that mark the divisions on the three verticals to create a very precise guide of where the converging parallel lines go for both sides of the box.

Fig. 4.44: If additional lines are needed above the horizon line, just create a mirror image of the previous example.

When it is time to draw the box, the lines might not coincide exactly with one of the existing lines in the guide, but it will be close enough to one of them to make a very educated guess. For this reason, the greater the number of guidelines, the more precise the drawing will be.

Horizon

A

B

fig. 4.42

fig. 4.43

fig. 4.44

fig. 4.45

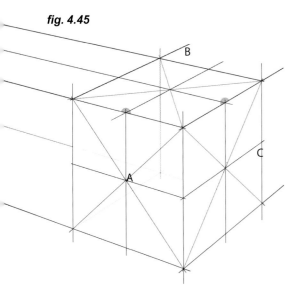

fig. 4.46

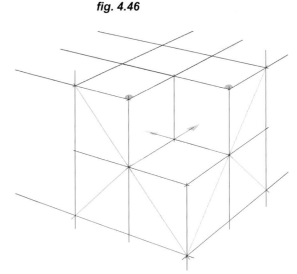

Fig. 4.45: We now decide to remove a portion of this cube in the shape of a smaller one.

Let's draw two diagonals crossing each one of the three visible sides. Using the resulting three crossing points "A," "B" and "C" we draw crosses that divide each side in four squares. This results in the cube being divided in eight smaller cubes.

Fig. 4.46: Next, 'carve out' one of the smaller cubes as shown.

fig. 4.47

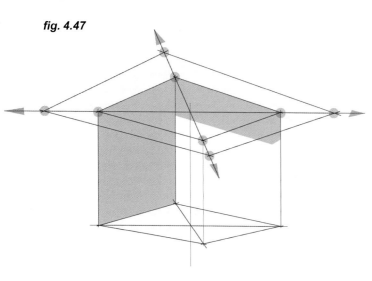

Fig. 4.47: To expand the top of the cube to represent something like a rooftop, again use diagonals. Extend the diagonals past each corner of the topside of the cube, and mark a new corner on one of the extended diagonals. This new corner will be the starting point of the extended rooftop, as it will allow us to automatically find its other three. Then draw a bigger rectangle, using the rules of perspective learned thus far.

Fig. 4.48: Once the top surface has been extended, draw verticals from each of its four corners. Decide upon the height or thickness of this roof and then draw the top of it with lines that converge to their corresponding vanishing points.

fig. 4.48

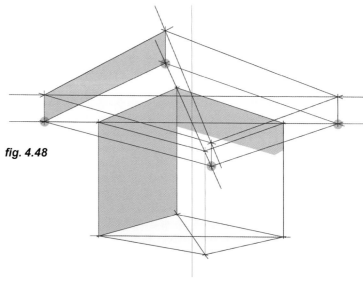

fig. 4.49

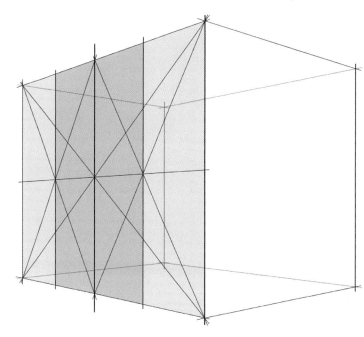

Fig. 4.49: Here is another case of building upon an existing base, again using a cube. The goal is to add a smaller cube at the top, like a cantilevered extension to a modern-looking apartment building.

Let's center it on the left side of the main cube. Use diagonals to divide the side into four equal portions and select the two central ones (shaded darker gray). The extension could go anywhere: on a different side or off-center, but for this exercise it will be positioned right in the middle.

If the divisions of the side of the cube are to be irregular in size, then follow the steps on page 048.

fig. 4.50

Fig. 4.50: Add the extra structure by making sure every line goes to the appropriate vanishing point. To double-check that everything is perfect, draw the additional cube as though the bigger one were made of glass. This shows how the structure works, even in the areas that will ultimately be hidden behind solid materials, like the side of the main cube facing us.

For the window on the right side, follow practically the same routine. Draw full crossing diagonals, chose one corner of the window we want to carve on one of them, from this corner we will then find the others following the perspective of that side of the cube.

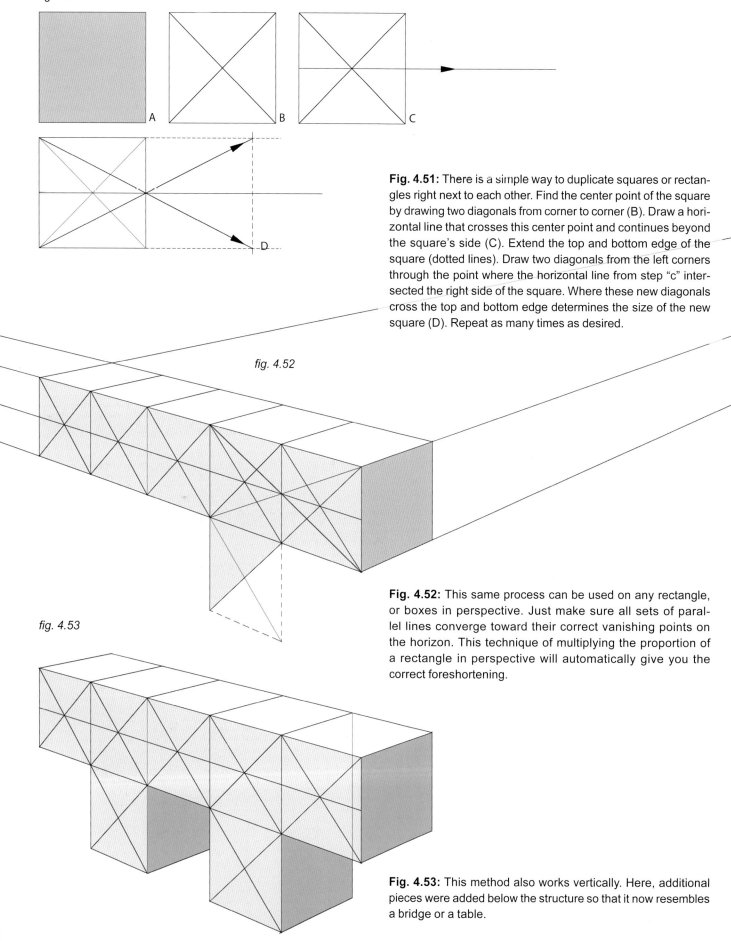

fig. 4.51

Fig. 4.51: There is a simple way to duplicate squares or rectangles right next to each other. Find the center point of the square by drawing two diagonals from corner to corner (B). Draw a horizontal line that crosses this center point and continues beyond the square's side (C). Extend the top and bottom edge of the square (dotted lines). Draw two diagonals from the left corners through the point where the horizontal line from step "c" intersected the right side of the square. Where these new diagonals cross the top and bottom edge determines the size of the new square (D). Repeat as many times as desired.

fig. 4.52

Fig. 4.52: This same process can be used on any rectangle, or boxes in perspective. Just make sure all sets of parallel lines converge toward their correct vanishing points on the horizon. This technique of multiplying the proportion of a rectangle in perspective will automatically give you the correct foreshortening.

fig. 4.53

Fig. 4.53: This method also works vertically. Here, additional pieces were added below the structure so that it now resembles a bridge or a table.

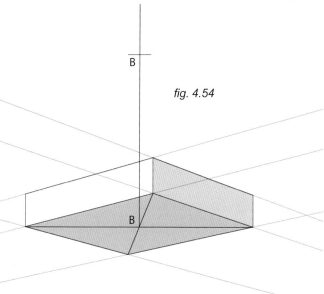

fig. 4.54

fig. 4.55

Figs. 4.54 and 4.55: It is possible to use these principles to construct pyramid shapes, like the top of a bell tower. After finding the center point (B), draw a vertical line upward from there.

Choose a point along this line to be the "tip" of the structure (A). Then draw lines from the four corners of the top of the box up to that point.

Fig. 4.56: For this new exercise/example, start by drawing a low box as the base of a pyramid. Draw diagonals (lines 5 and 6) and then connect corners to draw a smaller rectangle of the same proportion perfectly centered on the box's surface.

Fig. 4.57: Time to draw another box on top of the first one, using the shaded rectangle from fig. 4.56 as its base.

Now that the two corners are established (lines 1 and 2 – which in this case are of equal length, although they do not need to be), draw lines "A" and "B" by linking the top and bottom ends of the corners – and onward. This will keep the box heights consistent all the way to the top. These two lines will be the guidelines for all the box corners on that side of the pyramid.

Fig. 4.58: Repeat the steps, centering each box on the surface of the previous one by using the crossing diagonals, until the pyramid has reached the desired height.

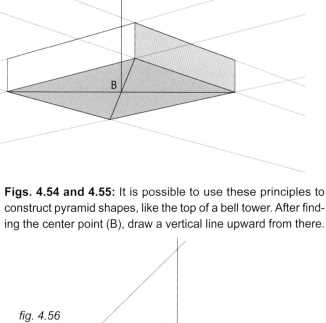

fig. 4.56

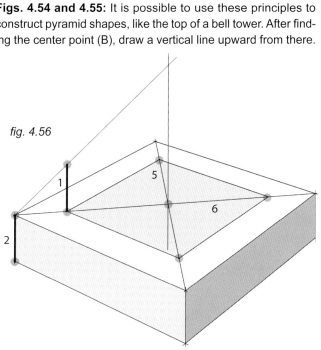

fig. 4.57

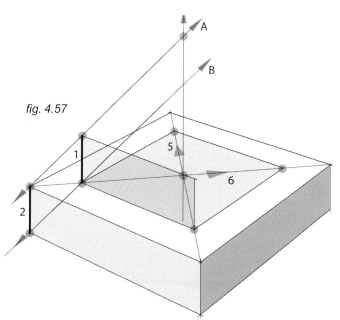

fig. 4.58

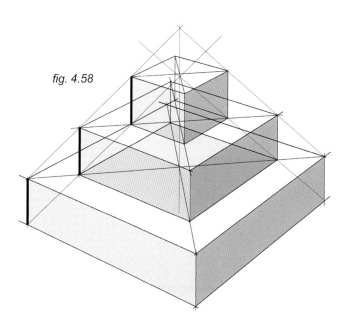

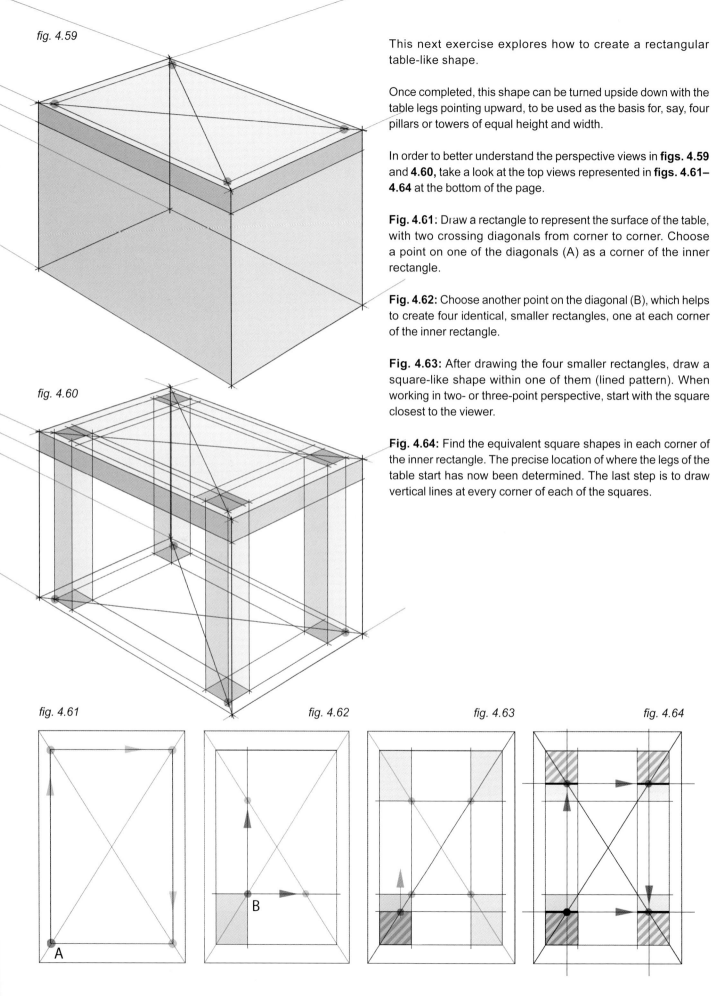

fig. 4.59

fig. 4.60

This next exercise explores how to create a rectangular table-like shape.

Once completed, this shape can be turned upside down with the table legs pointing upward, to be used as the basis for, say, four pillars or towers of equal height and width.

In order to better understand the perspective views in **figs. 4.59** and **4.60**, take a look at the top views represented in **figs. 4.61– 4.64** at the bottom of the page.

Fig. 4.61: Draw a rectangle to represent the surface of the table, with two crossing diagonals from corner to corner. Choose a point on one of the diagonals (A) as a corner of the inner rectangle.

Fig. 4.62: Choose another point on the diagonal (B), which helps to create four identical, smaller rectangles, one at each corner of the inner rectangle.

Fig. 4.63: After drawing the four smaller rectangles, draw a square-like shape within one of them (lined pattern). When working in two- or three-point perspective, start with the square closest to the viewer.

Fig. 4.64: Find the equivalent square shapes in each corner of the inner rectangle. The precise location of where the legs of the table start has now been determined. The last step is to draw vertical lines at every corner of each of the squares.

fig. 4.61 A

fig. 4.62 B

fig. 4.63

fig. 4.64

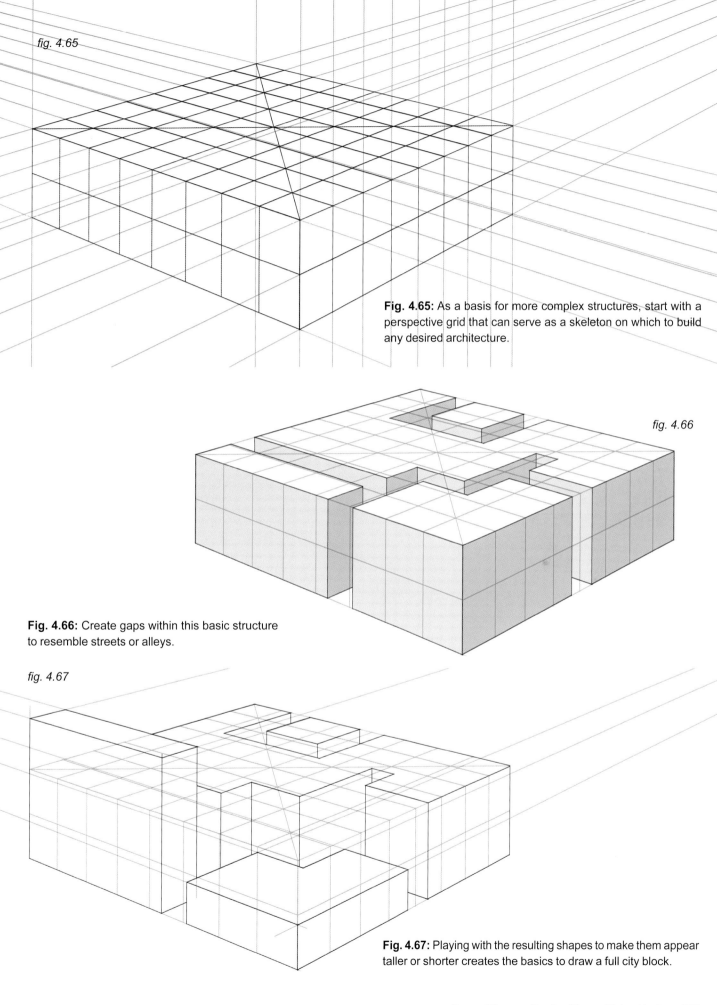

fig. 4.65

Fig. 4.65: As a basis for more complex structures, start with a perspective grid that can serve as a skeleton on which to build any desired architecture.

fig. 4.66

Fig. 4.66: Create gaps within this basic structure to resemble streets or alleys.

fig. 4.67

Fig. 4.67: Playing with the resulting shapes to make them appear taller or shorter creates the basics to draw a full city block.

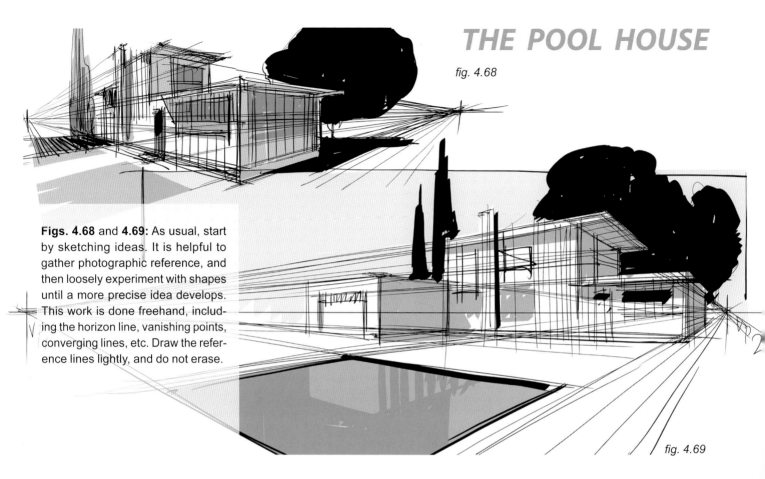

fig. 4.68

fig. 4.69

Figs. 4.68 and **4.69:** As usual, start by sketching ideas. It is helpful to gather photographic reference, and then loosely experiment with shapes until a more precise idea develops. This work is done freehand, including the horizon line, vanishing points, converging lines, etc. Draw the reference lines lightly, and do not erase.

Fig. 4.70: Once an idea has been decided upon, start building the simplest shapes in order to distill the building to its essence. As much as possible, aim for boxes defining the most dominant features.

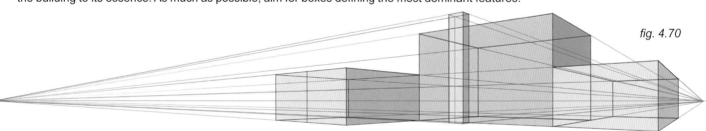

fig. 4.70

Fig. 4.71: Now that the sketch is being drawn in perspective, it is very important to stick to the shapes and general sense of proportion already created in the original sketch. Build on that. Do not treat this perspective drawing as a separate reality from what was already designed. This is not the time to do something new and different, but to put what you already have into proper and correct perspective. It is very easy to stray from the original idea and end up with a totally deformed version that neither resembles the original, nor has its intended charm.

Also, pay attention throughout the process to the distance between the two vanishing points. Too far apart will make the building appear unrealistic and spread out, lacking the strong sense of identity of the original sketch. Too close together and the building will appear distorted, like a wide-angle lens effect (which, then again, might be the goal after all).

fig. 4.71

Fig. 4.72: Now begins a quite laborious part of the process: making sure the architectural details make spatial sense and that every line and shape is as it should be, either vertical, horizontal or going toward the appropriate vanishing point.

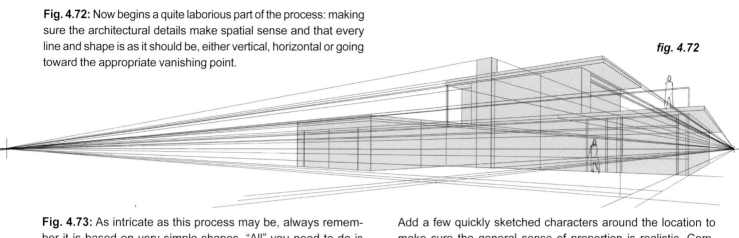

fig. 4.72

Fig. 4.73: As intricate as this process may be, always remember it is based on very simple shapes. "All" you need to do is add the necessary details and carve out the unneeded. Doing so would create a balcony at the top-left of the house.

Add a few quickly sketched characters around the location to make sure the general sense of proportion is realistic. Compare the size of the characters to the size of the doors. By taking these size relationships into account at this stage, problems will be avoided later.

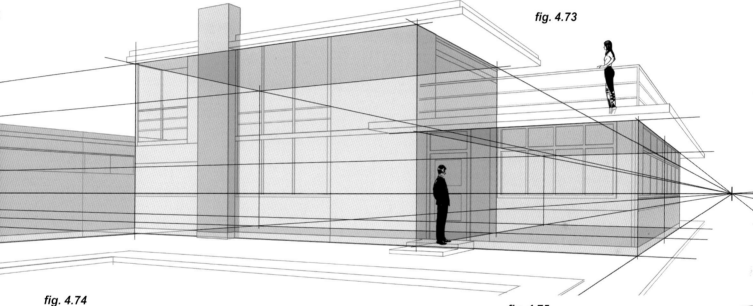

fig. 4.73

fig. 4.74

fig. 4.75

Fig. 4.74: When working out the details within the bigger shapes, keep in mind not only what is exposed to the viewer's eye, but also what is behind. Imagine the whole structure were made of glass to get an all-around idea of how every piece works and how it connects to the piece next to it. This concept is called "drawing through."

Fig. 4.75: For example, look at how the balcony (top-left) works and connects with the things around it, even when these shapes and connections are hidden from view.

In the case of the chimney, it is better to draw it in full, then carve out the shapes and parts that will not be seen by the viewer, given the existing connections and overlaps among pieces.

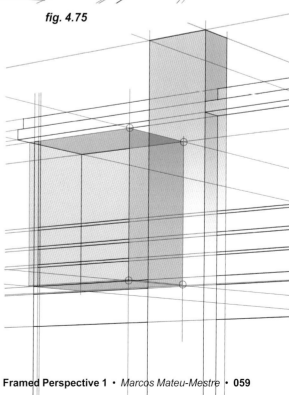

Fig. 4.76: This is the final version. After addressing every detail in the shapes, adjusting the tones and shades of gray gives an even better sense of volume to the piece. The trees in the background help to bring the house forward and enhance a sense of depth by adding tonal contrast. This was discussed extensively in my previous book, *Framed Ink*.

This image can be used as a backdrop for a storyboard or graphic novel panel. To do that, extend the perspective coming forward (closer to the camera) so that there is room to add more elements (characters in this case) to the foreground, therefore enhancing the overall narrative meaning of the location.

And by the way, very important, **integrating characters within a perspective** will be discussed in more detail in *Framed Perspective 2*.

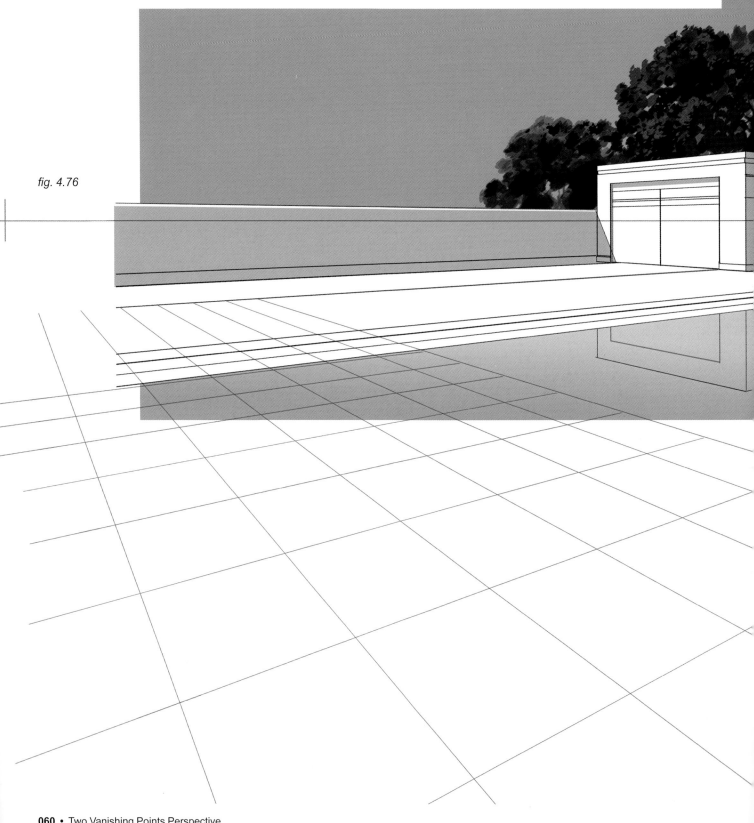

fig. 4.76

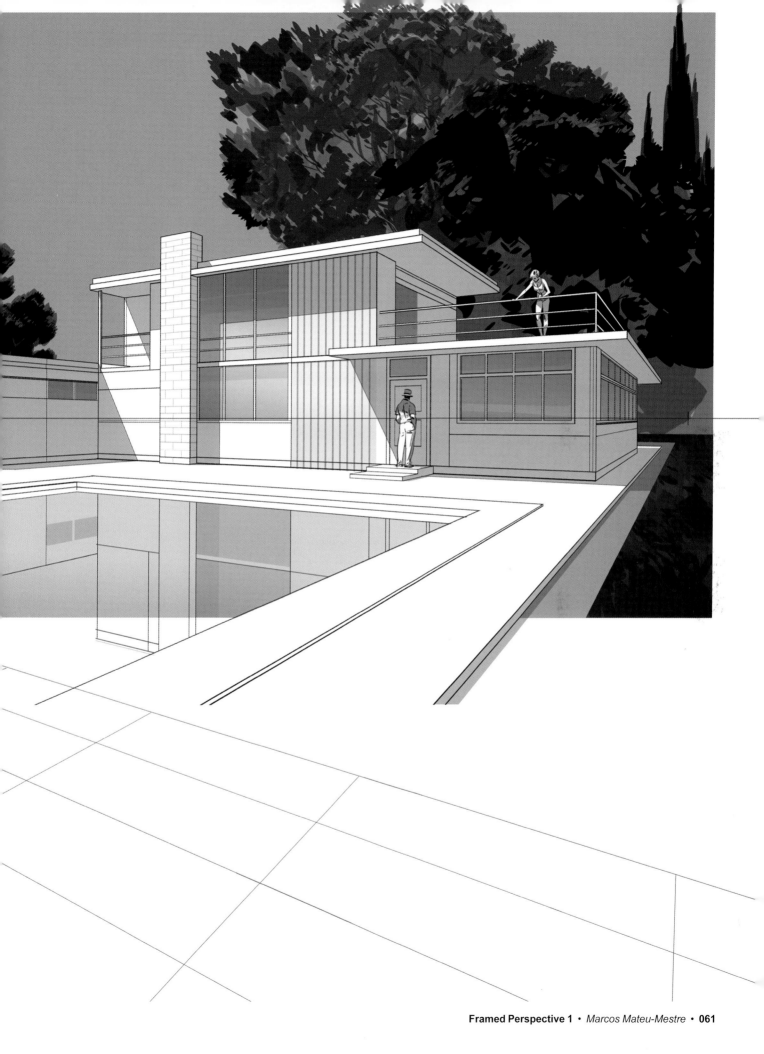

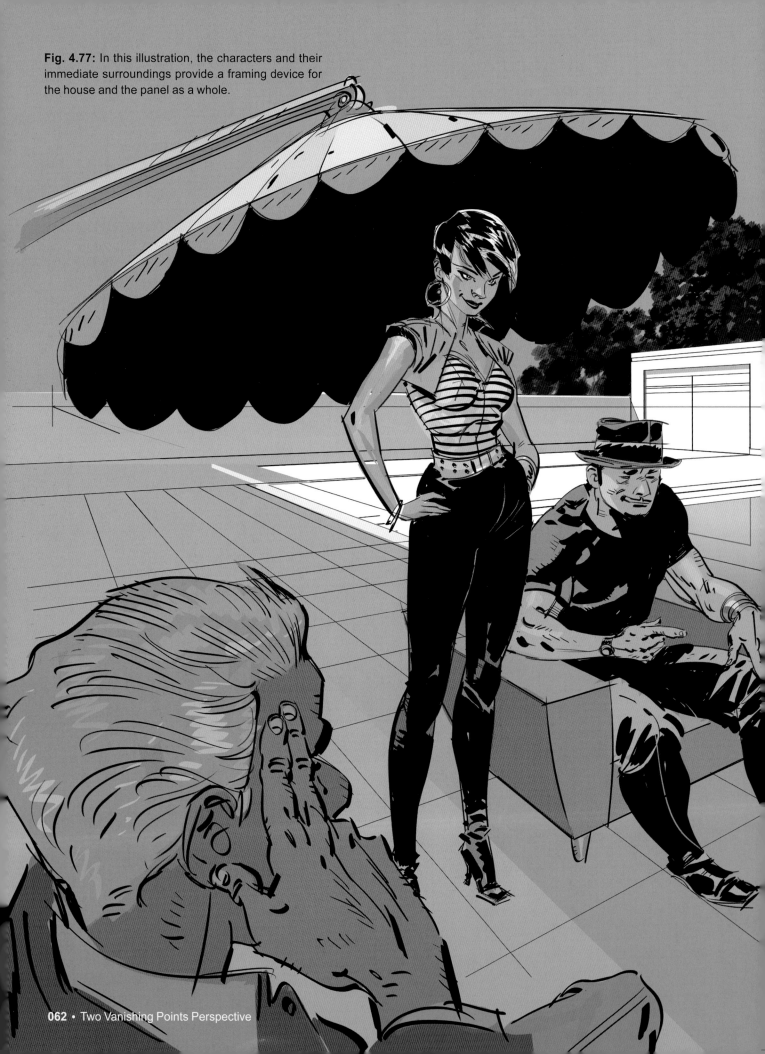

Fig. 4.77: In this illustration, the characters and their immediate surroundings provide a framing device for the house and the panel as a whole.

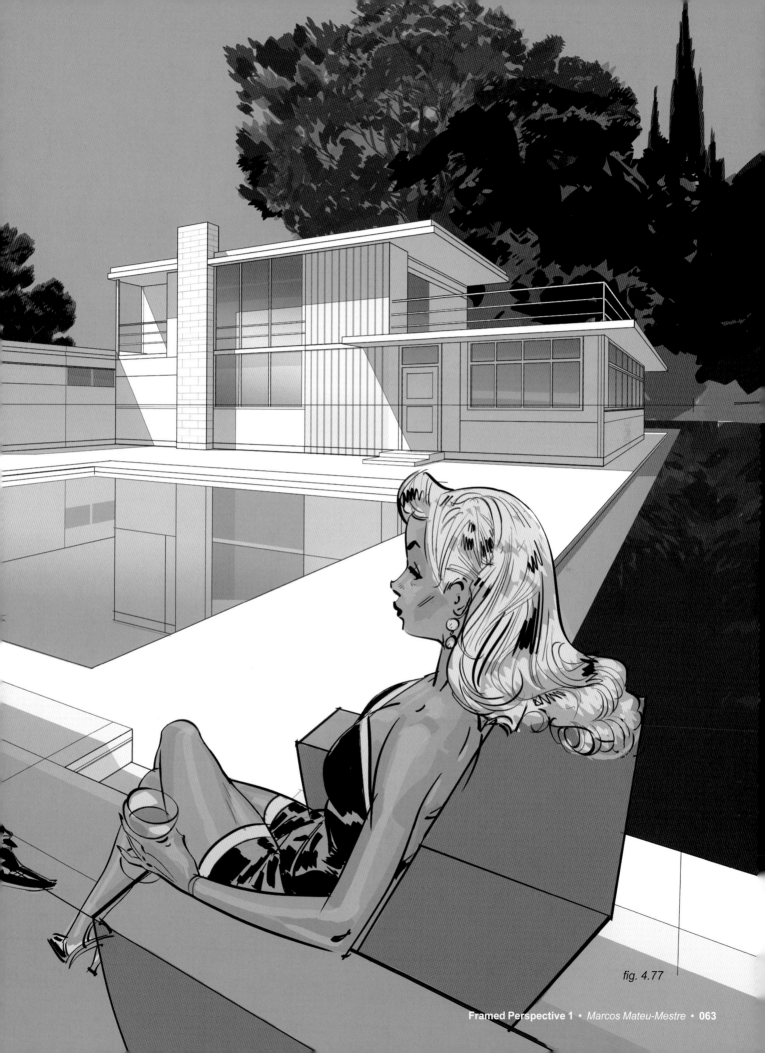

fig. 4.77

fig. 4.78

Fig. 4.78: In a new approach to fig. 4.76, going back momentarily to one-point perspective, the focus is on the two characters. They are both pictured as the same size, giving them the same visual importance.

Fig. 4.79: This presents a much closer point of view, which portrays an obvious difference in their sizes and therefore alters the importance of the role they are each playing at that particular moment of the story.

fig. 4.79

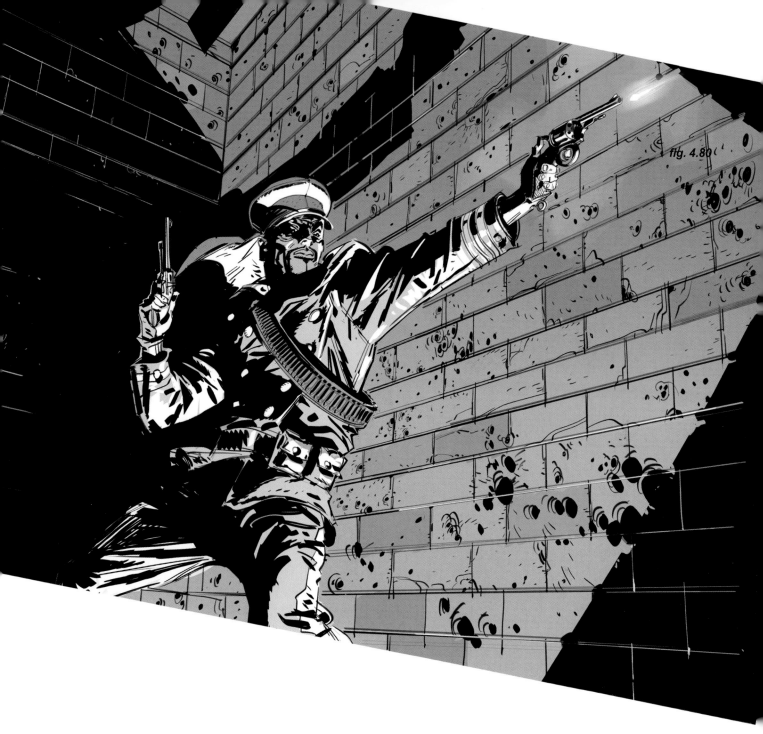

fig. 4.80

Fig. 4.80: This panel shows how the use of two-point perspective can emphasize the sense of a character literally being cornered by whatever is menacing or threatening him. Within this sense of perspective, the bricks, patterns and shadows on the walls help create mood and dynamics.

Fig. 4.81: This was the starting point that became the claustrophobic environment around this wild explorer. In order to make the action more vibrant, the horizon line was placed at an angle so that the whole image lacks a sense of balance, making an even bigger statement for the drama.

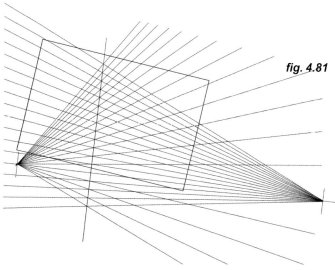

fig. 4.81

fig. 4.82

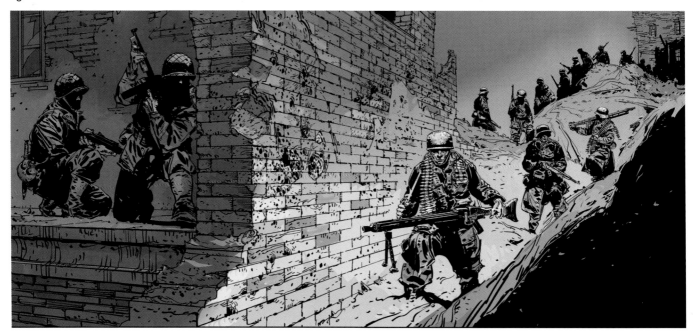

Figs. 4.82–4.84: For the example above, a preliminary sketch was done (not shown) and then the perspective grid that matched its needs was created (fig. 4.83). When establishing such a grid, extend it beyond what you expect will be required for the drawing. Do not do a grid that just barely covers, in this case, the foreground building and the hill, because eventually the illustration might require other structures in the background.

The walls were blocked in (fig. 4.84) as if they were intact and following correct perspective, then the missing chunks due to the explosions were carved out.

The choice of a two-point perspective enhances the idea of literally showing the two sides of the story at this moment, creating tension by having the audience be the only ones aware of what is happening on both sides of the building ruins.

Fig. 4.85: This simple sketch, in two-point perspective, led to the finished illustration on the next page (fig. 4.86).

fig. 4.83

fig. 4.84

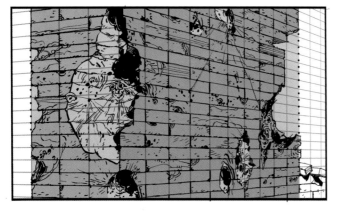

fig. 4.85

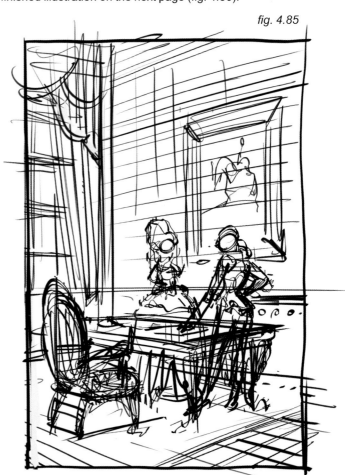

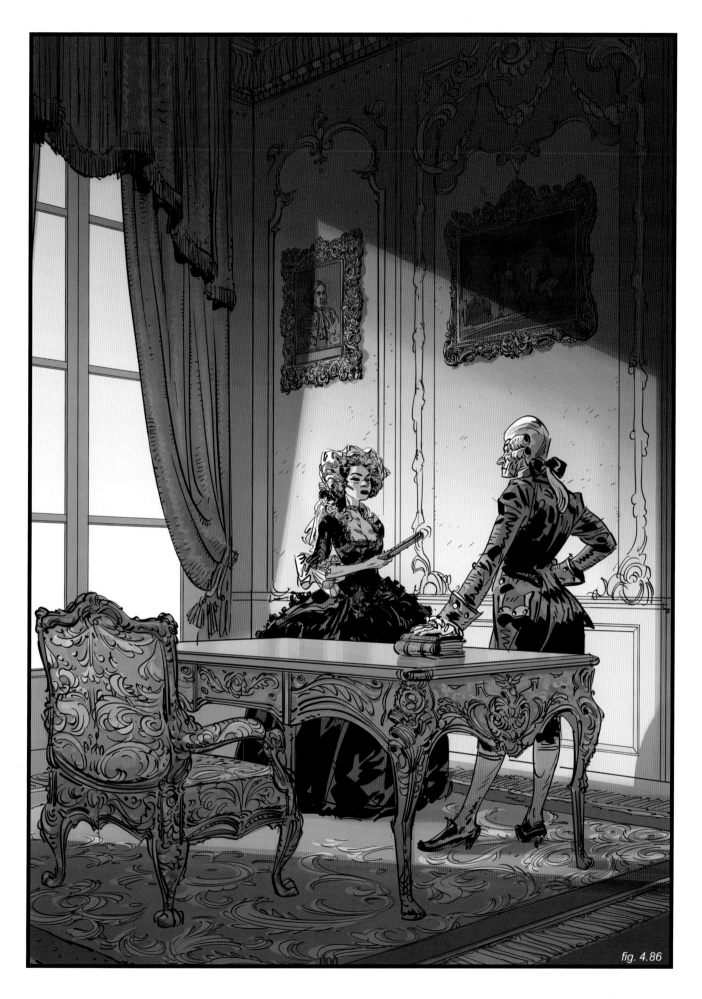

fig. 4.86

Framed Perspective 1 • *Marcos Mateu-Mestre* • **067**

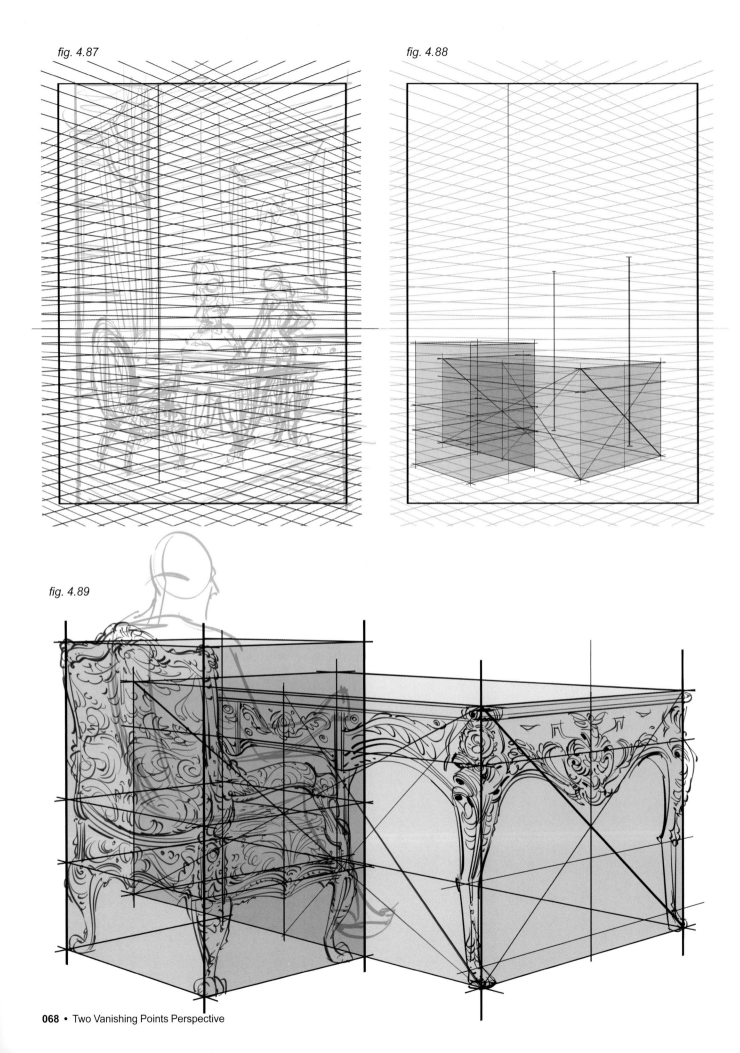

fig. 4.87

fig. 4.88

fig. 4.89

fig. 4.90

Fig. 4.87: As usual, the illustration started with a sketch. The horizon line was decided upon and a solid perspective grid was drawn on top of the sketch. The corner of the room is an important compositional element and had to be placed properly.

Fig. 4.88: The desk and chair are featured elements, so drawing them first as boxes helps to get the proportions right. In this case, the chair is to be centered with the desk because they are not being used and appear to be in perfect order, so the centerlines of the sides of both pieces must be established with the use of diagonals. Later, when symmetrical designs are drawn on these pieces, the centerlines will be essential. Simple vertical lines can establish the height of the characters within the perspective, making sure they are proportionate with the rest of the room.

Fig. 4.89: Once the size and proportion of the boxes is established and the sides have been divided by diagonals, it is time to draw the objects within these geometrical shapes. The boxes are for guidance purposes only; the object may fit within the box, short of touching its sides or corners, or reach beyond the box. It all depends on the actual shape of the furniture. (For more on creating irregular shapes within boxes, see page 139.)

It was helpful to sketch a character sitting in the armchair to make sure the chair does not end up appearing to big or too small in relationship to the other elements in the room.

Fig. 4.90: Geometrical shapes, boxes, rectangles, etc. are used constantly to make sure all the architectural elements are within the proper perspective.

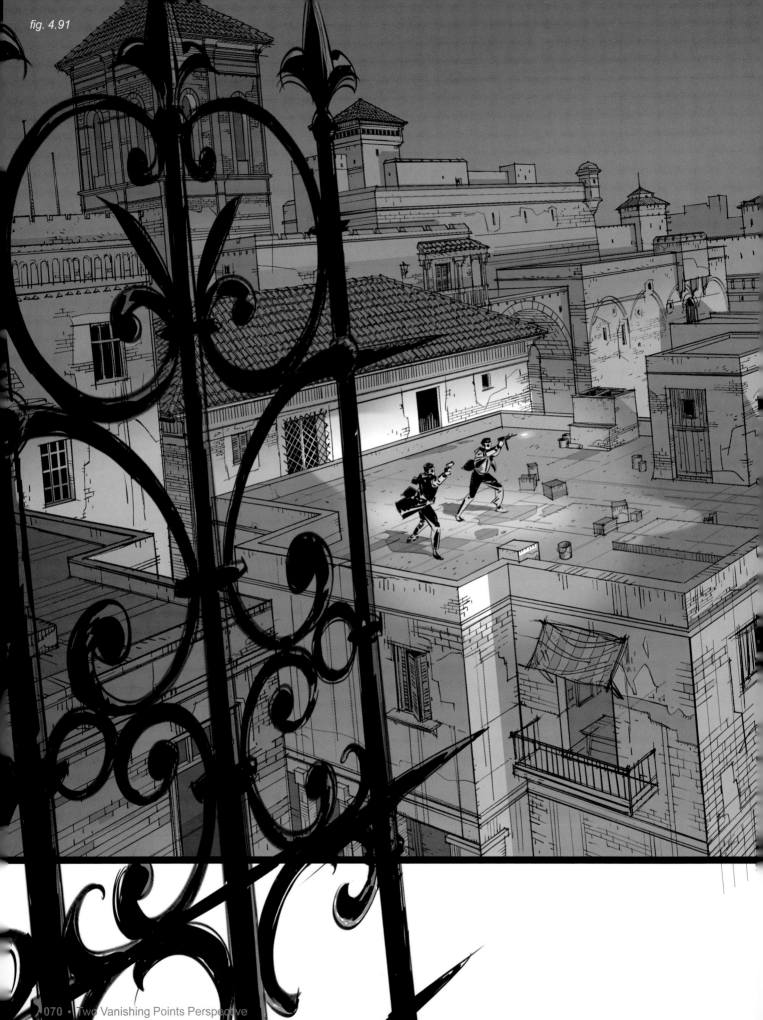

fig. 4.91

Fig. 4.91: Two-point perspective can also be ideal to describe the space and volume of a maze-like neighborhood. Tilting the horizon line achieves an out-of-balance look that gives the whole action a more dynamic feel. Additionally, having one of the vanishing points near the eyes of the main character enhances the general sense of drama.

The following pages show how to work out some of the basic shapes and structures described in this shot. When creating a two-page spread like this, one must carefully plan ahead so that no essential parts of the image are right in the center and thus obscured by the book's binding.

Fig. 4.92: As usual, after achieving a satisfactory compositional sketch for the panel, create the perspective grid which suits the space to be depicted. The horizon is tilted so the vertical lines (corners of the buildings) also appear tilted because they are perpendicular to the horizon. Observe that when drawing in two-point perspective it can occur that both VPs are outside the drawing, or one or even both of them are inside of it, if the drawing surface allows.

fig. 4.92

Figs. 4.93–4.95: To construct the building with the Spanish tile roof on page 071, the process is based on exercises we have seen before. Draw an X on the top of the building to find the center lines of the roof. Divide the front edge of the roof line in three parts (three equal parts for the sake of this example). Pay attention to the fact that since the horizon is tilted, the auxiliary measuring line needs to be tilted as well and parallel to the horizon.

fig. 4.93 fig. 4.94 fig. 4.95

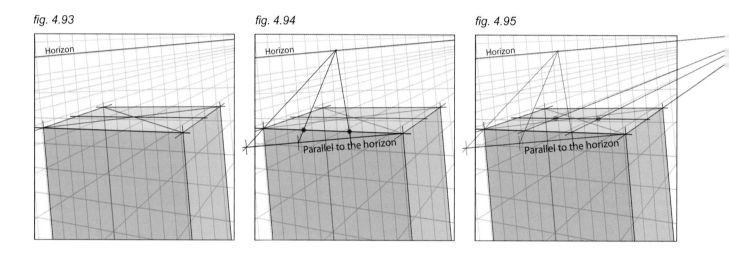

Figs. 4.96–4.98: Draw two "vertical" lines from the intersection points created (fig. 4.96). They do not appear truly vertical because the whole perspective has been tilted, so follow the grid that was created for this purpose. Then decide where to interrupt these verticals (fig. 4.97) in order to create the rest of the structure. In fig. 4.98, part of the corner of the building has been "removed" after the fact, to break up the monotony of an otherwise picturesque city.

fig. 4.96 fig. 4.97 fig. 4.98

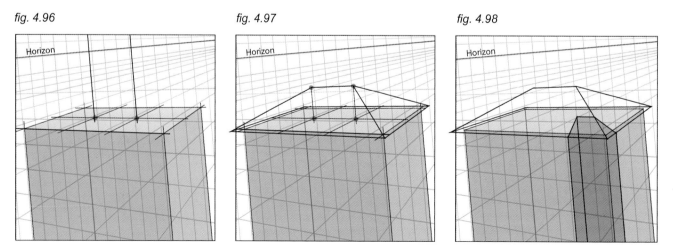

5

MULTIPLE VANISHING POINTS

Fig. 5.1: We already know how to draw a frontal view of two cubes in perspective when all sides are parallel to each other (as seen below, in top view).

Fig. 5.2: What happens the moment one of them rotates and the sides of the two different boxes are no longer parallel to each other?

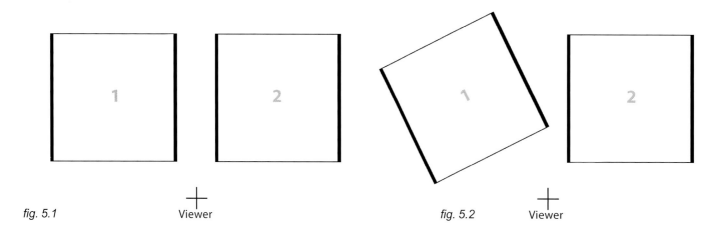

fig. 5.1 Viewer

fig. 5.2 Viewer

Fig. 5.3: The cubes in the first case create one single, central vanishing point on the horizon where all parallel lines converge into the distance, away from the viewer.

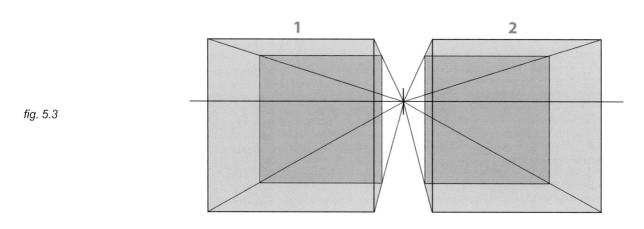

fig. 5.3

Fig. 5.4: Although cube 2 is still aligned with this central vanishing point, cube 1 needs two new vanishing points to properly define it in this perspective. (Vanishing Points have been labeled A, B, C)

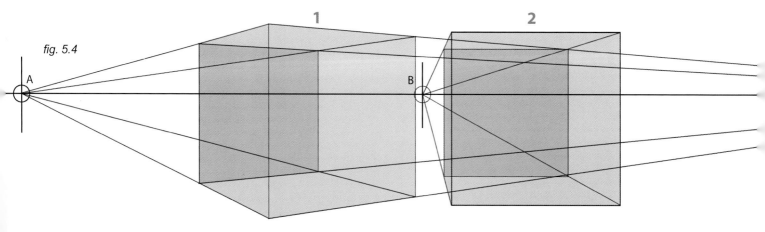

fig. 5.4

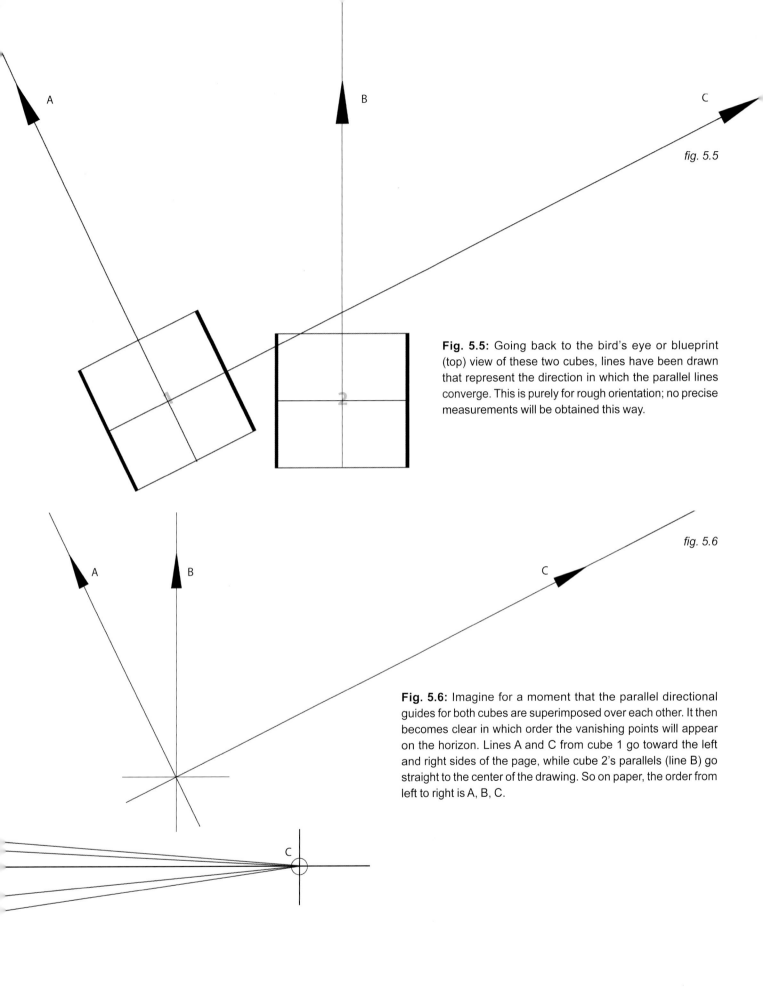

Fig. 5.5: Going back to the bird's eye or blueprint (top) view of these two cubes, lines have been drawn that represent the direction in which the parallel lines converge. This is purely for rough orientation; no precise measurements will be obtained this way.

Fig. 5.6: Imagine for a moment that the parallel directional guides for both cubes are superimposed over each other. It then becomes clear in which order the vanishing points will appear on the horizon. Lines A and C from cube 1 go toward the left and right sides of the page, while cube 2's parallels (line B) go straight to the center of the drawing. So on paper, the order from left to right is A, B, C.

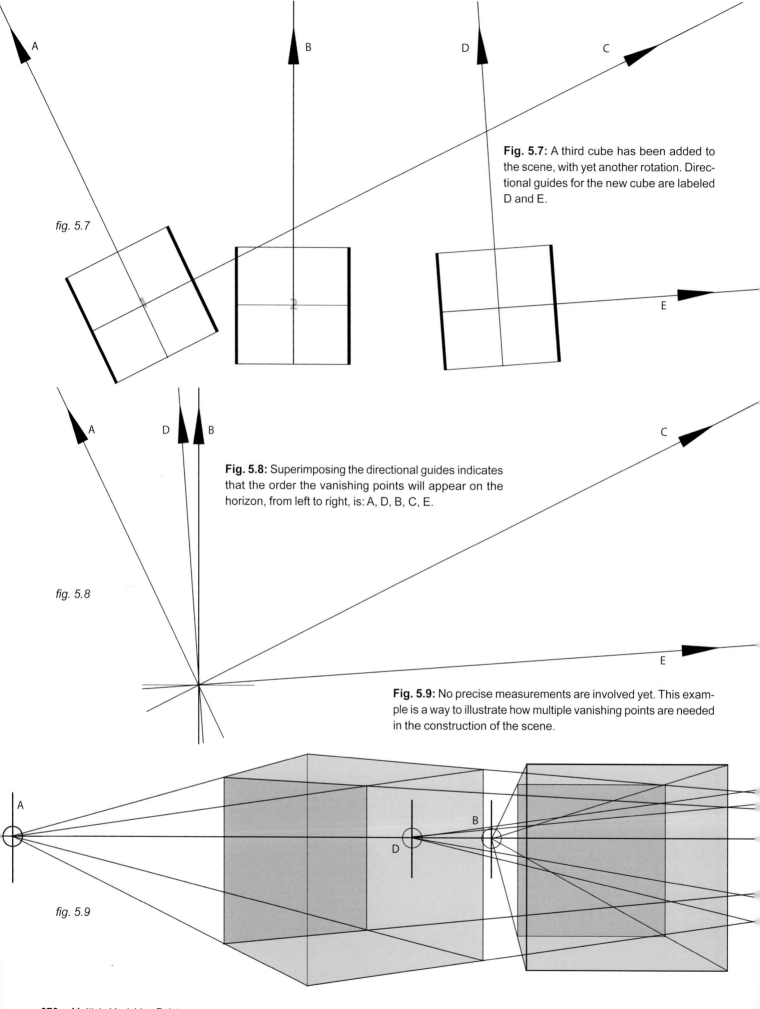

fig. 5.7

Fig. 5.7: A third cube has been added to the scene, with yet another rotation. Directional guides for the new cube are labeled D and E.

fig. 5.8

Fig. 5.8: Superimposing the directional guides indicates that the order the vanishing points will appear on the horizon, from left to right, is: A, D, B, C, E.

Fig. 5.9: No precise measurements are involved yet. This example is a way to illustrate how multiple vanishing points are needed in the construction of the scene.

fig. 5.9

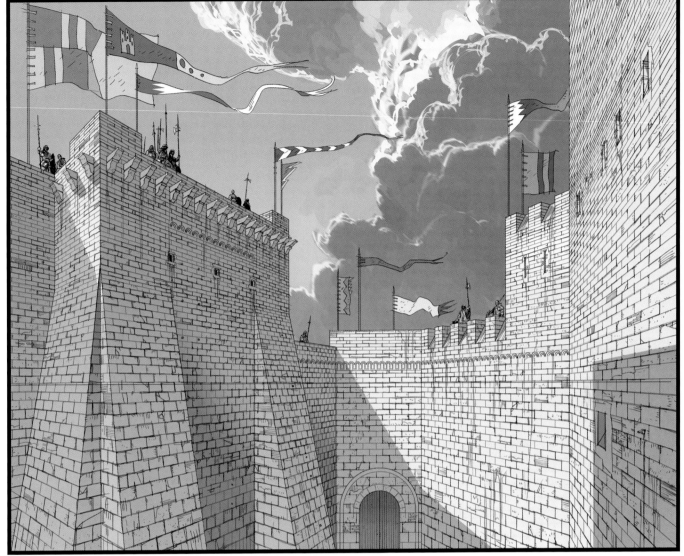

fig. 5.10

Fig. 5.10: This medieval castle illustration required the use of several vanishing points to represent properly the number of geometrical objects and figures in the panel, with its irregular placement of its various towers. Page 078 details the steps in the drawing process.

fig. 5.11

Fig. 5.11: This is the approximate blueprint or top view of the castle's walls, drawn with geometrical, rectangular shapes.

Fig. 5.12: The structure of the ramparts reduced to its basic shapes and the vanishing points used in the drawing.

Fig. 5.13: In this preliminary sketch, light and shadow create a graphic, structured and organized view of the image.

fig. 5.12

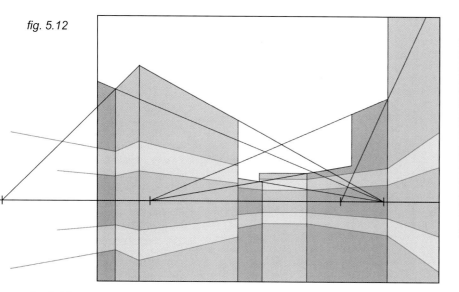

fig. 5.13

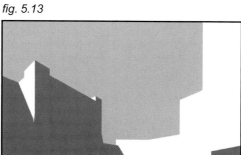

*Please refer to the process explained on pages 180–181, Chapter 9.

fig. 5.14

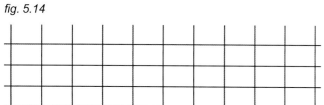

Fig. 5.14: For the rendering of the walls, the process starts by creating a full grid, following the appropriate perspective for each wall, as the basis for the final looks.

fig. 5.15

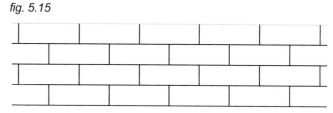

Fig. 5.15: To achieve the brick look, erase the unnecessary parts of the grid.

fig. 5.16

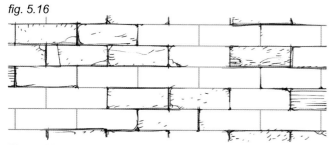

Fig. 5.16: The more mechanical-looking grid was toned down by digitally reducing the opacity of its layer in Photoshop. Then, a more irregularly applied freehand texture was drawn on top.

fig. 5.17

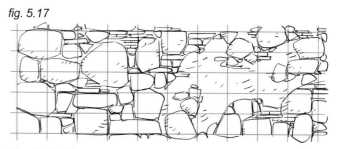

Fig. 5.17: The same process applies even in the case of a wall built with irregularly shaped rocks. A properly drawn grid used as an underlay helps to keep a solid sense of perspective and structure.

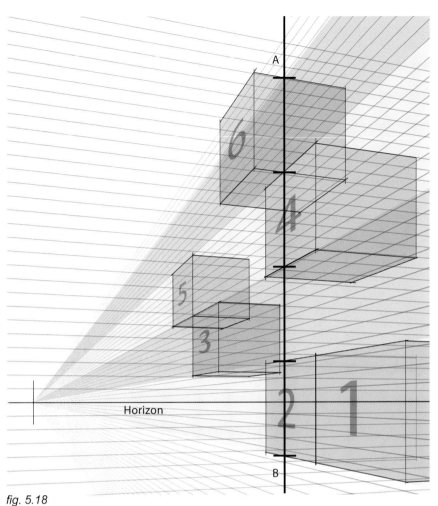

Fig. 5.18: This next illustration (fig. 5.21 on page 081) is of an architectural structure composed of modular units, all with the same measurements, positioned at different angles and distances from the observer.

To keep the size of the modules consistent throughout, a reference point is needed within the represented space. In this case, a vertical line (A–B) was drawn, on which was established the height of the different floors of this structure.

Given the fact that objects and measurements appear smaller as they get further away and bigger as they get closer, the only point on which all measurements can be represented as they truly are, in correct proportion to each other, is on a line that stands at an equal distance from the viewer from top to bottom. Therefore, it does not distort the proportions of the measurements represented.

In this case, all of the floors are equal in height. Using line A–B as the reference, the cubes can slide back and forth (cubes 1–5) as well as to the side (cube 6), all while keeping the required module height consistent.

fig. 5.18

fig. 5.19

Fig. 5.19: While always referring to reference line A–B for size and proportion consistency, it is possible to spin some of the modules around so that different blocks have different orientations and therefore different vanishing points on the horizon line.

The dotted lines represent one common size-reference as a sort of hinge around which some of the cubes have spun.

fig. 5.20

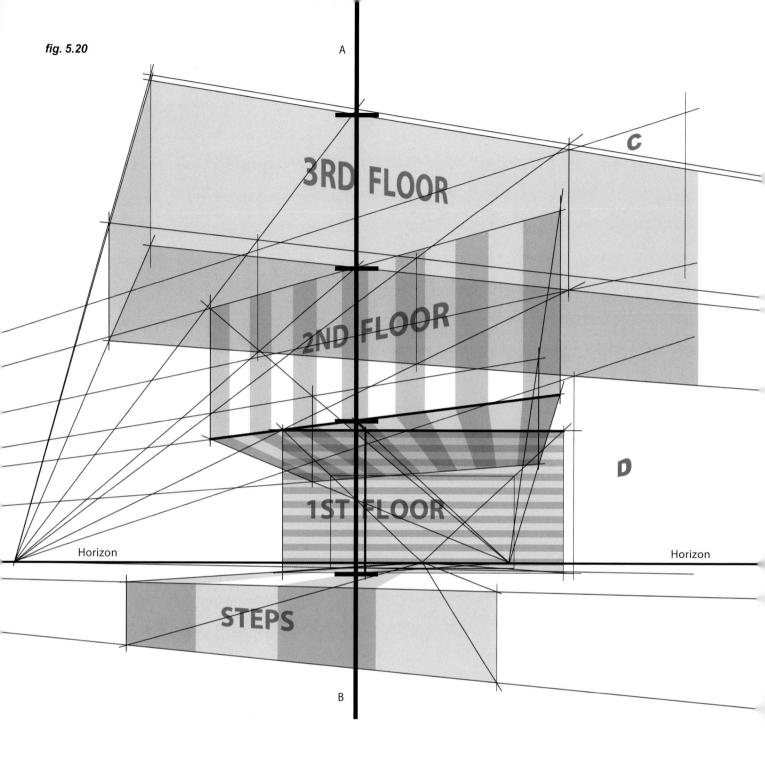

A

3RD FLOOR

C

2ND FLOOR

1ST FLOOR

D

Horizon

Horizon

STEPS

B

Fig. 5.20: Here is the basic perspective diagram of the blocks being used to create the illustration on the next page. Basically, each floor has its own set of converging lines and vanishing points, although a few are still shared. For example, the section of the 3rd floor marked C (the additional wall that comes out at an angle on fig. 5.21) is parallel to the 2nd floor and its lines converge to the same vanishing point, as do the parallel lines of section D on the 1st floor, with the 3rd floor. All of this is done in order to achieve a more dynamic feeling than one- or two-point perspective.

Again, one of the first steps taken to create this image was to draw a vertical line or axis (line A–B) on which the height of the floors were marked. These three stories of the house are of equal height, which is represented on this diagram by a thicker set of lines.

After that it is a matter of taking the receding lines to the appropriate vanishing points and creating the perspective effect needed for each floor.

fig. 5.21

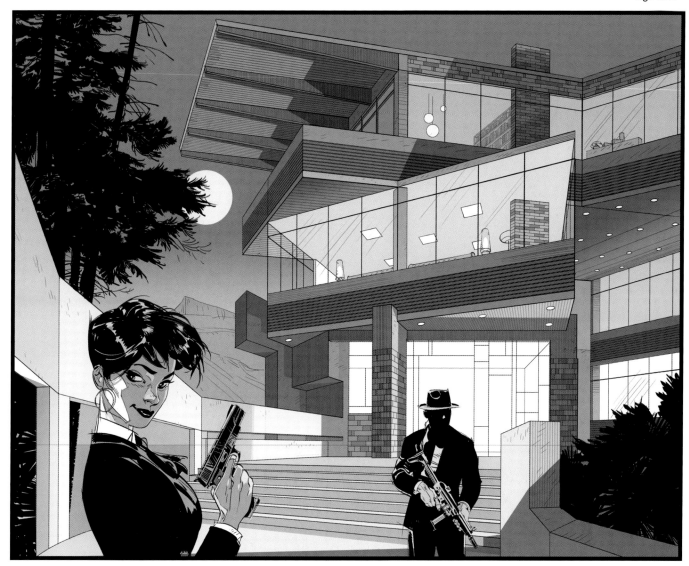

fig. 5.22

Fig. 5.21: Creating a building formed of blocks which are oriented in different directions, therefore with groups of parallel lines converging toward different vanishing points, can be the perfect tool for creating a level of tension and complexity which a regular structure pointing in one single direction would rarely be able to achieve. This type of building can be used to describe the personality of the character living within.

Fig. 5.22: In a night shot like this, try to concentrate the areas of light in certain spots only, rather than flattening everything out by "switching on" every light in the house. Here the female character has hot spots of light on her face against a generally darker background while the male character stands out more as dark on light.

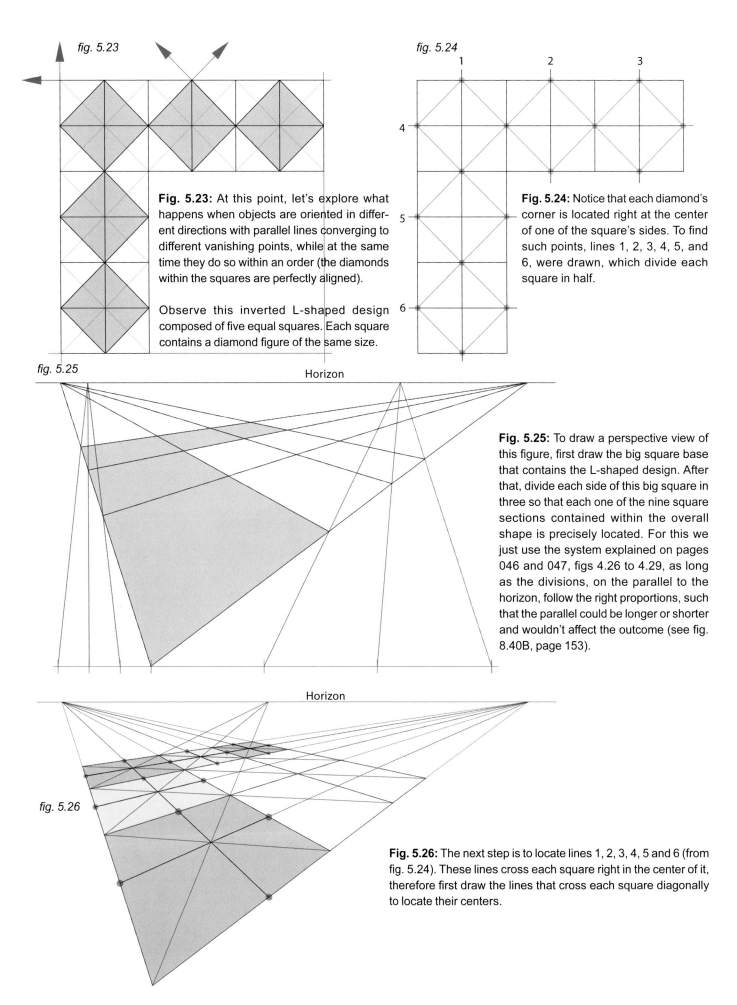

fig. 5.23

fig. 5.24

Fig. 5.23: At this point, let's explore what happens when objects are oriented in different directions with parallel lines converging to different vanishing points, while at the same time they do so within an order (the diamonds within the squares are perfectly aligned).

Observe this inverted L-shaped design composed of five equal squares. Each square contains a diamond figure of the same size.

Fig. 5.24: Notice that each diamond's corner is located right at the center of one of the square's sides. To find such points, lines 1, 2, 3, 4, 5, and 6, were drawn, which divide each square in half.

fig. 5.25

Horizon

Fig. 5.25: To draw a perspective view of this figure, first draw the big square base that contains the L-shaped design. After that, divide each side of this big square in three so that each one of the nine square sections contained within the overall shape is precisely located. For this we just use the system explained on pages 046 and 047, figs 4.26 to 4.29, as long as the divisions, on the parallel to the horizon, follow the right proportions, such that the parallel could be longer or shorter and wouldn't affect the outcome (see fig. 8.40B, page 153).

Horizon

fig. 5.26

Fig. 5.26: The next step is to locate lines 1, 2, 3, 4, 5 and 6 (from fig. 5.24). These lines cross each square right in the center of it, therefore first draw the lines that cross each square diagonally to locate their centers.

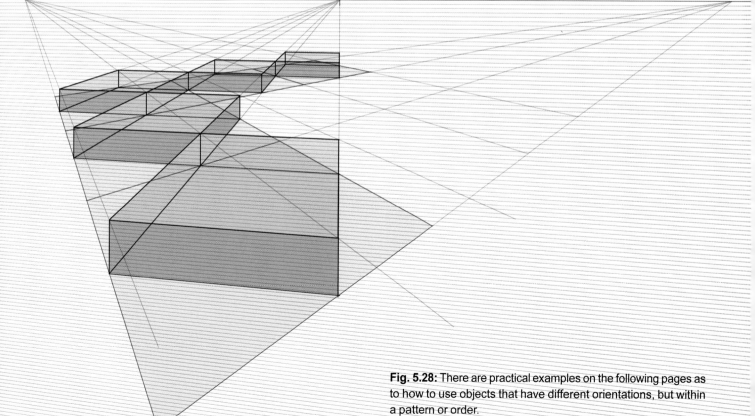

fig. 5.27

Fig. 5.27: Each diamond has now been placed precisely within each square. To give the diamonds a sense of three-dimensionality, just raise each one of them up to the desired height.

We know that the sides of each square in the design recede to two different vanishing points (one per set of parallel lines), but this also applies to the diamond shapes, as they also have two sets of parallels going in different directions than those of the squares. Therefore such parallels converge toward two different vanishing points.

fig. 5.28

Fig. 5.28: There are practical examples on the following pages as to how to use objects that have different orientations, but within a pattern or order.

fig. 5.29

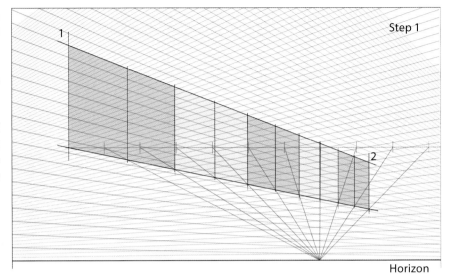

Step 1

Horizon

Fig. 5.30: Take a look at this floor plan for an apartment complex. It is made of five equal diamond-shaped forms.

Choose a point of view, a horizon line and a two-point perspective grid, as shown in fig. 5.29.

These two main vanishing points will help build the box defined by line 1–2 and its parallels; and line 3–4 and its parallels, as a structure (see fig. 5.32) within which to build the entire apartment block.

fig. 5.30

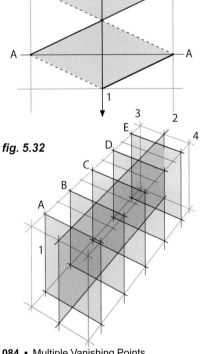

fig. 5.31

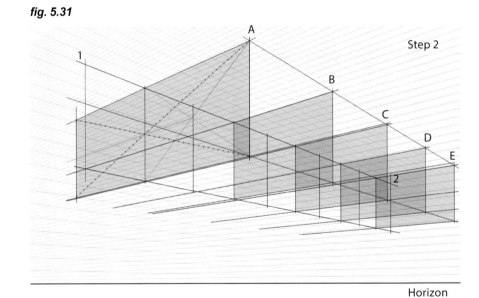

Step 2

Horizon

fig. 5.32

fig. 5.33

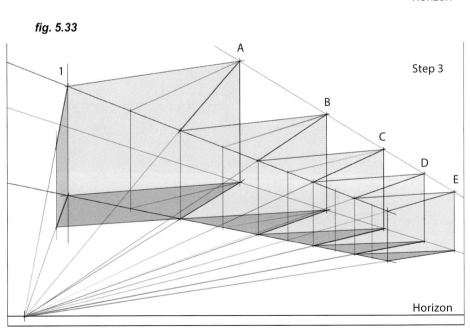

Step 3

Horizon

fig. 5.34

STEP 1, fig. 5.29: First, draw a view of the wall that is the main axis of the building (represented in the blueprint by the line 1–2) in the proper perspective within the grid.

Then, divide it into five equal parts using the same system as on pages 044-045. This determines where the center of each diamond-shaped structure is to be placed. Next, divide each of these five spaces in two (resulting in a total of ten segments of the axis wall).

STEP 2, fig. 5.31: Why divide each space in two? The blueprint (fig. 5.30) shows that the front angle of each diamond shape (represented in the floor plan by points A, B, C, D, and E) is also the end of each of the five perpendiculars to axis 1–2.

To find A, B, C, D and E in perspective, draw five perpendicular planes that divide the five sections. In this example, the length of these planes has been eyeballed to a measurement that felt right.

STEP 3, fig. 5.33: Connect point 1 with point "A" and so on, in a zigzag fashion, to create the basic structure for the building.

Notice that in this general structure there are four distinct sets of parallel lines which all need vanishing points:
 • Line 1–2 and its parallels
 • All perpendiculars to line 1–2
 • Two sets of parallels that form the arrowhead shape of the diamonds (represented in the blueprint by both the dotted and the thicker lines).

Fig. 5.34: After that, render the drawing properly and it will become a rather dramatic location.

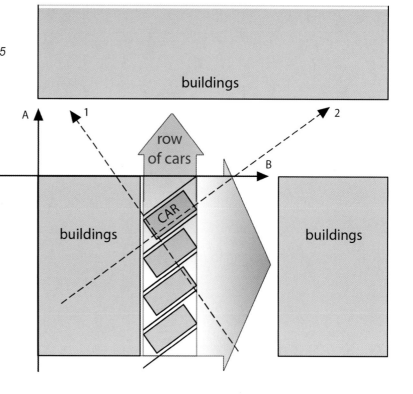

fig. 5.35

Fig. 5.35: A diagonal parking lot is another typical example where the buildings and general layout of the neighborhood use a specific set of (two) vanishing points ("A" and "B"), while the individual cars parked in the alley use another set of vanishing points ("1" and "2"). Again, this is only when looking at each car individually.

The moment the cars are considered as a unit ordered within a row as a whole, it becomes clear that the row is structured in a way that uses the same two vanishing points as the buildings in the neighborhood (see all arrows aligned with directions "A" and "B").

Fig. 5.36: A quick "on the spot" sketch or photograph for reference of this everyday location can help you visualize how the general structure of a shot like this can work. It needs two different sets of vanishing points: "A" and "B" for the street and its parallels (the nearby buildings)...

Fig. 5.37: ...and vanishing points "1" and "2" for the cars and their rectangular parking places.

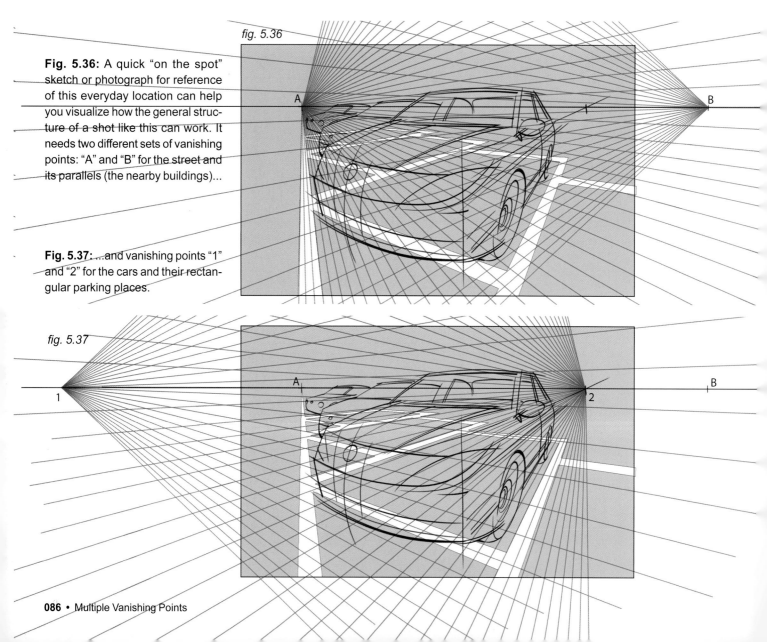

Fig. 5.38: Before drawing and rendering the cars, create the boxes (shaded gray) that will contain the cars in the correct perspective.

As shown, the corners of the boxes align and are labeled here as Lines F, G, H, and J. These lines are parallel to the street, building and sidewalks.

Fig. 5.39: Here are the same alignments, shown in perspective.

Fig. 5.40: The last step is to draw the cars (plus the buildings, characters, etc.) within the boxes. The boxes are the basic structure and core of the final image, as seen on page 088.

This general set-up is used to determine the placement of the various elements that compose a scene. More details on how to draw a car in a similar perspective are found on page 151.

Fig. 5.41: See page 088. In this final illustration notice that by aligning structures differently and therefore using multiple sets of vanishing points and directions, the sense of dynamism of an action scene is enhanced.

* The measurements and angles have been eyeballed making sure they felt right to the eye. For a more accurate method when proper bueprints are available, please refer to chapter 9.

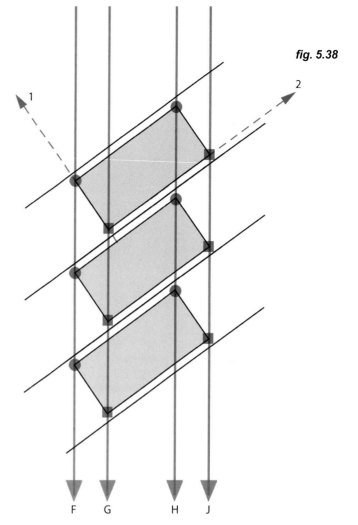

fig. 5.38

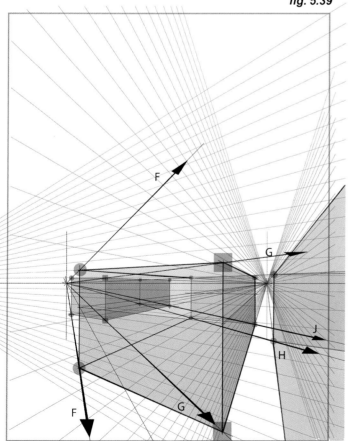

fig. 5.39

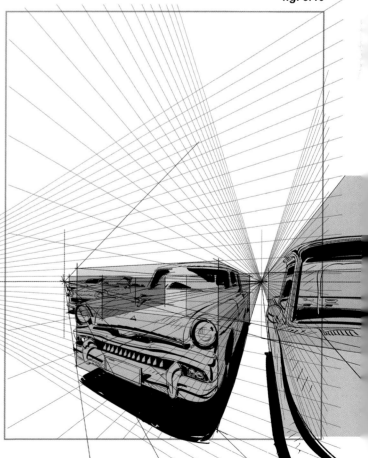

fig. 5.40

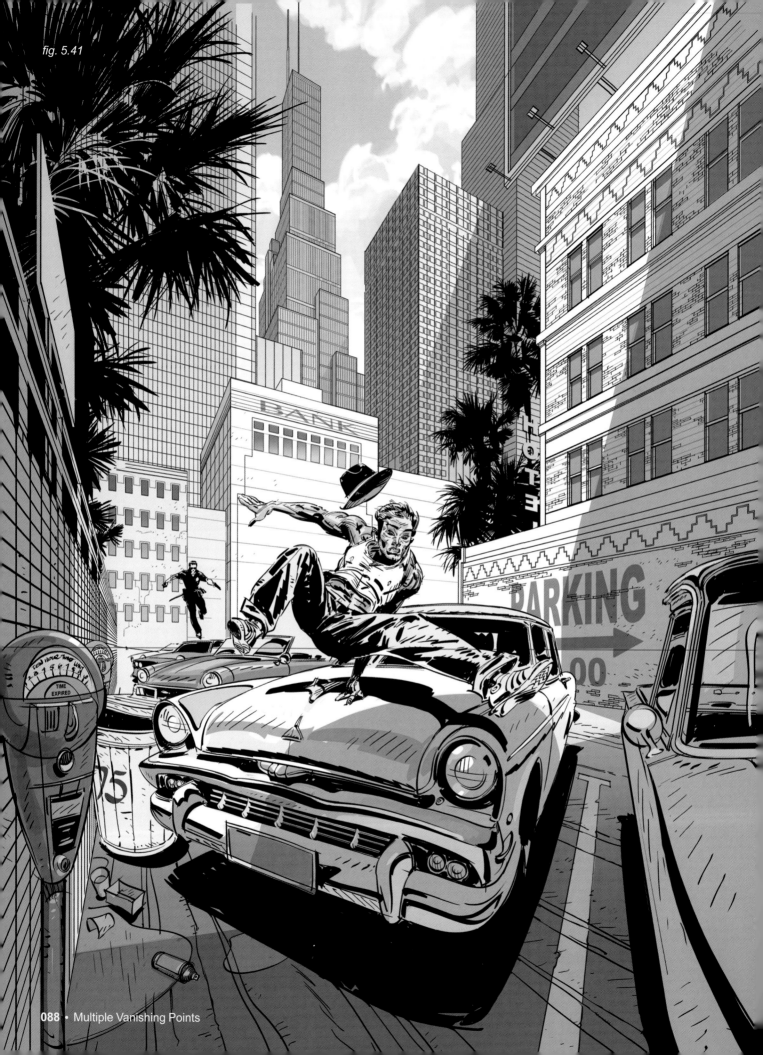

fig. 5.41

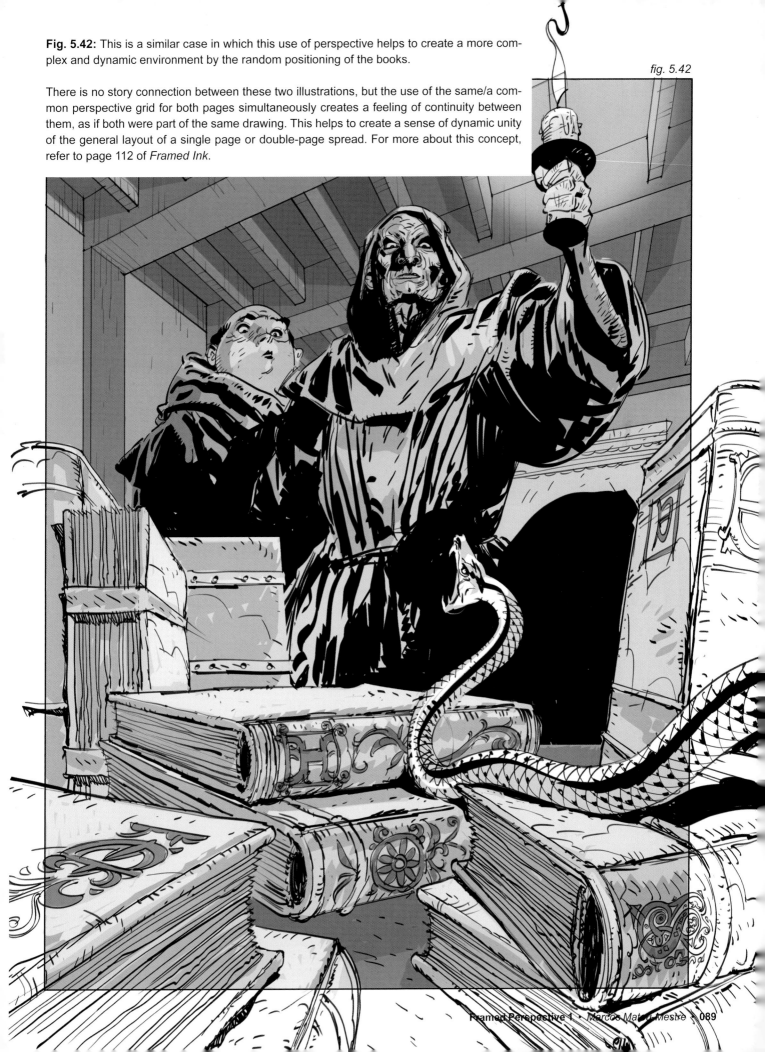

Fig. 5.42: This is a similar case in which this use of perspective helps to create a more complex and dynamic environment by the random positioning of the books.

There is no story connection between these two illustrations, but the use of the same/a common perspective grid for both pages simultaneously creates a feeling of continuity between them, as if both were part of the same drawing. This helps to create a sense of dynamic unity of the general layout of a single page or double-page spread. For more about this concept, refer to page 112 of *Framed Ink*.

fig. 5.42

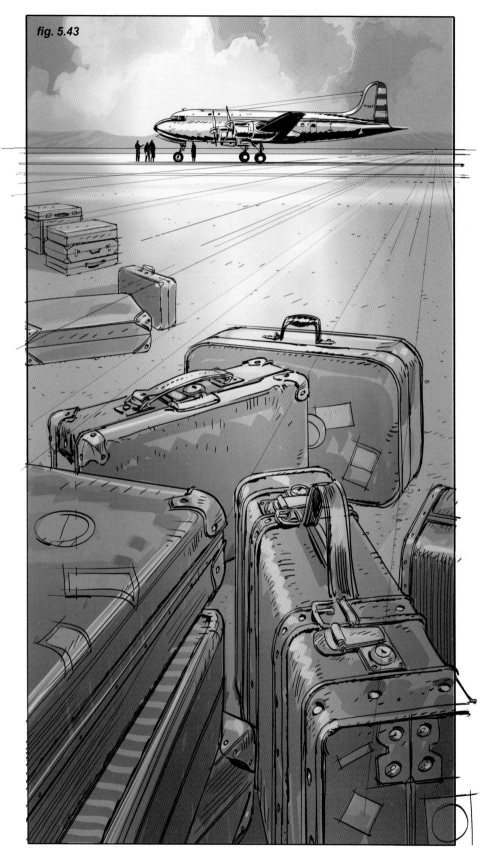

fig. 5.43

Fig. 5.43: This illustration is similar in its general layout to the *Mystery in the Abbey* on the previous page, that is, some elements are randomly placed in the foreground within an environment that serves as a backdrop. The main difference between the two panels is that in this new one (call it *Traveling into the Unknown)*, the main backdrop elements (the airplane and distant tarmac) are located at a much greater distance to the foreground suitcases than the monks were to the books.

The moment perspective is used to connect these two levels, it needs to be especially accurate. Why? Because in any given environment, bigger distances imply an automatic magnification of any mistake made in the use of measurements and proportions. A tiny error near the vanishing point translates into a much bigger problem the closer it gets to the camera (or the viewer).

There is one main concern here, to make sure that the suitcases in the foreground, the other suitcases in the distance, the people and the airplane all look proportionally related to each other within this one single environment.

In other words, how do we make sure the suitcases in the foreground do not end up looking too small or too big in relationship to the plane in the distance? It is tempting to try to figure it out by instinct and come up with something that looks decent today...but then look at the illustration again two months from now and you will probably be appalled at how wrong the proportion really appears.

*The measurements and angles have been eyeballed making sure they felt right to the eye. For a more accurate method when proper blueprints are available, please refer to chapter 9.

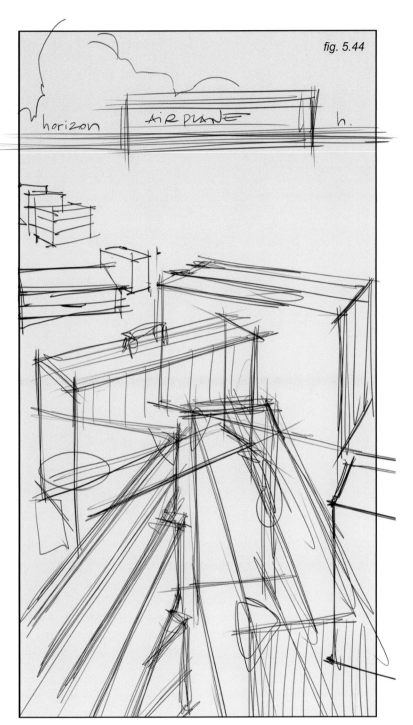

Fig. 5.44: Let's go through the full process from the beginning: Start with a quick sketch that gives a good idea where everything needs to be so that the composition works.

The horizon line has been estimated. Where exactly should the horizon line be placed so that the right perspective can be built with confidence?

Fig. 5.45: The plane model closely follows a type built in the 1950s, so look for information regarding its actual measurements, basically length and height. Once these measurements are known, draw a character right near it that represents a person of average height. Therefore, that character is at the same distance from the observer as the plane. Right next to this character, draw a suitcase that is of a believable size within the whole context.

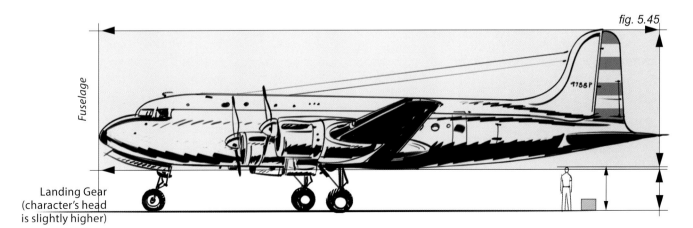

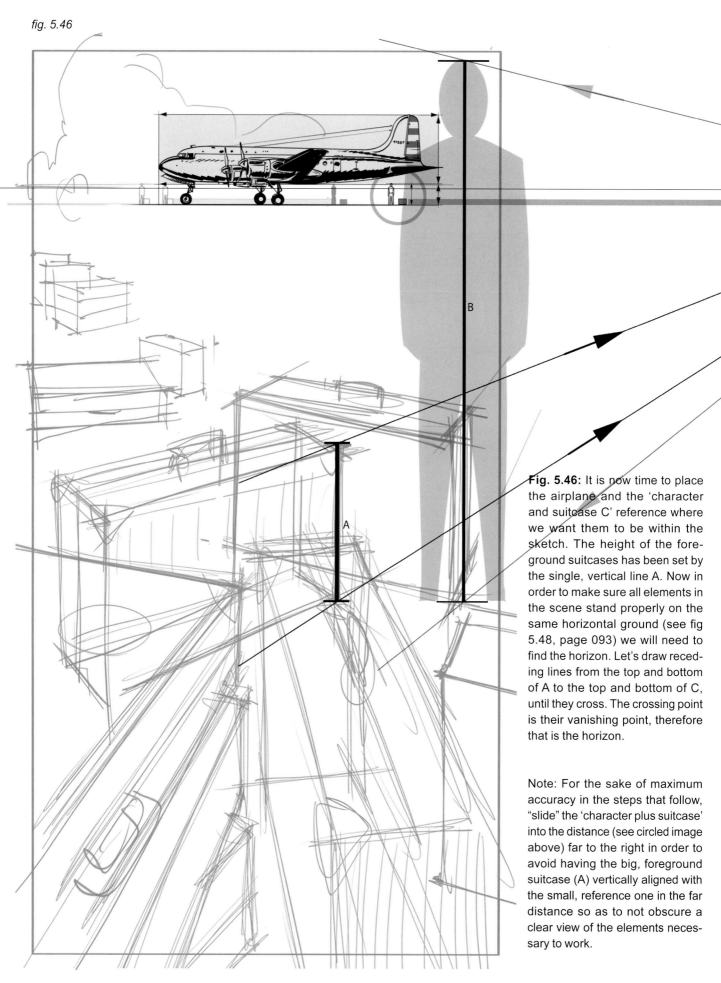

fig. 5.46

Fig. 5.46: It is now time to place the airplane and the 'character and suitcase C' reference where we want them to be within the sketch. The height of the foreground suitcases has been set by the single, vertical line A. Now in order to make sure all elements in the scene stand properly on the same horizontal ground (see fig 5.48, page 093) we will need to find the horizon. Let's draw receding lines from the top and bottom of A to the top and bottom of C, until they cross. The crossing point is their vanishing point, therefore that is the horizon.

Note: For the sake of maximum accuracy in the steps that follow, "slide" the 'character plus suitcase' into the distance (see circled image above) far to the right in order to avoid having the big, foreground suitcase (A) vertically aligned with the small, reference one in the far distance so as to not obscure a clear view of the elements necessary to work.

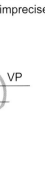

Fig. 5.47 Notice we previously slid the 'character and suitcase C' reference to the right so that C would not be close to the same vertical as A anymore, otherwise the receding lines would appear cluttered and imprecise.

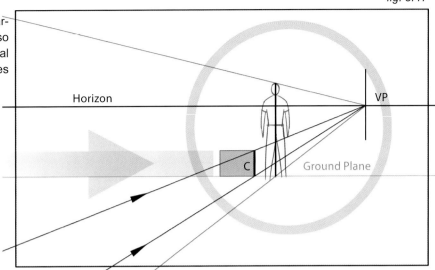

fig. 5.47

Horizon

VP

C

Ground Plane

Observe the top and the bottom points of line A (foreground suitcase's height) with the top and bottom points of line C (see **fig. 5.47**, detail) which represents the height of the reference suitcase positioned in the distance. This way, two receding vertical lines have been created, that have the two key positions of the suitcases, close and far away, as the common element. A line drawn across the top of the height of these two receding vertical height lines converges at a common vanishing point because these two suitcases are sitting on flat ground.

We know that vanishing point will be precisely located on the horizon line, which is the reference line we were searching for!

It is very important to make sure the job is done accurately. Once the horizon line is established, project the character's shape forward (B), right by the suitcases in the foreground. This helps ensure that the proportion and positioning of all elements is accurate and no size distortions have occurred, which might

have happened if we had relied on only one single element like the suitcases.

Notice how when two characters stand on a perfectly flat surface, no matter how far or close, or right or left of the viewer, the horizon line always crosses both characters, near and far, at the exact same level (in this case, around the chest). This will be discussed in more detail later in this book.

That being said, while double-checking everything, minor adjustments and repositioning of some elements might be necessary to make sure everything sits in the right place.

Essentially, this is reverse engineering. If instead of the two suitcases and *no* horizon line, we had the horizon line plus only one suitcase, the second suitcase could have been found easily by using the existing one and a vanishing point on the horizon.

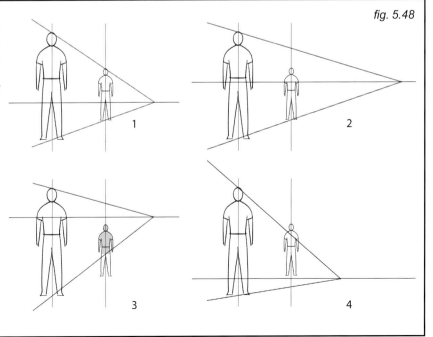

Fig. 5.48: Before proceeding with the rest of this exercise, here are a few examples of how, by positioning the horizon line differently behind two steady elements (in this case, two characters), we completely change the visual perception of them and their set-up.

1- Two same-height characters, both stand on the same floor.

2- Two different-height characters, both stand on the same floor.

3- The character in the distance appears to be sunk into the ground if the horizon is wrongly placed too high.

4- The character in the distance appears to be hovering above the ground if the horizon is wrongly placed too low.

fig. 5.48

fig. 5.49

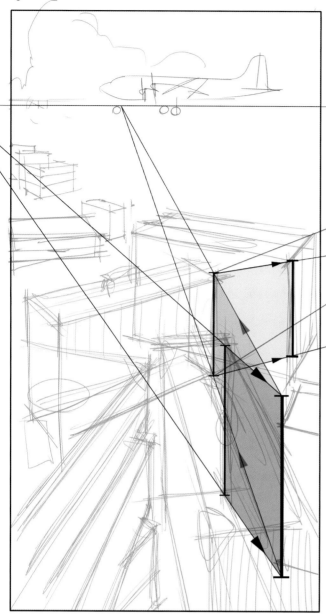

Fig. 5.49: It is possible to slide a specific measurement on top of a flat ground plane to determine how big or small that same measurement appears at different spots on the same surface, closer or farther away from the viewer (see pages 056 to 059 of *Framed Perspective 2*).

Notice how the height of equally tall suitcases would appear in different spots on the tarmac.

After having moved this standard, average-height suitcase to different areas on the tarmac, it is time to decide if all the suitcases should be of the same height, and if not, to make certain size variations to each of them.

fig. 5.50

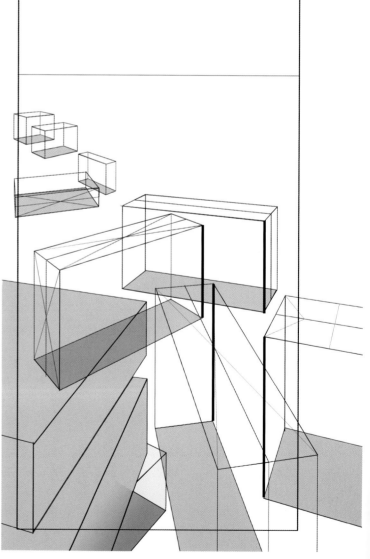

Fig. 5.50: Once all of these height references have been worked out perfectly, create a perspective grid for each suitcase, so that its parallel lines converge to two different vanishing points on the horizon.

Because the exact position of the horizon line was determined, the positioning and size of every element in the shot makes perfect sense within this context.

Lastly, *draw through!* Draw all of the suitcases as if they were transparent or made of glass. This way it is easy to double-check that all of the suitcase bottoms are either separate from each other or touching, but never overlapping! (The three in the foreground do not overlap at the base; they are stacked in a pile.)

6

THREE VANISHING POINTS PERSPECTIVE

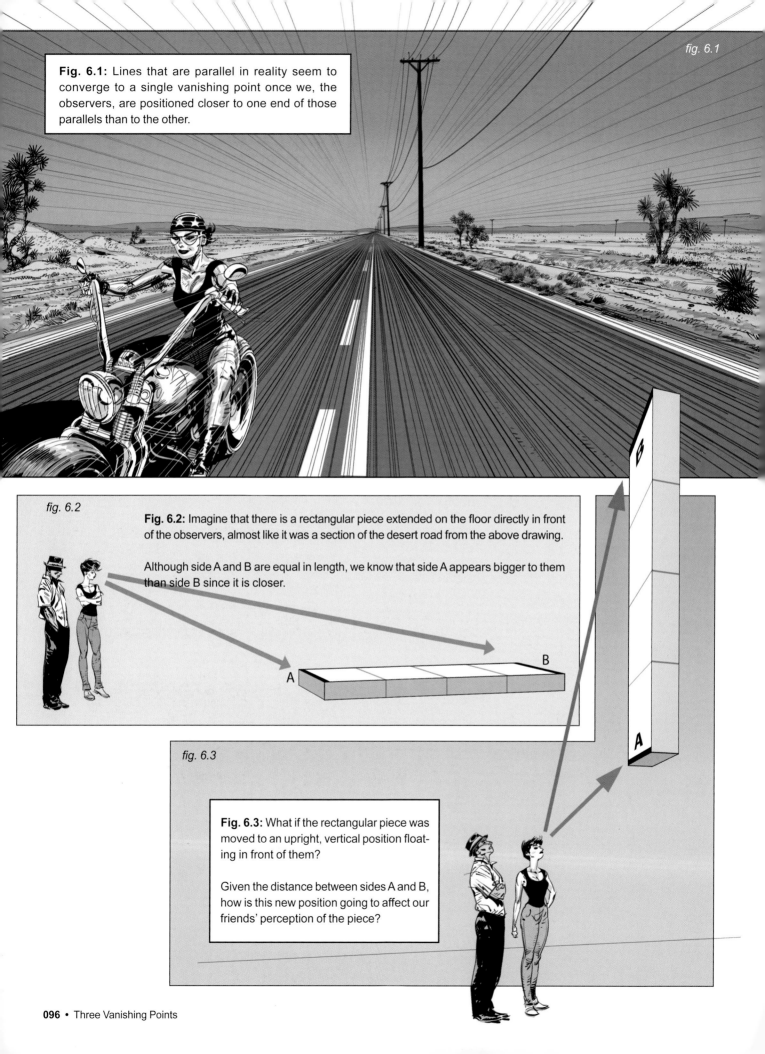

fig. 6.1

Fig. 6.1: Lines that are parallel in reality seem to converge to a single vanishing point once we, the observers, are positioned closer to one end of those parallels than to the other.

fig. 6.2

Fig. 6.2: Imagine that there is a rectangular piece extended on the floor directly in front of the observers, almost like it was a section of the desert road from the above drawing.

Although side A and B are equal in length, we know that side A appears bigger to them than side B since it is closer.

A B

fig. 6.3

Fig. 6.3: What if the rectangular piece was moved to an upright, vertical position floating in front of them?

Given the distance between sides A and B, how is this new position going to affect our friends' perception of the piece?

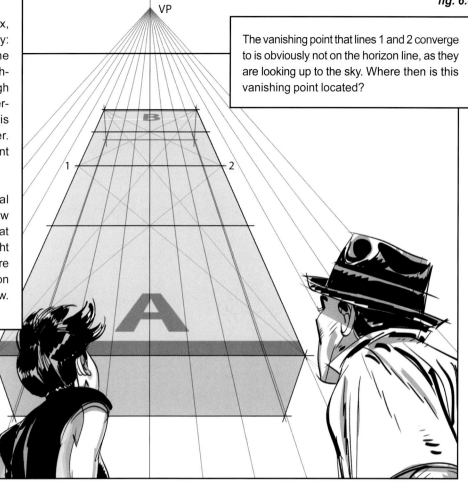

fig. 6.4

Fig. 6.4: As they look up at the box, the same principles from fig. 6.1 apply: Parallel lines that go away into the distance converge to the same vanishing point; and sides A and B, although equal in length, are perceived as different given the simple fact that one is closer to the viewers than the other. Essentially what they see is equivalent to the desert road image.

Caveat: For the sake of the visual example, this illustration does not show exactly what they see, but rather what we would see if we were positioned right behind Arianna and Julio. Since they are both included in the shot, this illustration cannot technically be their point of view.

The vanishing point that lines 1 and 2 converge to is obviously not on the horizon line, as they are looking up to the sky. Where then is this vanishing point located?

fig. 6.5

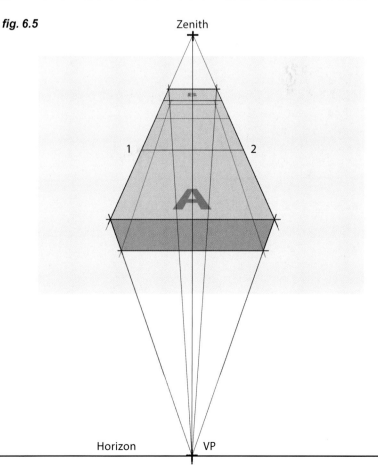

Fig. 6.5: Parallel lines 1 and 2 are perfectly vertical, meaning they are perpendicular to the ground plane as if they were coming straight out from the center of the Earth. Their vanishing point is the zenith itself; an imaginary point right above the location of the object.

There is no need to do anything special to locate the zenith on the drawing surface, just place it wherever it feels right, as with any other vanishing point.

Technically speaking, if the vanishing point for lines 1 and 2 is placed elsewhere than what is designated as the zenith (meaning, just another "random spot"), then the sides A and B would not appear to be aligned vertically. Rather it would look like a simple, inclined plane positioned, relative to the ground plane, at an angle other than the desired 90 degrees.

Compared to the drawing in fig. 6.4, the illustration in 6.5 has pulled back to give a more complete view of all the elements involved in drawing the perspective of this rectangular box from this particular point of view.

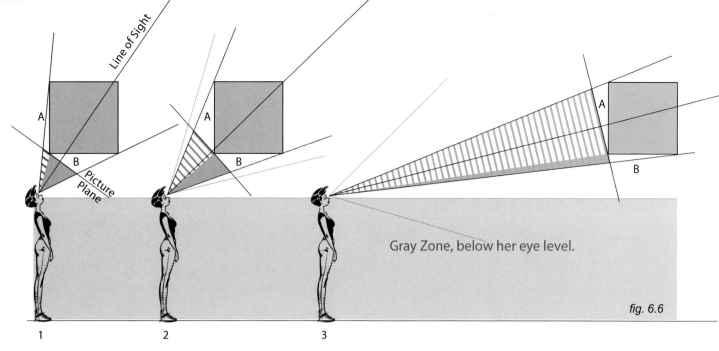

fig. 6.6

Fig. 6.6 (Poses 1, 2 and 3): Here is a side view of Arianna looking up at a cube.

Pose 1: She is closest to the floating cube and has to bend her neck quite a bit to see it in its entirety.

Pose 2: She can relax a bit more as the cube is a little farther away from her.

Pose 3: The distance between her and the cube has increased dramatically.

The picture plane is perpendicular to her line of sight. The amount of side "A" that she can see in any of the poses is represented within her cone of vision by the striped area, while the amount of side "B" she can see is indicated by the zone of solid gray.

The closer she is to the cube, the less she sees of side "A" (facing her), and the more she sees of side "B" (bottom). In Pose 1, she can barely see side "A."

The farther she is from the cube, the more she can see of side "A" and the less she can see of side "B."

fig. 6.7

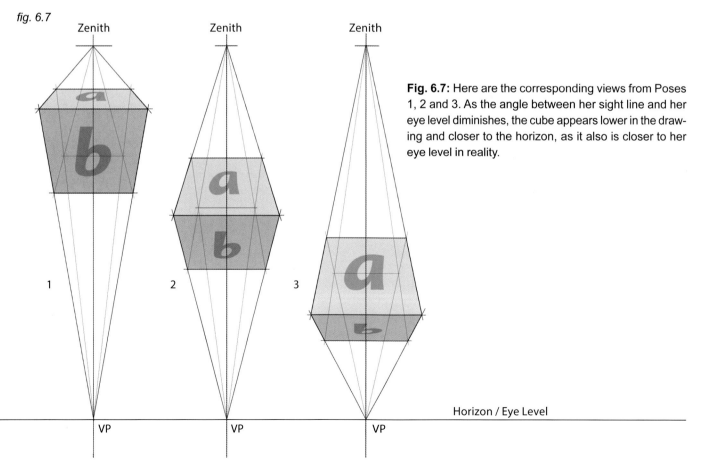

Fig. 6.7: Here are the corresponding views from Poses 1, 2 and 3. As the angle between her sight line and her eye level diminishes, the cube appears lower in the drawing and closer to the horizon, as it also is closer to her eye level in reality.

fig. 6.8

Horizon

Fig. 6.8: The previous example explained how a cube looks when it is positioned above eye level and so close to the viewer that in order to see it, she has to look up. Here is a similar example, but with many more polyhedrons in the scene. All vertical lines converge to the zenith, and all lines that are parallel to the ground plane converge to a vanishing point on the horizon line.

Again, all sides labeled "A" face the viewer and all sides labeled "B" are parallel to the floor. The three tallest polyhedrons rest on the ground while the others float in midair. Notice that the boxes in the drawing appear somewhat distorted. This is because the drawing includes way more than what our cone of vision would actually allow us to see. If we bent our neck and looked up enough to see the boxes at the very top of the drawing, we would not see the horizon nor the base of these boxes, unless our eyes were the super wide-angle lenses that they are not. For more on lenses, see chapter 10.

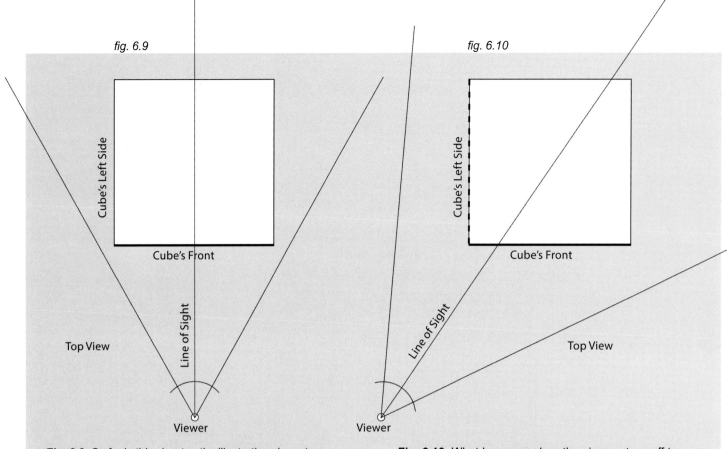

Fig. 6.9: So far in this chapter, the illustrations have two vanishing points, one up at the zenith where the verticals converge, and the other on the horizon where the horizontal lines converge. This is the case only when the viewer is positioned perfectly in front of the cube, like in the graphic above.

Fig. 6.10: What happens when the viewer steps off to the side, or the cube is rotated so that the front side of the cube is no longer perpendicular to the line of sight?

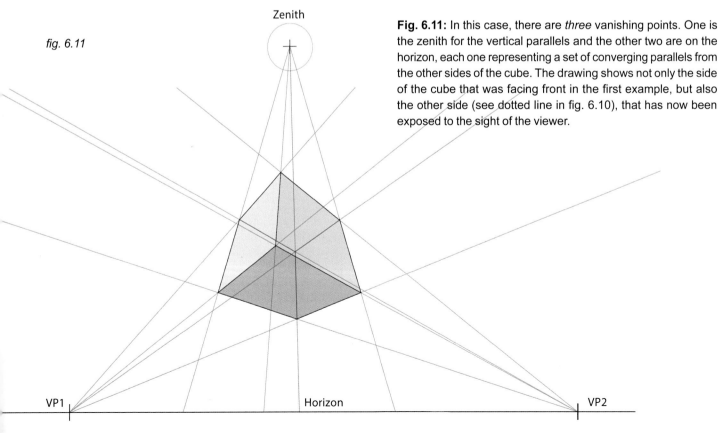

Fig. 6.11: In this case, there are *three* vanishing points. One is the zenith for the vertical parallels and the other two are on the horizon, each one representing a set of converging parallels from the other sides of the cube. The drawing shows not only the side of the cube that was facing front in the first example, but also the other side (see dotted line in fig. 6.10), that has now been exposed to the sight of the viewer.

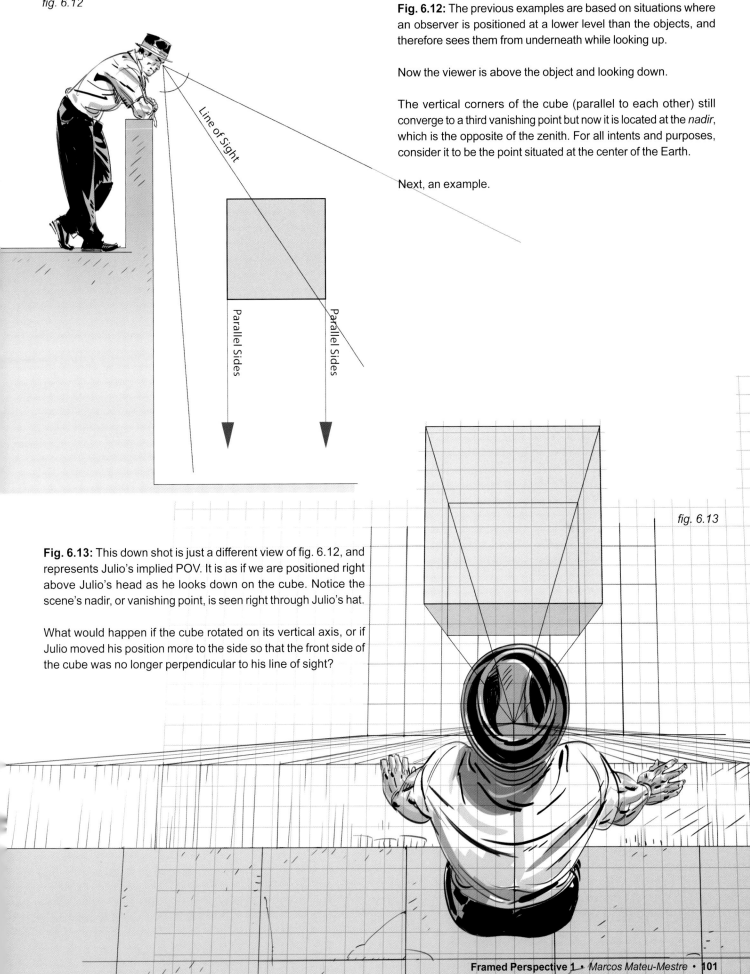

fig. 6.12

Fig. 6.12: The previous examples are based on situations where an observer is positioned at a lower level than the objects, and therefore sees them from underneath while looking up.

Now the viewer is above the object and looking down.

The vertical corners of the cube (parallel to each other) still converge to a third vanishing point but now it is located at the *nadir*, which is the opposite of the zenith. For all intents and purposes, consider it to be the point situated at the center of the Earth.

Next, an example.

Line of Sight

Parallel Sides

Parallel Sides

fig. 6.13

Fig. 6.13: This down shot is just a different view of fig. 6.12, and represents Julio's implied POV. It is as if we are positioned right above Julio's head as he looks down on the cube. Notice the scene's nadir, or vanishing point, is seen right through Julio's hat.

What would happen if the cube rotated on its vertical axis, or if Julio moved his position more to the side so that the front side of the cube was no longer perpendicular to his line of sight?

fig. 6.14

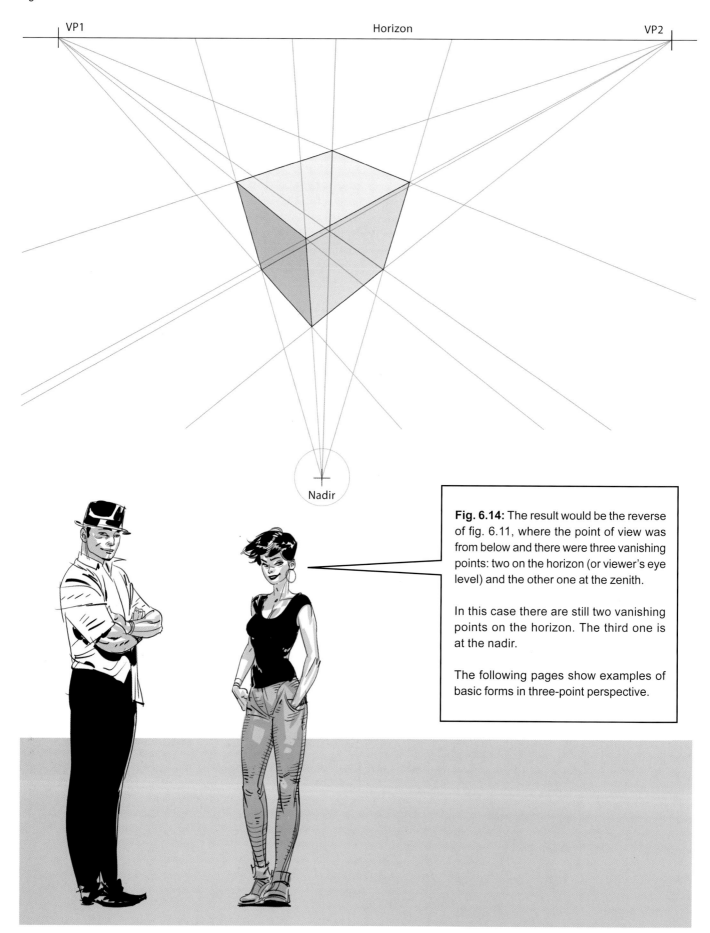

VP1 · Horizon · VP2

Nadir

Fig. 6.14: The result would be the reverse of fig. 6.11, where the point of view was from below and there were three vanishing points: two on the horizon (or viewer's eye level) and the other one at the zenith.

In this case there are still two vanishing points on the horizon. The third one is at the nadir.

The following pages show examples of basic forms in three-point perspective.

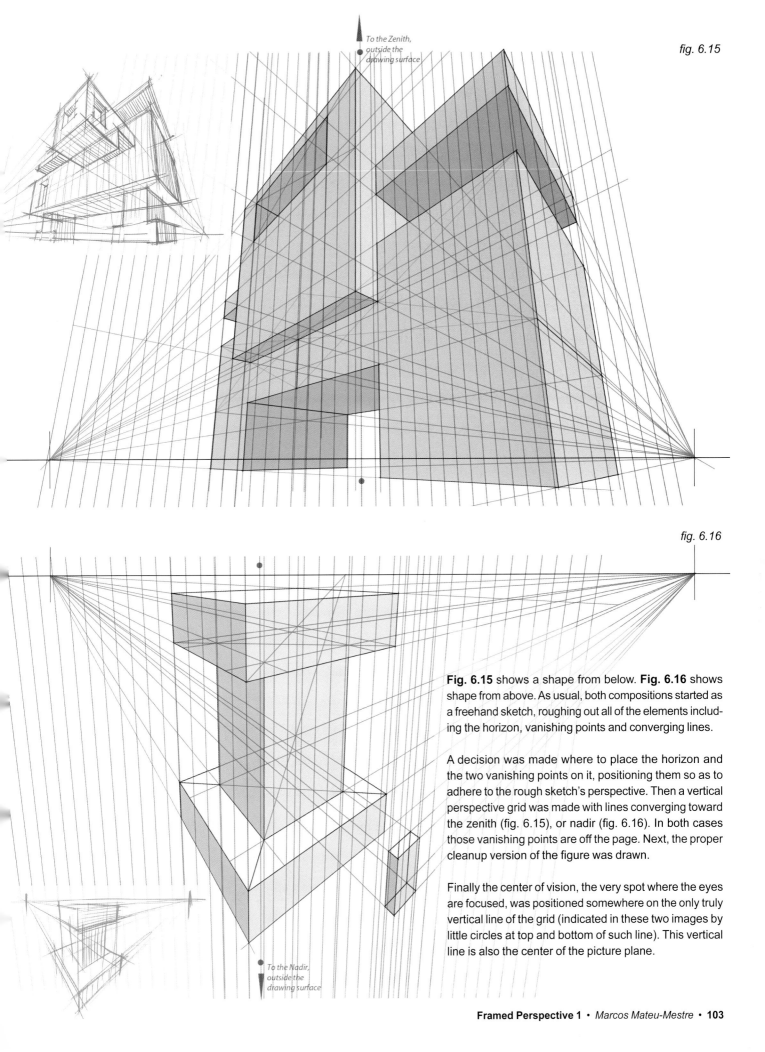

fig. 6.15

To the Zenith, outside the drawing surface

fig. 6.16

Fig. 6.15 shows a shape from below. **Fig. 6.16** shows shape from above. As usual, both compositions started as a freehand sketch, roughing out all of the elements including the horizon, vanishing points and converging lines.

A decision was made where to place the horizon and the two vanishing points on it, positioning them so as to adhere to the rough sketch's perspective. Then a vertical perspective grid was made with lines converging toward the zenith (fig. 6.15), or nadir (fig. 6.16). In both cases those vanishing points are off the page. Next, the proper cleanup version of the figure was drawn.

Finally the center of vision, the very spot where the eyes are focused, was positioned somewhere on the only truly vertical line of the grid (indicated in these two images by little circles at top and bottom of such line). This vertical line is also the center of the picture plane.

To the Nadir, outside the drawing surface

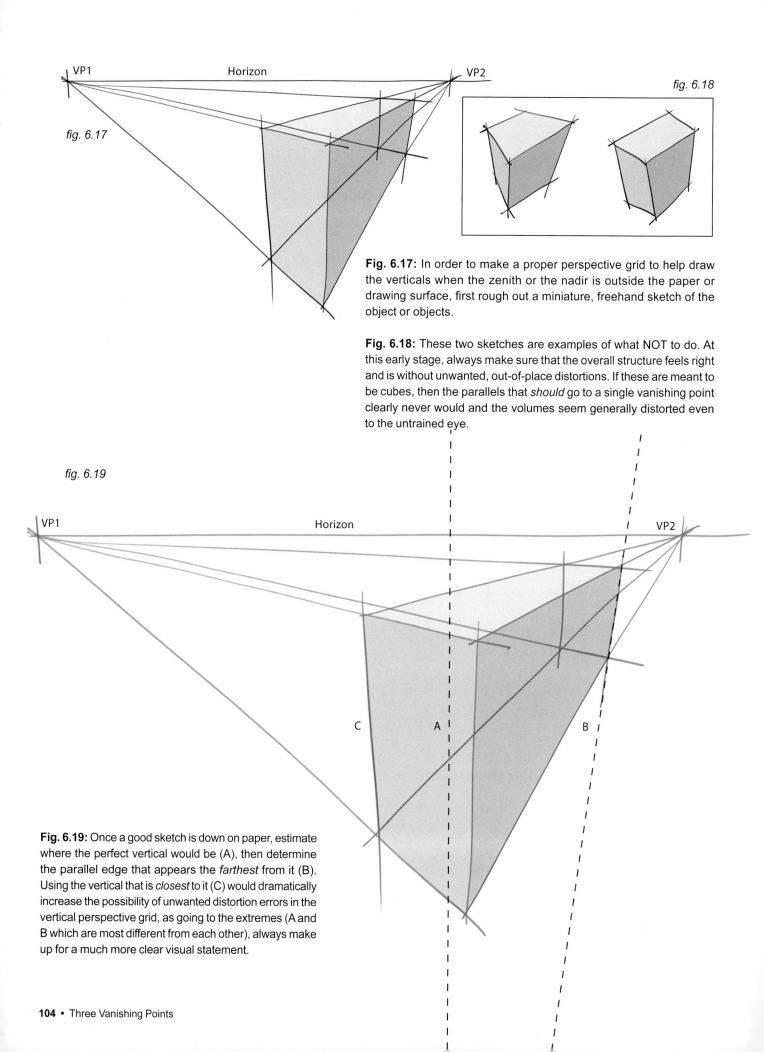

VP1 · Horizon · VP2

fig. 6.17

fig. 6.18

Fig. 6.17: In order to make a proper perspective grid to help draw the verticals when the zenith or the nadir is outside the paper or drawing surface, first rough out a miniature, freehand sketch of the object or objects.

Fig. 6.18: These two sketches are examples of what NOT to do. At this early stage, always make sure that the overall structure feels right and is without unwanted, out-of-place distortions. If these are meant to be cubes, then the parallels that *should* go to a single vanishing point clearly never would and the volumes seem generally distorted even to the untrained eye.

fig. 6.19

VP1 · Horizon · VP2

C · A · B

Fig. 6.19: Once a good sketch is down on paper, estimate where the perfect vertical would be (A), then determine the parallel edge that appears the *farthest* from it (B). Using the vertical that is *closest* to it (C) would dramatically increase the possibility of unwanted distortion errors in the vertical perspective grid, as going to the extremes (A and B which are most different from each other), always make up for a much more clear visual statement.

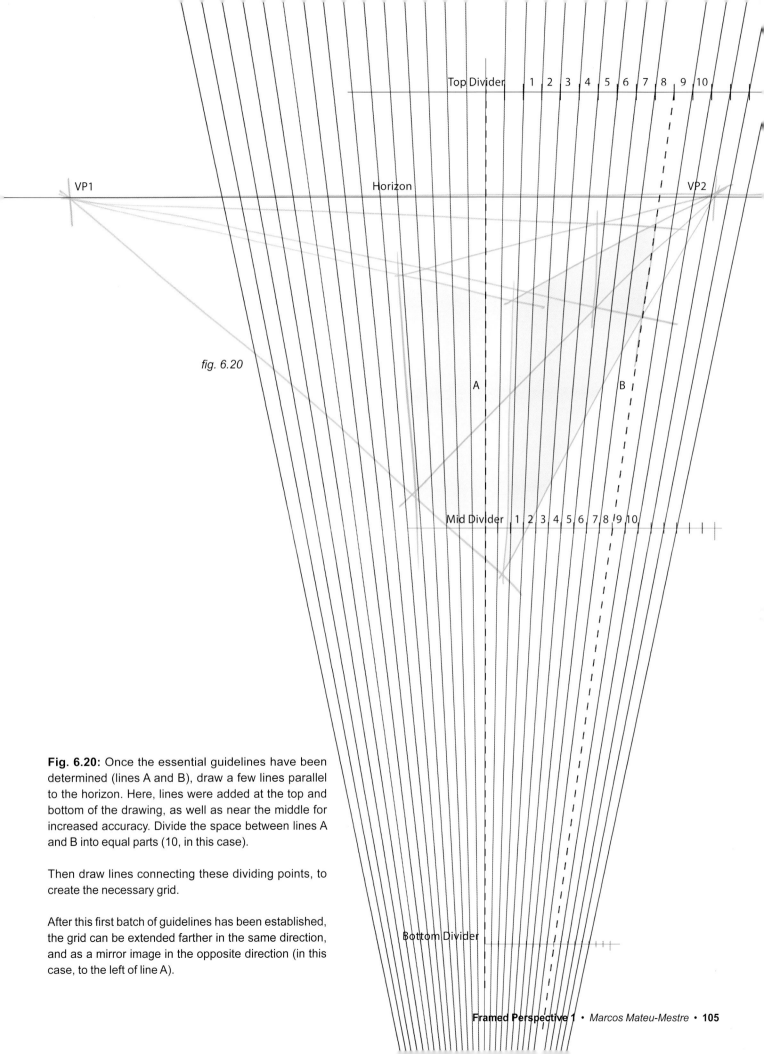

Top Divider | 1 | 2 | 3 | 4 | 5 | 6 | 7 | 8 | 9 | 10

VP1

Horizon

VP2

A

B

fig. 6.20

Mid Divider | 1 | 2 | 3 | 4 | 5 | 6 | 7 | 8 | 9 | 10

Bottom Divider

Fig. 6.20: Once the essential guidelines have been determined (lines A and B), draw a few lines parallel to the horizon. Here, lines were added at the top and bottom of the drawing, as well as near the middle for increased accuracy. Divide the space between lines A and B into equal parts (10, in this case).

Then draw lines connecting these dividing points, to create the necessary grid.

After this first batch of guidelines has been established, the grid can be extended farther in the same direction, and as a mirror image in the opposite direction (in this case, to the left of line A).

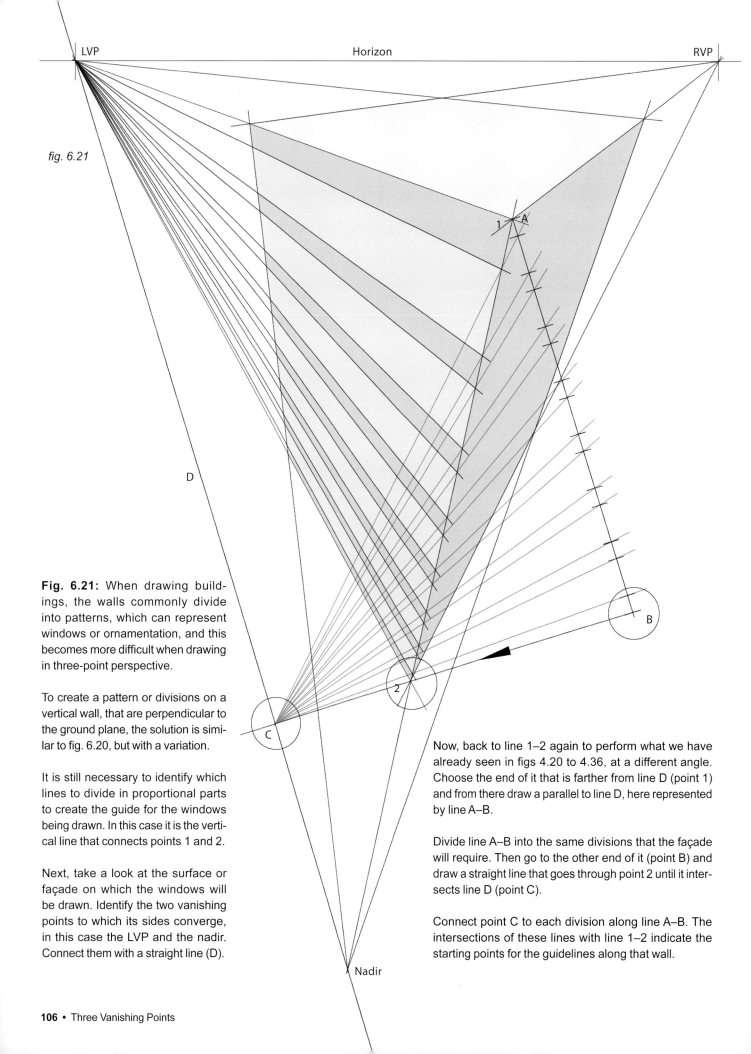

fig. 6.21

Fig. 6.21: When drawing buildings, the walls commonly divide into patterns, which can represent windows or ornamentation, and this becomes more difficult when drawing in three-point perspective.

To create a pattern or divisions on a vertical wall, that are perpendicular to the ground plane, the solution is similar to fig. 6.20, but with a variation.

It is still necessary to identify which lines to divide in proportional parts to create the guide for the windows being drawn. In this case it is the vertical line that connects points 1 and 2.

Next, take a look at the surface or façade on which the windows will be drawn. Identify the two vanishing points to which its sides converge, in this case the LVP and the nadir. Connect them with a straight line (D).

Now, back to line 1–2 again to perform what we have already seen in figs 4.20 to 4.36, at a different angle. Choose the end of it that is farther from line D (point 1) and from there draw a parallel to line D, here represented by line A–B.

Divide line A–B into the same divisions that the façade will require. Then go to the other end of it (point B) and draw a straight line that goes through point 2 until it intersects line D (point C).

Connect point C to each division along line A–B. The intersections of these lines with line 1–2 indicate the starting points for the guidelines along that wall.

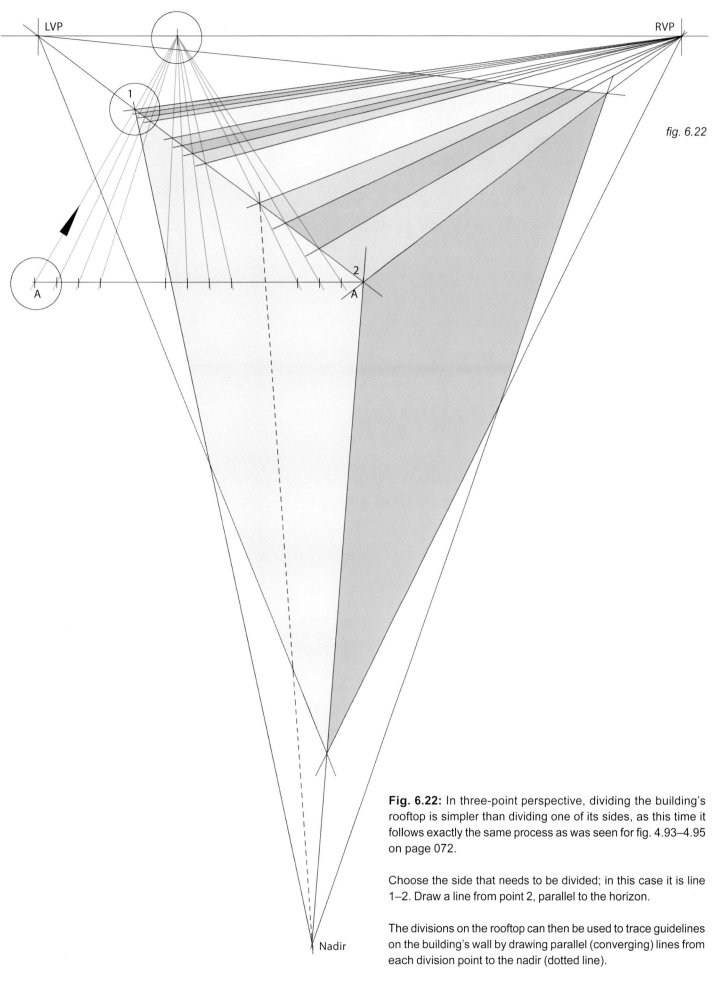

LVP

RVP

fig. 6.22

1

A

2

A

Nadir

Fig. 6.22: In three-point perspective, dividing the building's rooftop is simpler than dividing one of its sides, as this time it follows exactly the same process as was seen for fig. 4.93–4.95 on page 072.

Choose the side that needs to be divided; in this case it is line 1–2. Draw a line from point 2, parallel to the horizon.

The divisions on the rooftop can then be used to trace guidelines on the building's wall by drawing parallel (converging) lines from each division point to the nadir (dotted line).

fig. 6.23

Figs. 6.23 and 6.24: As much as possible, try to draw buildings as see-through "wireframe" structures to help make sense of the general details and to prevent one building's base plan from overlapping with the next, as was explained in the suitcases example (figs. 5.43–5.50).

By drawing these skyscrapers to be transparent, we will have a clear shot at each one's rooftop from below so that we can find each of the centers by crossing diagonals and use these centers to locate the buildings' antennae. This also ensures that the three different sections of the featured tower have the same width from top tom bottom, as if it were a staircase (see chapter 7 for inclined planes).

Double-checking that the corners of this tower's three rooftops are perfectly aligned also helps to create a sense of harmony and dynamics that otherwise could look unnatural and even get a certain amount of unwanted visual attention if the structure overall felt too odd.

As far as the characters are concerned, always correlate their sizes in proportion throughout the scene, in the foreground, mid-ground and background. Remember to allow some room for actual height differences between different characters in the story. It is crucial that the bottom of the buildings is drawn precisely. When the characters are placed proportionally, small errors tend to magnify the closer they are to the camera (or viewer). (See page 071 of *Framed Ink*).

In a case like this, it is helpful to draw a character right at the foot of a distant building (5) in order to accurately draw the proportion between such character and the buildings around him with all the details included, like windows and doors.

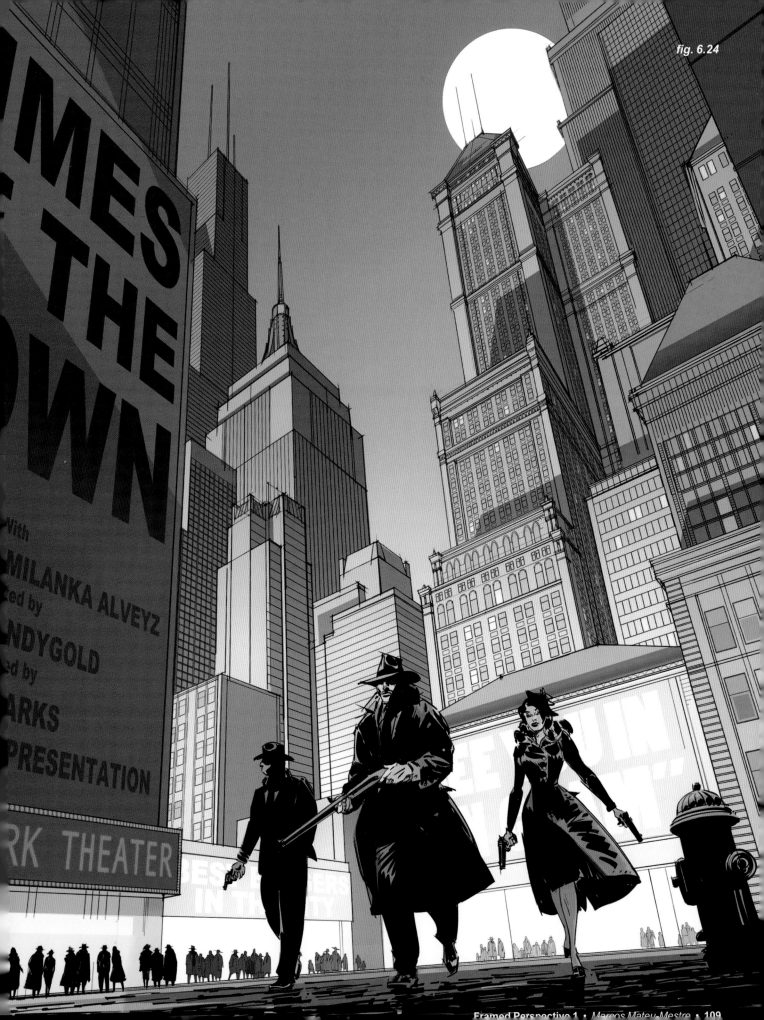

fig. 6.24

fig. 6.25

Fig. 6.25: The same way that we might use an upshot to create a sense of awe; a down shot, specifically with the use of a third vanishing point at the nadir, helps establish a sense of a character's dominance. In other words, the characters or elements down below appear at a (visual) disadvantage in relationship to either the surrounding landscape in general, or the specific character or characters observing them from a higher point.

Fig. 6.26: As usual, the first step was to create a quick compositional sketch that was refined little by little until it suited the purpose for the panel in this sketch. A rough sense of perspective was established representing the "boxy" space of this cul-de-sac alley. When coming up with a composition for a shot like this, if it is for a double-page spread, as in a graphic novel, take into account where the middle of the page spread will be and make sure that no essential visual information appears there.

fig. 6.26

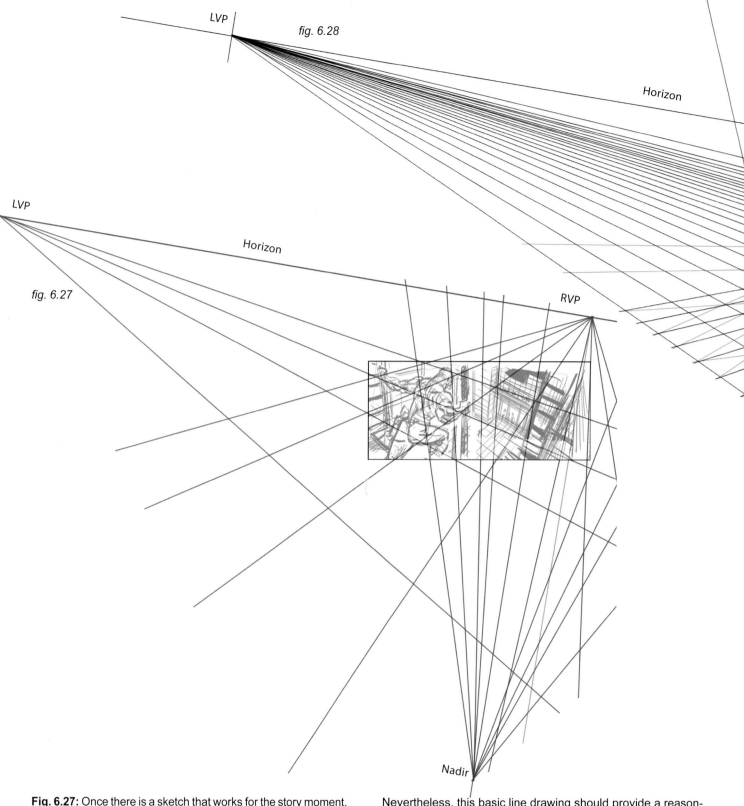

LVP

fig. 6.28

Horizon

LVP

Horizon

fig. 6.27

RVP

Nadir

Fig. 6.27: Once there is a sketch that works for the story moment, the next step is to create a basic perspective grid that more accurately represents the space created in the sketch.

Upon doing so it becomes clear that in this quick thumbnail, the lines that should technically converge to the same vanishing point just do not, at least not accurately, since in the process of drawing the thumbnail the horizon line and vanishing points were all approximated.

Nevertheless, this basic line drawing should provide a reasonable enough structure to build a proper perspective grid on top of it. In doing so, some compromise will be needed to find a balance between the original blueprint and a realistic grid on which to base the final drawing.

In order to achieve all this, the elements that were lacking at the time of doing the sketch (horizon, VPs) must be found. Therefore, the first step is to reduce the size of the sketch (either digitally or by photocopying) to provide enough space around it to draw a complete, full and accurate perspective grid.

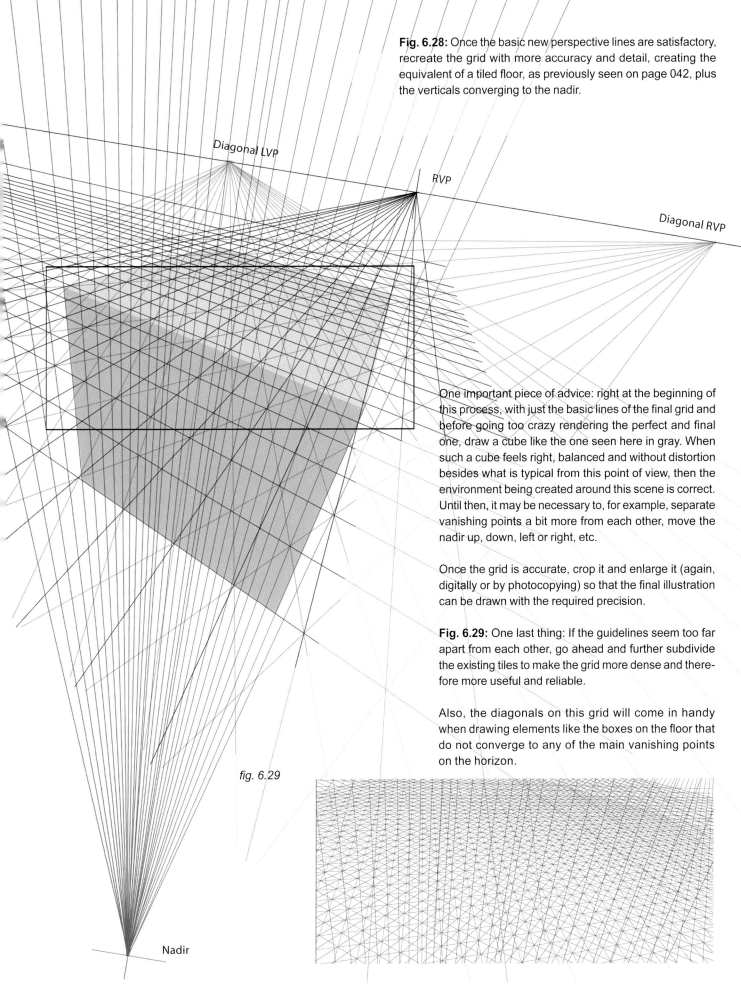

Fig. 6.28: Once the basic new perspective lines are satisfactory, recreate the grid with more accuracy and detail, creating the equivalent of a tiled floor, as previously seen on page 042, plus the verticals converging to the nadir.

Diagonal LVP

RVP

Diagonal RVP

One important piece of advice: right at the beginning of this process, with just the basic lines of the final grid and before going too crazy rendering the perfect and final one, draw a cube like the one seen here in gray. When such a cube feels right, balanced and without distortion besides what is typical from this point of view, then the environment being created around this scene is correct. Until then, it may be necessary to, for example, separate vanishing points a bit more from each other, move the nadir up, down, left or right, etc.

Once the grid is accurate, crop it and enlarge it (again, digitally or by photocopying) so that the final illustration can be drawn with the required precision.

Fig. 6.29: One last thing: If the guidelines seem too far apart from each other, go ahead and further subdivide the existing tiles to make the grid more dense and therefore more useful and reliable.

Also, the diagonals on this grid will come in handy when drawing elements like the boxes on the floor that do not converge to any of the main vanishing points on the horizon.

fig. 6.29

Nadir

fig. 6.30

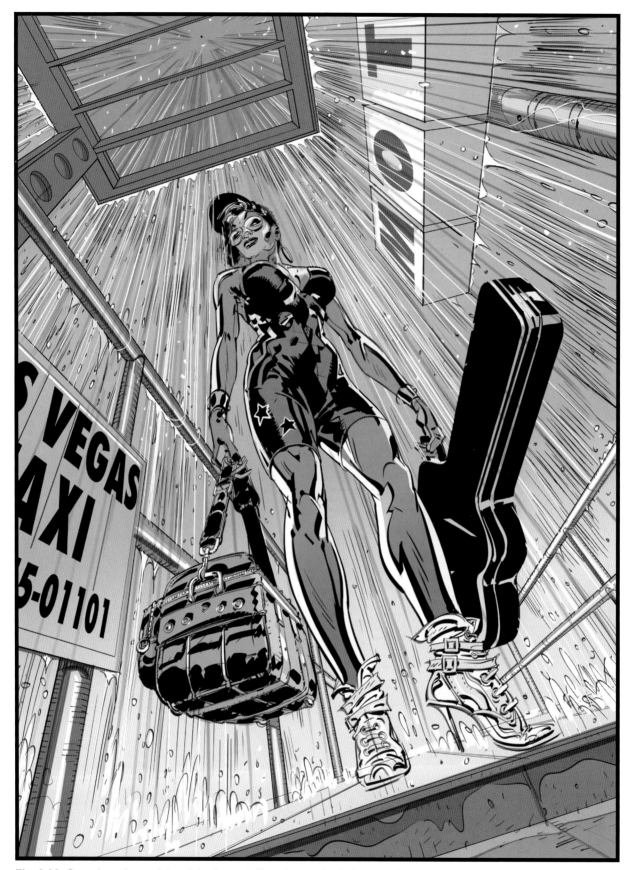

Fig. 6.30: Organic and more intangible elements like rain can also help to emphasize a more dramatic sense of perspective in the scene. In this case, it is applied to a view that mostly relies on the zenithal vanishing point to convey dynamism and tension (see *Framed Perspective 2* for figure drawing in perspective).

7

INCLINED PLANES

fig. 7.1

So until now we have been dealing with vertical lines and planes, and horizontal lines and planes...

fig. 7.2

...but what happens the moment that planes are inclined and start tilting at angles?

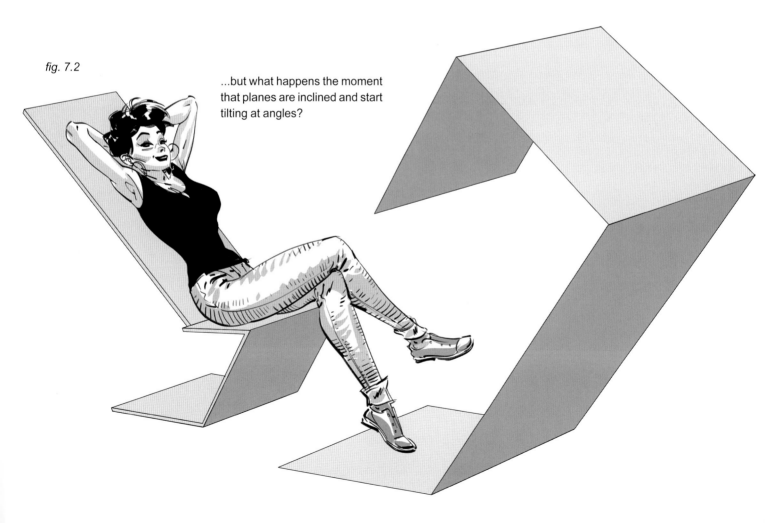

Fig. 7.3: Imagine a piece of board, flat on the floor, viewed from a two-point perspective angle. The board is attached to the floor by hinges on side A. Sides A and B are parallel to each other, as are sides 1 and 2. Therefore sides A and B converge to the LVP (left vanishing point) and sides 1 and 2 converge to the RVP (right vanishing point).

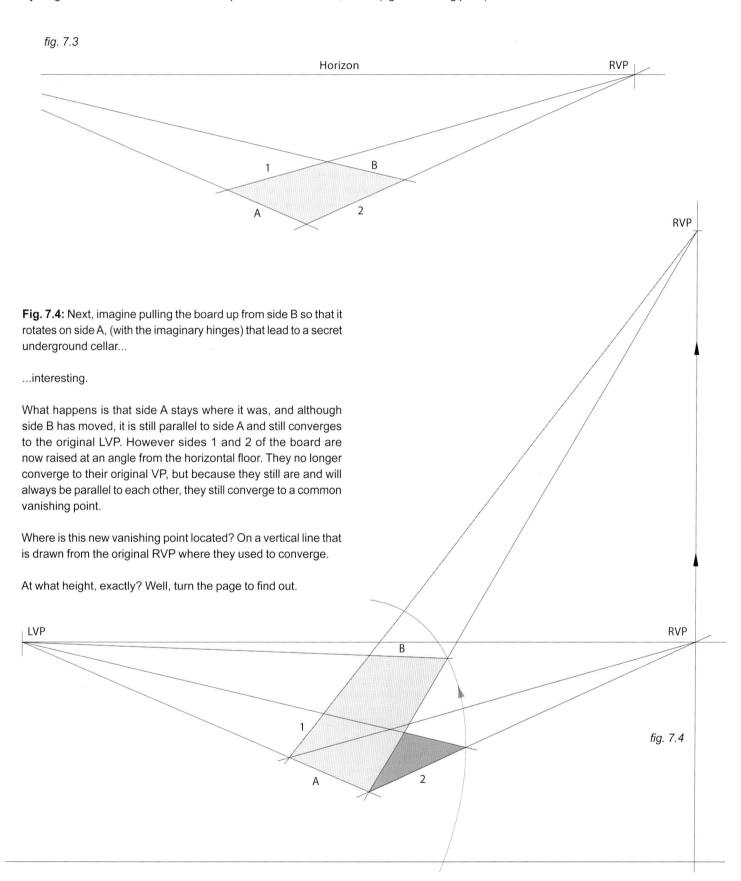

fig. 7.3

Fig. 7.4: Next, imagine pulling the board up from side B so that it rotates on side A, (with the imaginary hinges) that lead to a secret underground cellar...

...interesting.

What happens is that side A stays where it was, and although side B has moved, it is still parallel to side A and still converges to the original LVP. However sides 1 and 2 of the board are now raised at an angle from the horizontal floor. They no longer converge to their original VP, but because they still are and will always be parallel to each other, they still converge to a common vanishing point.

Where is this new vanishing point located? On a vertical line that is drawn from the original RVP where they used to converge.

At what height, exactly? Well, turn the page to find out.

fig. 7.4

Fig. 7.5: It all depends on how far the "door" opened: The greater the angle from the ground plane, the higher the new vanishing point goes.

This basic rule can be applied to any sort of ramp, staircase, rooftop, or even the speeding lines of an airplane taking off or a rocket lifting off.

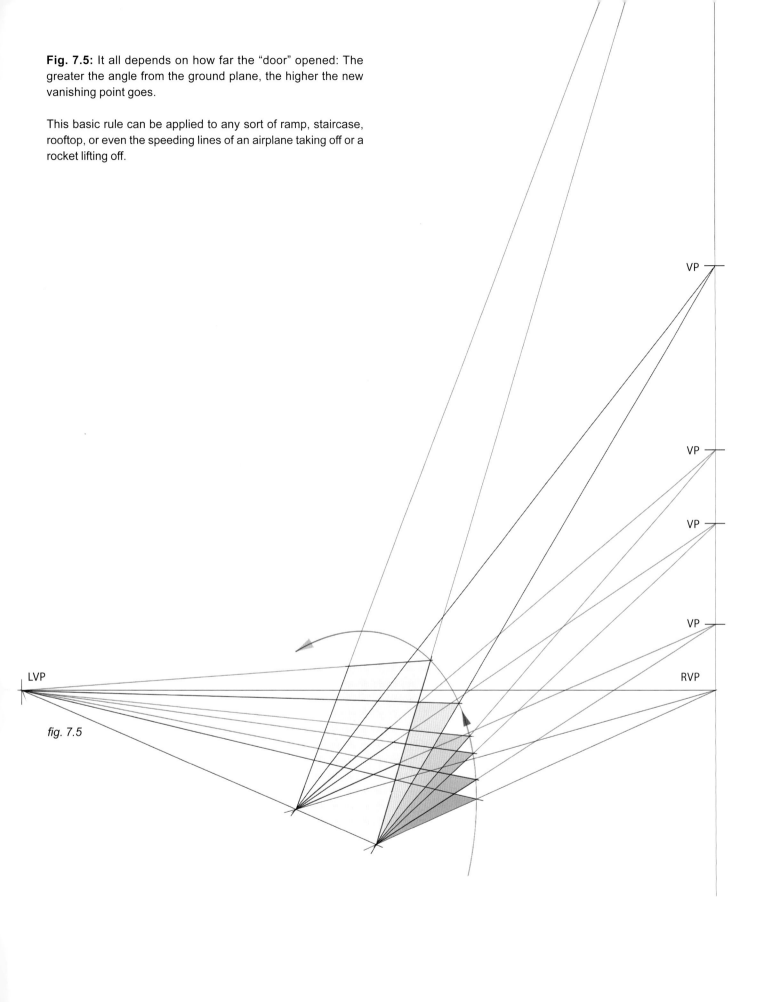

fig. 7.5

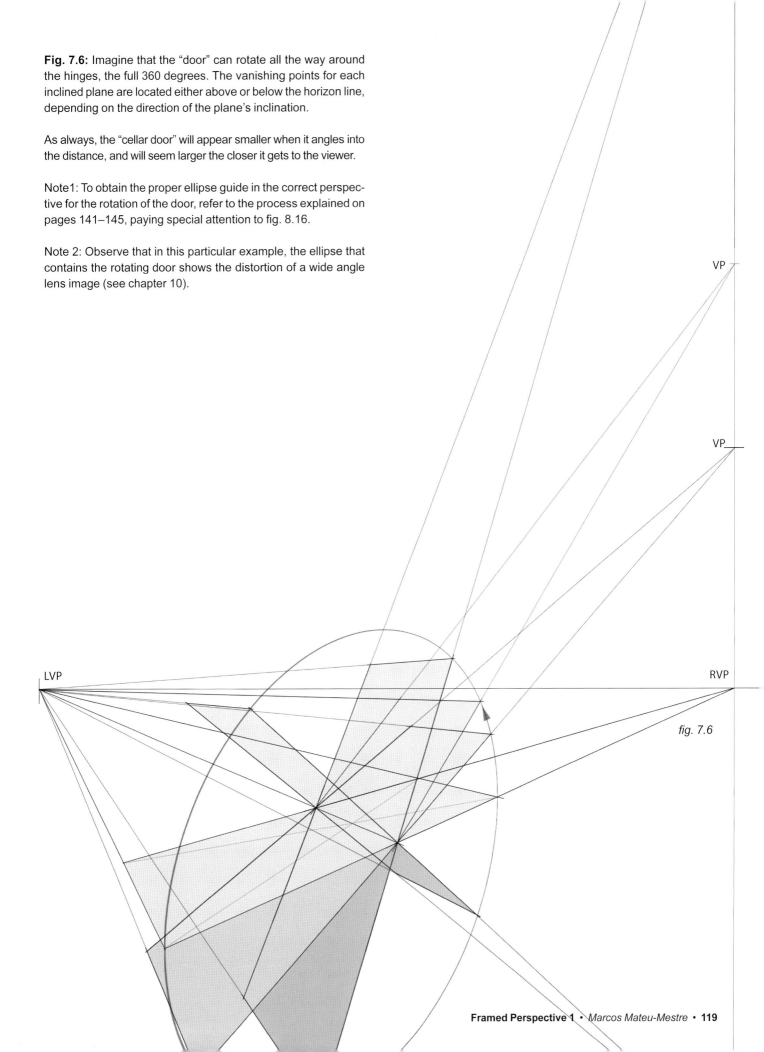

Fig. 7.6: Imagine that the "door" can rotate all the way around the hinges, the full 360 degrees. The vanishing points for each inclined plane are located either above or below the horizon line, depending on the direction of the plane's inclination.

As always, the "cellar door" will appear smaller when it angles into the distance, and will seem larger the closer it gets to the viewer.

Note1: To obtain the proper ellipse guide in the correct perspective for the rotation of the door, refer to the process explained on pages 141–145, paying special attention to fig. 8.16.

Note 2: Observe that in this particular example, the ellipse that contains the rotating door shows the distortion of a wide angle lens image (see chapter 10).

VP

VP

LVP

RVP

fig. 7.6

Fig. 7.7: Speaking of angles, imagine a rooftop shape, basically a triangle like this one seen in side view.

When both sides have the same angle of inclination, then the distance will be equal between the horizon line and each of the two new auxiliary vanishing points, one above and one below the horizon line.

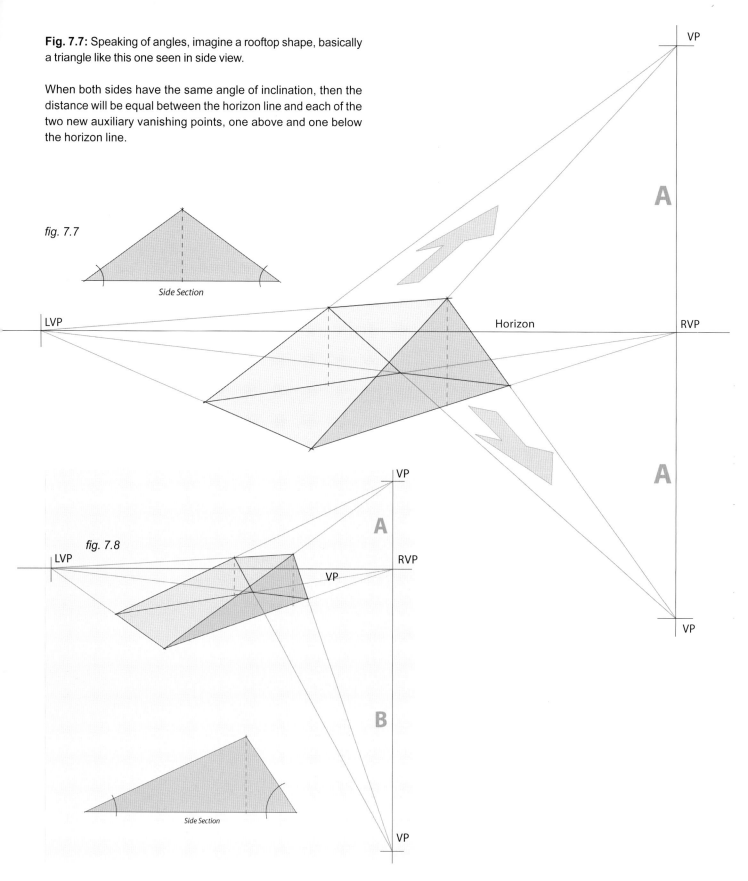

fig. 7.7

Side Section

Fig. 7.8: On the other hand, if the inclination angle of one side of the rooftop is greater than the other, then the distance between each of their two auxiliary vanishing points and the horizon line will be different.

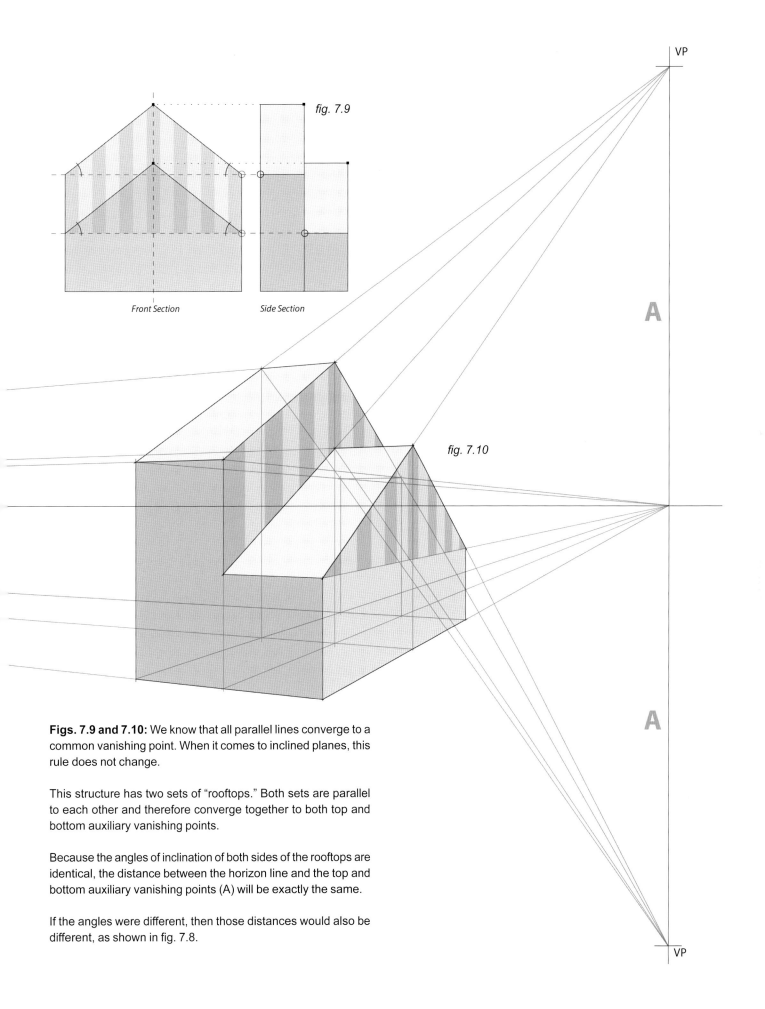

VP

fig. 7.9

Front Section Side Section

A

fig. 7.10

A

VP

Figs. 7.9 and 7.10: We know that all parallel lines converge to a common vanishing point. When it comes to inclined planes, this rule does not change.

This structure has two sets of "rooftops." Both sets are parallel to each other and therefore converge together to both top and bottom auxiliary vanishing points.

Because the angles of inclination of both sides of the rooftops are identical, the distance between the horizon line and the top and bottom auxiliary vanishing points (A) will be exactly the same.

If the angles were different, then those distances would also be different, as shown in fig. 7.8.

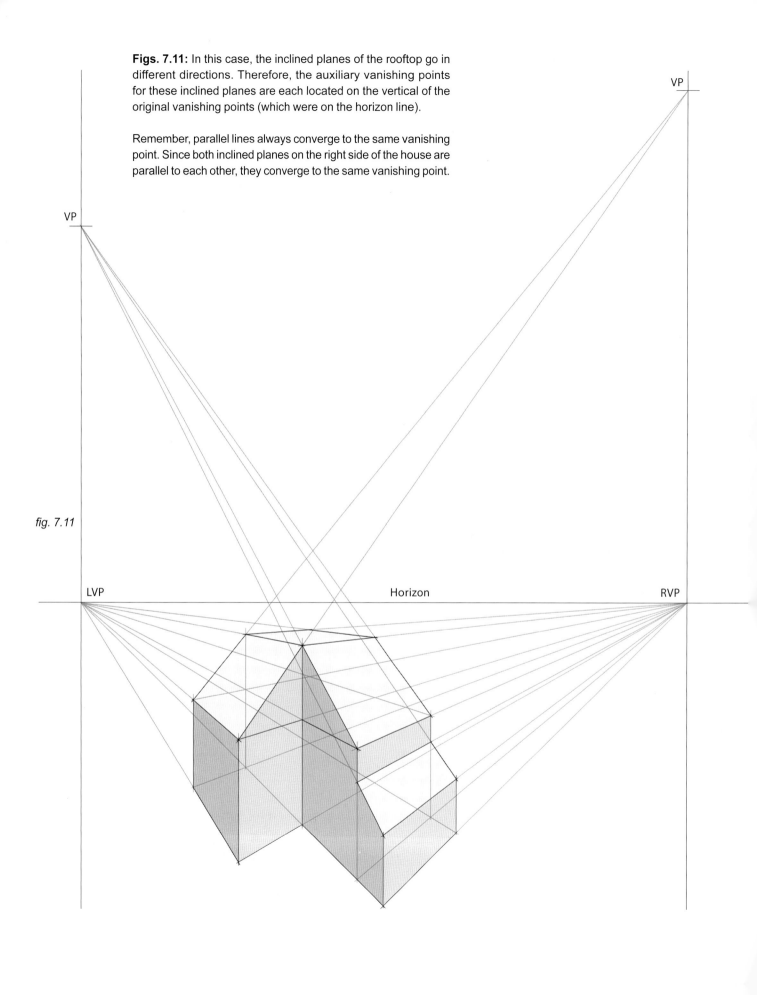

Figs. 7.11: In this case, the inclined planes of the rooftop go in different directions. Therefore, the auxiliary vanishing points for these inclined planes are each located on the vertical of the original vanishing points (which were on the horizon line).

Remember, parallel lines always converge to the same vanishing point. Since both inclined planes on the right side of the house are parallel to each other, they converge to the same vanishing point.

fig. 7.11

VP

VP

LVP

Horizon

RVP

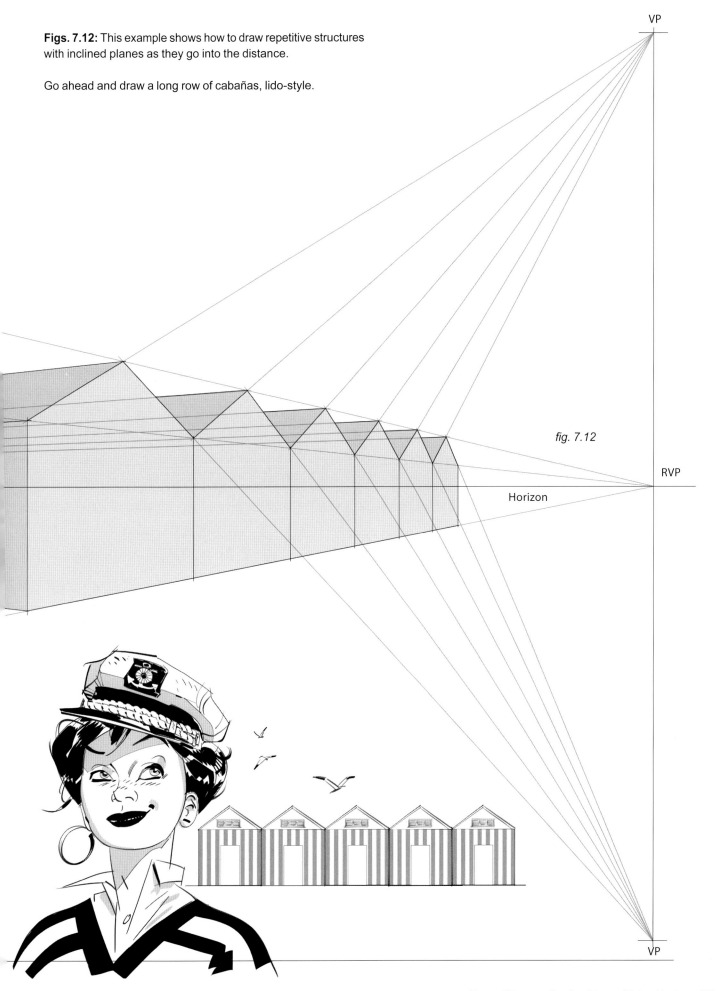

Figs. 7.12: This example shows how to draw repetitive structures with inclined planes as they go into the distance.

Go ahead and draw a long row of cabañas, lido-style.

VP

fig. 7.12

RVP

Horizon

VP

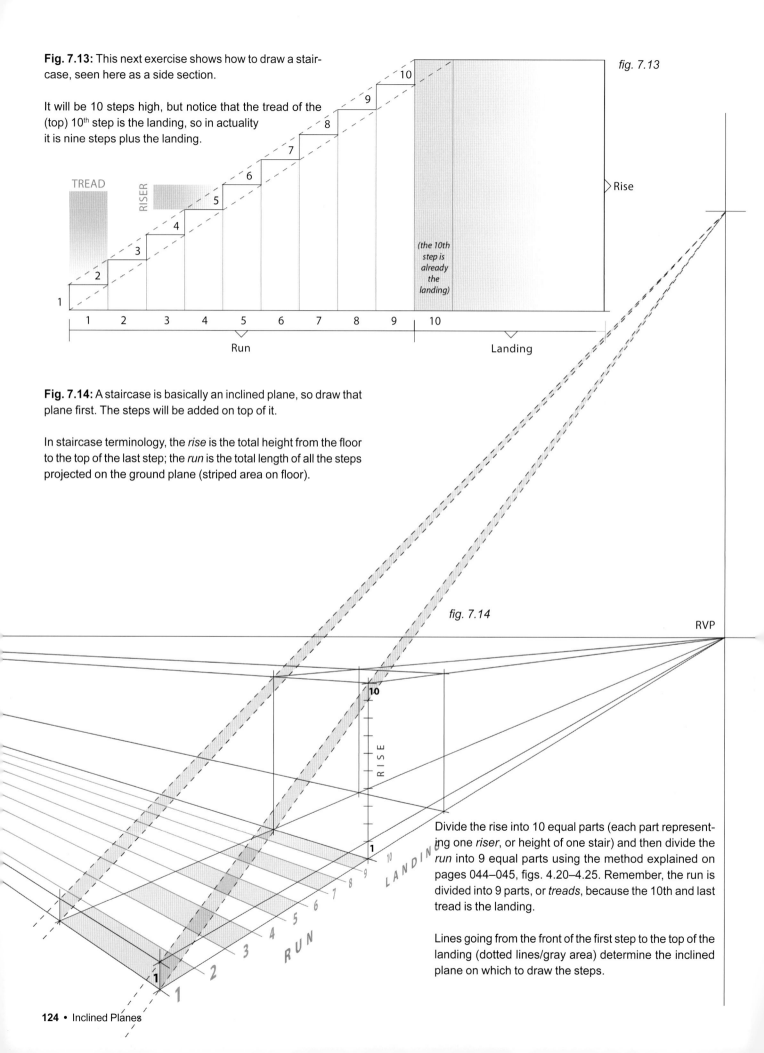

Fig. 7.13: This next exercise shows how to draw a staircase, seen here as a side section.

It will be 10 steps high, but notice that the tread of the (top) 10th step is the landing, so in actuality it is nine steps plus the landing.

fig. 7.13

TREAD

RISER

Rise

(the 10th step is already the landing)

Run

Landing

Fig. 7.14: A staircase is basically an inclined plane, so draw that plane first. The steps will be added on top of it.

In staircase terminology, the *rise* is the total height from the floor to the top of the last step; the *run* is the total length of all the steps projected on the ground plane (striped area on floor).

fig. 7.14

RVP

RISE

LANDING

RUN

Divide the rise into 10 equal parts (each part representing one *riser*, or height of one stair) and then divide the run into 9 equal parts using the method explained on pages 044–045, figs. 4.20–4.25. Remember, the run is divided into 9 parts, or *treads*, because the 10th and last tread is the landing.

Lines going from the front of the first step to the top of the landing (dotted lines/gray area) determine the inclined plane on which to draw the steps.

Fig. 7.15: The length of the run was divided into 9 steps projected on the floor and the vertical rise was divided by 10. To determine the height of the stairs, draw a vertical line up from each division on the run. Then, transfer the height divisions of the rise forward by drawing lines from the RVP through each dividing point on the rise and continuing to the front of the staircase. The intersections of these lines and the vertical lines determine the height of the stairs. Follow the perspective grid going to the LVP to draw the front edge of each stair.

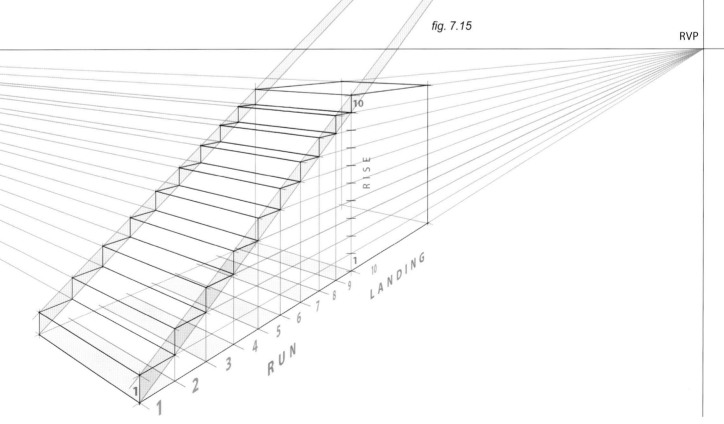

fig. 7.15

RVP

Figs. 7.16 and 7.17: To build the next flight of steps (B in the blueprint), double the width of the first staircase's base (A) following the process explained by fig. 4.51 on page 054, so that A and B co-exist in the proper perspective.

Next, divide the new base (B) into 9 sections that represent the 9 steps that the new run will also contain.

Then, project the whole new base (B) upward to define the area that will contain the second flight of steps (gray area).

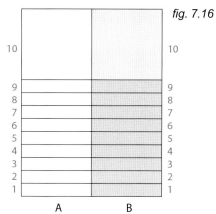

fig. 7.16

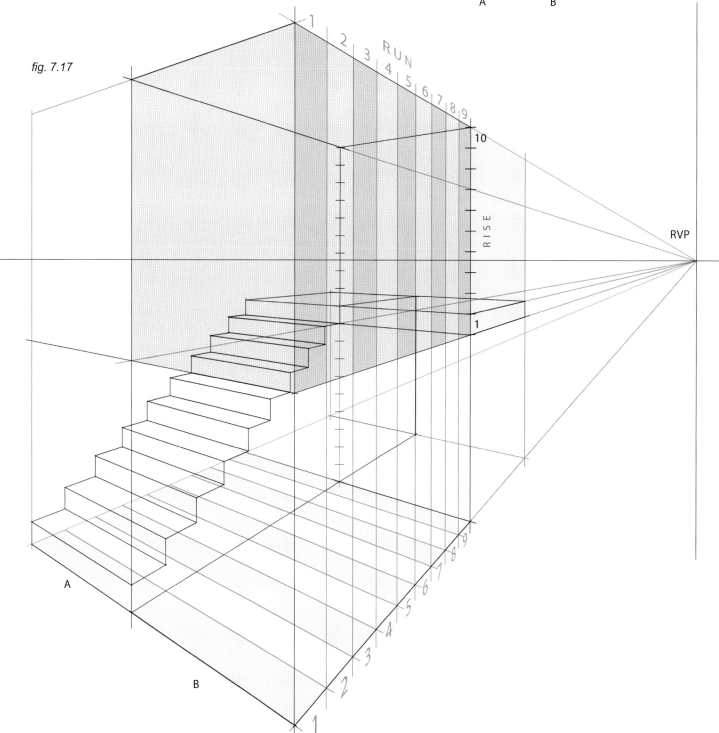

fig. 7.17

Figs. 7.18: After that, draw the inclined plane for the second stretch of steps using the proper vanishing point directly underneath the original RVP on the horizon.

Reminder: Since the angle of inclination of both flights is the same, the distance between the RVP on the horizon and the other two, north and south of it, will be exactly the same.

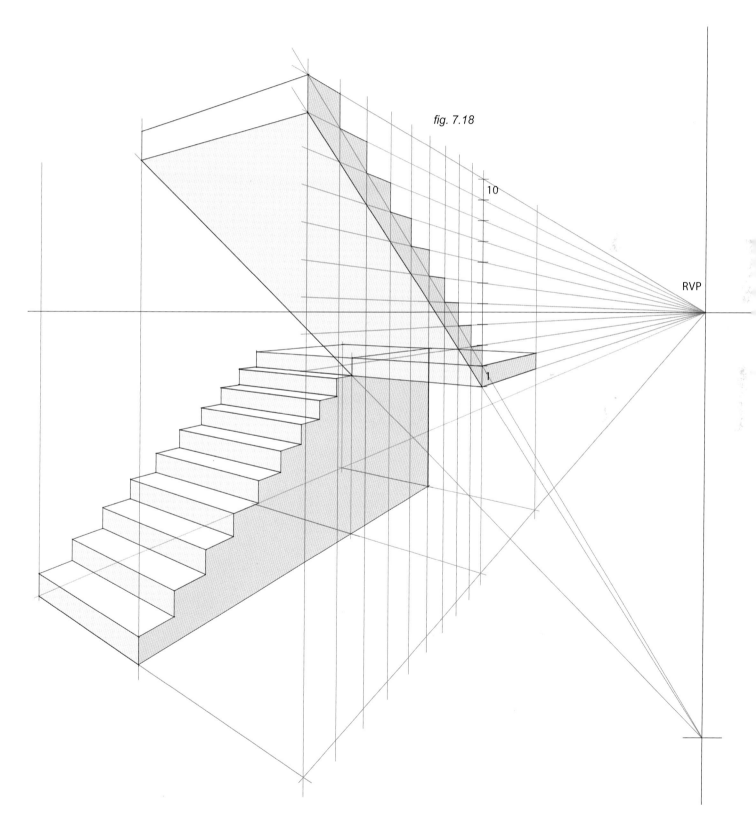

fig. 7.18

10

RVP

1

fig. 7.19

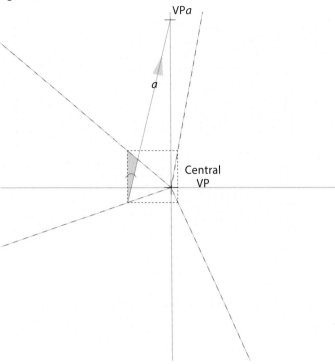

Fig. 7.19: This next exercise explains how to draw a 4-sided staircase, looking straight down from one of the landings. This presumes that a preliminary freehand sketch was already done, or that photo reference is available.

First, draw the gap at the center of the staircase, a square section void that will reach all the way to the bottom. Cross two perpendiculars (the horizontal one being the horizon line) that are parallel to the sides of the square staircase gap. Their intersection determines the vanishing point. Then draw lines from that vanishing point through the four corners of the square to the edge of the drawing surface, indicating the four vertical corners of the gap (dotted lines).

Now that the central gap is established, it is time to draw the staircase around it. First, draw a line (A) that indicates the inclination of one of the staircase's runs. Choose an angle that mimics the freehand sketch or photo reference. Where line "*a*" intersects the vertical line of the "cross" determines the vanishing point (VP*a*) of the first run of steps.

fig. 7.20

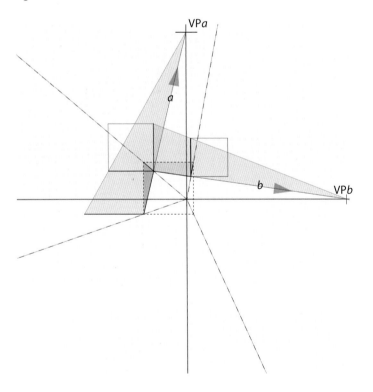

Fig. 7.20: We know that all runs in a staircase are essentially inclined planes (with steps on top) that have the same angle of inclination. We also know that when various inclined planes have the same angles of inclination, whether they point up or down, the distance between their vanishing point and the horizon line is equal.

The peculiarity here is that the staircase runs go in four different directions, so their vanishing points recede in four different directions.

Nonetheless, the distance between the central vanishing point and the various vanishing points of the different runs remains exactly the same.

Regarding the width of the staircase, choose whatever feels right based on the references that you use.

fig. 7.21 *fig. 7.22*

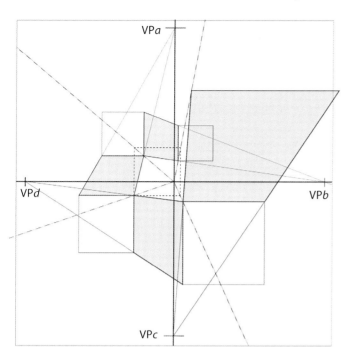

Fig. 7.21: Here are the four inclined planes going in four different directions.

Fig. 7.22: After drawing the basic structure (fig. 7.21), divide each side of the gap's original square section into a number of parts equal to the number of stairs desired for each flight. In this case, five (5) was chosen.

Draw lines from the gap's vanishing point, through each division on each side of the square. These serve as guides to draw the actual steps on each run.

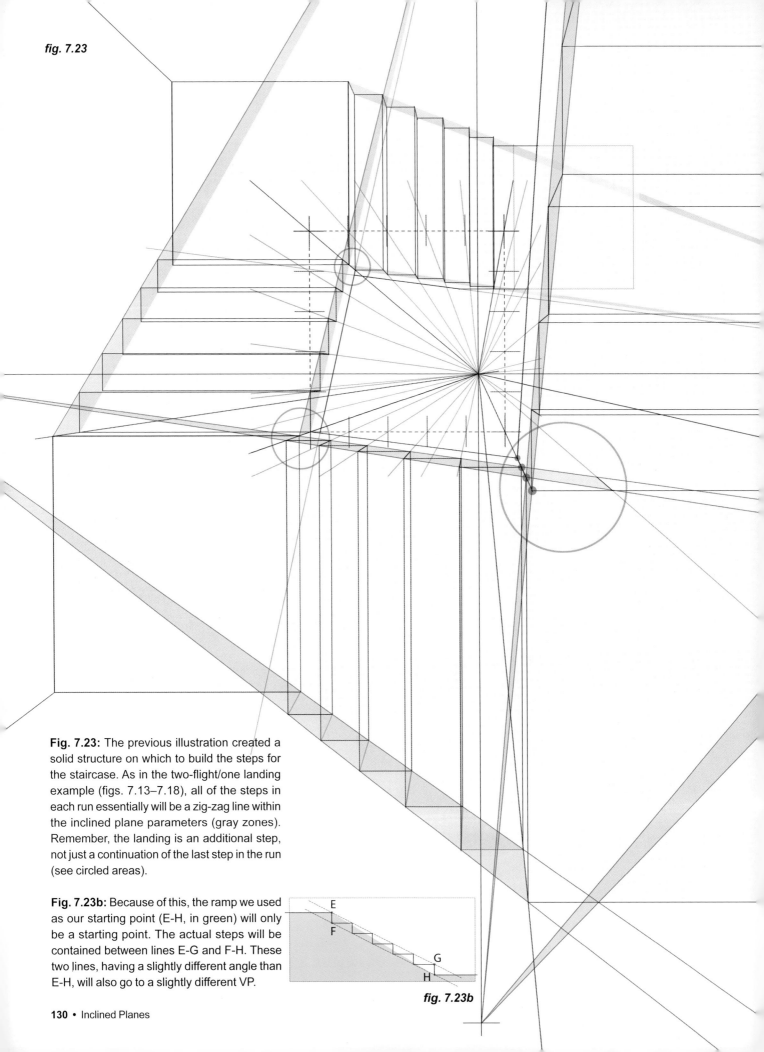

fig. 7.23

Fig. 7.23: The previous illustration created a solid structure on which to build the steps for the staircase. As in the two-flight/one landing example (figs. 7.13–7.18), all of the steps in each run essentially will be a zig-zag line within the inclined plane parameters (gray zones). Remember, the landing is an additional step, not just a continuation of the last step in the run (see circled areas).

Fig. 7.23b: Because of this, the ramp we used as our starting point (E-H, in green) will only be a starting point. The actual steps will be contained between lines E-G and F-H. These two lines, having a slightly different angle than E-H, will also go to a slightly different VP.

fig. 7.23b

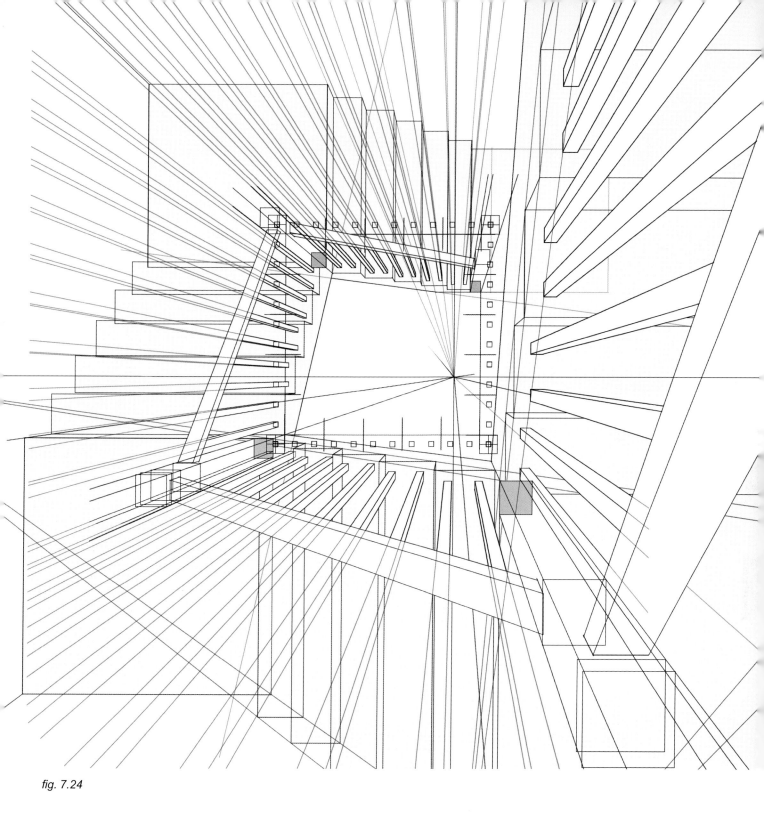

fig. 7.24

Fig. 7.24: Finally, it is time to add the banister. Refer back to the original square guide that was divided into five parts. To add, in this case, two supporting balusters on each step, draw the placement of each baluster around the square guide (see the little square sections) with equal spacing in between, as they would be seen on the staircase's blueprint or top view.

Once these guides are on paper, draw full-length vertical balusters converging to the central vanishing point. Refer to your references and choose the height of one baluster based on what feels right, then transfer the height of this first baluster to the others by using the auxiliary VPs used for the inclined planes of each flight of stairs.

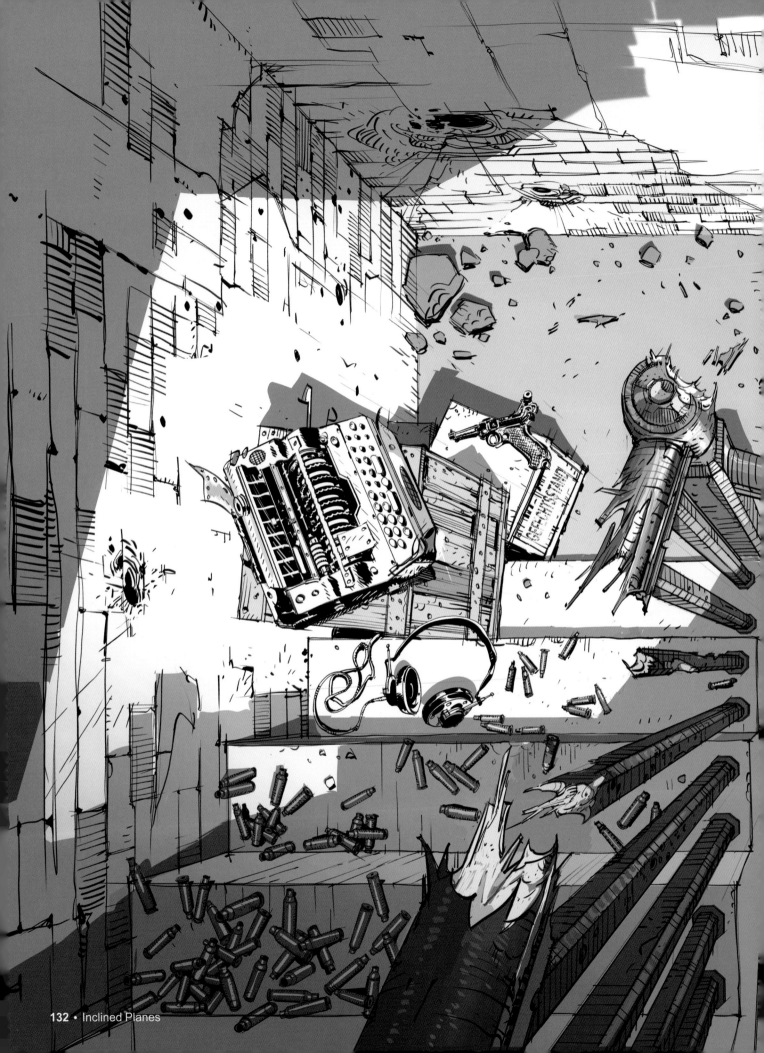

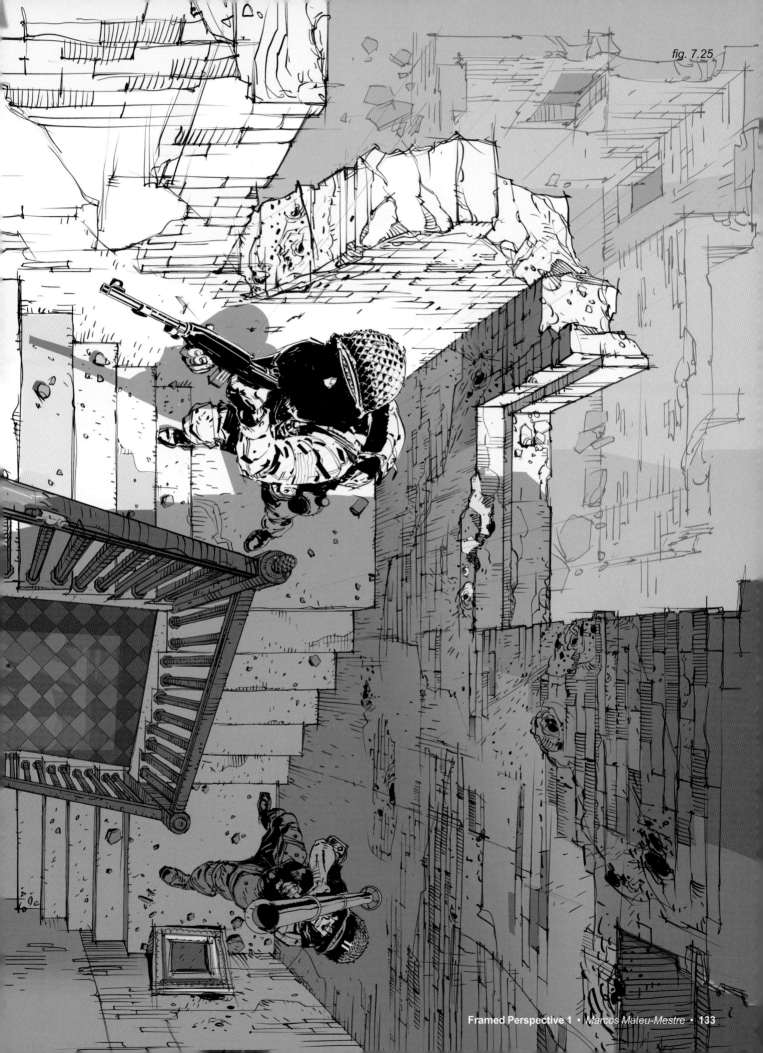

fig. 7.25

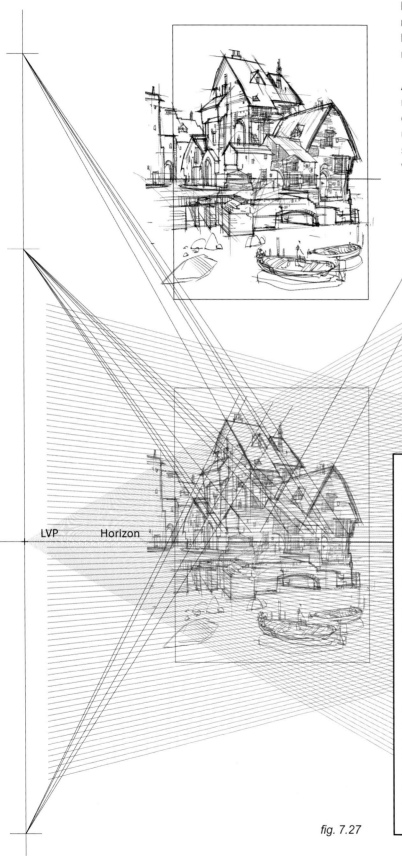

fig. 7.26

Fig. 7.26: Here is a freehand sketch that incorporates many of the principles discussed so far. The design is loosely based on Georgian/Tudor architecture where rooftops and inclined planes are featured prominently.

Although a location such as this is meant to feel rather organic, as opposed to sharp and exact in its construction, it still needs a solid perspective structure underneath to make sure everything makes proper visual sense. Left, the horizon line was added to determine where to place the vanishing points.

LVP Horizon

Fig. 7.27: Digitally or by means of a photocopy, reduce the size of the sketch so that the proper perspective grids can be worked out for lines that converge to a vanishing point on the horizon line, as well as for lines that converge to a vanishing point on an inclined plane.

Fig. 7.28: Once all these elements are on the drawing surface, crop the image at the illustration's final frame line, then enlarge the cropped image back to a size that is comfortable to work with for the final version.

All of the perspective guidelines remain, providing support for every final line drawn.

Given the rather organic nature of these buildings, a decision was made to draw freehand rather than with perfectly straight lines that would have given the whole work a colder, too modern feel. Finally, as the building took shape, some minor changes were made compared to the original basic sketch, based on the information provided by the perspective grid.

fig. 7.27

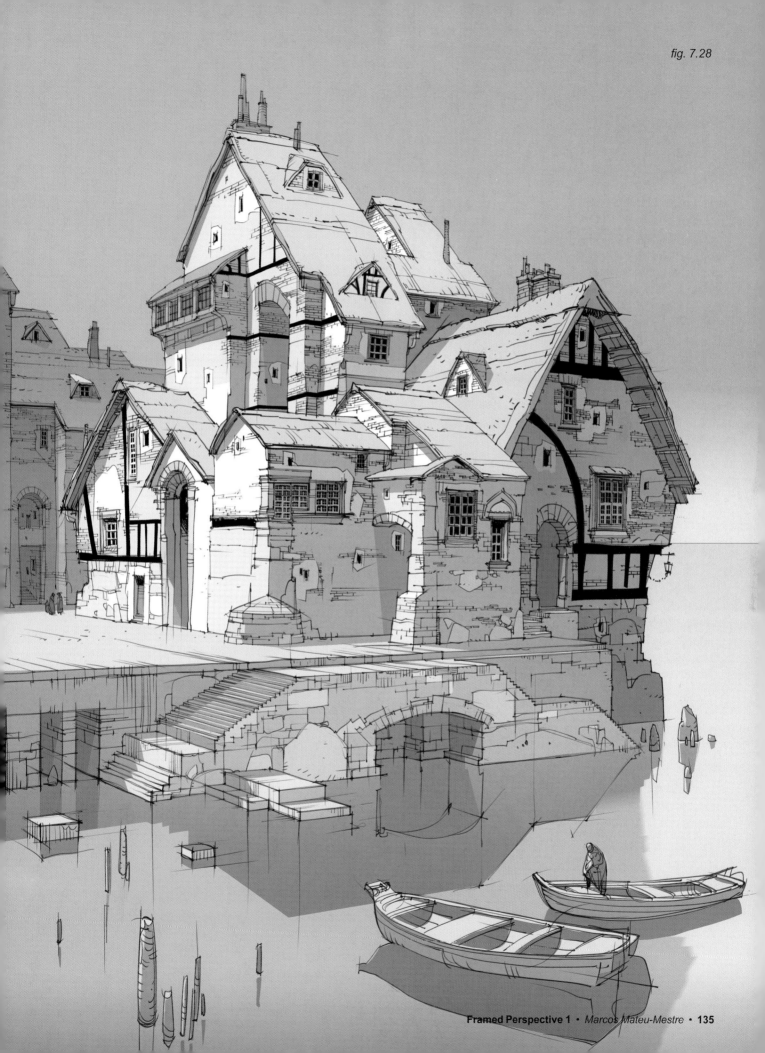

fig. 7.28

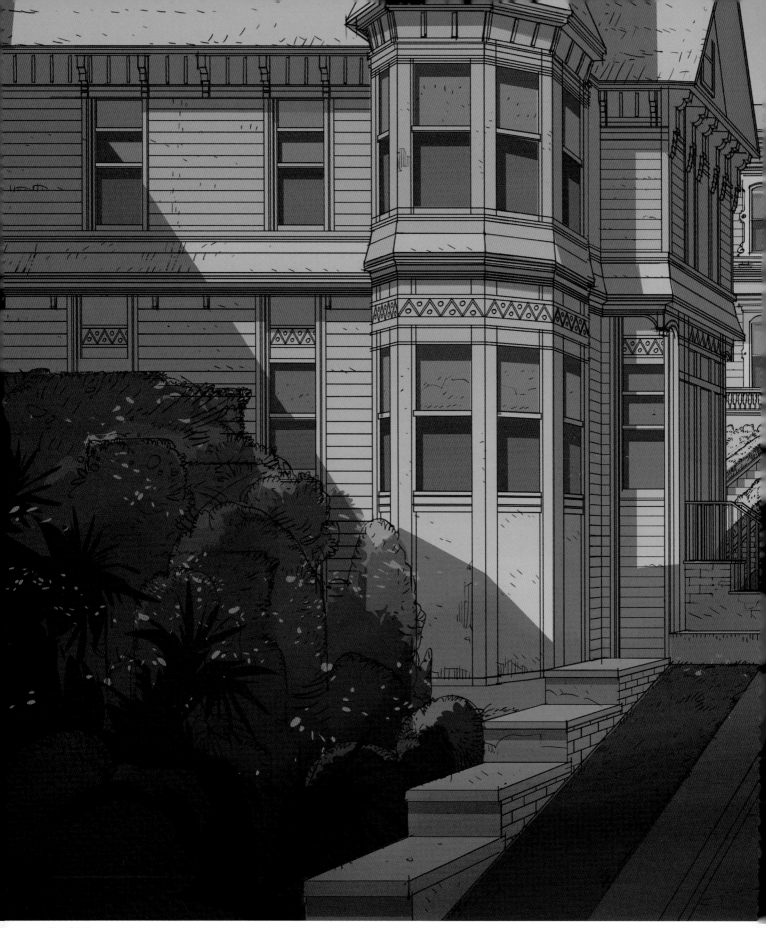

fig. 7.29

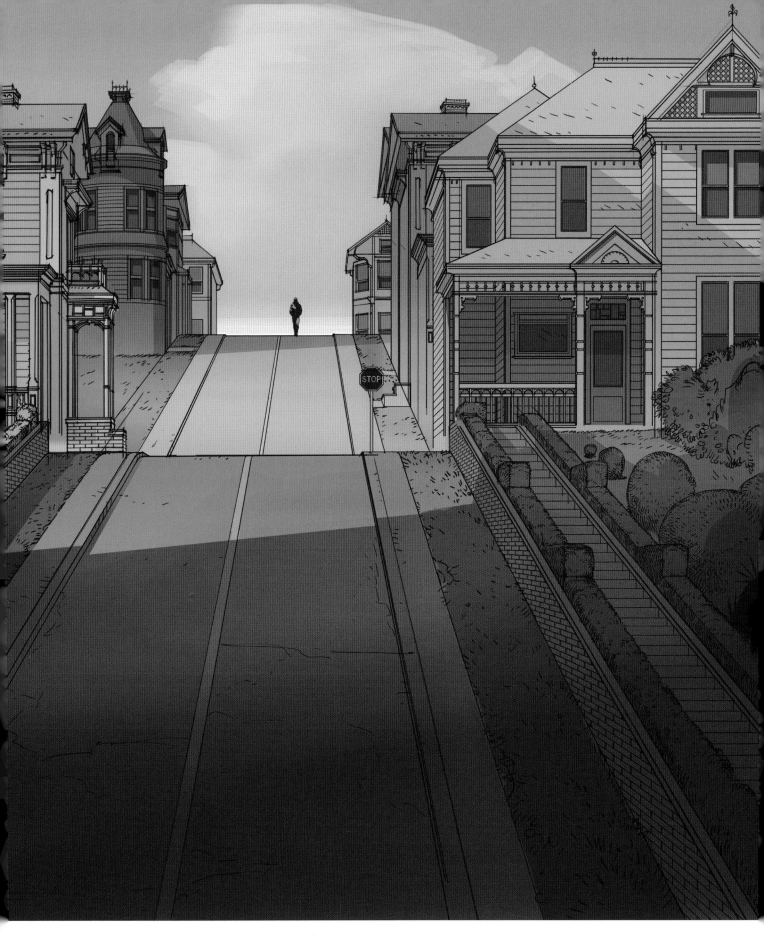

Fig. 7.29: The use of inclined planes in this shot's set-up creates a stage that provides a clear read of the character's silhouette, on top of a hill with an open backdrop, within the context of an otherwise complex and elaborate image. The next page shows a schematic view of the basic perspective structure for this drawing.

fig. 7.30

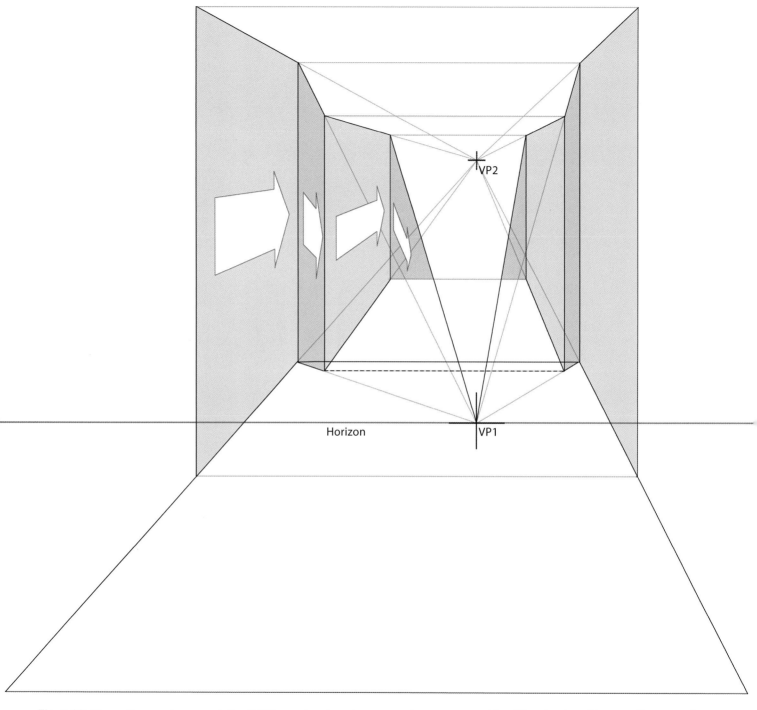

Horizon

VP1

VP2

Fig. 7.30: The entire previous panel (fig. 7.29) was developed based on this basic structure. The road goes uphill, reaches a certain level, flattens out (this landing is clearly horizontal because its side lines converge to VP1 on the horizon line). Then the road picks up at the same uphill angle as the previous stretch (and therefore converges to VP2), and inclines again until it reaches the top of the hill. Then it goes flat again (meaning it converges again to VP1).

After using the above information to figure out the ground planes, the next step is to figure out how tall to make the buildings. All the houses are of a similar style and size, therefore draw the height of one house on one side of the street, making sure the proportion makes sense against the width of the street. Next, create a guide for both sides that helps to contain each house within a space that makes sense within the perspective grid.

Obviously, all of the buildings do not need to be exactly the same size. Varying the height and width of each building makes the environment feel more credible, appealing and realistic.

BENDING THE LINE

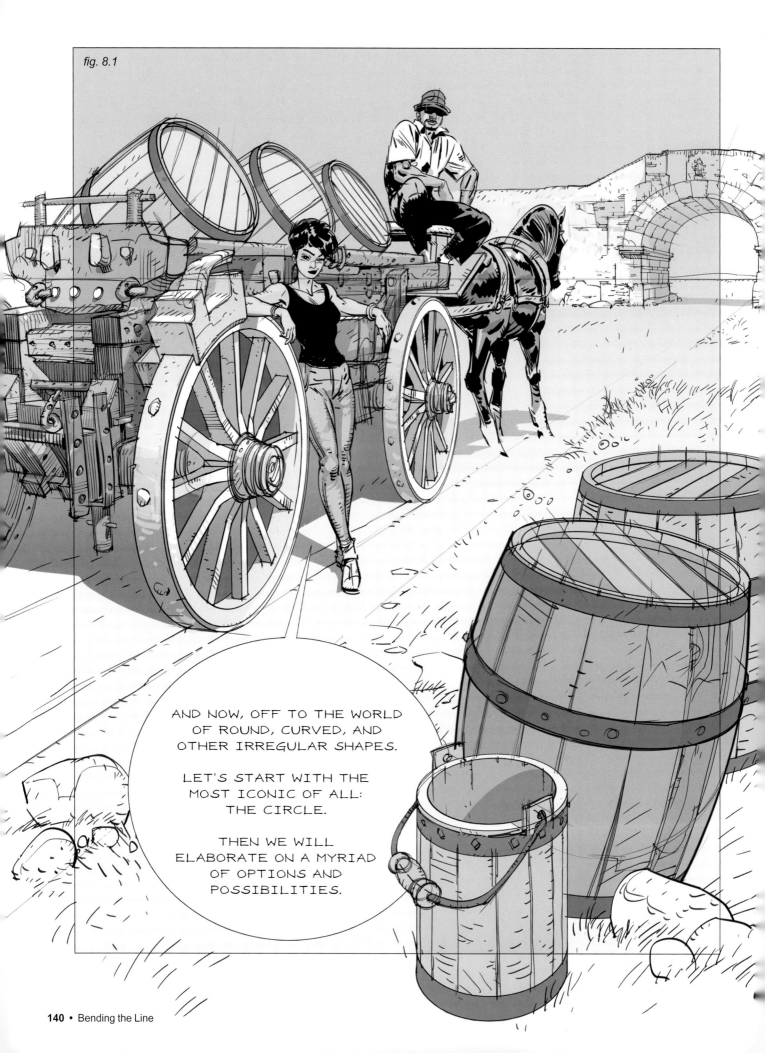

fig. 8.1

AND NOW, OFF TO THE WORLD OF ROUND, CURVED, AND OTHER IRREGULAR SHAPES.

LET'S START WITH THE MOST ICONIC OF ALL: THE CIRCLE.

THEN WE WILL ELABORATE ON A MYRIAD OF OPTIONS AND POSSIBILITIES.

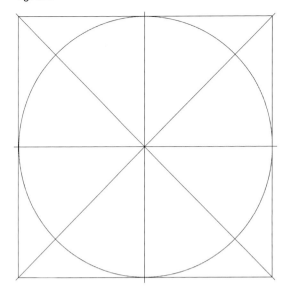

fig. 8.2

Fig. 8.2: The reason the book started off with straight lines, squares, rectangles, and cubes is simply because these are the types of lines, shapes and surfaces that are needed to be able to comprehend many other different types of shapes and lines, such as the ones in this new chapter.

Draw a circle within a square; making sure the circle is tangent to each side of the square. This will facilitate drawing the circle in perspective. Once the square is in perspective, the circle literally follows.

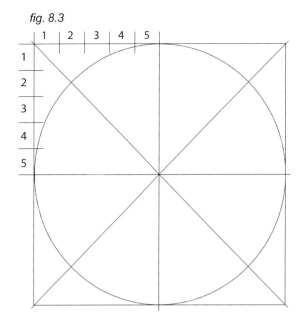

fig. 8.3

Locate the center of the circle by drawing two diagonals across the square. Then draw a vertical and a horizontal that intersect the center.

Fig. 8.3: As a result, the original square is divided into four quarters. Take one of these quarters and divide two of its sides (one vertical, one horizontal) into five equal segments.

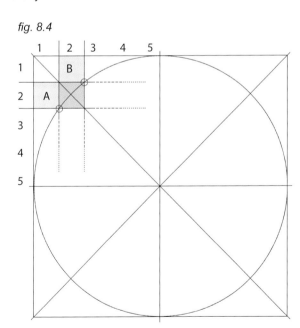

fig. 8.4

Fig. 8.4: Next, extend the divider lines at both sides of segment 2 (from both the vertical and the horizontal sides) until they cross both the diagonal and the circumference. As a result, points A and B were created along the circle's circumference.

The upcoming pages show how, once the full square is drawn in perspective, these two points become crucial in the accurate drawing of the circle in perspective.

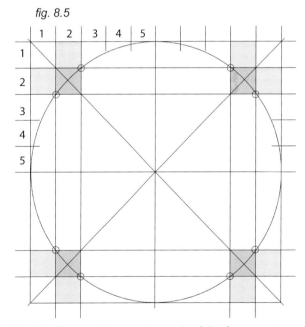

fig. 8.5

Fig. 8.5: Repeat the steps in each of the four quarters of the square to create enough points to help define a full circle once the square (and the circle within) is in perspective.

Next, observe how this works.

fig. 8.6

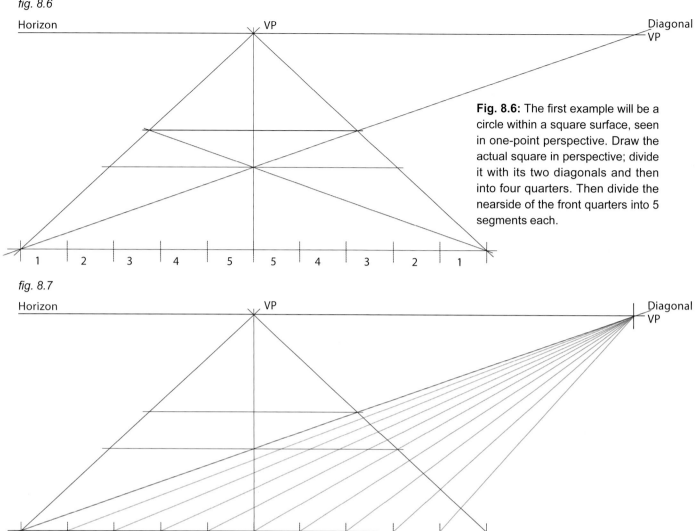

Fig. 8.6: The first example will be a circle within a square surface, seen in one-point perspective. Draw the actual square in perspective; divide it with its two diagonals and then into four quarters. Then divide the nearside of the front quarters into 5 segments each.

fig. 8.7

Fig. 8.7: Drawing lines from each segment on the nearside to the diagonal VPs determines how to divide the sides into 5 equal segments.

fig. 8.8

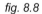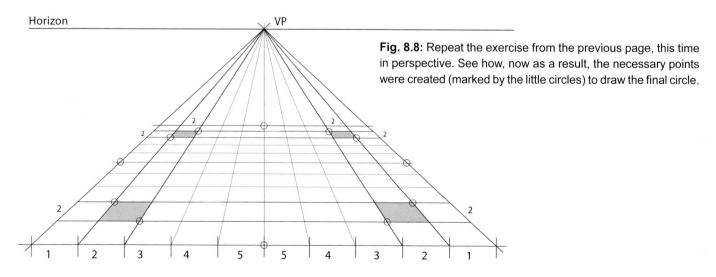

Fig. 8.8: Repeat the exercise from the previous page, this time in perspective. See how, now as a result, the necessary points were created (marked by the little circles) to draw the final circle.

fig. 8.9

Horizon VP

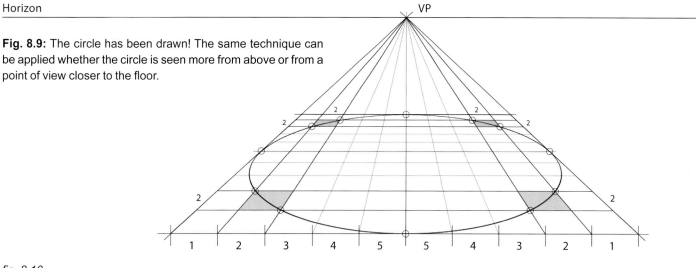

Fig. 8.9: The circle has been drawn! The same technique can be applied whether the circle is seen more from above or from a point of view closer to the floor.

fig. 8.10

Horizon VP

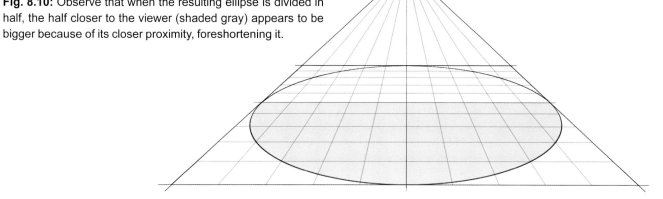

Fig. 8.10: Observe that when the resulting ellipse is divided in half, the half closer to the viewer (shaded gray) appears to be bigger because of its closer proximity, foreshortening it.

Fig. 8.11 and 8.12: By rotating the previous drawing, it is clear that this same system can be applied to different positions of the circle.

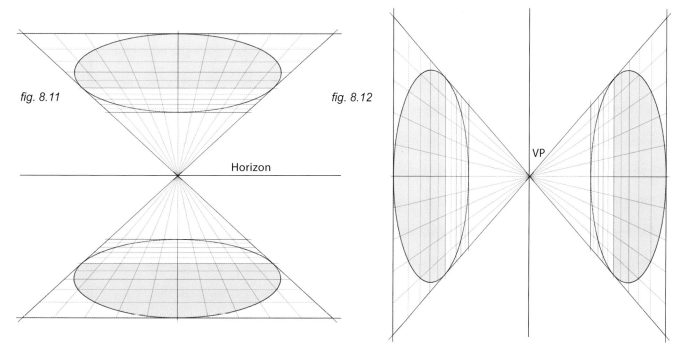

fig. 8.11

Horizon

fig. 8.12

VP

fig. 8.13

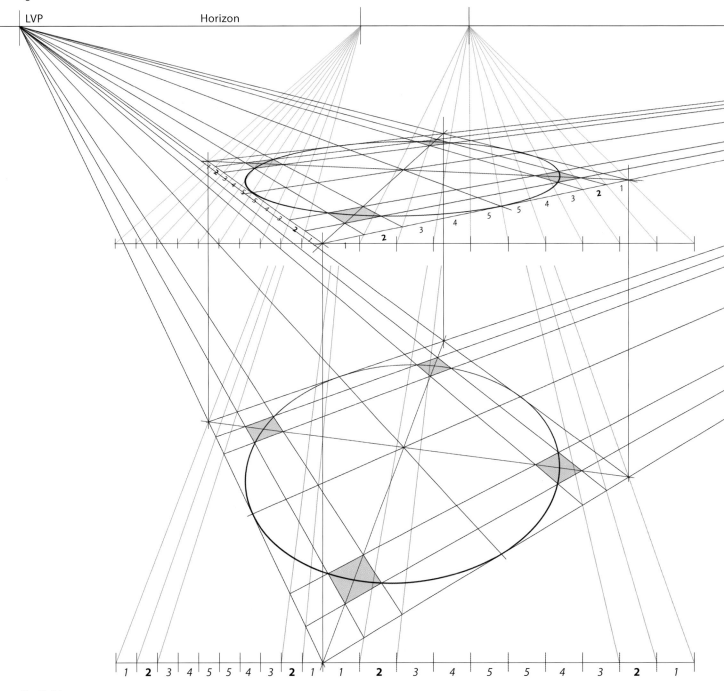

fig. 8.14

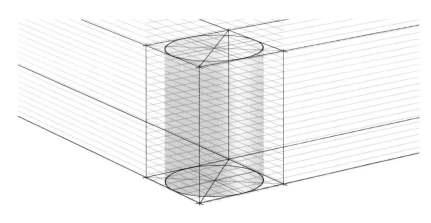

Fig. 8.13: These same principles apply to two-point perspective.

Fig. 8.14: Here is a similar case, but with vanishing points farther apart (off the page). As a result, both ellipses (top and bottom) are more similar in size and proportion to each other. Remember, the closer together the vanishing points, the more distorted the view will appear. It is always up to us to decide how far apart (or close together) to put them, which will influence the feel of the scene. This will be explained in more detail in chapter 10.

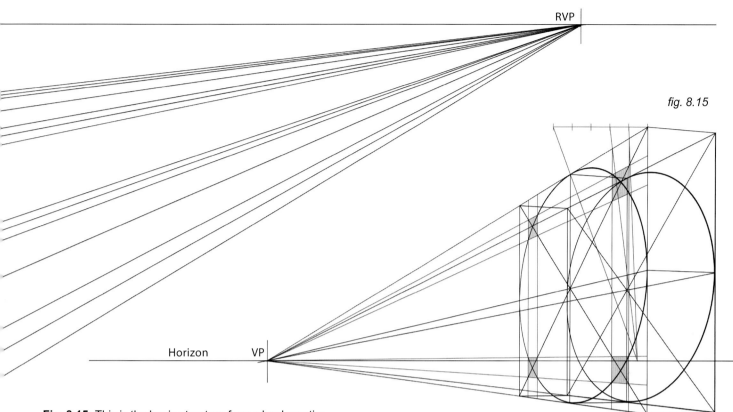

RVP

fig. 8.15

Horizon VP

Fig. 8.15: This is the basic structure for a wheel or a tire.

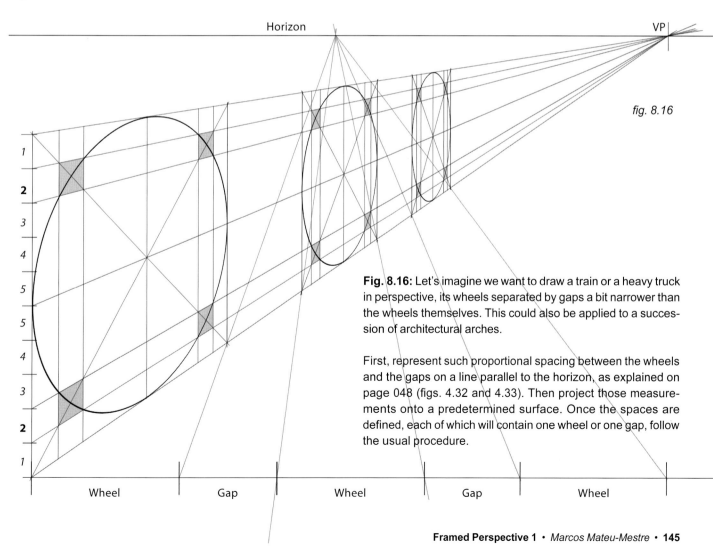

Horizon VP

fig. 8.16

Fig. 8.16: Let's imagine we want to draw a train or a heavy truck in perspective, its wheels separated by gaps a bit narrower than the wheels themselves. This could also be applied to a succession of architectural arches.

First, represent such proportional spacing between the wheels and the gaps on a line parallel to the horizon, as explained on page 048 (figs. 4.32 and 4.33). Then project those measurements onto a predetermined surface. Once the spaces are defined, each of which will contain one wheel or one gap, follow the usual procedure.

Wheel Gap Wheel Gap Wheel

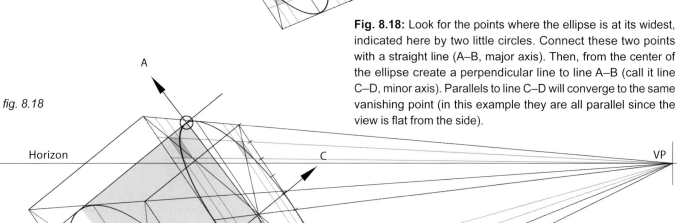

fig. 8.17

Horizon — VP

Fig. 8.17: An ellipse is a circle in perspective. This ellipse is meant to be the top of a cylinder. Even when it is tilted, the ellipse itself follows the same construction techniques inside the perspective square.

Fig. 8.18: Look for the points where the ellipse is at its widest, indicated here by two little circles. Connect these two points with a straight line (A–B, major axis). Then, from the center of the ellipse create a perpendicular line to line A–B (call it line C–D, minor axis). Parallels to line C–D will converge to the same vanishing point (in this example they are all parallel since the view is flat from the side).

fig. 8.18

Horizon — VP

WHAT IF THESE CIRCLES TURN OUT TO BE THE WHEELS OF A MOTORBIKE, A CAR, OR A BICYCLE? WHAT HAPPENS WITH THE SPOKES? HOW DO WE FIGURE THEM OUT IN PERSPECTIVE?

As usual, the first step is to draw them in a flat view, and to divide a circle into a number of segments in order to place the spokes properly. There are many different possibilities, but here are the most basic and the ones that occur most frequently, starting with the simplest—dividing a circle into 6 equal segments.

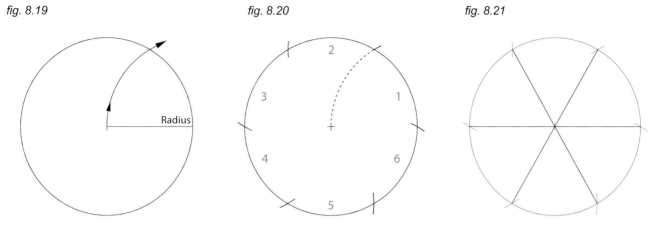

fig. 8.19 *fig. 8.20* *fig. 8.21*

Figs. 8.19–8.21: The total length of a circumference equals 6 times the length of its radius. Choose any point along the circumference and from there, using a compass, consecutively draw the length of the radius 6 times. Connect the center of the circle with the resulting 6 points to obtain the wheel's spokes.

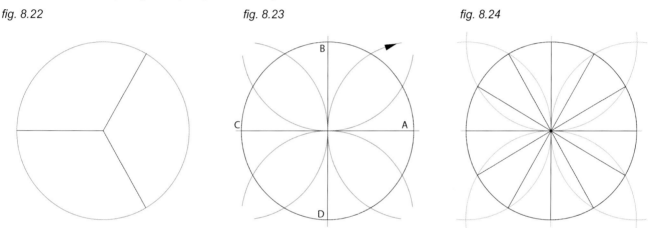

fig. 8.22 *fig. 8.23* *fig. 8.24*

Figs. 8.22: Obviously, once there are 6 partitions it is easy to reduce to 3 partitions by eliminating every other partition of the previous 6.

Figs. 8.23 and 8.24: To make 12 partitions, use points A, B, C and D as the center points. Use a compass to draw arcs with the same length of radius as the circle itself.

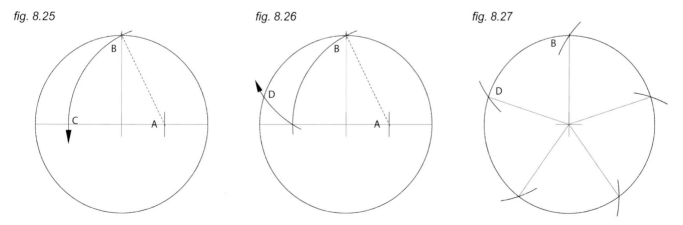

fig. 8.25 *fig. 8.26* *fig. 8.27*

Fig. 8.25–8.27: Another common case is the 5-spoke wheel. To divide the circumference by 5, find the midpoint of the radius (A). Draw a line at a 90-degree angle to that radius from the center point, creating point B. Use point A as a center point and draw an arc from point B past the diameter, creating point C. Then use point B as a center point and draw an arc from point C out to the circumference, creating point D. The distance from point B to point D is one-fifth of the circumference and this measurement is the one needed to divide the rest of the circumference into five equal sections.

fig. 8.28

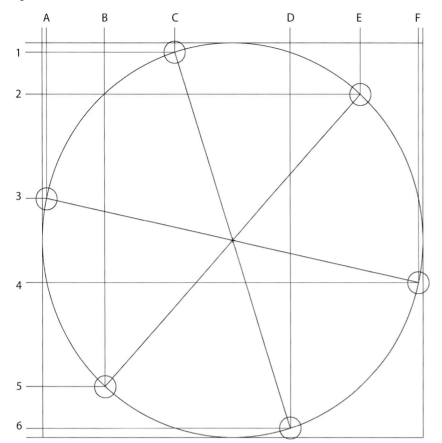

Fig. 8.28: Here is a flat view of a wheel with the spokes slightly rotated to give it a more natural feeling position in the scene.

To aid in drawing it in perspective, draw a square around the circle. Spot the coordinates located at the ends of the spokes (circled). Project the coordinates of these spots out to the sides of the square by drawing verticals and horizontals.

As a result, points 1–6 were created on the vertical side of the square and points A–F were created on the horizontal side of the square.

Fig. 8.29: The next step is to draw the square and the wheel in the desired perspective. Then transfer horizontals 1 to 6 and verticals A to F from the original flat view via the previously practiced methods (figs. 4.32 and 4.33 on page 048).

fig. 8.29

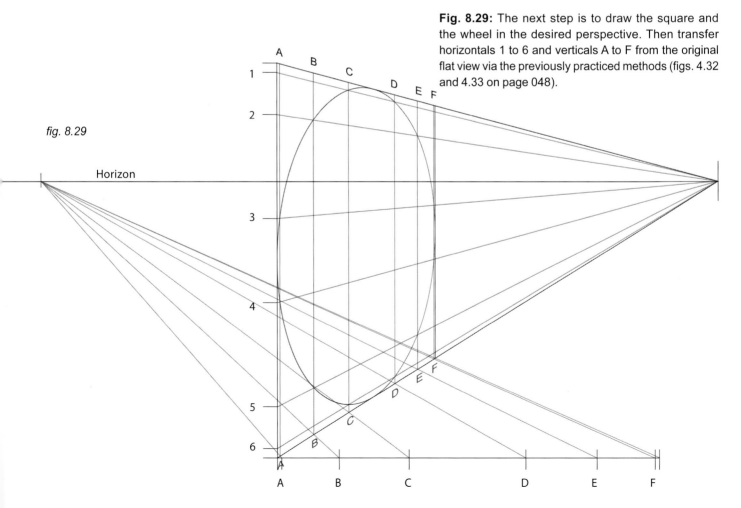

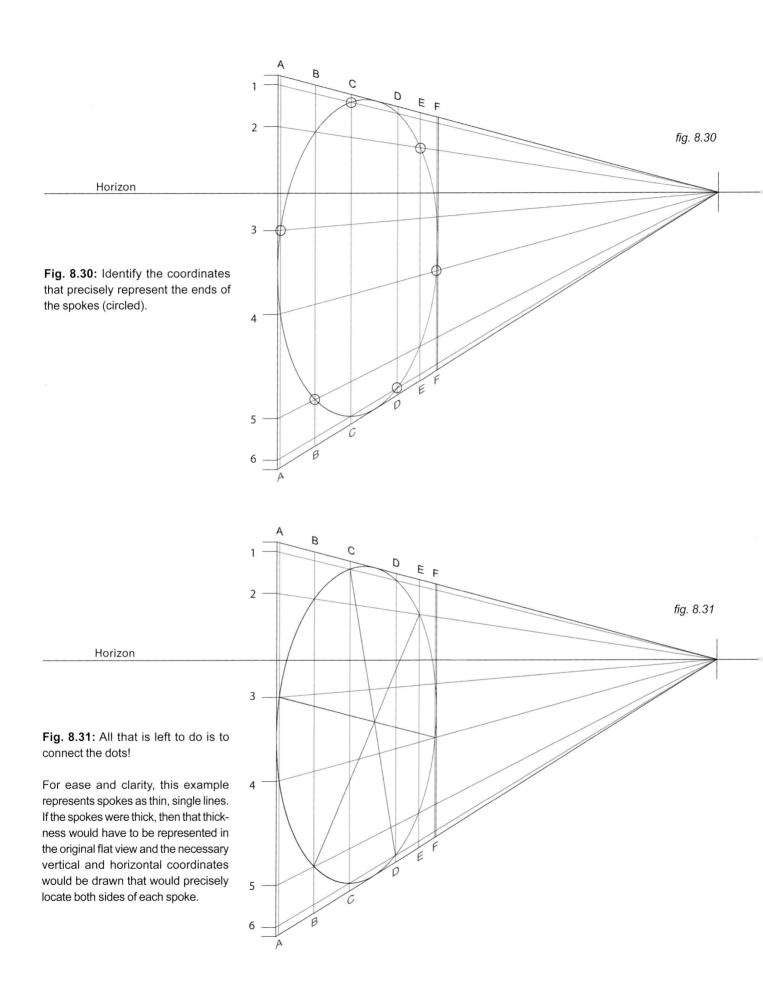

Fig. 8.30: Identify the coordinates that precisely represent the ends of the spokes (circled).

Fig. 8.31: All that is left to do is to connect the dots!

For ease and clarity, this example represents spokes as thin, single lines. If the spokes were thick, then that thickness would have to be represented in the original flat view and the necessary vertical and horizontal coordinates would be drawn that would precisely locate both sides of each spoke.

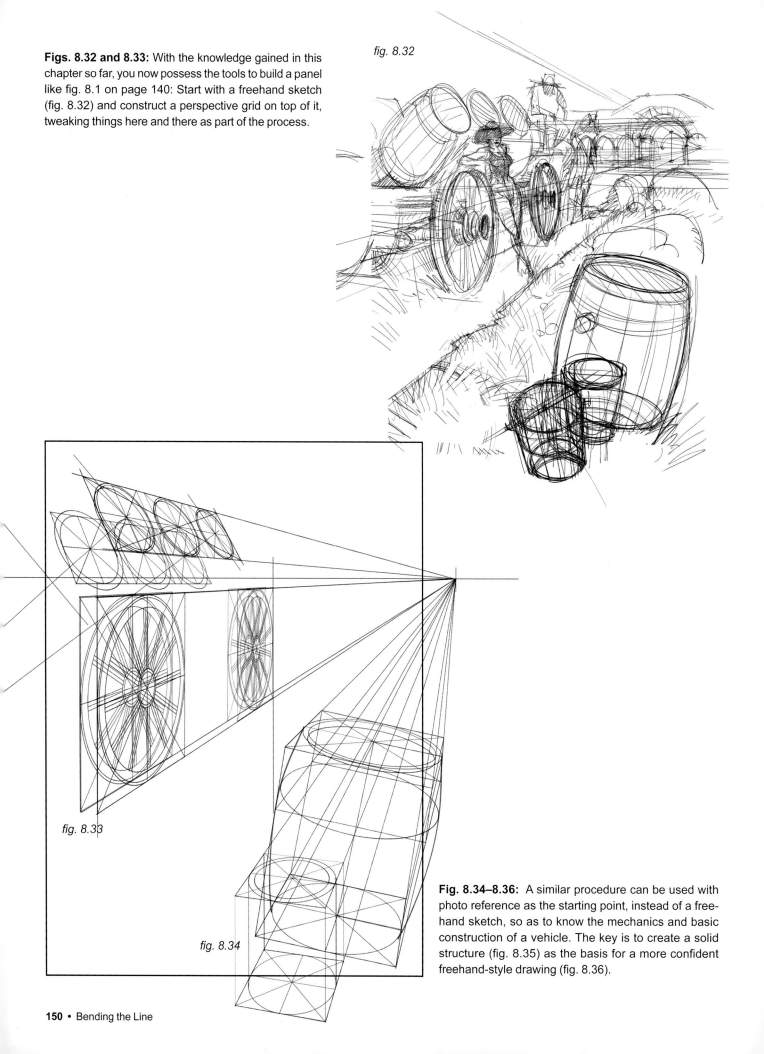

Figs. 8.32 and 8.33: With the knowledge gained in this chapter so far, you now possess the tools to build a panel like fig. 8.1 on page 140: Start with a freehand sketch (fig. 8.32) and construct a perspective grid on top of it, tweaking things here and there as part of the process.

fig. 8.32

fig. 8.33

fig. 8.34

Fig. 8.34–8.36: A similar procedure can be used with photo reference as the starting point, instead of a freehand sketch, so as to know the mechanics and basic construction of a vehicle. The key is to create a solid structure (fig. 8.35) as the basis for a more confident freehand-style drawing (fig. 8.36).

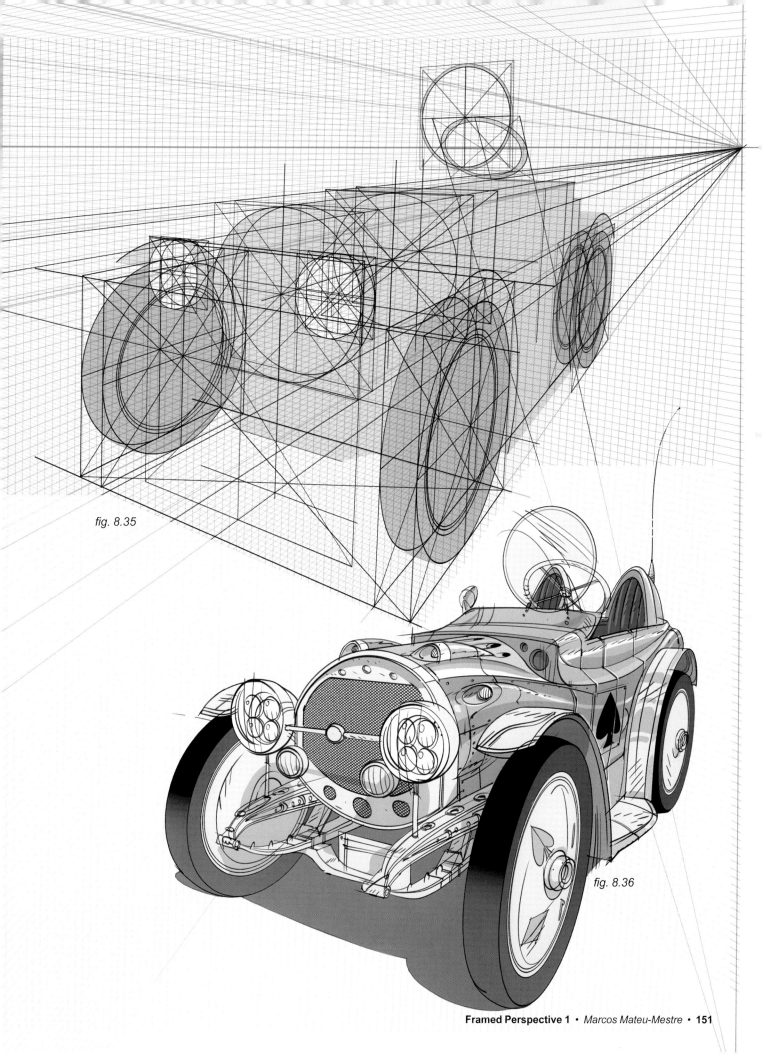

fig. 8.35

fig. 8.36

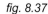

fig. 8.37

fig. 8.38

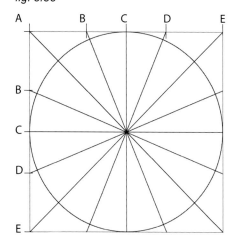

fig. 8.39

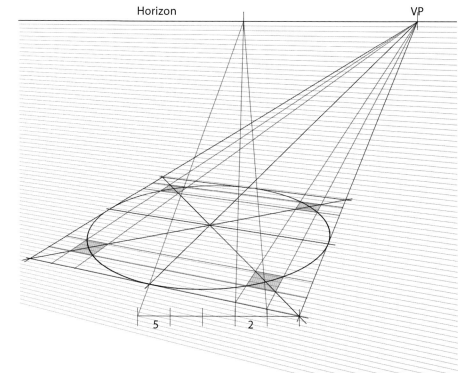

Next, let's draw a building that has a circular base and a façade made up of consecutive triangular shapes.

Fig. 8.37 and 8.38: These two views describe the building in side section and top view, respectively.

Fig. 8.39: First establish a circle in a square, and then transfer it into a perspective view, following the steps on the previous pages.

Fig. 8.40: Next divide the circle (now in perspective) into sixteen segments, as per the indication in fig. 8.38. For this we will transport the measurements ("A" to "E" on both sides of the square) onto a horizontal that tangents the square's bottom corner to follow the procedure explained on pages 044-046. Please observe that "E" to "A" on the left side is bigger than 'A' to 'E' on the right one. But that doesn't matter as long as the proportion between the (in this case four) segments within the same side maintain the right proportion to each other (see drawing 8.40b, next page).

fig. 8.40

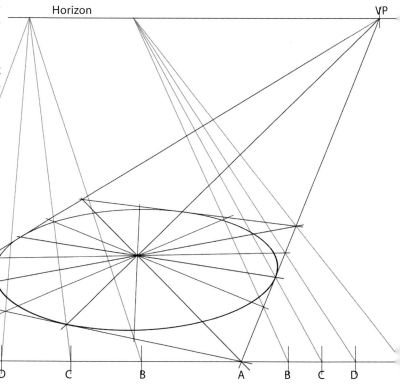

fig. 8.40b

This example proves that the three segments in which this line is divided (A, B and C) can be projected onto the side/edge of a tile in perspective independently from the length of such line, as long as the size proportion (ratio) amongst the different segments "A," "B" and "C" are always the same.

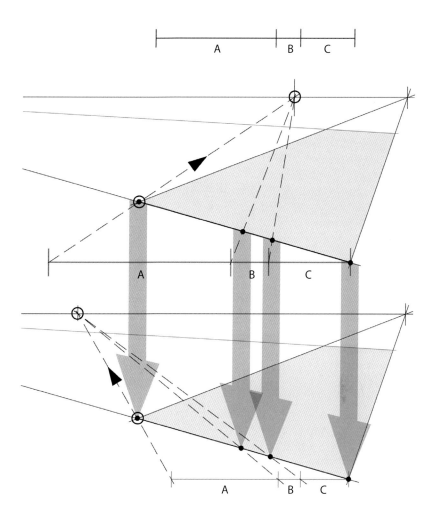

Fig. 8.41: Draw verticals from each of the 16 intersections, and then draw the circumference that represents the ceiling level of the building. Divide it into 16 portions as well.

Fig. 8.42: Now all of the information is in place to give the structure the final look with the zigzag lines described in the side section (fig. 8.37).

fig. 8.41

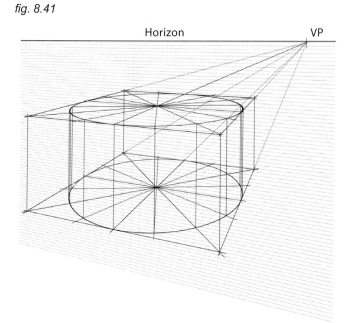

fig. 8.42

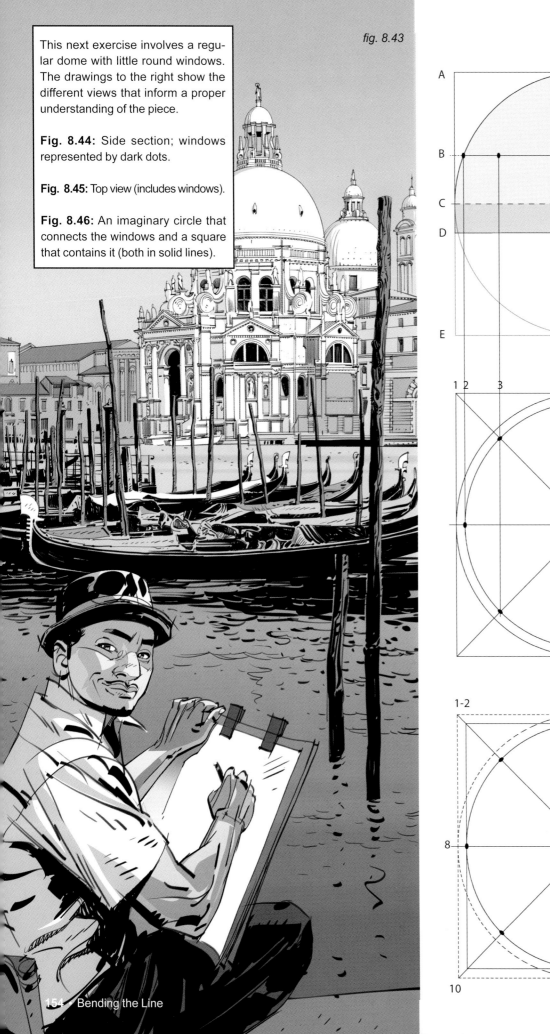

This next exercise involves a regular dome with little round windows. The drawings to the right show the different views that inform a proper understanding of the piece.

Fig. 8.44: Side section; windows represented by dark dots.

Fig. 8.45: Top view (includes windows).

Fig. 8.46: An imaginary circle that connects the windows and a square that contains it (both in solid lines).

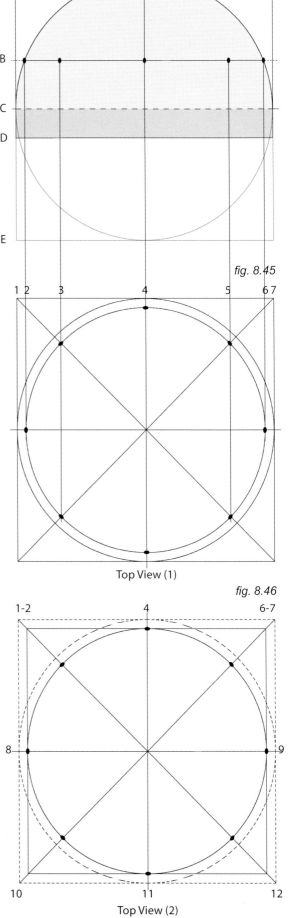

fig. 8.43

fig. 8.44

Side View

fig. 8.45

Top View (1)

fig. 8.46

Top View (2)

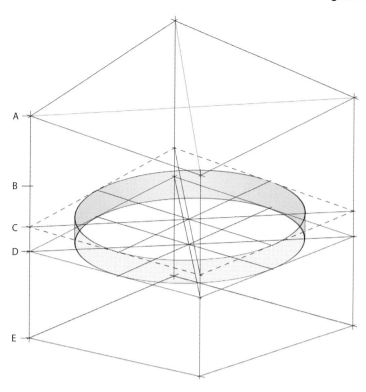

fig. 8.47

Fig. 8.47: With this understanding of the dome from its different points of view, first draw the box in which it will eventually be contained. Take into account that the dome itself, once drawn, will not use the full width of the box, given its basically semispherical shape and volume. In other words, however big or wide the dome needs to be in the shot, the box will need to be even bigger.

After creating the box, transfer the proportional measurements of the height. The necessary elements are located within the vertical side of the box (fig. 8.44):

A: Top of the box

B: Round windows level

C: Vertical center of both the box and the circumference

D: Base or bottom limit of the dome. The dome will not be just semispherical, but will have an extended base.

E: Bottom of the box

Next, use points C and D to define the cylindrical base at the bottom of the dome (shaded gray).

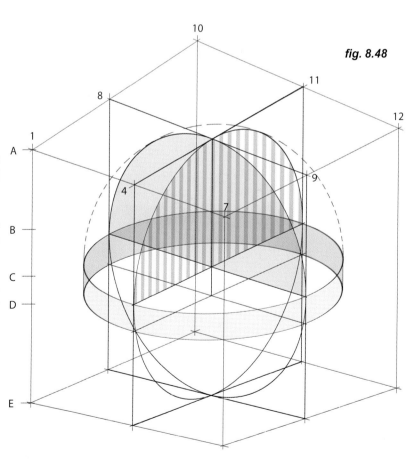

fig. 8.48

Fig. 8.48: After this, draw two semicircles within the parameters defined by points 9–8 (solid dark gray), and 4–11 (striped gray pattern).

Continuing to rotate these semicircles would give a more precise definition of the dome's volume, but these two should suffice for this exercise.

Now, just draw a line tangent to these semicircles in a way that defines the volume of the silhouette of the dome (dotted line).

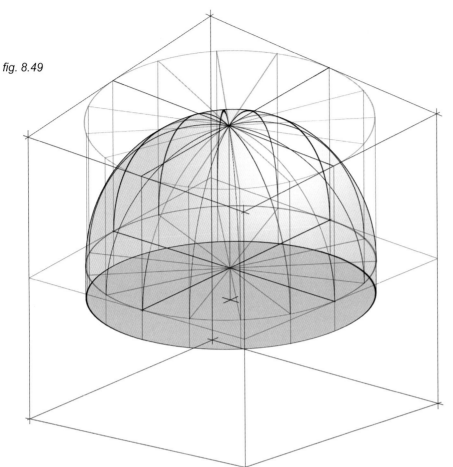

fig. 8.49

fig. 8.50

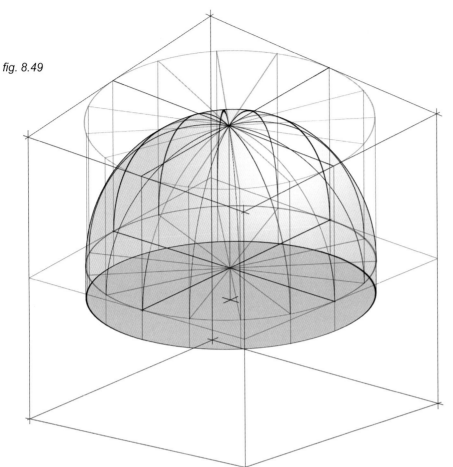

Fig. 8.50: Cylinder sections, top view

fig. 8.51

Fig. 8.51: Side section to be rotated on the dome's central axis to obtain its desired partitions.

Fig. 8.49: Here is the full dome as a finished volume.

To divide its surface into vertical sections, draw an imaginary cylinder tightly containing the dome from its base up, and draw at both the base and the top of this cylinder the desired number of sections (16 in this example, see fig. 8.50 for its top view). Connecting these top and bottom sections with vertical lines creates the rectangles that contain the semicircles needed to define such sections (fig. 8.51).

Fig. 8.52: Finally, to place the windows properly around the dome's surface, their exact height needs to be determined (see fig 8.44, page 154). Use point B to draw the square that cuts the dome at the right height. The thing is, at the level where the windows are placed the dome is already narrower than at its base. Therefore, draw another square within the first one that is perfectly tangential with the dome's surface at that level. For this, use reference points 1, 2, 6 and 7.

Fig. 8.53: Next, draw the ellipse within this smaller perspective square and divide it in the number of sections needed (8 in this case, as defined by the number of windows established in fig. 8.45, page 154). Finally, draw the windows!

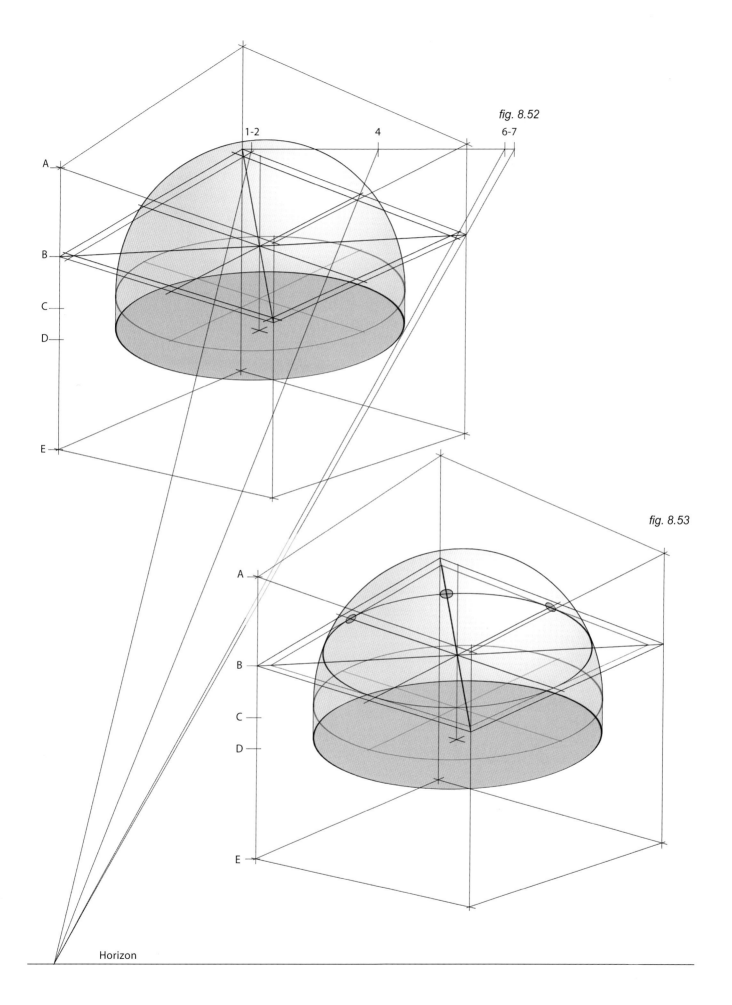

fig. 8.52

fig. 8.53

Horizon

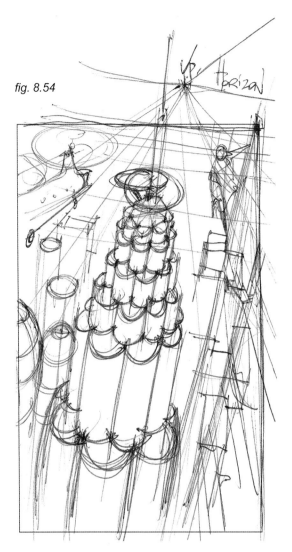

fig. 8.54

Using the theme of circles, ellipses and cylinders, let's put these ideas into service for a story point. Imagine that for dramatic purposes a certain building needs to stand out against the rest of the buildings in its surrounding environment, because this building has a specific significance within the context of the story. One way to make it stand out among a city of rectangles is to design it based on repeating cylindrical shapes and volumes.

Fig. 8.54: As usual, the first step is to create a general sketch of the shot that establishes the look and basic structure of the building, as well as the general composition.

Fig. 8.55: Although this exercise could be done with traditional drawing methods, given the amount of detail involved, such a solution would not be very practical here. The faster solution in this case would be to use digital drawing software.

Based on the freehand sketch, this is a precise blueprint of the building (top view). Given the fact that the skyscraper consists of several levels, each containing a number of orderly cylindrical volumes, this blueprint should contain the information pertaining to every one of the levels, as they keep becoming narrower in volume while getting closer to the very top of the building. Notice how each level has been assigned a number (from 1 to 8).

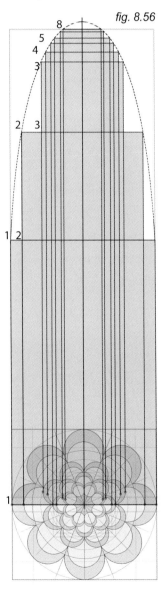

fig. 8.56

fig. 8.55

Fig. 8.56: The top view outline of level 1 also corresponds to the base of the building; the top view of section 2 also corresponds to its base, and so on.

In order to have the edges of all the sections existing harmoniously in continuity all the way to the top, it helps to predesign an arch (dotted line). Make sure that the top edge of each section is tangent to it.

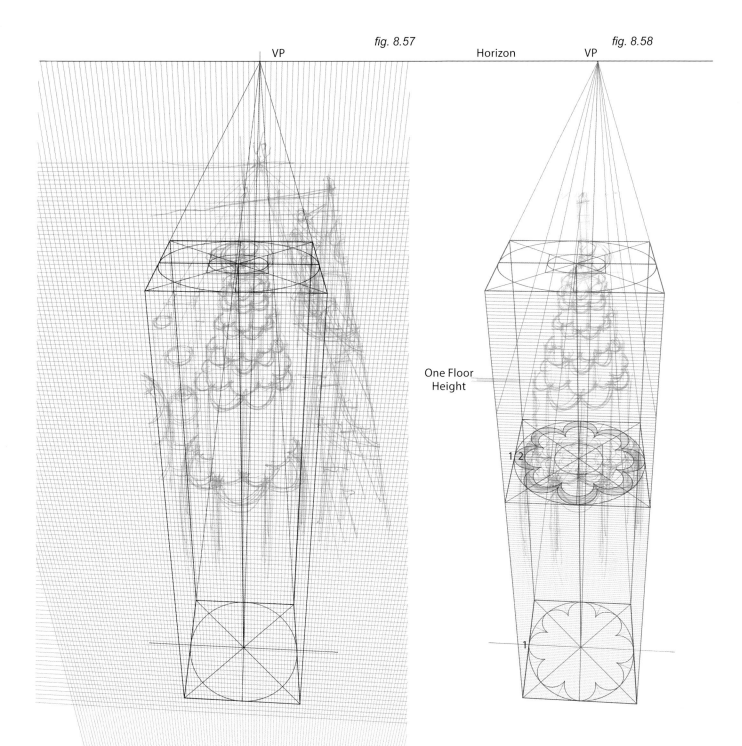

fig. 8.57

VP

Horizon VP fig. 8.58

One Floor
Height

1/2

1

Fig. 8.57: Based on the original freehand sketch, a full perspective grid was created, which includes verticals, horizontals (in this case they converge slightly toward the left to enhance the drama) and obviously the vanishing point on the horizon line.

In order to have a more objective view of the building while developing the image, the sketch was rotated to a vertical position. Once the perspective was resolved, it was rotated back to its original (tilted) position.

Also, while creating the grid, a decision was made to raise the horizon further to have a better view of all of the rooftops in the final image.

Fig. 8.58: The next thing is to establish the top and bottom of each block of floors, as done here with the first block. Take into account the top of each level includes two outlines: the outline of the level itself (1), plus the outline of the block above it (2).

Fig. 8.58 defines the bottom and the top of the first block (outline 1); plus the starting point of the second block of floors (outline 2). In addition, the lines that represent the height of each block of floors were defined for the whole building by the perspective grid.

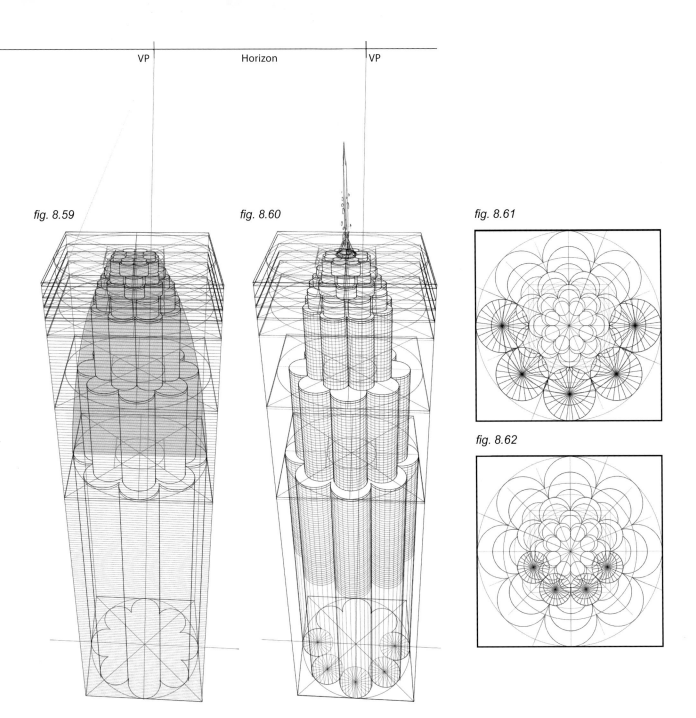

fig. 8.59

fig. 8.60

fig. 8.61

fig. 8.62

Fig. 8.59: Follow the same process until the positioning of all the different (and consecutively narrowing) building blocks have been established, one on top of the other, taking care that every one of them fits into the originally established perspective grid.

Although the drawing software helps tremendously to reduce the time required to render this whole image, it is still important to work on every floor within every block independently.

Fig. 8.60: The glass windowpanes were defined by the vertical lines that were already drawn on the image. Since these panes are "wrapped around" the cylinders that form the structure of the building, do not make the mistake of spacing them equally, since the closer they get to the sides, the narrower the space in-between should appear. To aid with this, first divide the cylinders as they are represented in the blueprints (figs. 8.61 and 8.62) and then draw the lines once the blueprints have been fit within the perspective.

Fig. 8.63: Surrounding the cylindrical main structure with angular-looking buildings establishes the visual contrast that was the original goal for this image.

Lastly, after keeping the buildings vertical on the drawing surface for practical reasons, working digitally provides the freedom to rotate the entire panel, back to the left in this case, to enhance the drama of the moment.

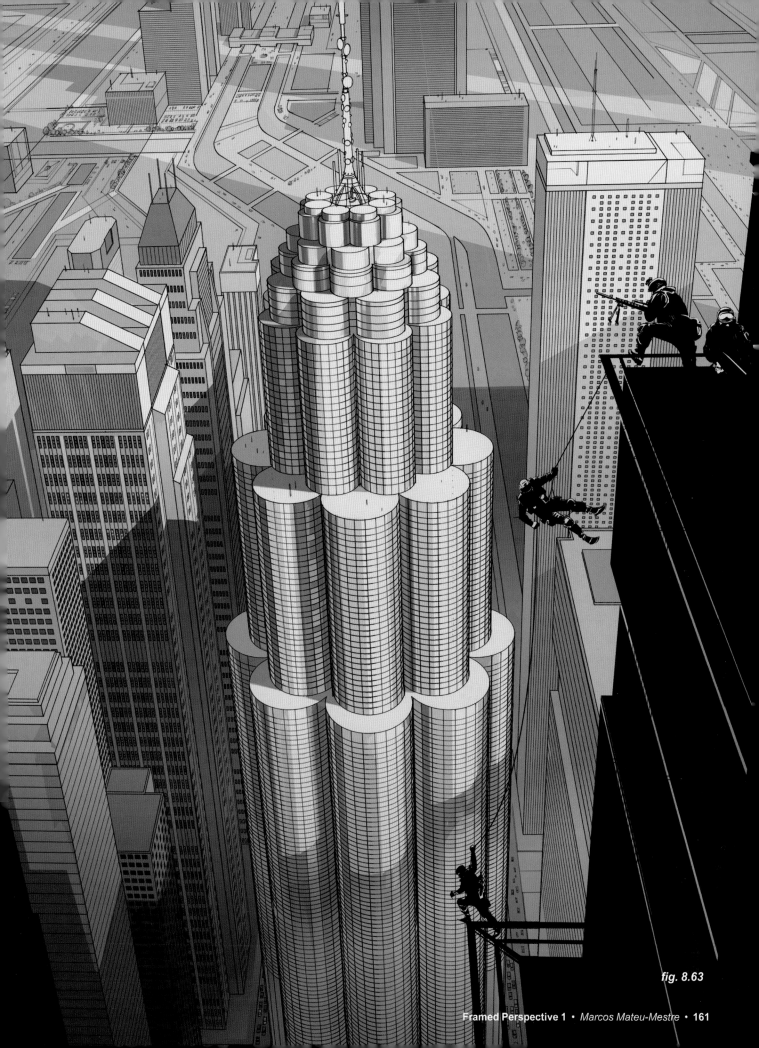

fig. 8.63

Framed Perspective 1 • *Marcos Mateu-Mestre* • 161

DRAWING IRREGULAR SHAPES IN PERSPECTIVE

Until now, the book has dealt with regular shapes or combinations of them. What happens when shapes start bending in unexpected ways or not following specific patterns? Sometimes irregular shapes are needed for things like a freeway underpass, or a building that does not follow the usual architectural standards, or just creating elements of interest and character within a story.

fig. 8.64

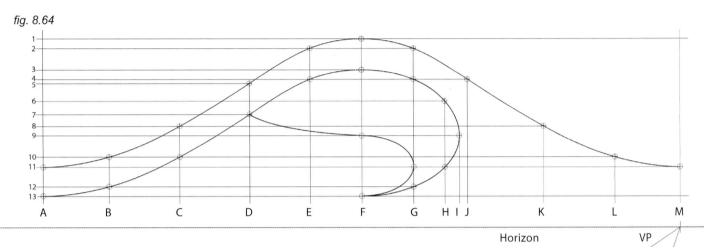

Fig. 8.64: Here is a random shape design that includes different sorts of curves, some wide open, some more closed, some have a symmetrical counterpart and some do not. The first thing to do is to create a big *regular* shape (in this case rectangular) that contains the overall design. After this, identify key spots within these curvy shapes that define them and the directions they take (marked by the little circles). Next, draw vertical and horizontal lines through these points to the edges of the rectangle (lines 1–13 and lines A–M). To simplify the process, try to align as many key spots as possible along a shared line.

Fig. 8.65: After all these elements have been located on the flat view, create a surface in perspective on which to transfer such information. Following standard procedures, divide the sides of the rectangle by the same proportional segments. The resulting coordinates indicate the points to connect in order to draw the curved lines in the chosen perspective. As we can see on page 042 fig 4.16, or page 047, fig 4.28, I always eyeball these base rectangles into perspective.

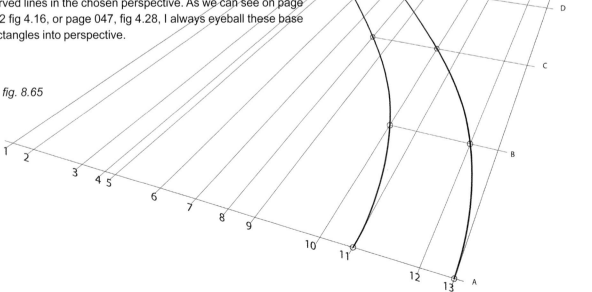

fig. 8.65

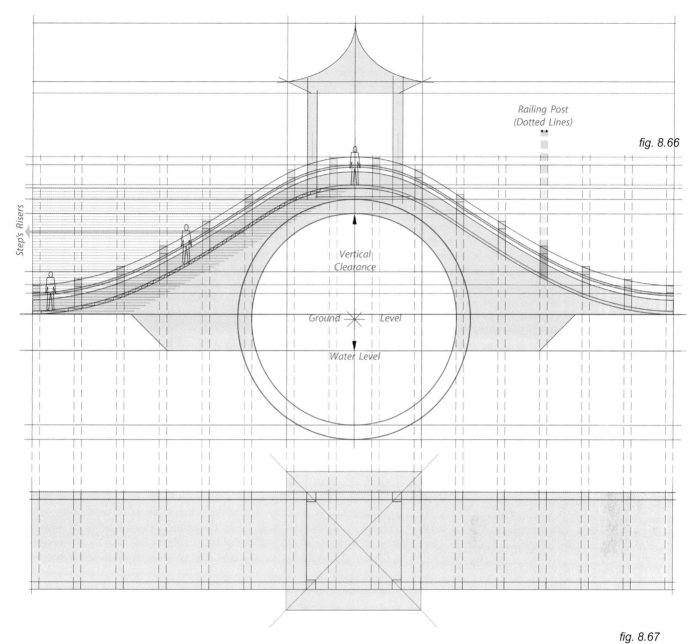

Railing Post
(Dotted Lines)

fig. 8.66

Step's Risers

Vertical
Clearance

Ground — Level

Water Level

fig. 8.67

Fig. 8.66: These same principles apply to the bridge depicted here in side view (top) and top view (above). It is basically divided into two main architectural bodies, the bridge itself and the gazebo structure. Again, draw straight lines tangent to all main shapes, creating a number of rectangles to contain those shapes.

Besides the main shapes, other details will need attention like the evenly spaced pylons, the steps and the size of an average person (already worked out in the blueprint) to keep a good sense of proportion.

Fig. 8.67: The original freehand sketch indicates the eventual perspective view of the scene.

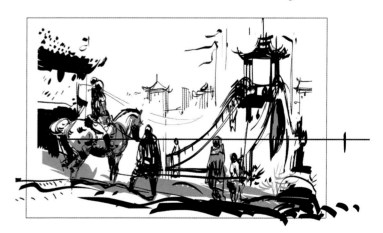

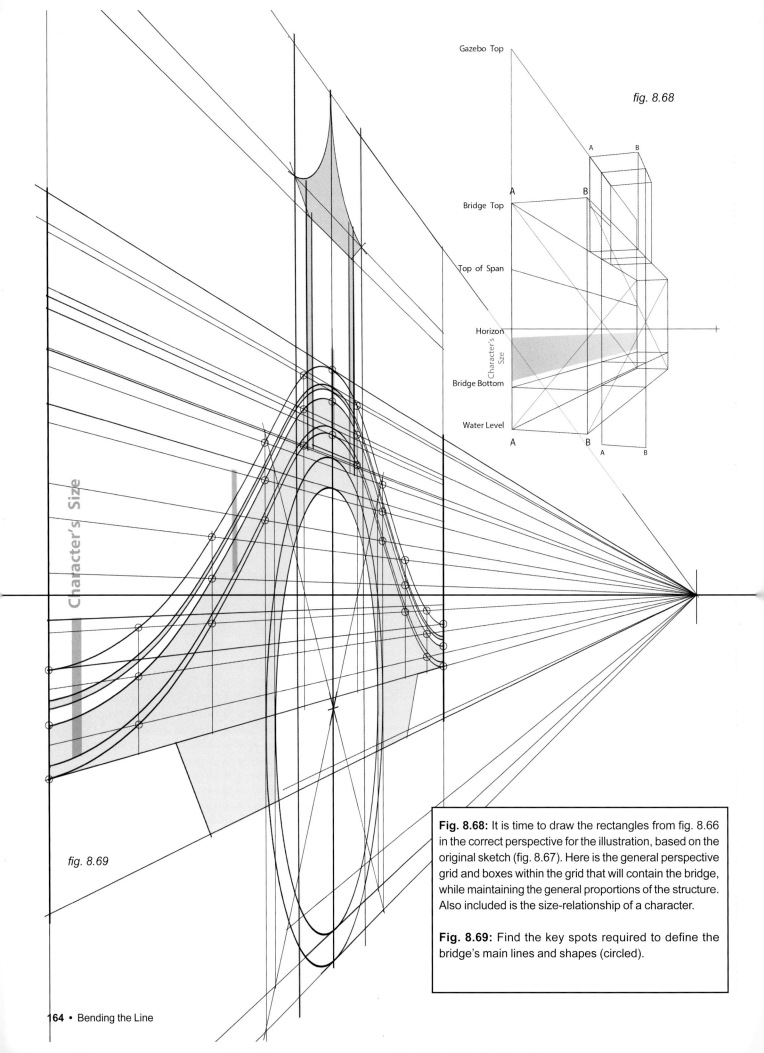

Gazebo Top

fig. 8.68

A B

Bridge Top

A B

Top of Span

Horizon

Character's Size

Bridge Bottom

Water Level

A B

A B

Character's Size

fig. 8.69

Fig. 8.68: It is time to draw the rectangles from fig. 8.66 in the correct perspective for the illustration, based on the original sketch (fig. 8.67). Here is the general perspective grid and boxes within the grid that will contain the bridge, while maintaining the general proportions of the structure. Also included is the size-relationship of a character.

Fig. 8.69: Find the key spots required to define the bridge's main lines and shapes (circled).

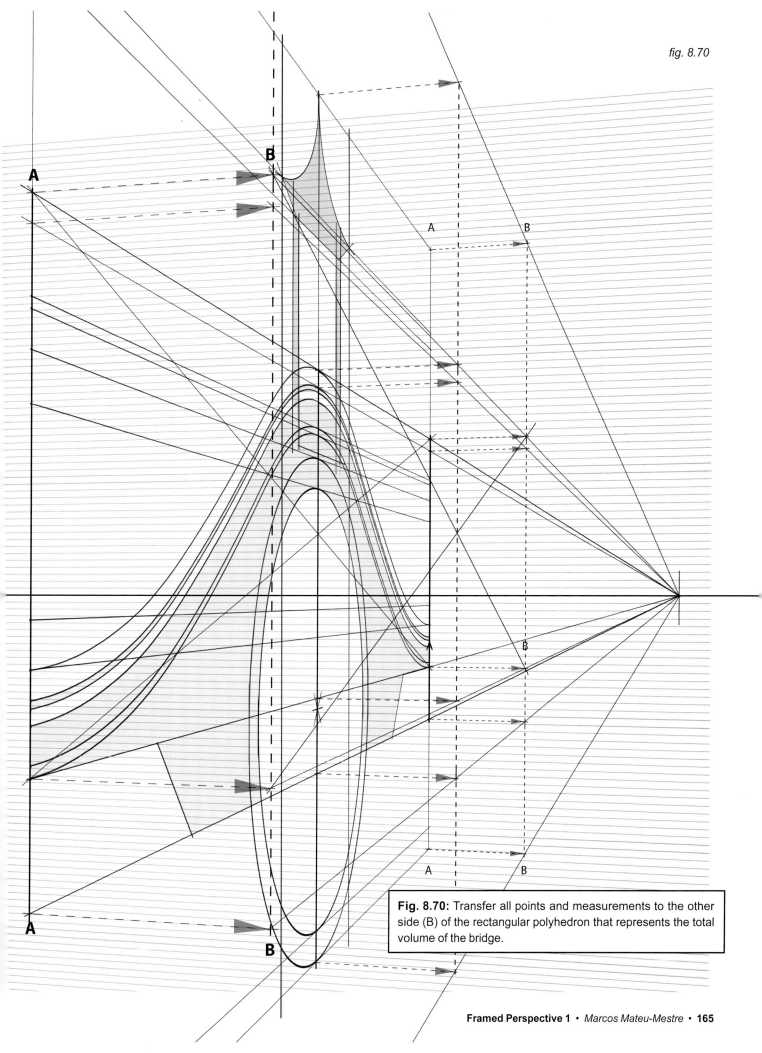

A

B

B

A B

A

B

A

A

B

A

B

fig. 8.70

Fig. 8.70: Transfer all points and measurements to the other side (B) of the rectangular polyhedron that represents the total volume of the bridge.

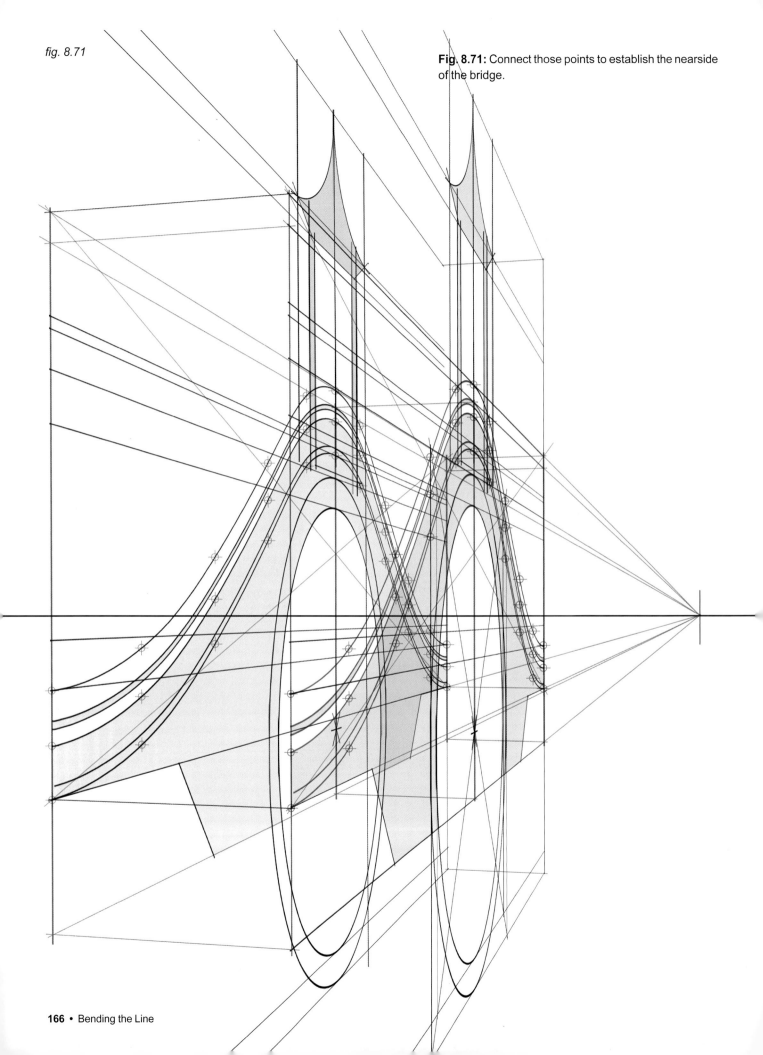

fig. 8.71

Fig. 8.71: Connect those points to establish the nearside of the bridge.

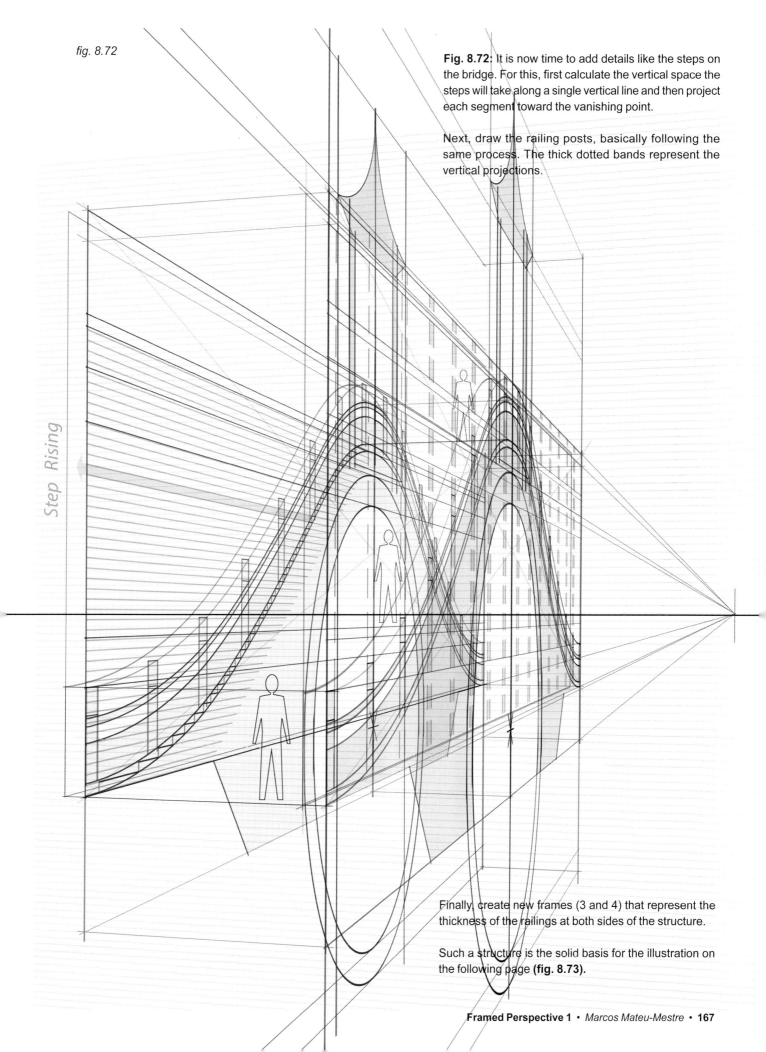

fig. 8.72

Fig. 8.72: It is now time to add details like the steps on the bridge. For this, first calculate the vertical space the steps will take along a single vertical line and then project each segment toward the vanishing point.

Next, draw the railing posts, basically following the same process. The thick dotted bands represent the vertical projections.

Step Rising

Finally, create new frames (3 and 4) that represent the thickness of the railings at both sides of the structure.

Such a structure is the solid basis for the illustration on the following page **(fig. 8.73).**

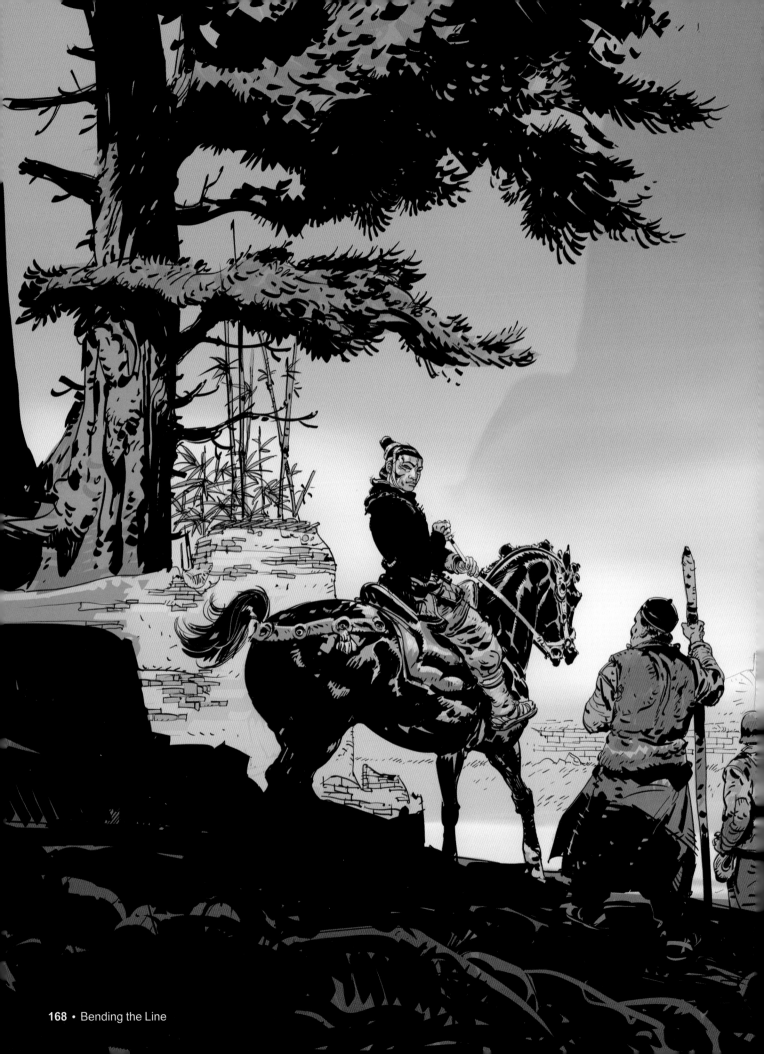

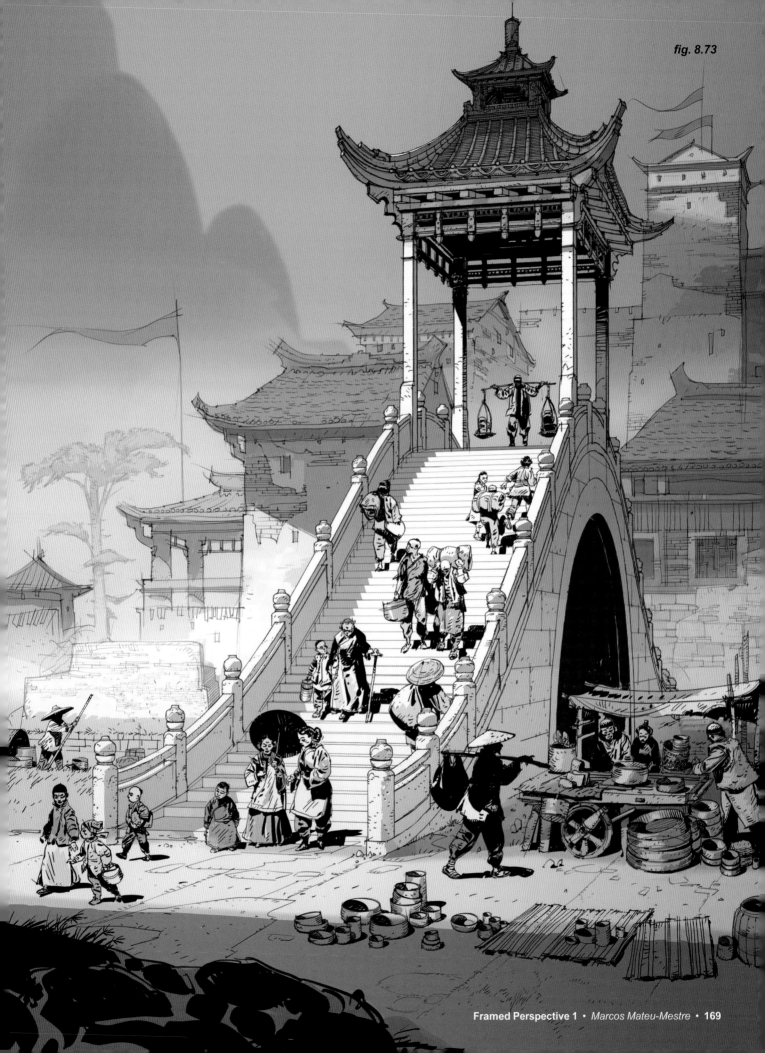

fig. 8.73

Fig. 8.74: This new exercise is a variation of the previous one. Here is a side section of a straight but hilly road, with telephone poles. *We will draw this road just as if we were on it,* right at the top of the ramp (big circle).

In order to precisely draw the wavy section of the road in perspective, define its profile with markings on both the vertical (numbers) and the horizontal (letters) that cross in key points. Again, pay special attention to the ramp between points 6 and C, as it will play a special role here.

fig. 8.74

fig. 8.75

Fig. 8.75: This three-quarters view helps us imagine this stretch of road within an elongated box, as a means to contain it within a regular-shaped space.

Fig. 8.76: Draw a quick, freehand sketch of the road, roughly approximating how it will look from a point of view at the top of the ramp.

And then draw the containing box around it.

fig. 8.76

Fig. 8.77: We said we are on the road, well, not only that, let's position ourselves flat on our bellies on the asphalt and look down ramp 6-C, with a line of sight that goes in a direction perfectly parallel to its surface, while keeping our eyes very close to the ground. This can be a cool effect.

From this point of view, the road looks like it is whizzing by right underneath the camera.

fig. 8.77

Now, here is today's challenge: how do we structure the whole drawing, including the box containing it, so that ramp 6-C is extremely close to the line of sight while, and this is the tricky part, faithfully respecting the measurements and inclinations carefully described in the original blueprint?

What are the correct positions for the vanishing points and horizon lines, so that such effect can be achieved while exactly following the given blueprint data? Yes, there will be more than one horizon line in this case.

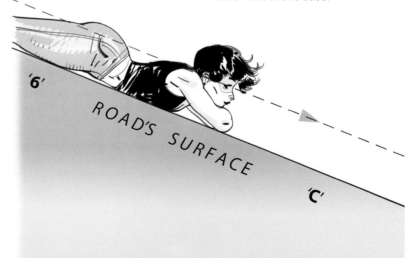

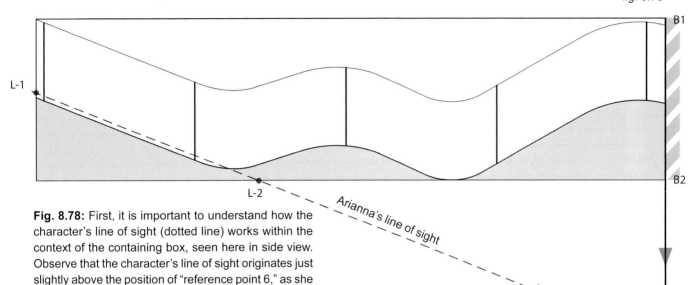

fig. 8.78

Fig. 8.78: First, it is important to understand how the character's line of sight (dotted line) works within the context of the containing box, seen here in side view. Observe that the character's line of sight originates just slightly above the position of "reference point 6," as she is laying down really close to it.

The dotted line intersects the section's frame at points L-1 and L-2. (For "line of sight," just to call it something). Extend the (dotted) line of sight even further, and also extend down the vertical line that represents the far edge of the box (B1–B2), until they intersect, creating point L-3. Point L-3 represents the level position of ramp 6-C's vanishing point as per the viewer's line of sight.

Fig. 8.79: The solution to the original challenge (posed in fig. 8.77) comes through **finding the exact position of the foreground frame of the box, relative to its background frame.** Getting this relative position correct achieves the sought-after effect of seeing the box exactly in the right position from the low point of view.

It is time to clean up the drawing in perspective, starting with the box. Draw a precise version of its far end (striped area) based on the specified proportions of the freehand sketch (fig. 8.76).

Calculate the distance between points L-3 and B2 relative to the distance between B1 and B2 (refer to fig.8.78), and draw those 3 points in the new drawing. Next, draw the horizon for the 6-C ramp's line of sight, right by the height of point L-3. (Incidentally, the fact that the distance between B1–B2 and B2–L-3 are practically the same is **pure coincidence.**)

Fig. 8.80: It is now time to decide where to locate the vertical B1–L-3, on which all of the vanishing points will be. To make the point of view feel a bit off-center, this line must also be off-center. For example, if Arianna is lying down in the right lane, the vertical B1–L-3 needs to be placed to the right of center. The point where this vertical line crosses horizon line L-3 determines the vanishing point for ramp 6-C's line of sight.

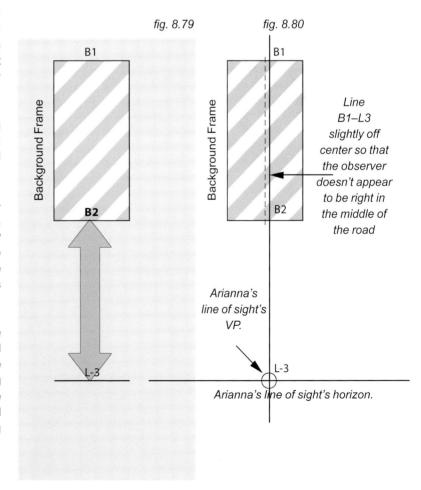

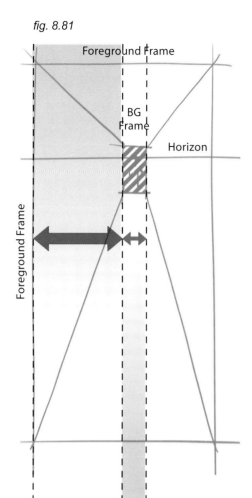

fig. 8.81

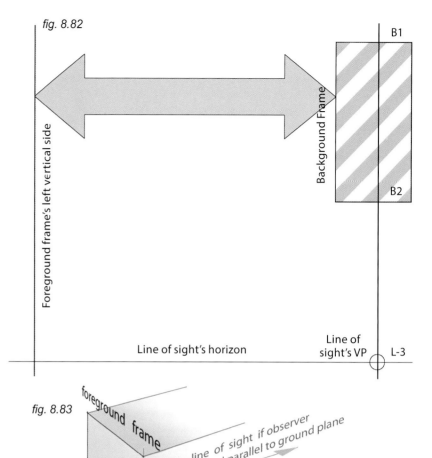

fig. 8.82

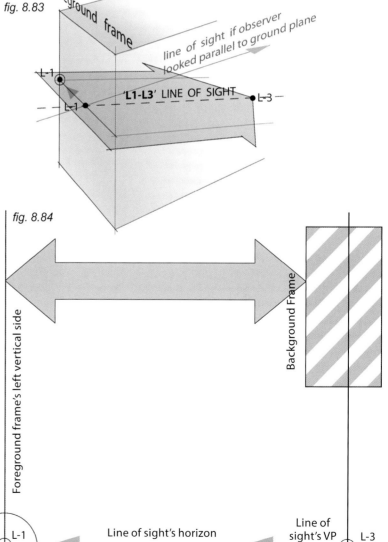

fig. 8.83

fig. 8.84

Fig. 8.81: There is one more piece of information to get from the freehand sketch, and that is the distance between one of the vertical sides of the box's background frame, and the vertical side of the foreground frame of the same side. For this example, the left side was chosen.

Fig. 8.82: That information is transferred to the new cleaned-up drawing.

Fig. 8.83 and 8.84: All points contained within an observer's horizon plane are drawn on the same horizontal line (notice that from Arianna's point of view L-1, L-2 and L-3 are seen as one single point, as they are perfectly aligned and overlapped). Transfer point L-1 (which represents the line of sight and, as explained, perfectly coincides with L-3) out to the vertical line that represents the left side of the foreground frame.

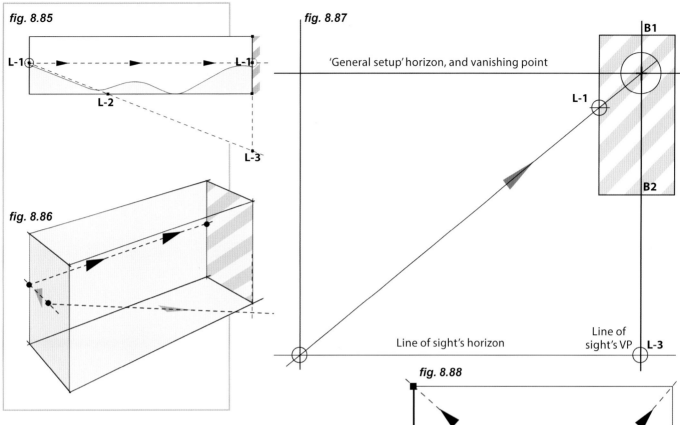

fig. 8.85

fig. 8.86

fig. 8.87

'General setup' horizon, and vanishing point

B1

L-1

B2

Line of sight's horizon

Line of sight's VP L-3

Figs. 8.85 and 8.86: L-1 continues its tour of the box and gets pushed all the way to its far end, right at the spot (or exact height on the vertical side of the background frame) where L-1 should be per the original side-section drawing.

Fig. 8.87: Take this move to the cleaned-up perspective drawing and it looks like this.

Extend the line and when it intersects the off-center vertical where it was decided all vanishing points would be (as established in fig. 8.80) **this is in fact the vanishing point of the box and of the general landscape** (large-circled point).

Fig. 8.88: Now that the box's vanishing point is established, reverse the move and draw lines from the box's vanishing point through the two left corners of the background frame (striped pattern), all the way to the line that represents the vertical left side of the foreground box. (Remember this line was positioned in fig. 8.81.) This determines the top and bottom end of this vertical side.

After that, close the full rectangle and the box is finished!

And that was the whole point, that from this exact height and point of view and accurately following the original side-section drawing, Ramp 6-C will appear to whiz right underneath the camera, as if we were laying down on it, as will be seen in the next two pages.

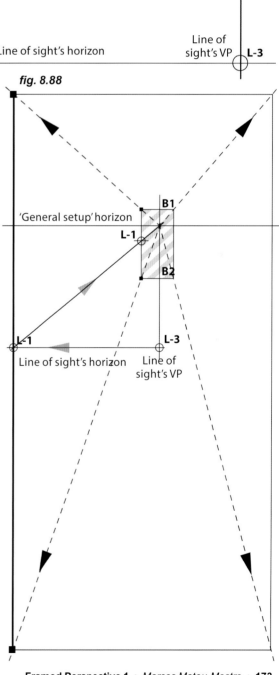

fig. 8.88

'General setup' horizon

B1

L-1

B2

L-1

L-3

Line of sight's horizon

Line of sight's VP

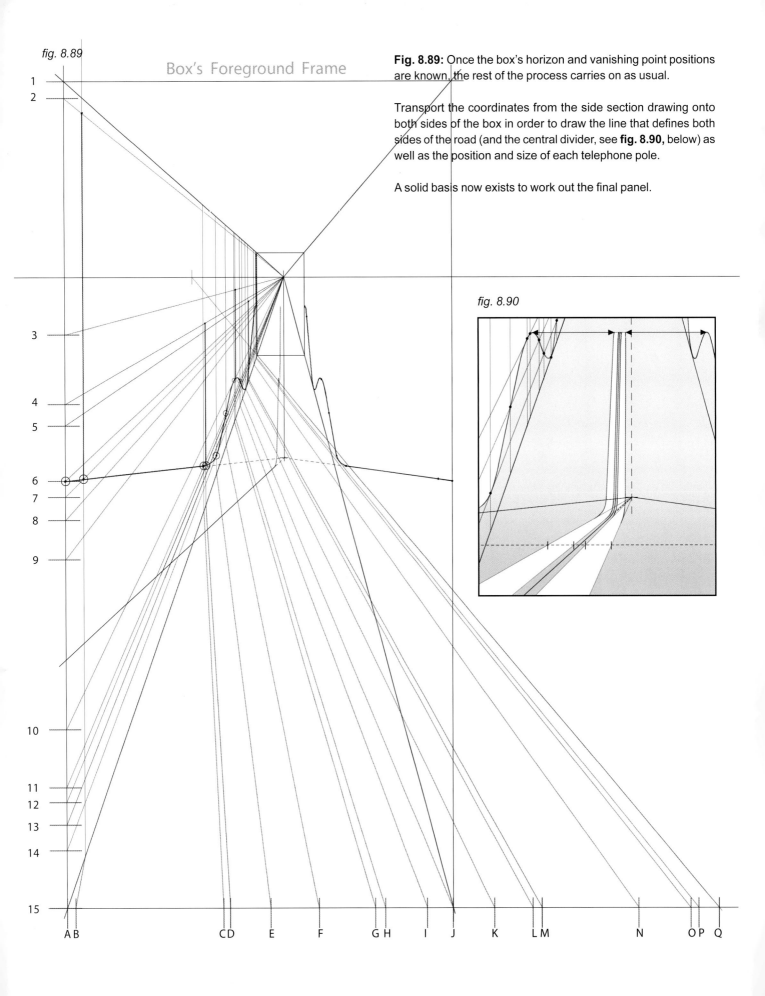

fig. 8.89

Box's Foreground Frame

Fig. 8.89: Once the box's horizon and vanishing point positions are known, the rest of the process carries on as usual.

Transport the coordinates from the side section drawing onto both sides of the box in order to draw the line that defines both sides of the road (and the central divider, see **fig. 8.90,** below) as well as the position and size of each telephone pole.

A solid basis now exists to work out the final panel.

fig. 8.90

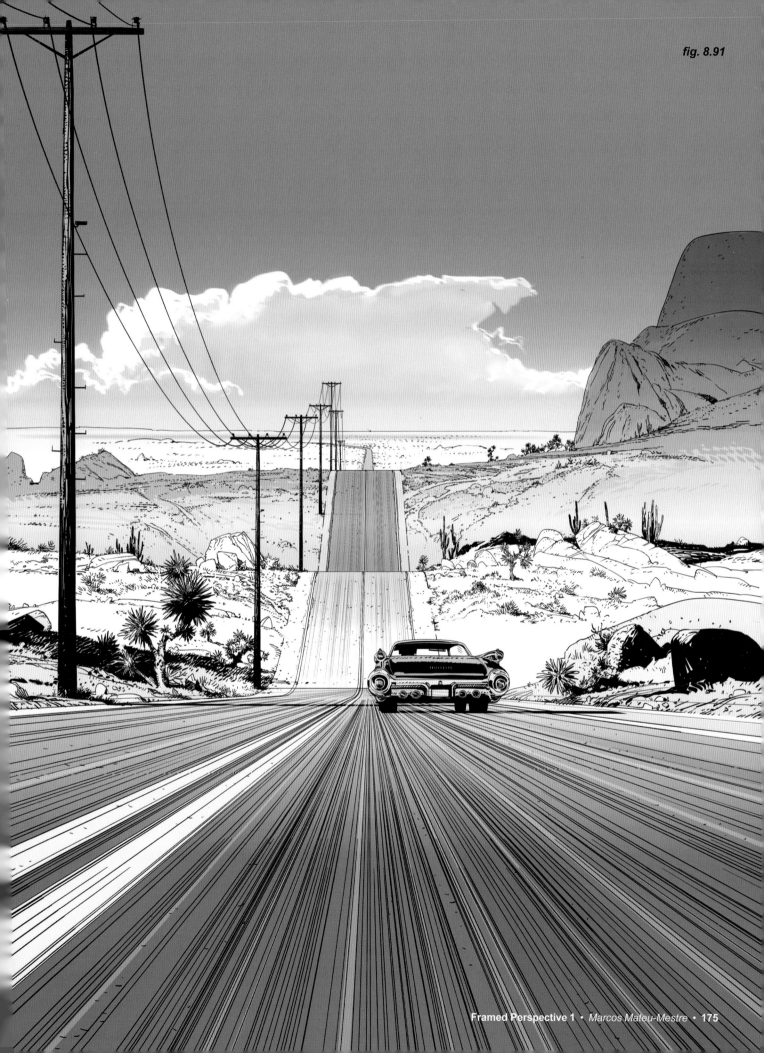

fig. 8.91

fig. 8.92

fig. 8.93

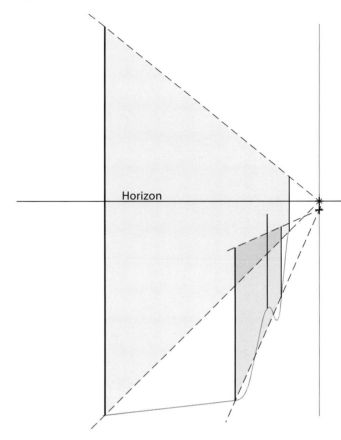

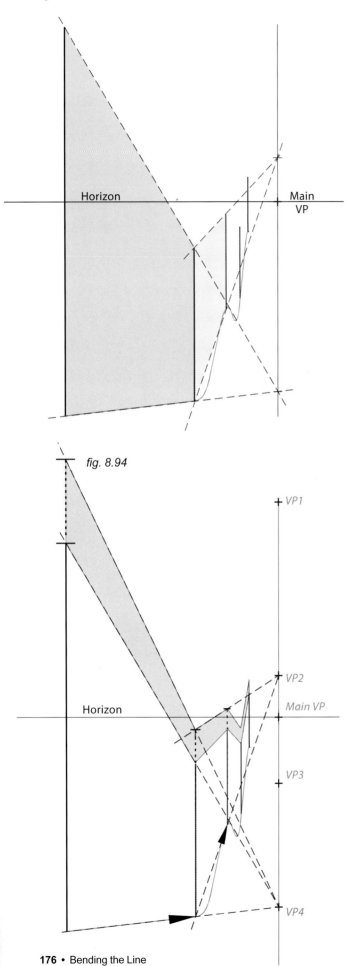

fig. 8.94

Figs. 8.92 and 8.93: As part of the final rendering for fig. 8.91, the telephone posts were elongated as an embellishment. The steps for this purpose are very simple.

Although each post is positioned at a different height within the landscape because of the ups and downs of the road's profile, and given that they are all in fact equal in height, the posts, whether consecutive or not, still follow the principle of inclined planes, as explained in chapter 7. This means they all converge to vanishing points located either on the main VP or along the vertical that crosses it, as seen here. (See also pages 056-058 of *Framed Perspective 2*).

Fig. 8.94: After deciding how much to elongate the posts, draw the extension on the post closest to the viewer. Then find the vanishing point for the base of this post and the next on the main VP's vertical, creating VP2. Draw a line from the new top of the first telephone post to VP2. Where this line crosses the vertical of the next post is where its new top is, and so on and so forth.

Fig. 8.95: As a shortcut for cases like this one, imagine the telephone poles are posts of a fence. Take three basic elements: the side section of the hill, the height of one of the posts, and the eye level or horizon line.

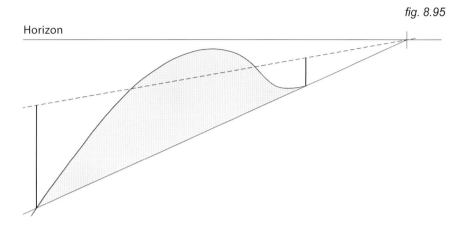

fig. 8.95

Fig. 8.96: Decide how many posts the "fence" will have...in this case, 8. Follow the standard procedure to divide the space between the first and last posts accordingly.

Then draw the posts as if they were sitting on a flat plane. This reveals the height measurement of each of the (8) posts in the drawing.

fig. 8.96

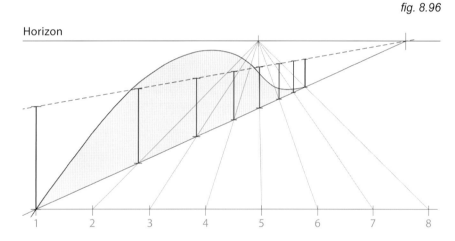

Fig. 8.97: Project the centerline of each post upward, then bring the measure of each individual post up on said line and place it on top of the hill's surface.

fig. 8.97

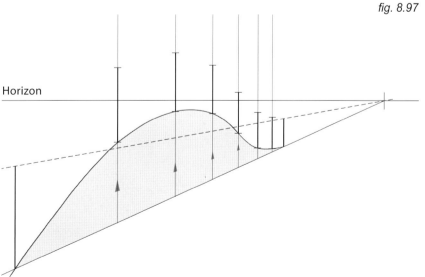

ELEVATION, PLAN AND PROFILE

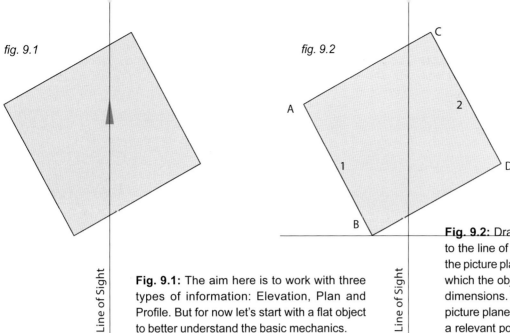

fig. 9.1

Line of Sight

Viewer's position or station point

fig. 9.2

A

2

1

D

B

Line of Sight

Fig. 9.1: The aim here is to work with three types of information: Elevation, Plan and Profile. But for now let's start with a flat object to better understand the basic mechanics.

As an example, let's take a tile, seen here in top view, aka plan view. The sketch also shows the position of the viewer, or station point. Remember, an object's appearance depends upon the position of the viewer, relative to the object.

Fig. 9.2: Draw a picture plane perpendicular to the line of sight. As explained on page 012, the picture plane is the imaginary plane through which the object is seen and measured in two dimensions. The most strategic place for the picture plane is to put it tangent to the object at a relevant point, usually the one closest to the viewer. (In this case, corner B).

Next, identify the key points of the tile, those needed in order to construct a perspective view of it from the viewer's vantage point (corners A, B, C, and D).

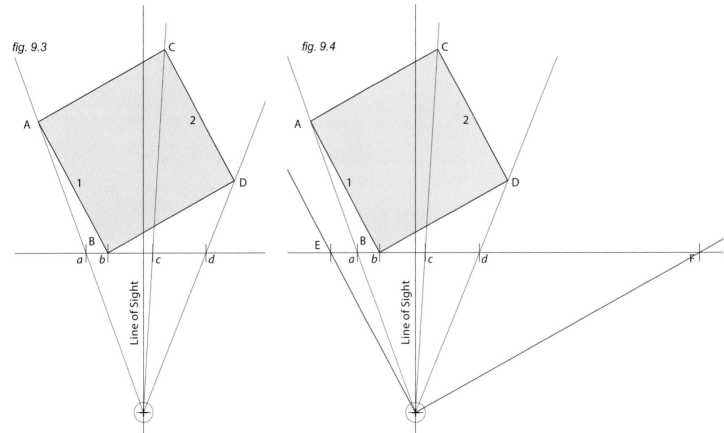

fig. 9.3

C

A

2

1

D

B

a b c d

Line of Sight

fig. 9.4

C

A

2

1

D

E B

a b c d F

Line of Sight

Fig. 9.3: Connect those key points to the station point with straight lines, so that those lines cross the picture plane. In this case, a line need not be drawn for point B since it is already on the picture plane. Note where each line crosses the picture plane.

Fig. 9.4: From the station point, draw parallels to sides 1 and 2 of the tiles toward the picture plane until they cross it, creating points E and F.

Fig. 9.5: To begin drawing the tile in perspective, start by drawing a horizontal line, which is the horizon line of the image. Refer back to the picture plane of fig. 9.4 and transfer all points (A, B, C, D, E and F) onto the just-created horizon line. Where lines E and F crossed the picture plane determines the vanishing points for the tile's drawing.

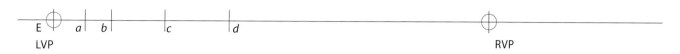

fig. 9.5

Figs. 9.6–9.9: Draw vertical lines through all of the tile's points (A, B, C, D). Whether these verticals extend above or below the horizon line depends on whether the observer's eye level is above or below the tile itself. Points A, B, C, and D will always occur somewhere along these verticals, so choose a position for point B and the rest will happen automatically. Fig. 9.8 shows the tile below eye level; in fig. 9.9 it is above eye level.

fig. 9.6

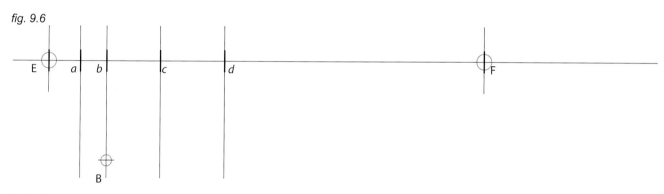

fig. 9.7

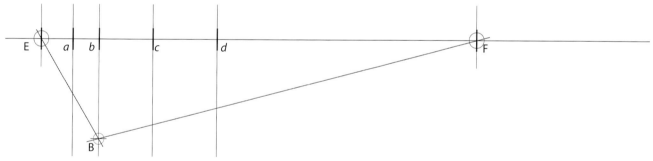

fig. 9.8

fig. 9.9

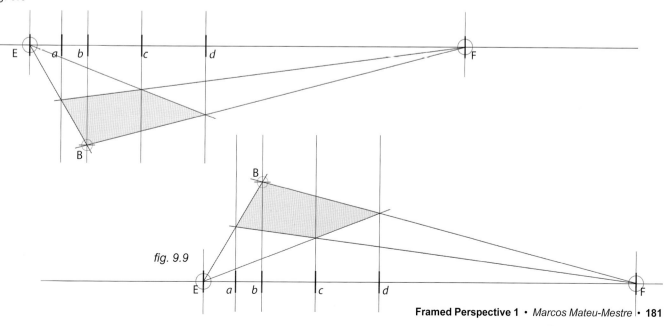

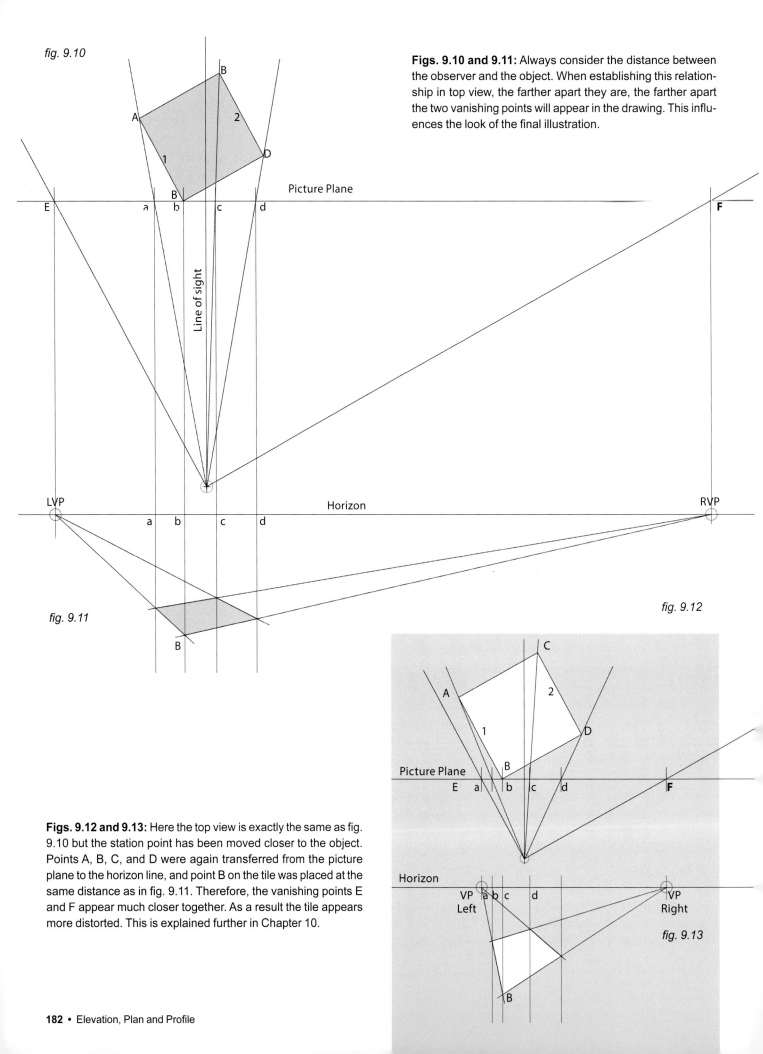

fig. 9.10

Figs. 9.10 and 9.11: Always consider the distance between the observer and the object. When establishing this relationship in top view, the farther apart they are, the farther apart the two vanishing points will appear in the drawing. This influences the look of the final illustration.

Picture Plane

Line of sight

fig. 9.11

LVP

Horizon

RVP

fig. 9.12

Picture Plane

Horizon

VP Left

VP Right

fig. 9.13

Figs. 9.12 and 9.13: Here the top view is exactly the same as fig. 9.10 but the station point has been moved closer to the object. Points A, B, C, and D were again transferred from the picture plane to the horizon line, and point B on the tile was placed at the same distance as in fig. 9.11. Therefore, the vanishing points E and F appear much closer together. As a result the tile appears more distorted. This is explained further in Chapter 10.

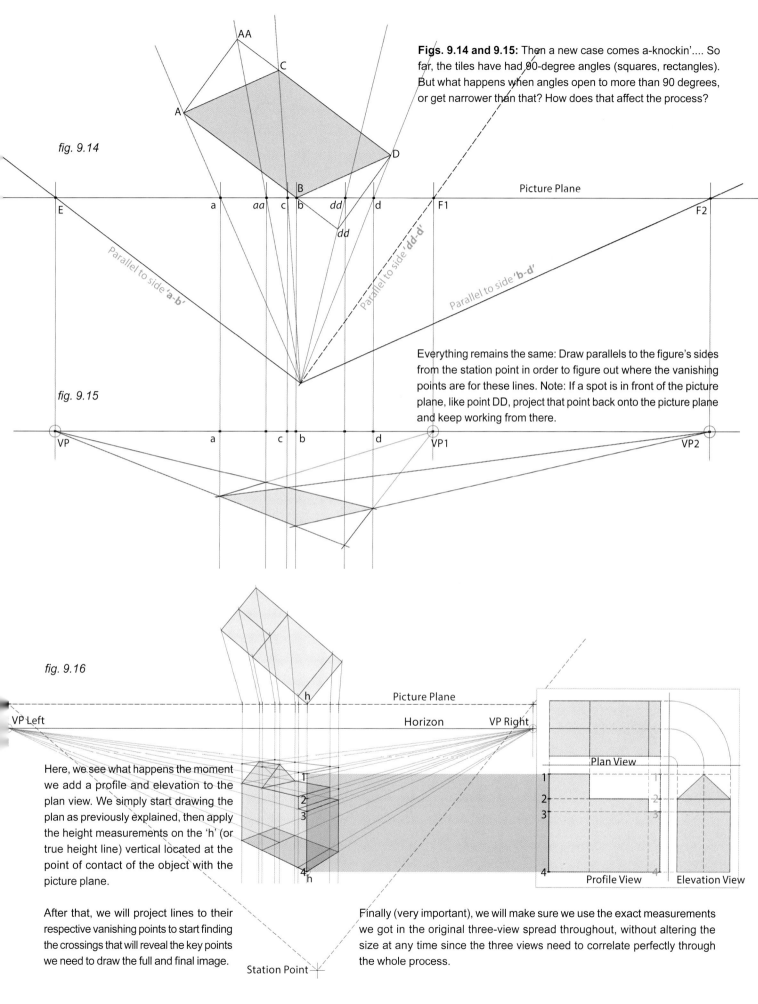

Figs. 9.14 and 9.15: Then a new case comes a-knockin'.... So far, the tiles have had 90-degree angles (squares, rectangles). But what happens when angles open to more than 90 degrees, or get narrower than that? How does that affect the process?

fig. 9.14

Picture Plane

Parallel to side 'a-b'

Parallel to side 'dd-d'

Parallel to side 'b-d'

Everything remains the same: Draw parallels to the figure's sides from the station point in order to figure out where the vanishing points are for these lines. Note: If a spot is in front of the picture plane, like point DD, project that point back onto the picture plane and keep working from there.

fig. 9.15

fig. 9.16

Picture Plane

Horizon

VP Left

VP Right

Plan View

Here, we see what happens the moment we add a profile and elevation to the plan view. We simply start drawing the plan as previously explained, then apply the height measurements on the 'h' (or true height line) vertical located at the point of contact of the object with the picture plane.

Profile View Elevation View

After that, we will project lines to their respective vanishing points to start finding the crossings that will reveal the key points we need to draw the full and final image.

Station Point

Finally (very important), we will make sure we use the exact measurements we got in the original three-view spread throughout, without altering the size at any time since the three views need to correlate perfectly through the whole process.

FOR THOSE OF YOU WHO HAVE READ *FRAMED INK*, YOU WILL RECOGNIZE THAT THE ILLUSTRATIONS ON THIS CHAPTER'S FIRST THREE PAGES ARE TAKEN DIRECTLY FROM THAT BOOK. AFTER THAT, WE WILL EXPAND THE LESSONS ON DIFFERENT TYPES OF LENSES AND HOW THEY AFFECT WHAT WE SEE AND THE PERSPECTIVE STRUCTURES THAT THEY SUPPORT.

10

LENSES

A QUICK WORD ON LENSES

Lenses dramatically influence the way we see things, even when the camera is positioned exactly in the same spot, pointing at the same subject in the same direction.

The two extremes, in broad terms, are the *wide-angle* lens (fig. 10.1) and the *long lens* (fig. 10.3). The 50-millimeter lens (fig. 10.2)—when using 35 mm film—is the approximate equivalent to how a human eye normally sees things, without any sort of distortion.

Both wide and long lenses give distorted views of the objects in front of the camera, compared to what is normally seen with the naked eye, each in a very different and distinctive way that influences the type of visual message imprinted on a particular bit of storytelling.

The wide-angle lens literally includes a wider view, from left-to-right and top-to-bottom, of the subject it points at. The long lens focuses on a much narrower portion of it. Therefore, in order to get the same section of landscape with either lens, the distance between the lens and such landscape will have to vary a lot from one to the other.

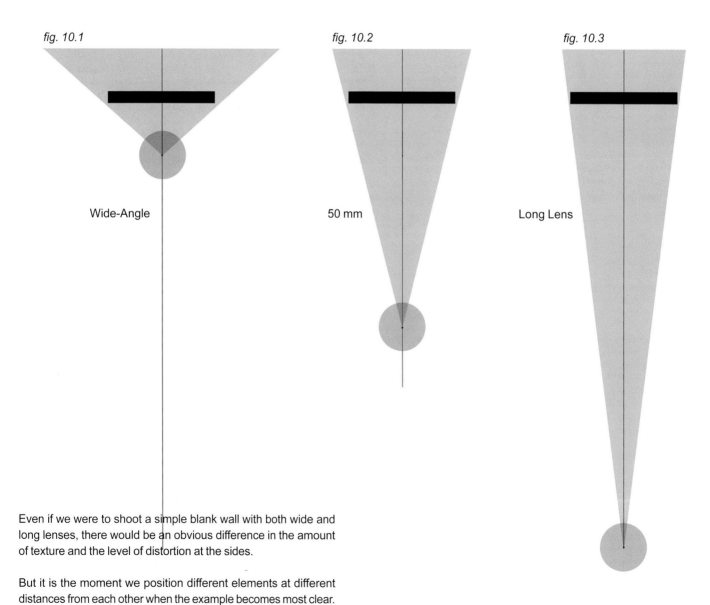

fig. 10.1

Wide-Angle

fig. 10.2

50 mm

fig. 10.3

Long Lens

Even if we were to shoot a simple blank wall with both wide and long lenses, there would be an obvious difference in the amount of texture and the level of distortion at the sides.

But it is the moment we position different elements at different distances from each other when the example becomes most clear.

So let's imagine there is a person in front of a wall or building….

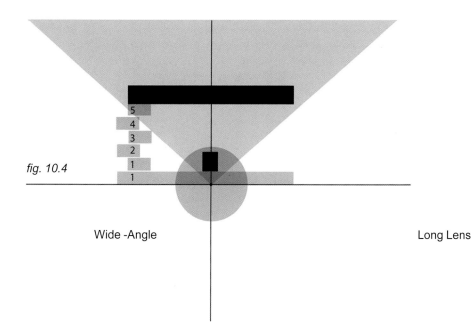

fig. 10.4

Wide -Angle

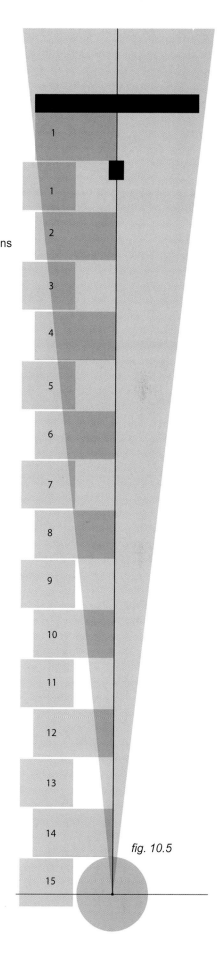

Long Lens

fig. 10.5

To get the entire façade in the shot, the camera needs to be positioned either closer or farther away from the wall, depending on the kind of lens being used.

Fig. 10.4 shows that when using a wide-angle lens the camera would be extremely close to the character, while **fig. 10.5** shows that when using a long lens the camera would be at quite a large distance from the character.

In other words, in fig. 10.4 the distance between the lens and the character is barely *one-fifth of the distance* between the character and the wall behind. In fig. 10.5 the distance between the lens and the character is *15 times the distance* between the character and the wall, resulting in the visual effect that both elements appear to be much closer together…because proportionally to the distance from the lens, they are.

The farther back the camera moves from the subject—while proportionally increasing the length of the lens to still crop the image by the sides of the building—the closer and closer the character and building appear to each other.

So bigger distance and longer focal length mean that any depth clues in the scene tend to get minimized, flattening the image. Using a wide-angle lens enhances all of the depth clues, to the point that (going to the extreme) we might even end up playing with the proportional distances between the tip of the character's nose and his cheek bones, and then focusing on one of his ears, resulting in a distortion of the features of that person's face that would create outrageously dynamic compositions on the screen.

fig. 10.6

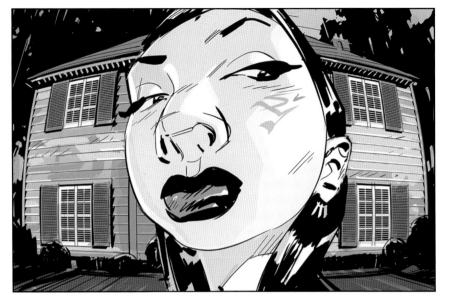

Here is how the same exact shot would look with three different lenses.

Fig. 10.6: Shooting with a **wide-angle lens** makes the face absolutely prominent since the camera is extremely close to it. The distortion of her features and the curved perspective in the background is very obvious since a small distance between the lens and the subject produces an exaggerated optical effect.

fig. 10.7

Fig. 10.7: Next, if we shoot the scene with a **long lens** while trying to include the whole width of the house in the frame, this is the result. The camera is many times further away than in the above example. The character and the house appear to be in a realistic proportion to each other since the distance between them is not relevant at all compared to the distance between the two of them as a unit and the camera.

fig. 10.8

Fig. 10.8: If the intention is to get the face within the frame like in the first shot, but to keep a realistic proportion between the face and the background, therefore barely seeing a small portion of the house's door, then place the camera at a great distance from the subject and use a **long lens.**

Fig. 10.9: Here we can also see the effect of the use of different lenses with three pictures taken from the same spot: the long lens focuses solely on the skylight and its immediate surroundings, cropping out everything else on the façade, while achieving a flattened and compressed look of the subject. This effect can be used to enhance the dramatic, narrative, presence of the window and anything that might be happening behind it, or simply as a visual reminder of something we know happened there before and that, as a visual icon, it will now represent or symbolize that same thing for the rest of the story.

Fig. 10.10: The middle image includes more of the façade and establishes a view that would be closer to what we see with the naked eye as we stand in front of the building and look up. This view puts the different elements in the façade more in context, establishing a dramatic and architectural relationship between all of them.

Fig. 10.11: The widest lens shows the building more as a whole and as one impressive mass that stands solid in front of us, without focusing on any particular or specific detail. This sense of grand depth is also enhanced by the strong perspective and the different diagonals established by the converging lines that only a wide angle lens can provide to this extent.

fig. 10.9

fig. 10.10

fig. 10.11

Fig. 10.12: Here is a wall divided into equal segments between the viewer's position (left) and deep into the distance. As already seen on page 028, notice that the more the lens captures, the more obvious the difference in size is between the sections of the wall. The section closest to the viewer appears to be a lot wider than those which are farther away. This sets up the basis for a wide-angle shot perspective.

fig. 10.12

Horizon

Fig. 10.13: On the other hand, when focusing further in the distance, like on the sections contained within the dotted frame from fig. 10.12, that part of the wall seen through this longer lens is much more compressed, making the width of the wall sections relative to each other a lot more similar, creating the basis for a long lens or telephoto lens shot.

fig. 10.13

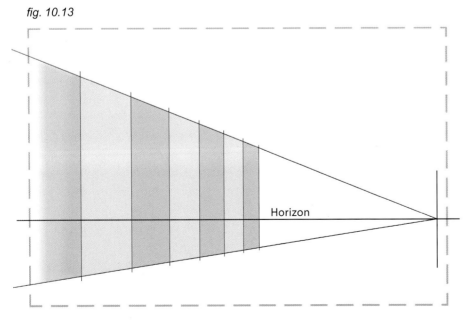

Horizon

fig. 10.14

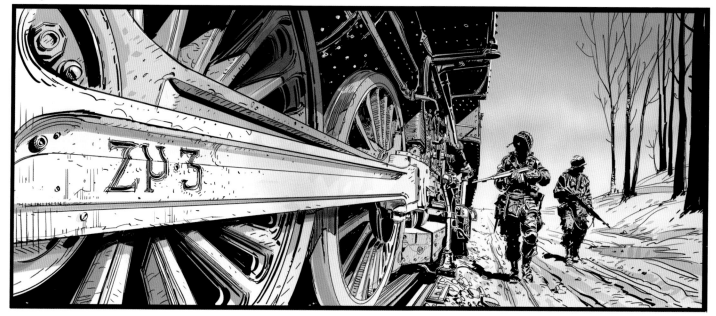

Fig. 10.14: In this shot, a wide-angle lens is used to create a sense of anticipation.

In this story, it was already established that something important would happen by the time these two soldiers reach a train engine marked "zμ.3."

A wide lens allows the mark to be prominently shown in the frame, highlighting the patrol's proximity to it, while the soldiers themselves are not yet aware.

fig. 10.15

Fig. 10.15: In this shot, a long lens is used to compress the image as a whole, making the soldiers and trains "become one." At this point, nothing is clearly more important than the other.

fig. 10.16

Fig. 10.16: Here is a way to create the distorted look of a fisheye lens. In order to get this effect right, think in terms of a sphere instead of just a flat circle and make a proper perspective grid.

STEP 1: Draw a circle, imagining it is a globe seen from above.

STEP 2: Draw a number of "meridians" and "parallels" on it, as if it were a globe such as Earth. Mark the even spacing between the meridians following the procedure explained on page 147, figs. 8.23 and 8.24. In this case, divide it into 24 equal parts (this number was a random choice).

Obviously the spacing between these lines appears wider the closer they get to the center of the globe. Conversely, the closer these lines get to the sides of the circumference, the narrower the spacing appears as they start going around the curve to the point of eventually being on what is the opposite side of the globe from the viewer.

Fig. 10.18 (next page): Transfer the measurements from the vertical (N–S) to the horizontal diameter (E–W). Where these dotted lines cross the diameter represents the intersections of the meridians from the viewer's standpoint.

Fig. 10.19 (next page): To find the center points of the arches representing each meridian:

STEP 1: Go to a spot representing the intersection of a meridian on the diameter (equator), in this case, number 4.

STEP 2: Centered on 4, draw a long arc \ crossing point N (North).

STEP 3: Now do the reverse, centered on N, draw a long arc that crosses 4. Both arcs cross each other at two points.

STEP 4: Draw a line (segmented) through these two points until it crosses the equator (in this case 4"). This will be the center of the meridian's arc.

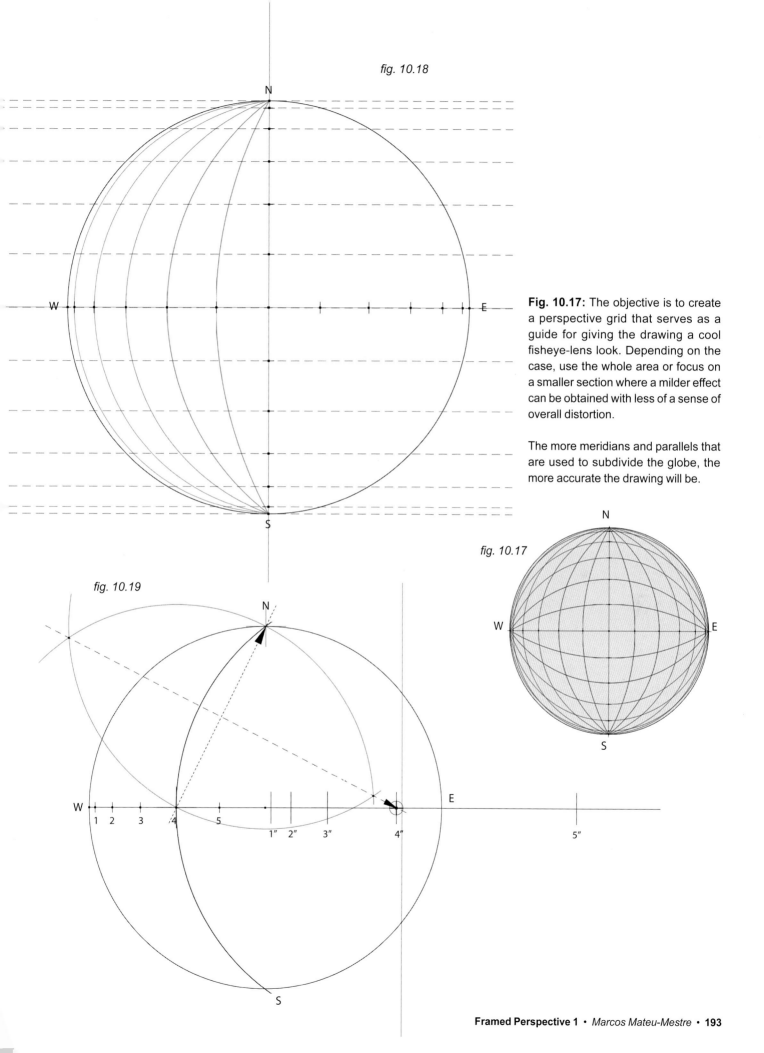

fig. 10.18

Fig. 10.17: The objective is to create a perspective grid that serves as a guide for giving the drawing a cool fisheye-lens look. Depending on the case, use the whole area or focus on a smaller section where a milder effect can be obtained with less of a sense of overall distortion.

The more meridians and parallels that are used to subdivide the globe, the more accurate the drawing will be.

fig. 10.17

fig. 10.19

fig. 10.20

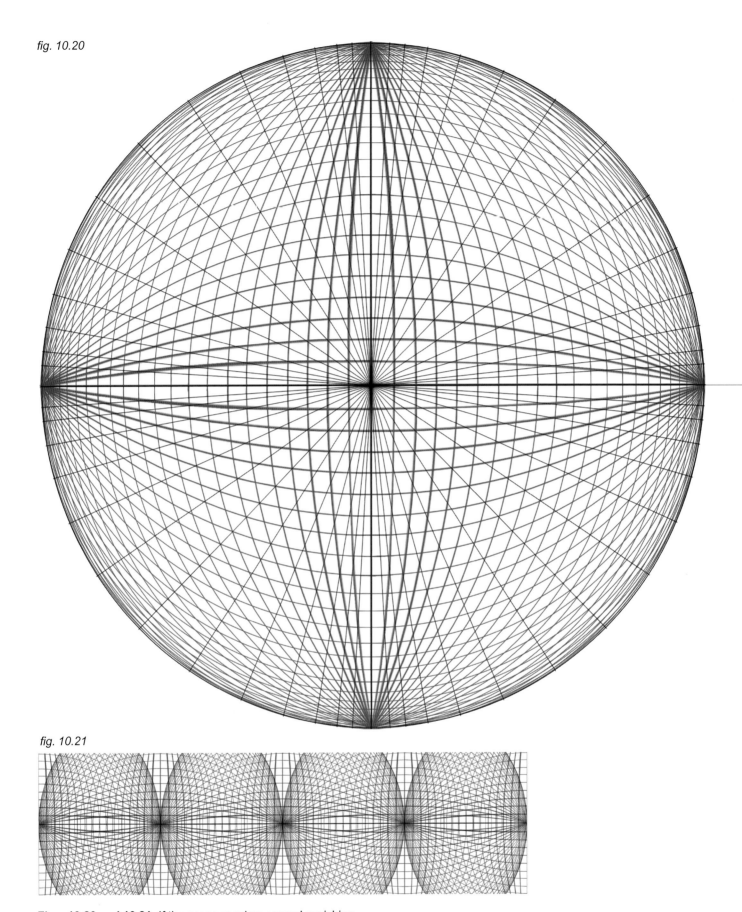

fig. 10.21

Figs. 10.20 and 10.21: If the scene requires several vanishing points on the horizon, combine and arrange these spherical perspective grids in continuity as indicated here (See also Fig 2.88 on page 060 of *Framed Perspective Volume 2*).

NOTES ON FREEHAND DRAWING AND SKETCHING

fig. 11.1

LIFE DRAWING

Basically there are two ways to tackle a drawing, using **lines** and **chiaroscuro,** which is the distribution of light and shadow in an image and was the basis of my book on composition, *Framed Ink*.

The process of drawing from a live model or reference essentially consists of:
STEP 1: Observe the model.
STEP 2: Identify the key points that describe or represent on a flat surface the shape, form and volume of that three-dimensional body in space. As always, if the observer changes position relative to the subject, the visual perception of it changes as well.
STEP 3: Gracefully connect the key points on the drawing surface.

As explained in *Framed Ink* and in Scott Robertson's *How To Draw*, these lines being drawn do not exist in reality; there are no outlines in real life describing the edges of a house or the nose on someone's face. When drawn correctly, these lines are a graceful and artistic means of defining spaces, delineating areas within which the object being represented exists.

So the challenge here, besides achieving a level of artistry and sense of style, is to describe volumes and the space occupied by them precisely and efficiently; to create a visual illusion that, by the means of line (or chiaroscuro), communicates to the audience how the elements are arranged within the space that contains them.

It is necessary to understand the importance of what a line is, means and represents. If too caught up in the line as a goal in itself, it is easy to end up drawing beautiful lines while at the same time messing up all sense of proportion and three-dimensionality, totally misrepresenting the scene on paper.

A line is there to describe the areas where specific volumes exist, whether they be a person, a nose, a window, or a treetop. Once the size and proportion of the volumes being represented is understood, then simply draw a line around it.

These thoughts apply to chiaroscuro too, since masses of light and dark also occupy a certain space within the context of what is being drawn. There is always a need to remain conscious and clear about what goes where on the paper.

EVERYTHING RELATES TO EVERYTHING ELSE

There are a number of reasons to draw from life: as reference for an illustration being worked on, to practice, or simply because of the desire to create a freehand piece. This chapter tackles the process of creating a drawing based on whatever is in front of the artist, and the methods and tricks that can be used for this purpose.

So there is a landscape, a person or some other kind of three-dimensional subject(s) before the artist. Whatever is in front of the artist is called the "model." The drawing surface at this point is blank. While it is blank, the drawing has nothing but potential; place the subject anywhere within the surface, imagine it as big or as small, as realistic or as stylized as you want. Make it line-based or chiaroscuro-based.

However, the moment pencil is put to paper and the first line or stroke is made, then everything must relate to this first mark, everything must be measured from this first mark and must be drawn in accordance with its placement, proportion, and even style.

A window is not going to seem too high within a row of windows unless the others are lower in relation to it; a gap between two columns is not going to seem too big unless the gaps between the other columns are consistently smaller.

Symbolically speaking, they say that when drawing, keep one eye on the line being made and the other eye circling around the rest of the drawing.

ANGLES AND PROPORTIONS:

Angles and proportions give most of the clues needed to place lines where they belong. In order to identify and represent these accurately on paper, the following tools and methods will be used: Grid of Squares, Wind Rose, and Pencil/Thumb.

Fig. 11.2: Observe everything as if there were a **grid of squares**, or evenly spaced verticals and horizontals, in front of the eyes. This is a quick way to figure out what is to the left or the right of what else, and what is higher or lower in reference to everything else.

Another thing that becomes easier to observe when seen through this grid is something that can be a bit deceptive, the inclination of a diagonal when it is close to being horizontal. The grid makes it more noticeable if the right end is higher than the left one or vice versa. This also applies to parallels seen in perspective and therefore perceived as diagonals.

Fig. 11.3: The **wind rose** is another "pretend" contact lens looked through at all times. It consists of four lines at different angles (vertical, horizontal, diagonal-right and diagonal-left) that help identify the angle of inclination for any given line being drawn, although the drawn line usually does not coincide exactly with any of the wind rose's lines.
Fig. 11.4: Sure enough, the good old **pencil/thumb** combination works every time.

This is used to compare the sizes of objects and the gaps (negative spaces) between them.

Simply stretch an arm in the direction of the object being viewed and hold the pencil (usually vertically or horizontally) to measure the distance between two key points. Hold the pencil in such a way that its tip precisely overlaps one of the key points and then slide a thumb along the pencil, stopping right at the position of another key point.

Still holding the pencil just so, move it until it is positioned over the other part of the model that is being compared to the first measurement. It will become obvious which one is relatively longer or shorter and by how much, providing a way to better estimate the proper proportions of the model/scene.

fig. 11.2 fig. 11.3

fig. 11.4

Here are a few exercises that can train the eye, the hand and the thought process when it comes to translating a three-dimensional object into a drawing on a flat surface.

Fig. 11.5: Practice drawing one straight line, freehand (no straightedges!). Grab a big sketchpad and mark an X at each side of the paper, as indicated.

Now draw straight lines from one X to the one across from it. Do that several times and see how it goes.

Whatever the result, try the following: Place the tip of the pencil on an X. Without moving the tip of the pencil, look at another X

fig. 11.5

to aim for. As they say in the movies, "Never look back." Just draw a line—fast and confident—keeping your eyes only on the destination X.

Repeat this exercise over and over until you feel very comfortable with it. I'll wait. You will see, like everything else in life, focusing on the goal makes us better achievers.

After completing two hundred or so of these, go ahead and do the same with verticals and diagonals. But here is another trick: it is only necessary to learn how to draw *one straight line*. If need be, go ahead and *rotate the paper*. Make your life a little easier, why not?

HIDE THE MODEL AWAY

Increasing your powers of observation is key to being able to draw from life. To make a successful freehand sketch, one must identify the important elements and key points on the model in order to get a solid representation of its structure on paper.

To train the eye for this, get an object like a vase, a jar, a fork, or a chair—something simple to start with.

Do not draw anything yet. Put the pen and paper away and just observe the model: Make sure to identify and memorize the main features and the shape of the overall structure. Is the object wider than its height, or taller than its width? What is higher or lower than what else? What is bigger, smaller, more to the right, or more to the left? What is the angle of inclination of a main structural line?

After gathering all of this necessary information *put the model away* where it cannot be seen, and start drawing. Chances are at this point you will realize that information is missing; that either you did not notice certain things or have forgotten details.

Repeat the exercise a hundred times (a thousand is even better). Eventually it will become second nature what to notice before attempting to draw an object.

Memory is always being used while drawing, even when there is a model present. You can either look at the model or look at the paper, not both at once, so it is important to learn how to memorize details, look away, and draw.

Fig. 11.6: This is a very simple rectangular chart. I suggest that you draw it on a separate piece of paper so that it can be used for a few exercises.

This chart consists of a rectangle with its four corners named A, B, C and D. Its top line A–B has been divided into thirds.

Additionally, draw a number of lines (perpendicular to each other) that cross all four corners, describing other additional rectangles (shown as dotted lines).

Here are some exercises that can be done based on the rectangle:

STEP 1: After drawing this rectangular chart on paper, lay it down in front of you on a flat table.

STEP 2: Grab a pencil and a sketchpad. Observe the chart on the table and draw the rectangle A–B–C-D (forgetting about the dotted lines for now) as seen from your point of view.

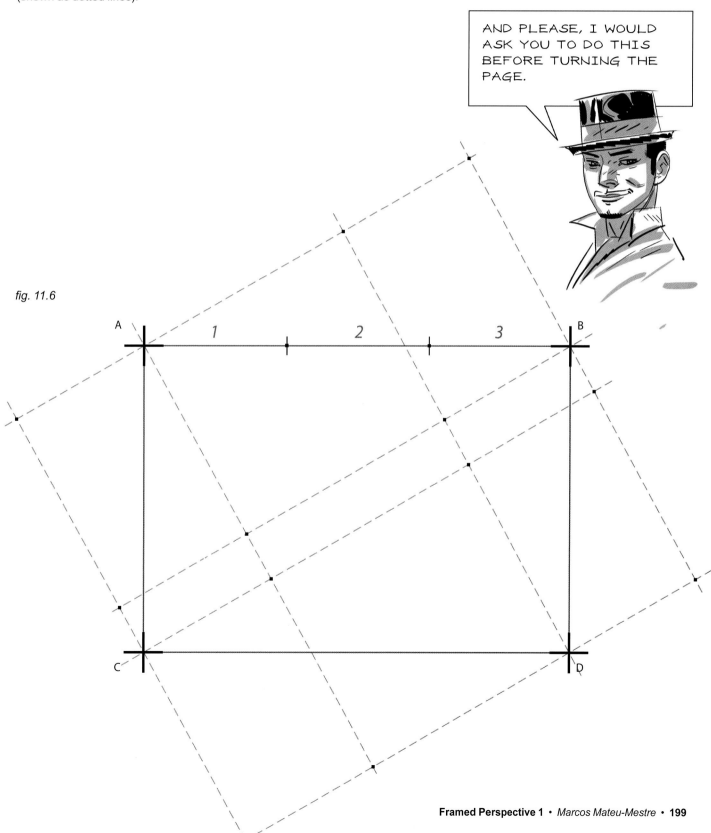

fig. 11.6

Fig. 11.7: As you sit at the table, the sketch will look something like this. (Obviously your unique point of view depends on your exact position relative to the drawing, but the image below should be a close approximation.)

To double-check the results of the rectangle you just drew in the sketchpad, use the sliding-thumb-on-pencil technique to compare the width of one of the three segments of line A–B with the foreshortened distance of lines A–B and C–D. Both measurements will be very similar (see striped area).

Because of the perspective effect, lines A–C and B–D converge toward a common vanishing point. The angle of inclination for both of these lines is obtained by accurately defining the negative spaces (in gray) at both sides of the rectangle.

Anyhow, the main purpose of this exercise is to become aware of the powers of observation and how this can affect the sense of proportion and depth in life drawings.

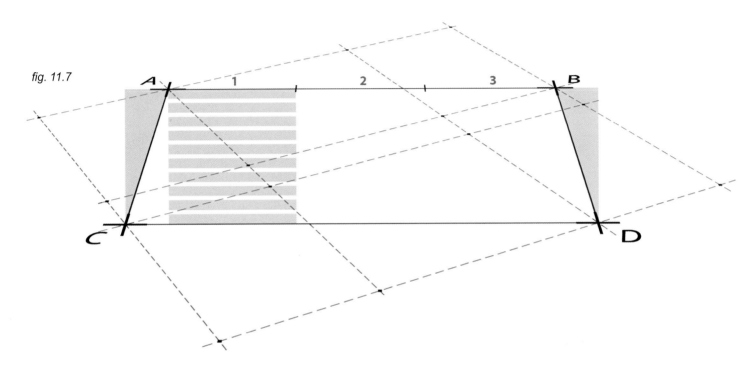

fig. 11.7

Fig. 11.8: Now, please rotate the chart to the right until the dotted lines are parallel and perpendicular to the plane of your eyes, as in this drawing.

Go ahead and draw the main rectangle again (once more the dotted lines are mere reference so they do not need to be drawn).

Also, please try to avoid the temptation of reading on before finishing the drawing. Thank you!

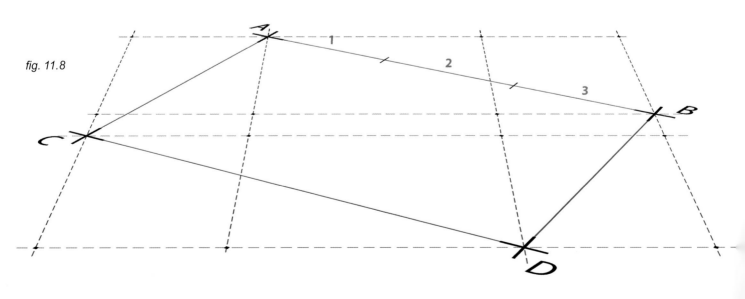

fig. 11.8

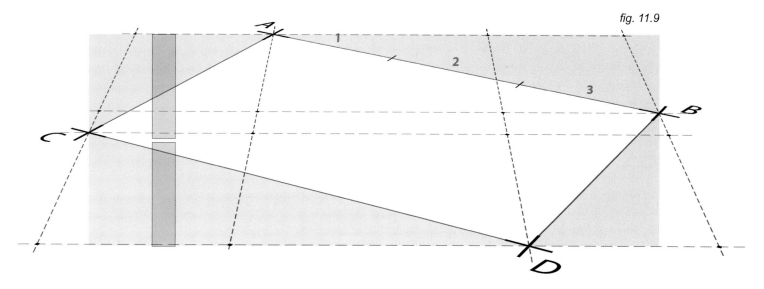

fig. 11.9

Fig. 11.9: There are many clues here regarding angles and proportions that can be taken into account in order to draw an accurate view of the chart from this point of view. Observe the four triangles, or negative spaces, (shaded light gray) outside the rectangle. And notice that the horizontal dotted line through point C is right above the halfway mark of the full drawing (as indicated by the two vertical bands on the left).

Fig. 11.10: Observe how the whole figure is almost three times wider than it is high, and the length between corner D of the main rectangle and the bottom-right corner where the two dotted lines cross (circled) has its midpoint exactly on the vertical where the top-right corner of the dotted lines is (in the double circle), and so on.

Another point of this exercise is to double-check that corner B has been drawn on a horizontal higher than corner C.
This chart can be really useful when it comes to practicing the spatial relationship of specific points on a drawing of a model.

If it was perfect on the first attempt, great! Otherwise, it still helped you take several steps forward in the way you perceive the things around you.

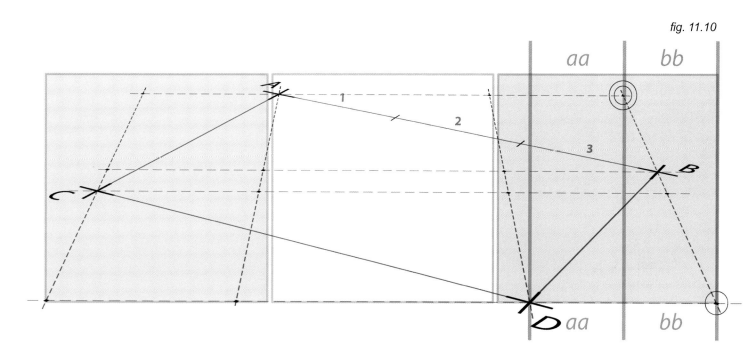

fig. 11.10

Fig. 11.11: Let's put all these methods into practice. Say you are observing this street scene with a building's façade and a car parked in front of it. To simplify for now, it is all viewed from the front so that it does not appear to have any perspective distortion.

The first step is to choose what part of the drawing offers the best basis to build upon. What should be the *first line,* from which all else is measured?

I would suggest the top line of the building, the one that represents the rooftop.

This line, however long or short it is drawn, obviously has a specific length. If the façade of the building is to be square (its height and width measure the same) then each vertical side of the building must be drawn to the same length as the rooftop.

Also, the windows need specific height and width measurements so that they fit properly within the façade. There need to be the correct number and proportion that suits the area, space or surface created for it, as per the actual model being referenced.

The first window must be drawn correctly because the rest are then drawn proportionally to it. If the first window is too big or too small, there will be trouble. If the windows are too big, they will go beyond the limits of the façade; if the windows are too small there will be a big blank space between the last window and the side of the building.

All elements of the architecture (and the car) must be measured correctly, *relative to each other.*

Figure out the proportion of each element in relationship to the others. If there are five windows across the façade, and say the space between two windows measures the same as the width of a window itself, then divide the width of the façade into 11 equal parts: 5 actual windows, 4 spaces in between them and another 2 spaces on either end of the row of windows and the sides of the building.

Then there is the vertical space to consider above and below each row of windows. If, for example, this space is half of a window's height, this will need to be reflected properly on the drawing too.

The same goes for the car. If the car is twice as long as the width of one of the windows, this proportion must be drawn correctly. If it is not, the car will appear either too big or too small depending on the mistake and the whole effect of the drawing's credibility will go to waste.

Always stay within the proportion established by the very first line drawn. Everything else evolves around it. If the general drawing needs to be bigger or smaller, higher or lower, more to the right or more to the left within the drawing surface, tackle this at the very beginning and correct this first line or lines as soon as possible. Otherwise the final result will be different than what was desired.

fig. 11.11

To sharpen this sense of predicting how a final drawing will appear on paper after drawing just a few simple, preliminary lines, *practice.* Then practice some more and then continue practicing. Do not get frustrated after a hundred (or a thousand) disappointments. Be assured that with each drawing you are a little (or a lot) wiser than before. Sometimes learning what not to do is even more important than getting it right. Do not doubt yourself on this one.

Let's look at everything through the **grid of squares** previously referenced on page 197 (fig. 11.2). As an example of something to draw, how about this nightstand with a telephone, a remote, and a bottle of water?

Fig. 11.12: The telephone is a good starting point, specifically its top-left corner. From there, figure out how the other corners are positioned in relationship to it (higher, lower, left, or right). The inclination of these lines can be double-checked with the help of the **wind rose** (page 197, fig. 11.3).

Fig. 11.13: Calculate the thickness of the telephone's base in relationship to the top half of the phone that has been drawn already.

Fig. 11.14: Add the remote control and the tabletop where everything is located.

Notice the negative space between the phone and the remote that, in this case, has the shape of a triangle (shaded gray). The topside of this negative-space triangle has a steeper angle of inclination (closer to a diagonal), than its lower side.

Fig. 11.15: Calculate the distance between the bottle and the telephone in relationship to the width of the telephone itself; then calculate the height of the bottle. From there, draw the rest.

To draw a bottle like this, it is extremely helpful to *draw through*, so that all ellipses are seen through the bottle's transparency. The hidden part can always be erased later, once it is known that the visible part makes perfect sense.

This applies to other examples of ellipses, such as a watch-band around someone's wrist, some painted rings around a telephone post, etc.

fig. 11.12

fig. 11.13

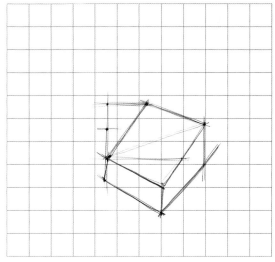

fig. 11.14

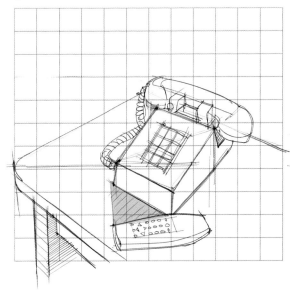

fig. 11.15

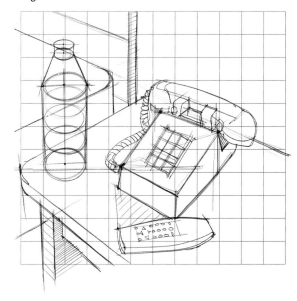

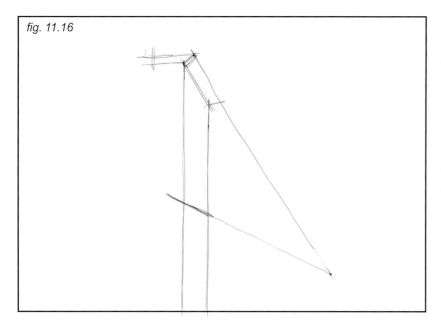

fig. 11.16

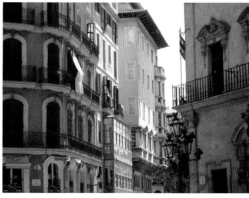

Fig. 11.16: To draw a cityscape, as usual first identify a line that is key to the whole composition, a line that gives something to build around, a sense of inclination and therefore perspective. Here, the top of the central building fulfills all these requirements.

Next, draw a lower line within the same façade, a parallel line that converges to the same vanishing point as the first one.

Make sure that the horizon line is exactly where it should be; it is a crucial element.

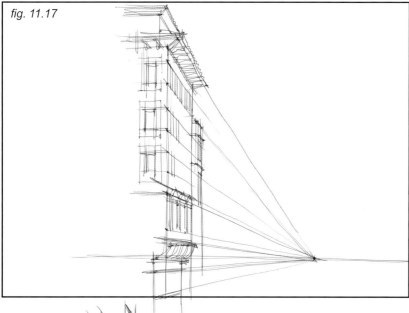

fig. 11.17

Fig. 11.17: This is the basis for the whole façade. From this point of view the side of the building toward the viewer is almost flat; it angles just enough to give a sense of perspective vanishing toward the left.

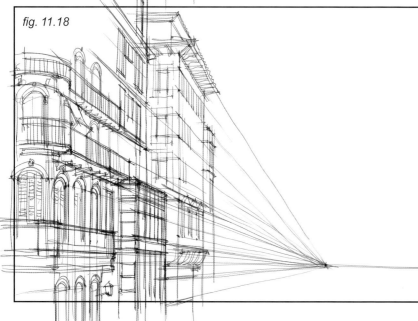

fig. 11.18

Fig. 11.18: Now add the building to the left using the original vanishing point.

Make sure that the architectural elements are properly ordered, as in vertically aligning the windows on the different floors.

Fig. 11.19: Finally, add the building to the right. This building is sitting at a different angle than the previous two. Although its vanishing points are obviously on the same horizon, they converge to different points.

fig. 11.19

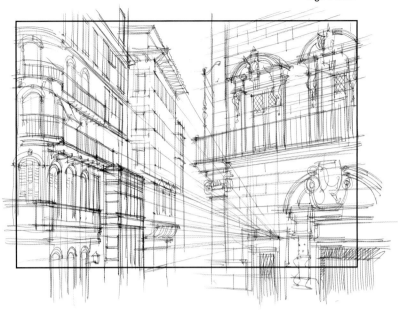

Fig. 11.20: Adding value helps to further define the shapes and the volumes.

fig. 11.20

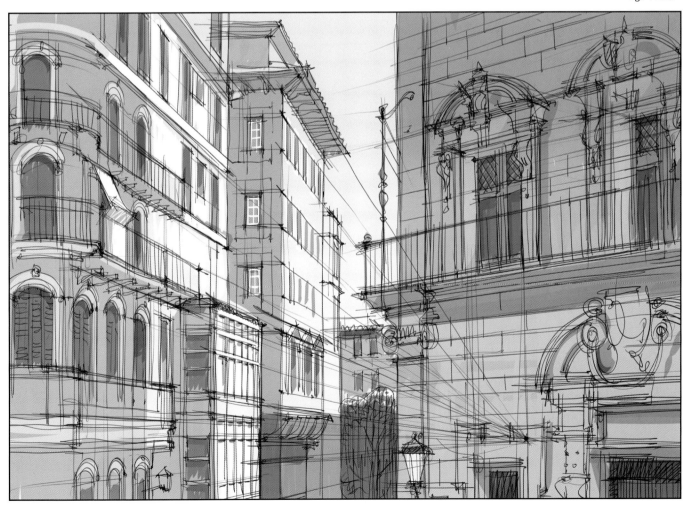

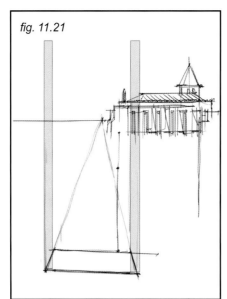

fig. 11.21

Fig. 11.21: Start by placing the church where it needs to be within the composition, and place the horizon line. Because the rest of the buildings will evolve from this position down, *identify key elements* of the city that frame specific spaces in the composition within which the rest of the buildings will be placed. A key element is the rectangular rooftop at the center of the drawing. Make sure it is properly positioned and that its size is correct by referencing verticals drawn from the church down (see areas in gray). Refer to the size of the temple to measure the distance between it and this rooftop. Also draw the sides of the roof as converging lines to a vanishing point on the horizon.

Here is the development of a cityscape from an elevated point of view. The only structure above the horizon line is the medieval church; so pretty much everything else will evolve from that level down. The outlined frames represent the drawing surface. It is always better to leave a little extra room at the edges in case the drawing needs to be extended a bit.

When drawing from life, try to stay as true as possible to what is actually in front of you. It is easy to think, "There are so many houses and so many shapes. Who will even notice if there are ten more or ten less and whether they are drawn larger or smaller?" This is true up to a point, but beware because it is easy to fall into the trap of drawing things for convenience and making shapes larger or smaller than they should be. Once this starts happening, it is all too easy to lose control of the whole thing. And while nobody will be able to account whether the exact number of houses is right or not, they will notice whether the general sense of proportion of the buildings within the general context feels credible or not. If not, that is a big problem.

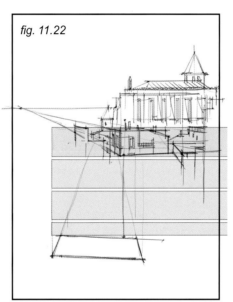

fig. 11.22

Fig. 11.22: Let's keep dividing our working area into sub-areas, this will help us keep the proportions right. For this, the yellow building is a great point of reference. Let's divide the vertical space between the church and the square roof in spaces equal to the height of the yellow building (it is roughly three parts and change). These divisions, indicated by the bands in gray, will help us to place all buildings properly in the area.

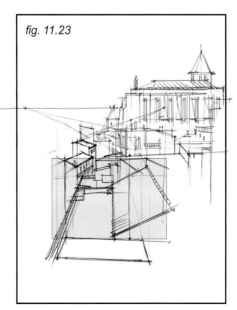

fig. 11.23

Fig. 11.23: The space between the yellow house and the square rooftop will be occupied by the shapes of a large, flat rooftop and a couple of big, Mediterranean-style tile roofs. Again, create vanishing points as needed.

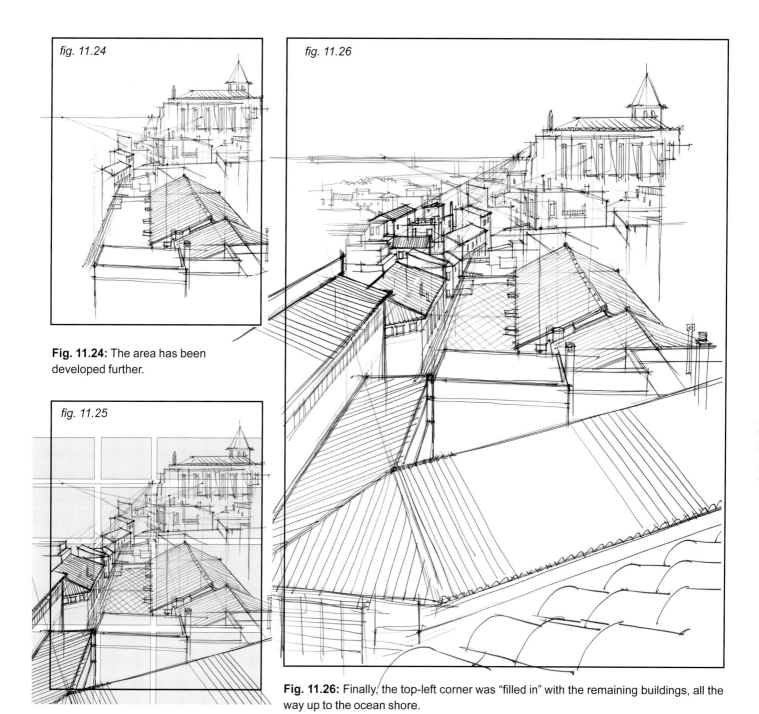

Fig. 11.24: The area has been developed further.

Fig. 11.25: Measuring off the church, the central square rooftop and everything else already drawn, the remaining big, key shapes were placed, including the prominent rooftop at the bottom (sections in gray indicate verticals and horizontals used for spatial reference).

Fig. 11.26: Finally, the top-left corner was "filled in" with the remaining buildings, all the way up to the ocean shore.

Fig. 11.27 (next page): Once the proper structure for the scene was established, some final details were cleaned up to obtain a final image.

fig. 11.27

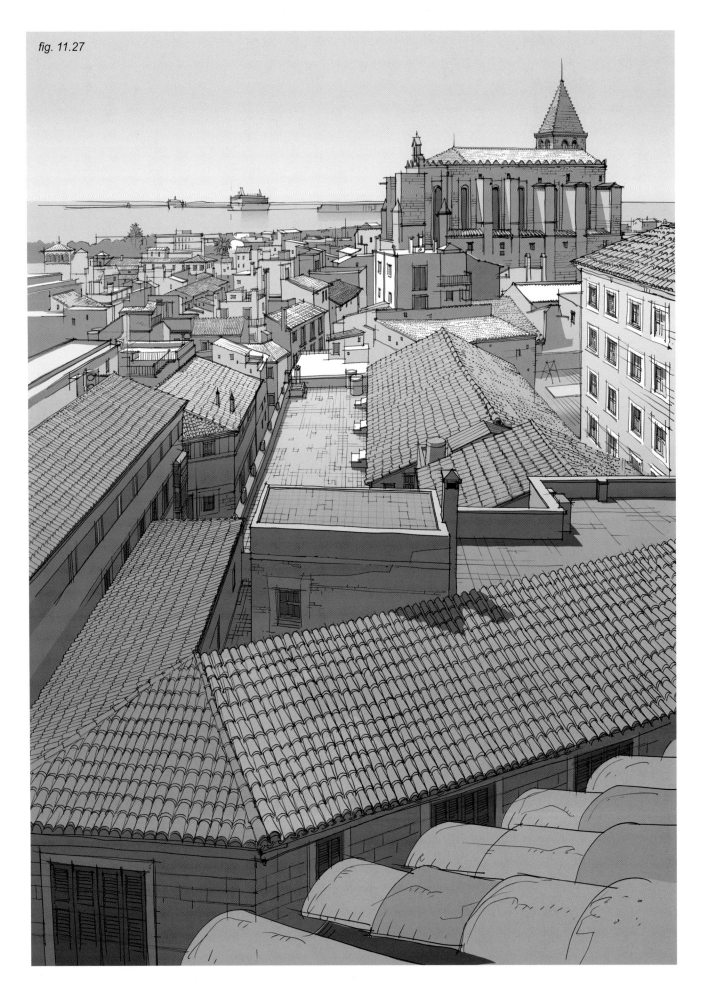

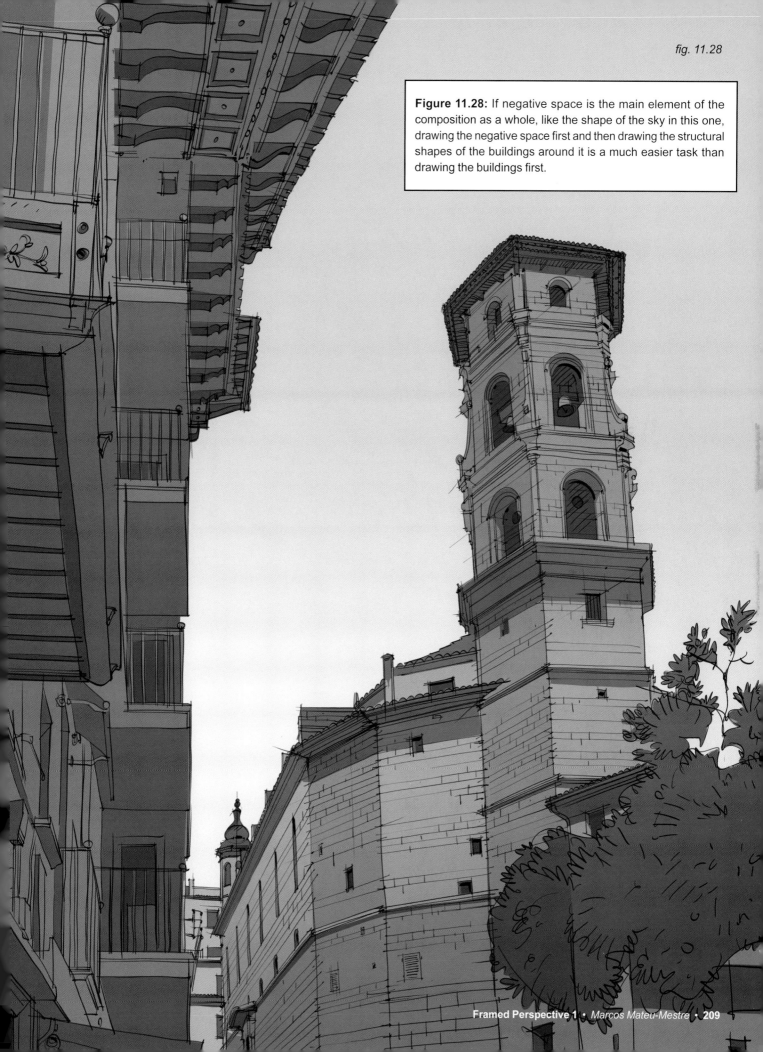

fig. 11.28

Figure 11.28: If negative space is the main element of the composition as a whole, like the shape of the sky in this one, drawing the negative space first and then drawing the structural shapes of the buildings around it is a much easier task than drawing the buildings first.

Fig. 11.29: The next drawing requires drawing circles and ellipses, so here is a good exercise to warm up the wrist: Draw groups of concentric, freehand circles, from biggest to smallest.

This is really handy. The secret is to go for it, get loose, it does not matter if they look bad at first...have fun. It is all about practice, repetition and improving hand-eye coordination as you progress.

Fig. 11.30: Practice drawing freehand ellipses within the confines of a rectangle.

By the way, again, it is better to repeat these exercises a thousand times than just a hundred!

fig. 11.29

fig. 11.30

fig. 11.31

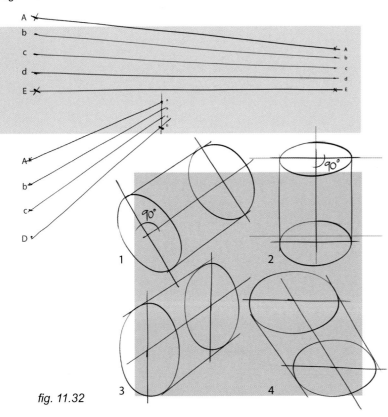

Fig. 11.31: Another thing to practice is drawing parallels converging toward a common vanishing point.

Once there is the top and bottom line of say, a wall, or the strings of a violin, divide the space between such lines (at both the start and the finish) into equal parts. It can be two parts, six, nineteen...whatever the number is make marks where the converging lines start and end, then draw lines through these points.

Fig. 11.32: This exercise helps when it comes time to draw the wheels of a vehicle. Take a look at these four poses of a cylinder.

As a general rule, draw cylinders with the three axes (representing the two ellipses and the main body) crossing at 90-degree angles (like cylinders 1 and 2) because otherwise they look skewed (like cylinders 3 and 4).

fig. 11.32

Fig. 11.33: Drawing subjects like this cycle, with so many different straight lines, curved lines, diagonals, and ellipses provides an opportunity to practice a good number of things.
Notice the 90-degree angle created by the tires axis (C) and the imaginary axis that links tire to tire (D).

Also, there are parallels converging toward the same vanishing point.

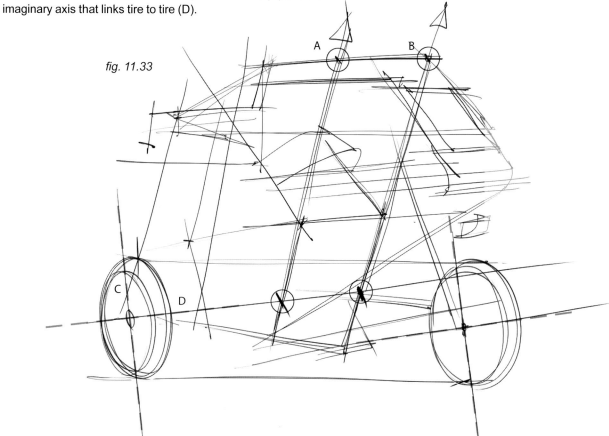

fig. 11.33

Another important thing is observed in the two diagonals that define the sides of the sidecar's front. In order to get their inclination right, elongate them upward until they cross the canvas top of the bike at points A and B. These two intersections, together with the precise origin of these two lines, give the correct inclination.

Fig. 11.34: When it finally comes time to draw the ellipses (tires) be practical and rotate the drawing surface around as much as necessary to get a comfortable angle from which to draw them.

fig. 11.34

These methods apply not only to perspective drawing but also to any sort of freehand work. Here is an example of a rider on horseback from an actual model. This displays the thought process as we work through angles and proportions.

Fig. 11.35: The first thing to set up is the head, its height measuring roughly three times its width.

Fig. 11. 36: Establish the negative space between its jaw, neck and shoulder, which gives the line of the neck.

Fig. 11.37: Draw the shoulder block, which is a bit larger than twice the size of its head.

Fig. 11.38: Measure the distance between the front of its muzzle (A) and the end of its shoulder block (B), which is basically the same as from the shoulder block to the flank (C).

Fig. 11.39: Starting from the muzzle, draw a continuous dynamic curve that becomes the abdomen. The top of its back is horizontally aligned with a point just below its eye (D). Now draw the hindquarters (E).

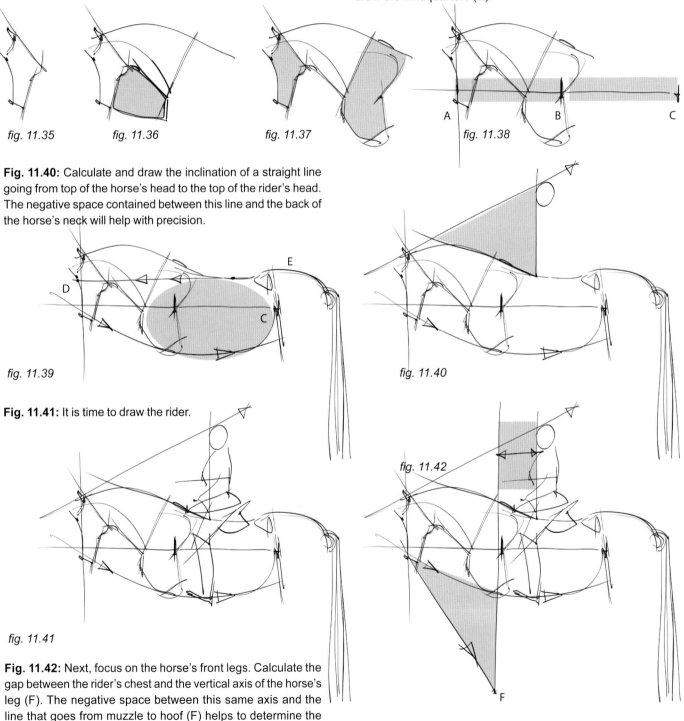

fig. 11.35 fig. 11.36 fig. 11.37 fig. 11.38

Fig. 11.40: Calculate and draw the inclination of a straight line going from top of the horse's head to the top of the rider's head. The negative space contained between this line and the back of the horse's neck will help with precision.

fig. 11.39 fig. 11.40

Fig. 11.41: It is time to draw the rider.

fig. 11.41 fig. 11.42

Fig. 11.42: Next, focus on the horse's front legs. Calculate the gap between the rider's chest and the vertical axis of the horse's leg (F). The negative space between this same axis and the line that goes from muzzle to hoof (F) helps to determine the length of the leg.

Fig. 11.43: Draw the horse's front legs.

Fig. 11.44: Determine the negative space between the front legs, abdomen line and ground plane, and make it a bit wider than high. This helps to position the rear legs.

Fig. 11.45: Almost finished. Draw a line that gives the angle of inclination between the top-front of the hindquarters (G) and the hock (H). Drawing an extended horizontal at the height of the front knee (J) is also a perfect reference to help find the height of the hock (H).

Fig. 11.46: Draw the back legs and the horse and rider are done.

As you have seen, everything relates to the first line. The moment you draw a line on the paper—at a certain place and of a certain size—it influences the position and proportion of everything that follows.

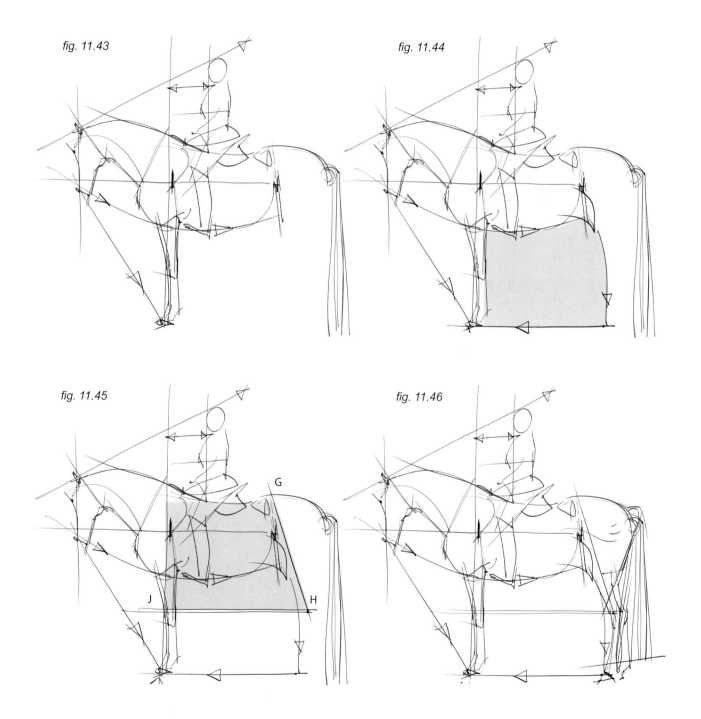

fig. 11.43

fig. 11.44

fig. 11.45

fig. 11.46

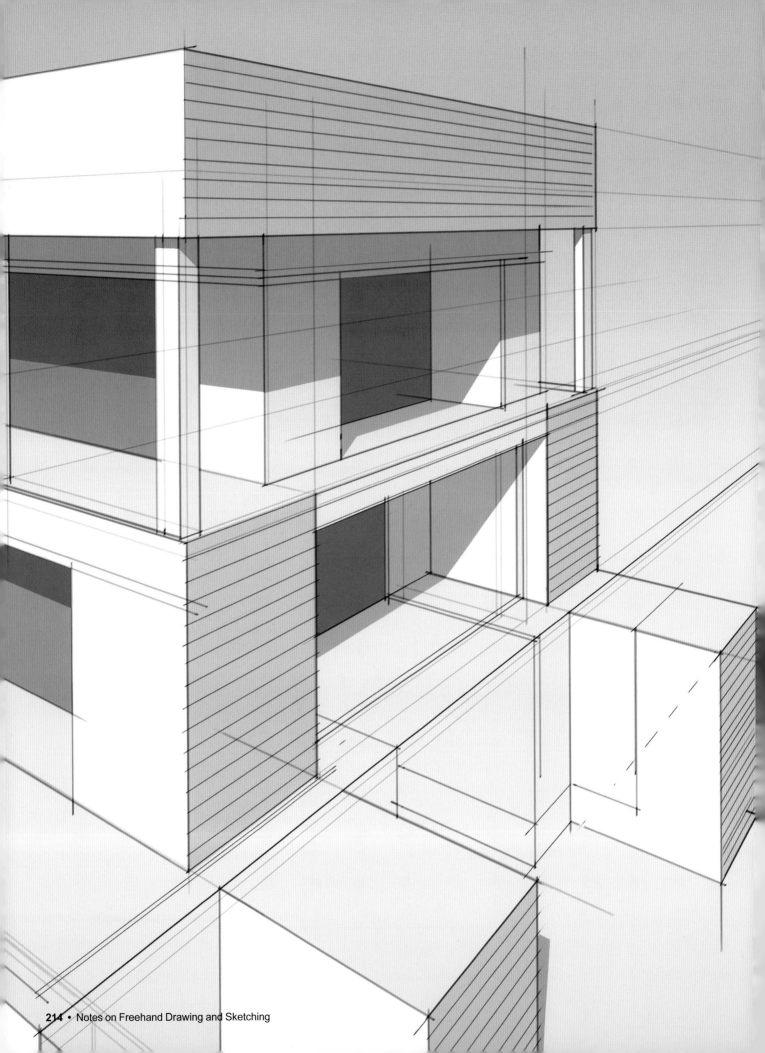

NOTES ON COMPOSITION

—This chapter briefly analyzes the illustrations in this book based on the compositional, chiaroscuro and inking techniques explained in depth in the previous book "Framed Ink"—

ILLUSTRATION	DARK / LIGHT	DYNAMICS	PAGE NUMBER / COMMENTS

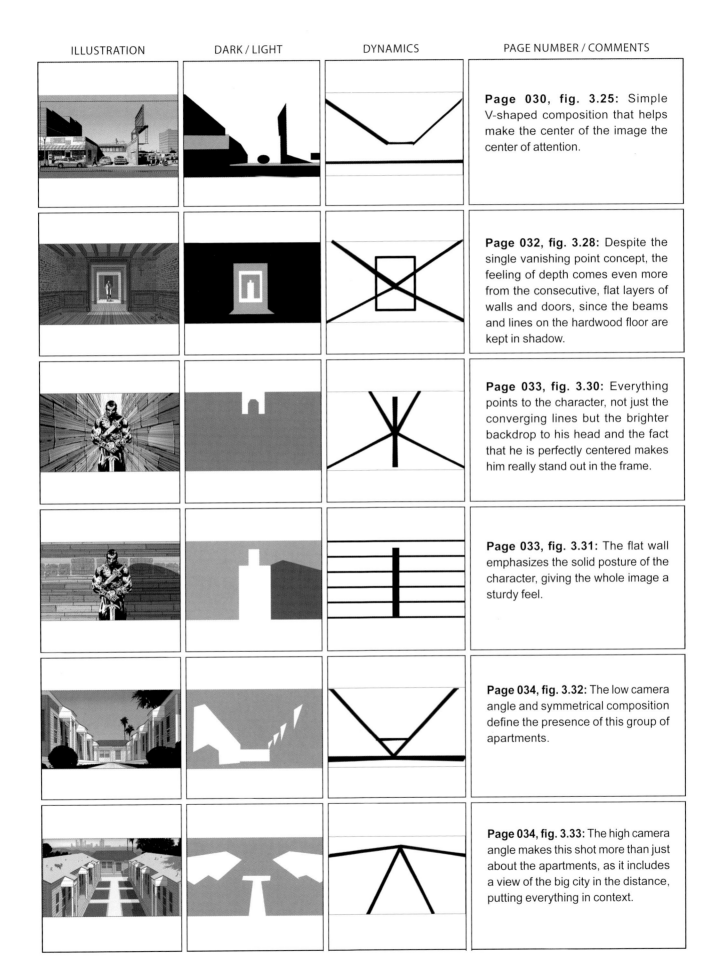

Page 030, fig. 3.25: Simple V-shaped composition that helps make the center of the image the center of attention.

Page 032, fig. 3.28: Despite the single vanishing point concept, the feeling of depth comes even more from the consecutive, flat layers of walls and doors, since the beams and lines on the hardwood floor are kept in shadow.

Page 033, fig. 3.30: Everything points to the character, not just the converging lines but the brighter backdrop to his head and the fact that he is perfectly centered makes him really stand out in the frame.

Page 033, fig. 3.31: The flat wall emphasizes the solid posture of the character, giving the whole image a sturdy feel.

Page 034, fig. 3.32: The low camera angle and symmetrical composition define the presence of this group of apartments.

Page 034, fig. 3.33: The high camera angle makes this shot more than just about the apartments, as it includes a view of the big city in the distance, putting everything in context.

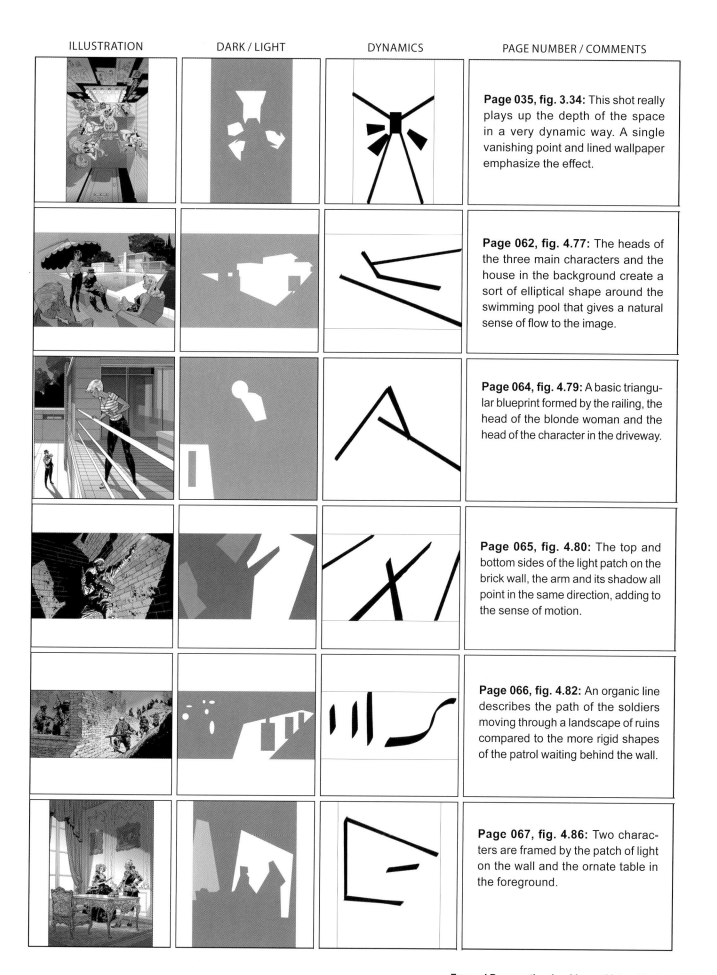

ILLUSTRATION | DARK / LIGHT | DYNAMICS | PAGE NUMBER / COMMENTS

Page 035, fig. 3.34: This shot really plays up the depth of the space in a very dynamic way. A single vanishing point and lined wallpaper emphasize the effect.

Page 062, fig. 4.77: The heads of the three main characters and the house in the background create a sort of elliptical shape around the swimming pool that gives a natural sense of flow to the image.

Page 064, fig. 4.79: A basic triangular blueprint formed by the railing, the head of the blonde woman and the head of the character in the driveway.

Page 065, fig. 4.80: The top and bottom sides of the light patch on the brick wall, the arm and its shadow all point in the same direction, adding to the sense of motion.

Page 066, fig. 4.82: An organic line describes the path of the soldiers moving through a landscape of ruins compared to the more rigid shapes of the patrol waiting behind the wall.

Page 067, fig. 4.86: Two characters are framed by the patch of light on the wall and the ornate table in the foreground.

ILLUSTRATION	DARK / LIGHT	DYNAMICS	PAGE NUMBER / COMMENTS

Page 071, fig. 4.91: H-shaped composition in which the horizontal connects the two main subjects in the action and the two verticals on either side frame the field where the action takes place.

Page 081, fig. 5.21: Z-shaped composition where the descending diagonals create a flow only interrupted at the end by the two verticals of the characters.

Page 085, fig. 5.34: One big, centered diagonal with dark masses at both ends to frame and contain the image.

Page 088, fig. 5.41: A highly dynamic composition that plays with perspective and vanishing points creates all of these diagonals that basically emanate from one spot.

Page 089, fig. 5.42: Star-shaped composition where the head of the snake clearly stands out because it was rendered light on dark, close to the center of the composition.

Page 090, fig. 5.43: Composition is divided into two clear blocks, the airplane and the suitcases, with a breathing gap in between. The suitcases pointing in different diagonals create an interesting rhythm.

ILLUSTRATION	DARK / LIGHT	DYNAMICS	PAGE NUMBER / COMMENTS
			Page 109, fig. 6.24: U-shaped composition at a slight Dutch angle, with the characters in dark over a bright backdrop.
			Page 110, fig. 6.25: H-shaped composition based purely on diagonals (Dutch angle, 3 vanishing points) to emphasize the tension of the moment.
			Page 114, fig. 6.30: Upshot to a third vanishing point at the zenith. All background elements are there to offer information about the environment and frame the character.
			Page 133, fig. 7.25: Spiral composition with the lower half in shadow in order to drive the eye to the upper part where the main action takes place.
			Page 135, fig. 7.28: A centered composition where the masses of light and dark are placed in big blocks to facilitate the reading of the image.
			Page 136, fig. 7.29: The houses and uphill road create a fairly uniform, non-dramatic frame to the upper part of the image where a dark silhouette gets all the attention while walking against a bright backdrop.

ILLUSTRATION	DARK / LIGHT	DYNAMICS	PAGE NUMBER / COMMENTS

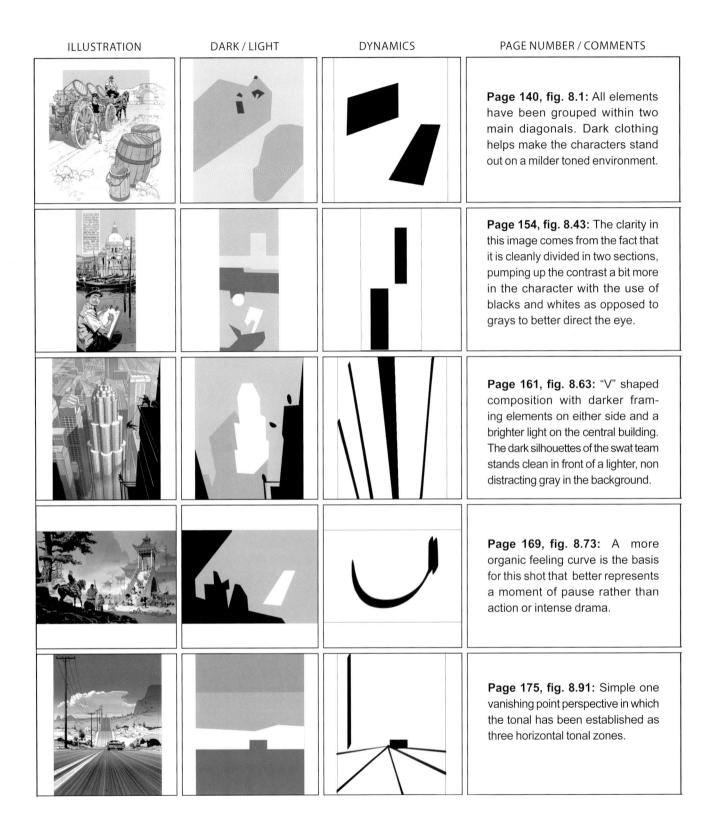

Page 140, fig. 8.1: All elements have been grouped within two main diagonals. Dark clothing helps make the characters stand out on a milder toned environment.

Page 154, fig. 8.43: The clarity in this image comes from the fact that it is cleanly divided in two sections, pumping up the contrast a bit more in the character with the use of blacks and whites as opposed to grays to better direct the eye.

Page 161, fig. 8.63: "V" shaped composition with darker framing elements on either side and a brighter light on the central building. The dark silhouettes of the swat team stands clean in front of a lighter, non distracting gray in the background.

Page 169, fig. 8.73: A more organic feeling curve is the basis for this shot that better represents a moment of pause rather than action or intense drama.

Page 175, fig. 8.91: Simple one vanishing point perspective in which the tonal has been established as three horizontal tonal zones.

ILLUSTRATION	DARK / LIGHT	DYNAMICS	PAGE NUMBER / COMMENTS
			Page 191, fig. 10.14: The train's perspective lines are all leading back to the characters. Heavy use of wide angle lens that exaggerates the sense of depth and distance.
			Page 191, fig. 10.15: Three vertical blocks, with the main action taking place in the central one. The blocks on either side are there to create a clean frame.
			Page 205, fig. 11.20: Straight forward vertical blocking of these three buildings.
			Page 208, fig. 11.27: Old city view where the church in the upper part establishes an architectural period and an overall flavor for this environment while breaking the general block's silhouette creating an interesting focal point.
			Page 209, fig. 11.28: "G" shaped composition where the different buildings don't interfere with each other. Also, the bigger shape on the left versus the smaller shapes on the church on the right create depth by contrast in size.

GLOSSARY

A

angle of inclination - The angle between a line and the x-axis. This angle is always been 0 and 180 degrees and is measured counterclockwise from the part of the x-axis to the right of the line.

auxiliary vanishing point - That point toward which receding parallel lines appear to converge for secondary elements of an object or a scene, such as a ramp or a pitched roof.

B

background - The part of a scene or picture that is farthest from the viewer. All background elements are there to offer information about the environment and frame the character.

baluster - An object or vertical member having a vaselike or turned outline.

bird's eye view - A view from a high angle as if seen by a bird in flight, often used in the making of blueprints, floor plans, and maps.

blueprint - A design plan or other technical drawing that shows how something will be made.

C

cantilever - A long projecting beam or girder that sticks out from a wall or other structure to support something above it.

center of vision - The precise point on which the eyes of the observer are focused. This point is at the end of the line of sight.

centered composition - The centered way in which something is put together or arranged.

centerline - A real or imaginary line that is equidistant from the surface or sides of something.

central vanishing point - A point in the picture plane that is the intersection of the projections of a set of parallel lines in space onto the picture plane.

chiaroscuro - The distribution of light and shadow in an image.

concentric - Pertaining to the relationship between two different-sized circular, cylindrical, or spherical shapes when the smaller one is exactly centered within the larger one, therefore having the same center.

cone of vision - The cone of vision is the visual region displayed by a drawing that relates to a person's normal vision without his/her peripheral vision.

converge - As parallel lines recede into the distance, they appear to merge at a single point at a person's eye level (also known as the horizon line).

D

diagonal - A straight line that connects two nonconsecutive vertices of a polygon.

diagonal vanishing point - A diagonal point where parallel lines appear to meet in the distance.

down shot - An elevated view from a high angle.

drawing through - Drawing through the form. Thinking about the 3D volume of the object and keeping the form in mind.

Dutch angle - A type of camera shot where the camera is tilted off to one side so that the shot is composed with vertical lines at an angle to the side of the frame.

E

ellipse - A circle in perspective.

eye level - Located exactly at the height of sight (or eyes) at any given time; therefore it follows wherever the viewer goes.

F

façade - The front of the building.

focal length - The distance from the surface of a lens to the point of focus.

foreground - The part of a scene or picture that is nearest to and in front of the viewer.

foreshortening - To shorten the lines of an object in a drawing or other representation to produce an illusion of projection or extension in space.

G

grid of squares - Evenly spaced verticals and horizontals.

ground plane - The theoretical horizontal plane receding from the picture plane to the horizon line.

H

horizon line - A horizontal line across a picture. Its placement defines the viewer's eye level.

horizon plane - A plane that, going through the viewer's eyes,- contains the line of sight.

L

left vanishing point - The spot on the horizon line to which the receding parallel lines diminish. In two-point perspective, the left side has its own vanishing point.

line of sight - An imaginary line that represents the straight direction in which the observer's eyes are looking

long lens - A lens with a long focal length.

M

mid-ground - The part of the picture that is between the foreground and background.

N

nadir - The point located at the opposite end of a zenith, basically the center of the Earth.

O

observer - The character through whose eyes the scene is viewed.

one-point perspective - A rendition of an object with a principal face parallel to the picture plane. All horizontal lines parallel to the picture plane remain as is, and all other horizontal lines converge to a preselected vanishing point.

opacity - The quality of a material that does not allow light to pass through it.

P

parallel - Lines or planes that extend in the same direction, everywhere equidistant, never intersecting.

pencil thumb - Simply stretch an arm in the direction of the object being viewed and hold the pencil (usually vertically or horizontally) to measure the distance between two key points. Hold the pencil in such a way that its tip precisely overlaps one of the key points and then slide a thumb along the pencil, stopping right at the position of another key point. Still holding the pencil just so, move it until it is positioned over the other part of the model that is being compared to the first measurement. It will become obvious which one is relatively longer or shorter and by how much, providing a way to better estimate the proper proportions of the model/scene.

peripheral vision - The act of seeing images that fall upon parts of the retina outside the macula lutea. Also known as indirect vision.

perpendicular - Lines that are right angles (90-degree angles) to each other.

perspective - A technique of depicting volumes and spatial relationships on a flat surface.

perspective grid - A network of lines drawn to represent the perspective of a systematic network of lines on the ground or on X-Y-Z planes.

Photoshop - 2D Digital rendering software designed by Adobe Systems (www.adobe.com).

picture plane - The plane of a drawing that is in the extreme foreground of a picture, is coextensive with but not the same as the material surface of the work, is the point of visual contact between the viewer and the picture.

point of view - A position from which someone or something is observed.

polyhedron - A solid formed by plane faces.

R

ramparts - A protective barrier.

right vanishing point - The spot on the horizon line to which the receding parallel lines diminish. In two-point perspective, the right side has its own vanishing point.

rise - The total height from the floor to the top of the last step.

run - The total length of all the steps projected on the ground plane.

S

spiral composition - Piecing your elements together and eliminating unwanted elements and chaos to create a spiral flow for the viewer to follow.

station point - The position of an observer that determines the perspective rendering of the objects or scene being represented in a drawing.

T

tangents - Meeting a curve or surface in a single point if a sufficiently small interval is considered.

three-point perspective - Often used for buildings seen from above (or below). In addition to the two vanishing points from each wall, there is now one for how the vertical lines of the walls recede.

tonal - Relating to color tones. The lightness or darkness of a color.

tread - The upper horizontal part of a step.

two-point perspective - Linear perspective in which parallel lines along the width and depth of an object are represented as meeting at two separate points on the horizon that are 90 degrees apart as measured from the common intersection of the lines of projection.

U

upshot - Seen from ground level or from the lowest level upwards.

V

vanishing point - That point toward which receding parallel lines appear to converge.

vision - The perception of light, reflected off objects, that comes straight toward the eyes.

W

wide-angle lens - Literally includes a wider view, from left to right and top to bottom, of the subject it points at.

wind rose - Another "pretend" contact lens looked through at all times. It consists of four lines at different angles (vertical, horizontal, diagonal-right and diagonal-left) that help identify the angle of inclination for any given line being drawn, although the drawn line usually does not coincide exactly with any of the wind rose's lines.

Z

zenith - A point located at the top end of an imaginary line that is perpendicular to the ground plane, as if such a line were coming straight out from the center of the Earth, past its surface, and up.

INDEX

MORE FROM MARCOS MATEU-MESTRE

Paperback: 978-1-933492-95-7

Paperback: 978-1-624650-53-6

Paperback: 978-1-624650-32-1

Paperback: 978-1-624650-40-6

FRAMED PERSPECTIVE 1 IS ALSO AVAILABLE IN THESE LANGUAGES

Japanese
from Born Digital

Simplified Chinese
from China Youth Press

French
from Editions Eyrolles

Spanish
from Grupo Anaya

OTHER TITLES BY DESIGN STUDIO PRESS

Paperback: 978-1-933492-73-5
Hardcover: 978-1-933492-75-9

Paperback: 978-1-933492-96-4
Hardcover: 978-1-933492-83-4

Paperback: 978-1-624650-12-3
Hardcover: 978-1-624650-11-6

Paperback: 978-1-933492-65-0
Hardcover: 978-1-933492-66-7

Paperback: 978-1-933492-25-4
Hardcover: 978-1-933492-26-1

Paperback: 978-1-933492-92-6
Hardcover: 978-1-933492-91-9

Paperback: 978-1-933492-56-8
Hardcover: 978-1-624650-29-1

Paperback: 978-1624650-21-5
Hardcover: 978-1624650-28-4

To order additional copies of this book, and to view other books we offer, please visit **www.designstudiopress.com**.

For volume purchases and resale inquiries, please email: **info@designstudiopress.com**.

tel: 310.836.3116

To be notified of new releases, special discounts, and events, please sign up for our mailing list on our website. Follow us on social media:

 facebook.com/designstudiopress

 instagram.com/designstudiopress

 twitter.com/DStudioPress